Public Relations Case Studies
from Around the World

This book is part of the Peter Lang Media and Communication list.
Every volume is peer reviewed and meets
the highest quality standards for content and production.

PETER LANG
New York • Bern • Frankfurt • Berlin
Brussels • Vienna • Oxford • Warsaw

Public Relations Case Studies from Around the World

SECOND EDITION

Edited by

Judy VanSlyke Turk and Jean Valin

PETER LANG
New York • Bern • Frankfurt • Berlin
Brussels • Vienna • Oxford • Warsaw

Library of Congress Cataloging-in-Publication Data

Names: Turk, Judy VanSlyke, editor. | Valin, Jean, editor.
Title: Public relations case studies from around the world /
edited by Judy VanSlyke Turk & Jean Valin.
Description: 2nd edition. | New York: Peter Lang, [2017]
Includes bibliographical references and index.
Identifiers: LCCN 2017019269 | ISBN 978-1-4331-4554-4 (hardcover: alk.paper)
ISBN 978-1-4331-3454-8 (paperback: alk. paper)
ISBN 978-1-4331-4551-3 (ebook pdf) | ISBN 978-1-4331-4552-0 (epub)
ISBN 978-1-4331-4553-7 (mobi)
Subjects: LCSH: Public relations—Case studies. | Organizational behavior—Case studies.
Classification: LCC HD59 .P789 2017 | DDC 659.2—dc23
DOI 10.3726/b11746
LC record available at https://lccn.loc.gov/2017019269

Bibliographic information published by **Die Deutsche Nationalbibliothek.**
Die Deutsche Nationalbibliothek lists this publication in the "Deutsche
Nationalbibliografie"; detailed bibliographic data are available
on the Internet at http://dnb.d-nb.de/.

The paper in this book meets the guidelines for permanence and durability
of the Committee on Production Guidelines for Book Longevity
of the Council of Library Resources.

© 2017 Peter Lang Publishing, Inc., New York
29 Broadway, 18th floor, New York, NY 10006
www.peterlang.com

Printed in the United States of America

Contents

List OF Illustrations AND Tables

CHAPTER 4

CHAPTER 5

CHAPTER 6

CHAPTER 7

CHAPTER 8

CHAPTER 9

CHAPTER 10

CHAPTER 11

CHAPTER 12

Introduction FROM THE Editors

There have been recent and very worthwhile initiatives such as *PR Redefined* and *FuturePRoof,* two recent, separate crowd-sourced initiatives with public relations practitioners from several countries, have looked at the role played by public relations in today's society. But at its core, the mandate of public relations remains one that builds and sustains strong relationships between an organization and its publics, and in doing so, contributes to the betterment of society.

As public relations has become a global profession, relationships have expanded across every continent, region and country in the world. The literature of public relations, particularly case studies highlighting best practices from different parts of the world, has lagged behind this globalization of public relations. The two editors of this collection of case studies, during our travels around the globe, have heard from professors and students of public relations—as well as practitioners—in numerous countries outside North America that there is a lack of "best practices" case studies involving organizations from regions other than North America.

As in the first edition of this book, we wanted in this new edition to address that shortcoming and provide examples of best practices from around the world. Our motivation as editors is to source cases from around the world that demonstrate excellence and contribute to the public relations body of knowledge. As co-editors, we share in recruitment and selection of cases, editing duties and project management on an equal footing. That is why we are listed alphabetically as co-editors.

Both of us are or have been leaders in the Global Alliance for Public Relations and Communication Management (GA), http://www.globalalliancepr.org, a confederation of more than 70 professional societies and associations in

public relations and communication management which has initiated several global initiatives including the Global Body of Knowledge and Capabilities project, the Melbourne Mandate and Stockholm Accords, and a Global Code of Ethics, all of which now provide a global professional beacon for public relations practice. Throughout our global involvement, we have learned of award-winning cases in various countries, many of them unique and transformative cases with the power to shape society and improve lives.

For this second edition, we sought both unique and award-winning public relations cases from around the world that met our criteria of excellence (or in some cases highlighted "reverse" excellence, what not to do), innovation and creativity. Based on our collective experience, we selected 18 cases, some global in scope and others implemented in a given country, which we think are deserving of being shared. Readers will note that a majority of cases follow a typical case study format suggested by the editors. But a few exceptional cases were best presented in somewhat adjusted formats. Most cases won national or international awards; all are current even in today's fast-paced society. Furthermore, we think they reflect the variety of activities in managing public relations and how public relations is practiced in different parts of the globe. We are excited that we can make them available to scholars, practitioners and students at an affordable price point.

In the following pages, readers will find case studies about global brands such as Volkswagen, Cargill, Bayer and Lufthansa and issues addressed by governments. There also are cases that focus on industry initiatives, crisis communication, social justice, sustainability, social media, cultural diversity, measuring the effectiveness of public relations and country-to-country initiatives in public diplomacy.

Here is a very brief snapshot of the cases covered in the book:

- How elements of the theoretically developed "excellence model" of public relations could be used analyze the Volkswagen diesel emissions defeat device and the company's attempts to restore its reputation
- How a local wine producer in Chile created a truly global brand
- How Cargill demonstrated sensitivity to environmental issues surrounding the growth and production of palm oil in Indonesia
- How Italy instilled pride in everything "Made in Italy" while enhancing business and consumer relationships during the World Expo 2015
- How Japan restored a tarnished economic reputation through public diplomacy
- How Ukraine responded after being invaded by Russia and the Euromaidan to restore confidence and how its response had a positive effect on the citizens of Ukraine

- How Atlantic City used systematic measurement tools to evaluate its communications during a multi-year effort to bring tourists back to Atlantic City after Hurricane Sandy
- How Zurich Insurance tracked and measured its reputation on a corporate level and how AkzoNobel evaluated the impact of its corporate reputation on brand success
- How the Australian government measured the effect of a campaign against the use of cannabis
- How the African Union Commission responded to the Ebola virus epidemic
- How Lufthansa responded #indeepsorrow to the crash of Germanwings flight 4U9525
- How the campaign for marriage equality in Ireland illustrated the dynamics of a social justice issue
- How Kuwait used multilingual and multicultural tactics in its campaign to promote safety in food preparation and handling
- How Mead Johnson provided medical support and special infant formula to children with a condition called Phenylketonuria (PKU) in rural areas in China
- How Malaysia's straightforward communication won public acceptance of its introduction of a new consumer tax
- How Bayer Jovens bolstered confidence in a global brand in Brazil through a youth education campaign
- How the United Emirates introduced the world to its new space agency
- How Australia celebrated cultural diversity through food to celebrate differences and enhance social harmony

Case studies can be powerful teaching tools of public relations principles in action for both students and practitioners. They can bring to life theoretical frameworks. They can illustrate the role of public relations practitioners in achieving objectives. And they make the vital link between applied theory taught in classrooms to projects and campaigns such as those selected for this book.

This book's strengths are its global emphasis and our choice of cases that illustrate public relations practices in different countries and in various cultural, economic and even political systems. Furthermore, the case studies provide examples of best practices for practitioners and for educating graduate and undergraduate students all over the world: in Asia, Africa, Oceania, South America, Europe and North America. Together, the cases illustrate how the practice of public relations has evolved globally, is being increasingly practiced with two-way symmetrical characteristics and no longer imposes a universal "one size fits all" approach to global public relations practice.

We hope that through these cases, readers will be able to better appreciate how public relations is practiced around the world and gain insights into how the profession is evolving.

We are immensely grateful to the contributing authors and to the organizational representatives who provided information for these case studies. We also are grateful for the support and encouragement of the Global Alliance for Public Relations and Communication Management for supporting our effort and for helping disseminate information about our book to the global public relations community.

Judy VanSlyke Turk PhD, APR, Fellow PRSA
jvturk@vcu.edu

Jean Valin APR, Fellow CPRS, Honorary CIPR Fellow
jvalinpr@gmail.com

Foreword

What Case Studies Can Teach us in International Public Relations

Public relations scholarship—applied and basic—is bountiful these days. Every published thought is exposed to more rigorous comparison and to more diverse audiences than ever before. This, in turn, forces scholars and reflective practitioners to eke out the specific merit of their every contribution relative to prior published thought. This is good for the practice and the academy.

As in other mature industries and disciplines, the test of any new work becomes the amount of prior published work that no longer needs to be read in order to understand the state of public relations. In this respect, the second volume of "Public Relations Case Studies from Around the World" is already a success. It builds on the success of the first edition which has been used in several universities throughout the world to teach how public relations is practiced and as such provides a snapshot of practice evolution over time. And, it is filled with fresh new cases that explore best practices across a wide variety of niches and examine trending new developments in the application of public relations strategies and tactics.

Additionally, the contributions by the authors that Judy VanSlyke Turk and Jean Valin have convened-all widely respected academics and practitioners-illustrate the specific value of case studies in public relations in a wide variety of contexts. The reader will find insights into how public relations is practiced, how theory is applied (or not), and how success is measured, all this from countries where practice is evolved or evolving.

Unlike management and business education—where case studies are widely used and some of which have reached seminal status—the public relations academy

has too long suffered from the dichotomy between theory-driven empirical work on the one hand and industry anecdotes on the other. The former often gives answers to questions that were never asked; the latter often implies that one person's answer is a helpful response to all others' questions irrespective of context.

Real case studies therefore fill an important gap. Real case studies bear lessons that are valid beyond the situation they describe and thus prepare readers for operating in a cultural context other than their own. Real case studies may lack the certainty of theory or of aggregated data, but that's precisely because they describe the ambiguities and double binds of international practice or of practicing in a region where traditional practice requires a specific application of strategy. And real case studies stimulate experiential learning and self-guided discovery without which no cross-cultural or cross-boundary public relations will create value.

The case studies in this book do all of these things. They are therefore strong contenders for seminal status in the growing body of knowledge about the practices of international public relations.

Professor Gregor Halff
Deputy Dean, Lee Kong Chian School of Business
Singapore Management University
Chair 2016–2017, Global Alliance for Public Relations
and Communication Management

Preface

Readers of scholarly texts expect that the preface will be written by the authors or editors. Not so with this second edition, nor was it with the first. And happily so. Because this is not my own work, I feel free to praise it unabashedly. It is not enough to say that this text is a fine accomplishment. It is, in a word, a gem. Its editors, Judy VanSlyke Turk and Jean Valin, already had storied careers when they produced the first edition of *Public Relations Case Studies From Around the World* with their colleague John Paluszek.

That initial edition sharpened my appetite for more, and here we have it. Turk and Valin are still at the top of their game, attracting impressive authors from around the world. Each author has produced a chapter that is grounded in the literature that has come to serve as a solid foundation for public relations education and practice. Many have based their analysis on primary as well as secondary sources.

The book benefits both from singularity and from diversity of many kinds. Its skillful editing creates the sense of a single, clear voice. At the same time, the cases do indeed come from around the globe, countries as diverse as Japan and the United Kingdom, the United States and Sierra Leone, Kuwait and Chile, Germany and Malaysia, Indonesia and Italy. Readers come to understand the perspectives of communication managers in Africa, South and North America, Asia, Europe, the Middle East, and Australia. Thus, we gain an understanding of a world larger than any single country. The collection of these chapters offers us a rewarding stopover in more places than most of could ever hope to visit.

Some chapters, in particular, several heretofore largely neglected regions of public relations practice. Where else can we learn about public diplomacy, investor confidence, and branding in Ukraine? About the communication campaign for same-sex marriage in Ireland? Or about the launch of a space agency in the United Arab Emirates?

Not only are the chapters geographically diverse; but so, too, are the kinds of public relations described. Perhaps the book's center of gravity, its core, is the management of communication. More specifically, though, we deepen our understanding of crisis communication, public information campaigns, building national and consumer brands, issues management, ethics, corporate social responsibility, measurement, health communication, and special events. The descriptions that capture those varied practices are thoughtful, compelling, and satisfying.

Yet another aspect of the book's diversity is the array of organizational contexts. Chapters seamlessly flow from the top level of government in Japan to the casinos of Atlantic City, New Jersey, USA. We learn about public relations in the corporate setting, such as Volkswagen's global diesel scandal, and in the public sector, such as engaging youth with the life sciences in Brazil. Thus, *Public Relations Case Studies From Around the World*, in my view, appeals to readers of all kinds. It is a first-rate achievement on the part of its authors and editors.

In short, the book is rich and deep. Each chapter is insightful. Vivid details make the chapters live, even hinting at the inner lives of the professionals who were interviewed about their successes and, yes, failures. Chapters are steeped in the elusive depth characteristic of case-study research. As they chronicle what happened, where, and why, they inflame our hope for the future of this practice. The cases—many of them award-winning—meld the perceptions of some of this field's most accomplished scholars and practitioners.

Taken together, the cases make a wonderful addition to the literature of public relations. They also remind us of why Judy Turk and Jean Valin are two of the most important of our colleagues at work today. In this volume, they take us with them on a giant leap forward in our field. I am convinced the book will become required reading for public relations students and enlightened practitioners who value life-long learning. I am already looking forward to a third edition.

Larissa A. Grunig, Ph.D., Professor Emerita
University of Maryland Department of Communication
College Park, Maryland, USA

Case Studies IN Global Campaigns

Volkswagen Emission Scandal

An Example of Bad Public Relations on a Global Scale and the "Defeat Device" that Defeated a Reputation

SHANNON A. BOWEN
University of South Carolina

DON W. STACKS
University of Miami

DONALD K. WRIGHT
Boston University

EDITORS' NOTES

When this scandal broke, many public relations professionals cringed at the damage they saw being inflicted on a trusted brand and could not believe that such deceit had been perpetrated on a global scale. What followed was even harder to watch. Volkswagen management seemed unable, at first, to properly handle the ensuing crisis. The case study reported on in this chapter examines Volkswagen's case of less-than excellent public relations in dealing with its 2015 emissions scandal. The case analyses what is at the root of this issue: corporate culture, and how it contributed to the crisis and loss of reputation. It also offers pathways to redress and restore its reputation based on the theory of excellence in public relations. We chose this case because it represents what not to do in ethics, issue tracking and crisis management.

INTRODUCTION

Recently, Michaelson, Wright, and Stacks (2012) proposed a model of public relations campaign excellence that was explained in practical detail when Stacks, Wright, and Bowen (2014) examined how IBM made strategic use of theory and tactics in an excellent public relations campaign that redefined stakeholder perceptions of the company and its new mission, vision, and values.

This chapter deconstructs the case along multiple lines of analysis from inception to proposed solution and tracks Volkswagen's perceptions in three different cultures. It is important to note, however, that this is not solely a case of ethical misjudgments or miscalculations. This case is first and foremost a case of business wrongdoing through the use of intentional deception that falls well beyond a typical moral dilemma. We believe that this is not only an ethics case because as Bowen and Prescott (2015) and Bowen (2016) have argued, ethics involves complex decisions of competing duties and multiple rights or competing wrongs. Deception is viewed as simply unethical by moral philosophers, and is therefore not a challenging question for ethical analyses (De George, 2010). In other words, deception is *prima facie*, or on the face, unethical and therefore does not warrant the complex analyses of duty and good put forward in ethics.

THE PROBLEM

One of the biggest problems today, and one that has been highly correlated with climate change, is the discharging of toxic emissions into the atmosphere. In this regard governments, have been focusing on measures that limit the amount of emissions in a variety of ways. In the United States emissions are controlled through the Clean Air Act, which supposedly monitors industry to ensure that established standards are met. These standards apply across all industry, but are especially impactful for the auto industry. This case examines one such company—Volkswagen/Audi—and its deceptive practice of altering emissions through computerized software. It should be made clear, however, that this is not the first time the company has been criticized for a lack of ethics and poor managerial decisions. In 1997, for instance, Volkswagen agreed to pay General Motors $100 million U.S. dollars in a corporate espionage case (Meredith, 1997). This lapse in generally accepted business ethics is but one of several plaguing Volkswagen over the years. The emissions "scandal," however, goes beyond the pale and its impact has been worldwide.

Volkswagen

Volkswagen A. G. is Germany's largest corporation, founded over 80 years ago and headquartered in Wolfsburg, Germany. It manufactures both commercial and

passenger vehicles under several different brand names. Volkswagen generated revenues of over $200 billion U.S. dollars in 2014. It has over 600,000 employees worldwide. As such, Volkswagen is one of the world's largest light vehicle manufacturers, with over 10 million sales annually in 2014, clearly outpacing US brands General Motors and Ford Motors.

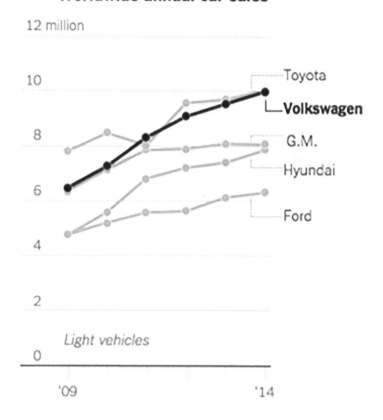

Fig. 1.1. Comparative car sales chart, worldwide. Credit: Russell, K., Gates, G., Keller, J., & Watkins, D. (*NY Times*, 2015, November 25).

THE SCANDAL

After an intensive examination, the US Environmental Protection Agency (EPA), responsible for evaluating and enforcing the US Clean Air Act issued a "notice of violation" to Volkswagen and its luxury brand, Audi (EPA, 2014). (US Department of Justice, 2016):

The Department of Justice, on behalf of the Environmental Protection Agency (EPA), today filed a civil complaint in federal court in Detroit, Michigan, against Volkswagen AG, Audi AG, Volkswagen Group of America Inc., Volkswagen Group of America Chattanooga Operations LLC, Porsche AG and Porsche Cars North America Inc. (collectively referred to as Volkswagen). The complaint alleges that nearly 600,000 diesel engine vehicles had illegal defeat devices installed that impair their emission control systems and cause emissions to exceed EPA's standards, resulting in harmful air pollution. The complaint further alleges that Volkswagen violated the Clean Air Act by selling, introducing into commerce, or importing into the United States motor vehicles that are designed differently from what Volkswagen had stated in applications for certification to EPA and the California Air Resources Board (CARB).

Fig. 1.2. The deception "defeat device." Credit: Russell, K., Gates, G., Keller, J., & Watkins, D. (*New York Times,* 2015, November 25).

The scandal involved installing software to "defeat" EPA testing of diesel exhaust emissions (see Figure 1.2). As such, over 10 million light vehicles had the "defeat device" installed in Volkswagen (5 million), Audi (2.1 million), VW Light trucks (1.8 million), Skoda (1.2 million), and Seat (7,000) company brands. The scandal, unearthed in the US, involved vehicles worldwide: 482,000 in the United States, 2.8 million in Germany, 2.3 million in Europe, and 1.2 million in the UK. The scandal's scale quickly expanded worldwide, resulting in a number of negative consequences. (See Table 1.3 for a timeline of the scandal).

Financially, in the wake of the scandal, Volkswagen share prices fell roughly 40 percent, yielding cuts in many corporate areas, including its capital spending plan. Reputational impact, however, was massive and immediate. Media coverage was worldwide and Volkswagen reached out to Finsburg, Kekst and Hering Schupper for crisis communication help.

Worldwide	> 1,000
Sources	
Newspapers	877
Web	201
News	97
Media Releases	15
Trade Publications	11
Newsletters	4
Magazines & Journals	3
News Transcripts	3
Legal News	1
Selected Regions/Countries	
North America	
United States	513
Canada	43
Europe	
Belgium	2
France	10
Germany	455
Spain	2
UK	172
Asia	
China	32
Australia & New Zealand	34

Fig. 1.3. Media Coverage of the Volkswagen Scandal*

Scandal Media Coverage

As part of the case analysis media coverage was examined. An analysis of the media coverage found two major themes: damage to humans and damage to the environment. An examination of media coverage through Lexis/Nexis Academic finds that coverage was truly worldwide.[1] As demonstrated in Table 1.4, coverage was primarily in developed countries and not only those where Volkswagen and its brand products were sold. As expected, the major coverage came from North America, Europe, and Asia.

Worldwide	> 1,000
Sources	
Newspapers	877
Web	201
News	97
Media Releases	15
Trade Publications	11
Newsletters	4
Magazines & Journals	3
News Transcripts	3
Legal News	1
Selected	
Regions/Countries	
North America	
United States	513
Canada	43
Europe	
Belgium	2
France	10
Germany	455
Spain	2
UK	172
Asia	
China	32
Australia & New Zealand	34

Fig. 1.4. Media Coverage of the Volkswagen Scandal* Author's creation.
*As reported by Lexis/Nexis Academic. Some numbers may be greater than 100 percent due to mixed reporting across platforms and pickups in other than first reported regions and countries.

Media Themes

Based on this, a review of media coverage themes points to four specific categories of themes: defining what specifically determined in the emissions and how they were tested, damage to humans, damage to the planet, and Volkswagen's actions.

What and How

As reported earlier, Volkswagen A. G. engineers created a "defeat device" that included software that detected when a vehicle was being tested and then changed

the engine and therefore emission performance during the test. The emissions first reported by the EPA were found in vehicle models with Type EA 189 engines to specifically reduce NOx (nitrogen oxides) under testing conditions.

Damage to Humans

Altering test results have demonstrated increase in health risks and an MIT study (2015) reported 60 premature deaths in the United States due to excess emission output by calculating the amount of excess pollution, multiplied by the number of affected vehicles sold in the US that significantly impacted on health and raised the *projected* risk as follows: (1) as noted, 60 premature deaths; (2) 31 cases of chronic bronchitis and 34 admissions involving respiratory and cardiac conditions; (3) 120,000 minor restricted activity days, including work absences, and about 210,000 lower-respiratory symptom days; and yielding $450 million in health expenses and other social projects.

Damage to the Planet

Media reports focused on the environmental risks associated with NOx emissions above the EPA Clean Air Act standards. It was reported that Volkswagen Type EA 189 engines emitted NOx pollutant at 40 times the allowed EPA standards. This emission level was projected to produce over one million tons of air pollution per year, releasing 10,392 and 41,571 tons of toxic gas yearly, and 237,161 and 948,691 tons of NOx emissions each year—10 to 40 times the pollution standard for new vehicle models in the US.

VOLKSWAGEN'S RESPONSE

Volkswagen's responses were tepid at best. It began by releasing public apologies, a questionable tactic (Coombs & Holladay, 2008). As typified by this headline: "Global CEO Winterkorn resigned and new management promises a full investigation and promised an action plan." It began to engage in limited social media tactics with the creation of a new website at www.vwdieselinfo.com. In the US, it activated its partnership with Edelman Worldwide to assist in consumer public relations and outside hired Finsburg, Kekst and Hering Schupper for crisis communication assistance.

On April 21, 2016, Volkswagen announced it would buy back over 500,000 light vehicles in the United States at an estimated cost of 7 billion dollars (Ewing, 2016). In early January it was estimated that Volkswagen could face a fine of up to 48 billion dollars (Zhang, 2016). Zhang noted that, "According to EPA officials, each of the 482,000 offending VW cars could be subject to a maximum fine of

$37,500." As early as January, however, the *CNN Monday* was reporting a fine of 18 billion dollars might be levied against the enterprise (Isadore, 2016). On April 21, 2016, The EPA announced a record fine of 18 billion dollars had been reached with Volkswagen (Ewing, 2016). It is, however, questionable whether the entire fine will be collected and analysts predict the final number may be around 1 billion dollars—still a record fine for the industry (Zhang, 2016).

CASE ANALYSIS

Reputational Impact

The emissions scandal hit Volkswagen's reputation hard not only in terms of corporate management, but also related to the overall lack of honesty and transparency of the company's corporate culture. Clearly, given past corporate behavior as described above, Volkswagen's corporate culture led to the enterprise's failure to act in several ways. First, it failed in its internal and external environmental scanning. That is, Volkswagen either observed deceptive engineering and reporting of its emissions and decided to look the other way, or based on its culture decided that sales were more important than transparency and followed business worst practices as demonstrated in past failures in moral behavior and best practices management. Second, Volkswagen's stock and sales were impacted, even after announcement of buy-backs, perhaps because many VW owners appeared ready to take the buy-back and search elsewhere for replacement vehicles. Third, their negative media coverage reached into markets that Volkswagen had yet to enter, thus impacting potential sales in new markets.

Inferring Motive

An interesting reputational analogy can be derived from the work of Gareth Morgan (2006) and tied into Otto Lerbinger's (2011) different crisis types. Morgan talks about corporate communication in terms of metaphors or different ways of viewing a company.[2] He further notes that metaphors can be created at both major and minor levels. A company, for instance, that operates from a scientific management approach (Taylor, 1911) is matched to a "machine" metaphor. If something is not working, the company simply replaces the inefficient element (i.e., worker) with another element. Lerbinger (2011) identifies several major types of crises that may occur, some natural and some human made. Three of these crises deal with management: management deception, management failure, and management misconduct. Looking at the interaction between crisis type and organizational metaphor it is easy to see that an organizational culture that thinks

bureaucratically (machine as major metaphor), with a subculture of deception and misconduct (cultural sub-metaphor) and managerial domination and illusions of realness (domination and psychic prison sub-metaphors) would find itself in crisis mode periodically due to managerial dysfunction. This mismanagement, in turn, leads to moral and ethical business practice lapses. We return to a discussion of the organizational culture inside Volkswagen after a brief examination of its issues management.

Issues Management

Issues management in this case offers another means of analysis. Issues management is the managerial activity of identifying potential problems, issues, or trends able to impact the organization that are ready for managerial analyses and decision-making. Issues management is the internal problem-solving activity that helps an organization adapt to its environment, including the regulatory environment, and solve potential problems *before* they become crises. Although it is clear that Volkswagen failed in issues management, a closer look at the process allows us to pinpoint exactly when and where that failure occurred.

A predominant issues management model was offered by Buchholz, Evans, and Wagley (1994). That model offered six steps of issues management:

1. Identify public issues and trends in public expectations
2. Evaluate impact and set priorities
3. Conduct research and analysis
4. Develop strategy
5. Implement strategy
6. Evaluate strategy. (p. 41)

In this approach, we can see that Volkswagen failed in the very first step of issues management: it failed to anticipate the public expectation of being dealt with honestly, as well as the public issues of environmental responsibility and stewardship.

During the unfolding of this crisis, Volkswagen's 2014 Sustainability Report states that all of its brands (VW, Audi, Scania, Man, Porsche, and Skoda) conduct issues management as part of their sustainability in compliance with the Global Reporting Initiative guidelines. Volkswagen stated that this Sustainability Report was important because: "… it facilitates coordination by creating internal transparency and bundling issues. In relations with the various external stakeholder groups, sustainability reports create the basis for dialogue, communication and trust. They also comply with politicians' growing demands for transparency" (np).

Although the rationale above is correct, the implementation of issues management clearly falls short of even the laxest expectations. Why was issues management

not used at Volkswagen to warn of the impending problem and crisis? On a closer analysis of the Sustainability Report, we conclude that Volkswagen made a similar mistake to that of Enron Corporation (Sims & Brinkman, 2003): A culture of simple compliance seems present in the organization rather than a culture of ethics (Bowen, 2015a). Evidence of this culture can be seen in the reports' emphasis that 185,874 employees participated in compliance training in 2014. However, only 72 employees were terminated for compliance-based wrongdoing in 2014. Further, the Sustainability Report emphasizes employees' "obligation to comply with" a Code of Conduct, yet does not mention the terms ethics, ethical, or moral principle.

The Volkswagen Code of Conduct, similar to that of the infamous Enron company (Bowen & Heath, 2005), fails to specify what moral framework drives decision-making in the organization. The document's preamble includes the ethical concepts honesty, responsibility, human rights, and respect, yet it does not offer ways to implement those concepts or examples of how those concepts can be applied. The Code of Conduct also fails to offer any recognizable framework of moral philosophy to help guide the organization. Like what happened with the Enron scandal (Bowen & Heath, 2005), the document is based on legal compliance rather than ethics based. Because ethics is overlooked, decision-making is driven by organizational culture (Bowen, 2010; Bowen & Heath, 2005; Sims & Brinkman, 2003). A culture of simple compliance is often problematic for an organization because it can exclude ethics in favor of minimalistic legal compliance (Bowen, 2015b). Intentional deception goes even further than a compliance-based culture allows, but we can look deeper into the organizational culture inside Volkswagen for an explanation.

At this point we return to Lerbinger's (2011) discussion of a culture of management deception. The inattention given to ethics and Volkswagen's Code of Conduct document and Sustainability Report are telling of an organizational culture that *assumes* ethics rather than enculturated ethics. Bowen's (2002) research found that assuming ethics meant that it was often not considered at all. Further, these documents seem to be isolated rather than enculturated and used throughout the organization's culture in routine decision-making (Seeger, 1997). Therefore, we can conclude that the organizational culture inside Volkswagen was one that allowed "workarounds" due to the inattention given to ethics, and that the issues management process was ignored—allowing a managerial culture of deception to arise as a workaround. It is likely that a culture of deception saw issues management as one more checkbox to be completed rather than an essential and valuable warning system of organizational problems, including ethical issues. When issues management is seen as one more hurdle to be complied with, simply a requirement of headquarters, it loses its predictive ability as an early warning system and a dangerous culture of workarounds and outright deception (Lerbinger, 2011) can take hold.

Actions

When an organization exists without making full use of an issues management system, management is at risk of making unchecked and ill-advised decisions. The system becomes out of balance with its environment and unhampered by the ethical concerns that should be a routine part of good strategic management and of any crisis-related public relations program. Workarounds become commonplace even when it means working around good management practices, and eventually even deception becomes commonplace (Lerbinger, 2011; Sims, 1994). This is what business ethicist Goodpaster (2007) termed "organizational pathology." Such is the case with Volkswagen.

Several actions could have been undertaken to prevent the large-scale crisis that ensued when the intentional deception of the defeat device was publicly revealed to the world. Volkswagen could study, understand, define, and codify a consistent set of ethical values and adopt a framework for ethical decision-making that can be consistently institutionalized (Goodpaster, 2007) and applied across the organization and its brands. Volkswagen's organizational culture should be revamped to include more reliance on ethics as responsible management, the ethical responsibilities of individuals, and using a consistent means of moral analysis to confront management dilemmas (Sims, 1994). It would then have to put its ethical beliefs into action, by modeling and rewarding ethical behavior, to demonstrate ethical commitment through actions, not only words (Goodpaster, 2007).

Volkswagen also should have used the issues management process to determine trends and identify problems. A revised and adapted issues management framework could help place moral responsibilities at the forefront of managerial decision-making. To Buchholz et al.'s (1994) issues management model, we add the following first step and ethical considerations that can help prevent a Volkswagen-type crisis:

> *Determine core values and emphasize them throughout organizational culture*
> Identify public issues and trends in public expectations, *including ethical responsibilities of management*
> Evaluate impact and set priorities
> Conduct research and analysis, *including an ethical framework*
> Develop strategy *based on enacting core values*
> Implement strategy
> Evaluate strategy *and ethical response.*

Although making ethical values more obvious in the issues management process does not guarantee ethical behavior, it does make it harder to ignore ethics in favor of deception. Even if the culture of workarounds takes hold, returning to this revised seven-step issues management process should help return clarity about good management practices to an organization.

Another action apparently overlooked in this situation was telling the truth and realizing how important such actions might be to Volkswagen's overall business success. Instead of immediately acknowledging the seriousness of the emissions problem, VW downplayed everything.

From the Excellence Campaign Perspective

As noted earlier, the Volkswagen scandal was more than a lapse in ethics: it was a concerted effort in deception and management misconduct. Had management taken the time to think through their actions prior to falsifying the data and backtracked their logic from an ethical standard (see Bowen & Stacks, 2013a), the results may have been quite different. As Martin and Wright (2016) note, the ethical decision-making process can yield faulty assumptions. That's why they highly recommend the corporate communications function should play a dominant role in organizational decision making. Advancing on this theme, Bowen and Stacks (2013a, 2013b) argue for a Kantian approach to decision making instead of a Utilitarian approach. Further, as discussed by Michaelson, Wright, and Stacks (2012) and Bowen and Stacks (2013a, 2013b), underlying all excellent campaigns is a question of ethical responsibility—responsibility to the stakeholder (customer, employee, stockholder and so forth), company, countries the enterprise operates in, and the general well-being of the public and environment. Based on what we have seen with Volkswagen, an analysis of the Excellence Pyramid inversed provides a new strategy to expand the profession's knowledge base regarding what some believe is a "crisis" and others view as simply extremely bad to terrible management decision-making. In this regard we believe the latter is a more appropriate evaluation of the events and communications that came out during the scandal.

The Excellence Pyramid

The campaign excellence pyramid sets three outcome levels, two of which have multiple components (see Figure 1.5). To be an excellent campaign an organization must meet criteria at each level; failure to meet one criterion disqualifies the campaign at that level and no further progress can be made. A quick examination of the first, or basic level, finds the criteria based on what Wright (1998; Stacks, in press) encompasses all three phases of a campaign: developmental, where strategy and baseline data are established; refinement, where the campaign tactics are employed and the campaign's informational, motivational, and behavioral objectives are measured against (1) the baseline and (2) the expected benchmarks (see Figure 1.6); and finally, the evaluation phase where the final outcomes are evaluated against baseline and client goals and objectives.

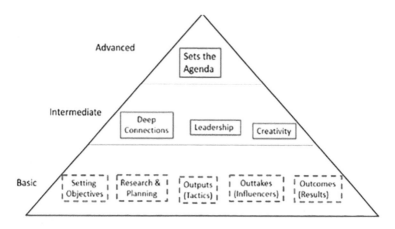

Fig. 1.5. Campaign excellence pyramid. Author's creation.

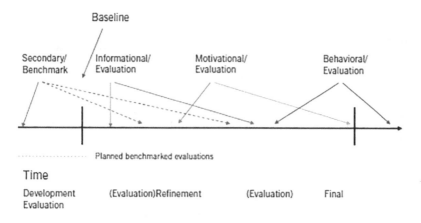

Fig. 1.6. Research timeline. Author's creation.

The second, or intermediate level, demonstrates how the campaign draws on and emphasizes stakeholder relationships as an indicator of campaign success. Setting "deep connections" with stakeholders helps build credibility, trust, reputation, and confidence in the campaign's objectives and overall goal. The leadership criterion focuses on the buy-in by and support of the senior management team as to the communication strategy devised by the public relations function relative to enterprise goals and objectives. The third criterion, creativity, focuses on new and novel approaches to the campaign (e.g., uses of social media, addressing stakeholders, traditional media, and other communication tactics).

The third, or advanced level, focuses on how the particular enterprise/industry, other public relations professionals, and the enterprise's own management team sees the campaign as excellent. As such, excellent campaigns will set the

agenda for campaign strategy within the industry and profession, while simultaneously bringing the campaign team (internal or external) into future discussions regarding other enterprise public relations campaigns.

In the pyramid (see Figure 1.5), it is clear that it closely approximates Abraham H. Maslow's (1943, 1954) "Hierarchy of Needs" as reflected by the significant others within the enterprise's industry and peer public relations professionals. In our analogy, self-actualization is rewarded by being regarded by professional industry peers as setting the requirements for success. Looking at the pyramid we can see where previous enterprise failures may lead to business decisions that leave the enterprise devoid of strategy due to feelings of superiority, ending in feelings of cognitive superiority (Whyte, 1952) and more described by Irving Janis (1971, November) as "groupthink," whereby he stated, "The main principle of groupthink, which I offer in the spirit of Parkinson's Law, is this: *The more amiability and esprit de corps there is among the members of a policy-making ingroup, the greater the danger that independent critical thinking will be replaced by groupthink, which is likely to result in irrational and dehumanizing actions directed against outgroups*" (p. 114). Coming back to Volkswagen's scandal it should be apparent that prior enterprise history, where ethical and/or moral business decisions may have built a self-actualization that others (competitors such as General Motors and regulators such as the EPA) were inferior to themselves, where groupthink led to bad business judgment.

Volkswagen set aside a large sum ($7.3 billion U.S. dollars) to "fix" vehicles impacted by the deceptive software. Given Volkswagen's previous experiences in buying out lawsuits it is unclear how much money was put aside to "pay off" any fines, but clearly from historical action it would fit with and demonstrates "groupthink" orientation to business as usual or simplistic compliance with minimal standards. Further, given a lack of deep connections with the media, it was described as a company that put profits above customers, countries, and the planet in general.

Looking back at the scandal's timeline, it is clear that the communication function failed to have an effective communication plan in place to meet the hostile media environment it found itself in. Hence, Volkswagen had not set clear goals and objectives (other than to hopefully wait out the scandal, pay a fine, and then continue as if was business as usual). Perhaps due to the lack of attention to issues management, it took Volkswagen almost four months to understand it had a major problem on hand. Not until late September were public relations counselors brought in to address the global reaction to the scandal. After this date a number of internal and external changes occurred that helped Volkswagen to regain some direction in crisis communications—corporate officer resignations, suspensions, and restructuring the management team, finally taking a social media stance, owning up to its actions, explaining to employees actions to be taken, and hiring outside public relations counsel.

The use of the revised issues management process model, introduced above, as well as the campaign excellence pyramid can help organizations guard against a culture of management deception leading to organizational calamity.

SUMMARY

This chapter deconstructed the public relations problem caused in 2015 when Volkswagen was accused of discharging toxic emissions into the atmosphere. The scandal involved installing software to defeat Environmental Protection Agency and Department of Justice testing of diesel exhaust emissions in Volkswagen and Audi automobiles. The chapter goes into detail about what happened and how this managerial decision impacted the reputation of the Volkswagen organization. It also outlines possible avenues Volkswagen might use for reputation redress and restoration.

Date	Event
May 2014	Researchers at W VA University and the International Council on Clean Transportation say VW diesel Jetta (2012) and Passat (2013) have significantly higher in-use emissions. VW insists the differences are due to technical issues.
Dec 2014	VW issues voluntary recall of diesel cars in CA to address the issues.
May 2015	CA Air Resources Board (CARB) tests the updated emissions on a 2012 Passat. Some improvement found, but not enough to meet CARB standards.
July 8	CARB shares its findings with VW.
July 8- September 3	CARB and EPA refuse to certify VW's 2016 diesel slate. Certification is necessary before the cars can be sold.
September 3	VW admits its diesel cars contain "a defeat device to bypass, defeat or render inoperative elements of the vehicle's emission control system," CARB says. The cars produce emissions 10-40 times higher than EPA limits.
September 18	VW story hits the news cycle Friday afternoon, Eastern Time, as EPA says VW violated Clean Air Act.
September 19	VW of America instructed dealers to stop selling their remaining 2015 diesel cars with 2.0 liter engines, a day after federal and California regulators said the company deliberately avoided meeting environmental regulators with technology installed in its diesel cars.

Date	Event
September 20	VW CEO Martin Winterkorn says he's "deeply sorry" for violating EPA standards and orders and external investigation.
September 21	VW's stock drops 18% on Wall Street. American CEO, Michael Horn, bluntly apologizes at launch of 2016 Passat.
September 22	VW says 11 million of its diesel cars globally contain the "defeat device." The automaker sets aside 7.3 billion to fix the cars. Share prices drop 20%.
September 23	CEO Martin Winterkorn resigns; says he lacks knowledge of the affair, but accepts responsibility for it.
September 25	Porsche chairman Matthias Muller named Volkswagen CEO. The company suspends several executives and announces restructuring.
September 27	VW launches vwdieselinfo.com, a consumer site containing company statements and answers to FAQs.
September 28	"Nothing can justify deception and manipulation," Muller says in a speech to 1,000 employees. Company suspends three of its top engineers, the executives leading R&D for its flagship Volkswagen, Audi and Porsche brands, on Monday morning.
September 30	The firm has taken on a trio of communications firms to assist its global reaction in the crisis. Also, VW pledged to contact all affected customers directly.
October 1	Hans-Gerd Bode replaces Stephan Gruhsem as Head of Group Communications, Investor Relations and External Relations.
October 8	Michael Horn testifies in front of the U.S. House of Representatives' Energy and Commerce Committee and Commerce Committee Subcommittee.
October 6	CEO Matthias Mueller told employees on Tuesday to get ready for large cutbacks as the automaker responds to the scandal. "This will not be painless," he told reporters.
October 15	First government-required recall, (2.4 million cars).
November 2	EPA said "defeat devices" were also installed in some Porsche models, adding 10,000 cars to the list. An unknown number of 2016 models include the technology.
November 10	Volkswagen's head of corporate communications quit on Monday, making him the latest high-profile executive to leave the company amid its emissions scandal.

Fig. 1.7. Volkswagen scandal timeline.

POSTSCRIPT

On October 25, 2016, Volkswagen AG won final approval with the U.S. Environmental Protection Agency and the Federal Trade Commission for a record $14.7 billion settlement over its emissions scandal. Bloomberg reported that the company has now earmarked $19.5 billion to cover the settlements to dealers, owners, and states (Kartikay & Fisk, 2016). Volkswagen is not out of the doghouse quite yet. There are multiple on-going civil and criminal investigations and class-action lawsuits that could still yield future trials. Additionally, *The New York Times* (Clark, 2016) reported that Volkswagen has yet to stabilize its brand after the scandal, with profits down 45 percent for passenger cars, including its Audi line. Adding to its troubles, Volkswagen may be facing legal trouble in its home country with a senior employee pleading guilty to fraud—thus leaving other high-level managers open to criminal prosecution in Germany. Finally, the agreement does not cover European or other country complaints. Over 500,000 more automobiles would have to be fixed or possibly repurchased by Volkswagen if similar agreements are not negotiated.

The diesel engine emission cheating has and will continue to affect Volkswagen AG's reputation and thus its bottom-line profits for the foreseeable future. In today's fast-paced and litigation-heavy world arrogance and deceptive practices are almost always going to be found, communicated about through social media consumer complaints, and damages will continue to hound companies that seek to put profits over social and civil responsibilities.

Authors' Note

The authorship of this chapter is alphabetical. Each author contributed equally to the chapter's content. The author would like to express their appreciation for helping research this case to Claudia McSweeney of the University of South Carolina; and Elizabeth Rhee, Sarah Blakely, Stephen Chang, Yi Yang, Ting-an Chung, Isabel Alvarez Medina, Charlotte Cohen-Lachkar, and Christy Chen of Boston University.

NOTES

1. Lexis/Nexis Academic limits searches to 1,000 articles, stories, or web-produced materials. Although this is a severe limitation, it is *probably* a good representation of the scandal's media coverage.
2. Morgan (2006) proposes eight general metaphors: Machine, Culture, Brain, Political System, Psychic Prison, Transformation, Psychic Prison, and Organism. Each metaphor, however, can be composed of several different sub-metaphors that deal with different functional elements within the enterprise.

REFERENCES

Bowen, S. A. (2002). Elite executives in issues management: The role of ethical paradigms in decision making. *Journal of Public Affairs, 2*(4), 270–283.

Bowen, S. A. (2015a, October 30). Thank goodness for Volkswagen: It reminded us of why ethics matter. *P. R. Week*. Retrieved from http://www.prweek.com/article/1370843/thank-goodness-volkswagen-reminded-us-why-ethics-matter

Bowen, S. A. (2015b). Exploring the role of the dominant coalition in creating an ethical culture for internal stakeholders. *Public Relations Journal, 9*(1), 1–23. Retrieved from http://www.prsa.org/Intelligence/PRJournal/Documents/2015v09n01Bowen.pdf

Bowen, S. A. (2016). Clarifying ethics terms in public relations from A to V, authenticity to virtue. BledCom special issue of PR review sleeping (with the) media: Media relations. *Public Relations Review*. Retrieved from http://dx.doi.org/10.1016/j.pubrev.2016.03.012

Bowen, S. A., & Heath, R. L. (2005). Issues management, systems, and rhetoric: Exploring the distinction between ethical and legal guidelines at Enron. *Journal of Public Affairs, 5*, 84–98.

Bowen, S. A., Rawlins, B., & Martin, T. (2010). *An overview of the public relations function*. New York, NY: Business Expert Press.

Bowen, S. A., & Stacks, D. W. (2013a). Understanding the ethical and research implications of the social media. In M. W. DiStaso & D. S. Bortree (Eds.), *Ethics of social media in public relations practice* (pp. 217–234). New York, NY: Routledge.

Bowen, S. A., & Stacks, D. W. (2013b). Toward the establishment of ethical standardization in public relations research, measurement and evaluation. *Public Relations Journal, 7*, 1–25.

Bowen, S. A., & Prescott, P. (2015). Kant's contribution to the ethics of communication. *Ethical Space: The International Journal of Communication Ethics, 12*(2), 38–44.

Buchholz, R. A., Evans, W. D., & Wagley, R. A. (1994). *Management responses to public issues: Concepts and cases in strategy formulation* (3rd ed.). Upper Saddle River, NJ: Prentice Hall.

Clark, N. (2016, October 27). How Volkswagen is faring after the emissions deception. *The New York Times*. Retrieved from http://mobile.nytimes.com/2016/10/28/business/volkswagen-earnings-emissions-deception.html?_r=0&referer=https://t.co/3U1eByMrs2

Coombs, W. T., & Holladay, S. J. (2008). Comparing apology to equivalent crisis response strategies: Clarifying apology's role and value in crisis communication. *Public Relations Review, 34*, 252–257.

De George, R. T. (2010). *Business ethics* (7th ed.). Boston, MA: Prentice Hall.

Environmental Protection Agency (EPA). (2014, November 2). *EPA, California Notify Volkswagen of Additional Clean Air Act Violations*. Retrieved from https://yosemite.epa.gov/opa/admpress.nsf/0/4A45A5661216E66C85257EF10061867B

Ewing, K. (2016, April 21). Volkswagen reaches deal with U.S. over emissions scandal. *New York Times*. Retrieved from http://www.nytimes.com/2016/04/22/business/international/volkswagen-emissions-settlement.html?_r=0

Goodpaster, K. E. (2007). *Conscience and corporate culture*. Malden, MA: Blackwell.

Isadore, C. (2016, January 4). Volkswagen could be hit with $18 billion in U.S. fines. *CNN Money*. Retrieved from http://money.cnn.com/2016/01/04/news/companies/volkswagen-emissions-cheating-suit-fine/

Janis, I. L. (1971, November). Groupthink. *Psychology Today, 5*, 43–46, 74–76.

Kartikay, M., & Fisk, M. C. (2016, October 25). VW buybacks to begin under $14.7 billion diesel-cheat accord. *Blumberg Markets*. Retrieved from http://www.bloomberg.com/news/articles/2016-10-25/vw-judge-approves-14-7-billion-diesel-cheating-settlement

Lerbinger, O. (2011). *The crisis manager: Facing disasters, conflicts, and failures* (2nd ed.). New York, NY: Routledge.

Martin, D., & Wright, D. K. (2016). *Public relations ethics: How to practice PR without losing your soul.* New York, NY: Business Expert Press.

Maslow, A. H. (1943). A theory of human motivation. *Psychological Review, 50,* 370–396.

Maslow, A. H. (1954). *Motivation and personality.* New York, NY: Harper and Row.

Meredith, R. (1997, January 9). VW agrees to pay GM $100 million in espionage suit. *New York Times.* Retrieved from http://www.nytimes.com/1997/01/10/business/vw-agrees-to-pay-gm-100-million-in-espionage-suit.html

Michaelson, D., Wright, D. K., & Stacks, D. W. (2012). Evaluating efficacy in public relations/corporate communication programming: Towards establishing standards of campaign performance. *Public Relations Journal, 6.* 20–21

Morgan, G. (2006). *Images of organizations* (updated edition). Beverly Hills, CA: Sage.

Russell, K., Gates, G., Keller, J., & Watkins, D. (2015, November 25). How Volkswagen got away with diesel deception. *New York Times.* Retrieved November 6, 2015, from http://www.nytimes.com/interactive/2015/business/international/vw-diesel-emissions-scandal-explained.html

Seeger, M. W. (1997). *Ethics and Organizational Communication.* Cresskill, NJ: Hampton.

Sims, R. R. (1994). *Ethics and organizational decision making: A call for renewal.* Westport, CT: Quorum.

Sims, R. R. & Brinkman, J. (2003). Enron ethics, or: Culture matters more than codes. *Journal of Business Ethics, 45,* 243–256.

Stacks, D. W. (in press). *Primer of public relations research* (3rd ed.). New York, NY: Guilford.

Stacks, D. W., Wright, D. K., & Bowen, S. A. (2014). IBM's smart planet initiative: Building a more intelligent world. In J. Turk, J. Valin, & J. Paluszek (Eds.), *Public relations cases from around the world* (pp. 1–22). New York, NY: Peter Lang.

Taylor, F. W. (1911). *The principles of scientific management.* New York, NY: Harper & Brothers.

US Department of Justice. (2016, January 4). *United States Files Complaint Against Volkswagen, Audi and Porsche for Alleged Clean Air Act Violations.* Retrieved from https://www.justice.gov/opa/pr/united-states-files-complaint-against-volkswagen-audi-and-porsche-alleged-clean-air-act

Volkswagen. (2014). *Sustainability report: Reporting und (sic) issues management.* Retrieved from: http://sustainabilityreport2014.volkswagenag.com/strategy/reporting-and-issues-management

Whyte, W. H., Jr. (1952, March). Groupthink. *Fortune.* 114–117, 142, 146. Retrieved from http://fortune.com/2012/07/22/groupthink-fortune-1952/

Wright, D. K. (1998, November). *Research in strategic corporate communication.* New York, NY: The Executive Forum.

Zhang, B. (2016, September 21). There's no way Volkswagen will pay the US $18 billion in fines for cheating on emissions tests. *Business Insider.* Retrieved from http://www.businessinsider.com/theres-no-way-volkswagen-is-going-to-pay-the-us-18-billion-in-fines-for-cheating-on-emissions-tests-2015-9

Chile Becomes A World Player OF THE Wine Industry

The Legend of "Casillero del Diablo"

JUAN-CARLOS MOLLEDA
School of Journalism and Communication,
University of Oregon

FRANCISCO SOLANICH
School of Public Relations, Universidad del Pacífico

EDITOR'S NOTE

This case was selected for our case study book because of the deliberate strategy to create a new global brand with the power of storytelling, careful marketing and public relations strategies. It shows the power of storytelling and demonstrates that companies who know how to market also know how to use public relations at the core of their business.

BACKGROUND

Concha Y Toro is the largest producer of wines from Latin America and one of the global leaders in this field. The company owns vineyards in Latin America and has purchased several vineyards in California.

In Chile, the company own vineyards in the Maipo valley (vineyards Puente Alto, Pirque and Santa Isabel), the Maule valley (vineyards Rauco, Lontué, San Clemente and Curico), the Rapel valley (vineyards Peumo and Rucahue), the Casablanca valley (vineyard El Triangulo) and in Argentina (vineyard Trivento).

Concha y Toro also bought the California portfolio of wines from Brown-Forman in 2011 which includes these companies (Wine Spectator, 2011):

- Fetzer, wine
- Bonterra, wine
- Five River Wines
- Bel Arbor Wines
- Jekel Vineyards
- Coldwater Creek Wines
- Sanctuary Wines
- Little Black Dress Wines

One of their brands-"Casillero del Diablo"-has a singular story and unique brand to match within the wine industry. By 2015, Chile-based winery Concha y Toro was the largest producer and exporter of wines in Chile and was considered "The World's Most Admired Wine Brand" by Drinks International (Concha y Toro, 2014). The winery was founded in the 19th century when Don Melchor Concha y Toro, a young lawyer, married into the up-scale Subercaseaux family. The marriage of Don Melchor to Doña Emiliana Subercaseaux linked the Concha y Toro family to her father, who owned most of the Maipu River Valley, south of the country's capital, Santiago. The winery was founded in 1883 soon after the new son-in-law imported grapevines from the Bordeaux region in France. He began planting them in the new vineyard and the wine that would soon become a legend was born. The company now produces several varietals including: Chardonnay, Sauvignon blanc, Semillon, Gewürztraminer, Cabernet Sauvignon, Merlot and Carmenère.

The legend grew from an actual anecdote, which was obviously elevated to create the lore behind the brand. Although bottles of wine were kept under key and lock, many bottles mysteriously kept disappearing from the cellar. To dissuade those mysterious wine thieves, Don Melchor decided to spread a rumor saying the devil lived in his cellar, which became known as "Casillero del Diablo," which translates as the "devil's cellar" in Spanish.

Legend has it that when this rumor was spread it was not long before people with access to the cellar trembled with fear and the wines stopped disappearing (Ibáñez, 2012). After Don Melchor's death in 1892, his son Juan Enrique Concha Subercaseaux took the position of general manager. By 1933, Concha y Toro was traded on Santiago's Stock Exchange (Viña Concha y Toro S. A., 2014). The multi-Latina company (a.k.a., Latin American multinational company) then launched in 1996, the brand "Casillero del Diablo," a wine that is made from selected cabernet sauvignon grapes and aged for almost two years. Nowadays the brand offers several varietal wines and blends trading under that banner. Based on the 130-year-old legend of the devil's cellar, Concha y Toro was "able to develop one of the most

successful wine brands in the world, based on tradition, quality and innovation," according to Sebastian Aguirre, global marketing director for Casillero del Diablo.

Marcelo Papa its winemaker commented, "Casillero del Diablo reflects Chile as a country, rather than a specific region. We seek the best expression of each variety and our work has been focused on identifying the most ideal zones for growing each grape. For example, 15 years ago, Casillero del Diablo Sauvignon Blanc was made from grapes from the Central Valley: today it comes from the coastal vineyards. Or Casillero del Diablo Chardonnay, which had a significant percentage of fermentation in casks but for which we have reduced the amount of wood in the blend, seeking a fresher and more mineralized wine. These shows that it is a brand that is constantly changing in order to remain in line with fashion and what our consumers want, something that we are always sensitive to" (Concha y Toro, 2014).

SITUATION ANALYSIS

"Old World" VS "New World" Wine

For many years, the world's wine industry has described itself in terms of a simple opposition between the "Old World" and the "New World" wines. The "Old World," primarily countries such as France, Italy, Greece, and Spain have been known, or perceived to be, of higher value. Wine from Chile and a host of other nations—e.g., Argentina, Australia, South Africa, and New Zealand—called "New World" wines, have had a comparatively lower perceived and real value in the market place. This distinction has influenced the marketing communication strategies and the political stances of wine producers on different sides of the globe (Banks & Overton, 2010). In the mid-1980s, Chile-based wine companies began exporting wines to European countries and the United States at a low price and emphasized quality to compete with the lower-priced wines available in those markets. Concha y Toro used this as a global strategy to secure a sizeable market share and visibility for Chilean wines throughout the world (Viña Concha y Toro S.A., 2016). In 2016, Concha y Toro is still known by the attributes of that earlier strategy: quality wine at an affordable price ("50 Wines You Can Always Trust," 2016). It has become indeed a truly global brand with a unique story. Casillero del Diablo isn't just one of the best value brands in the world; it's also a barometer of Chile's changing wine scene (Moore, 2014).

GOAL

For Casillero del Diablo to become the number one wine brand in the world both in sales level and brand recognition.

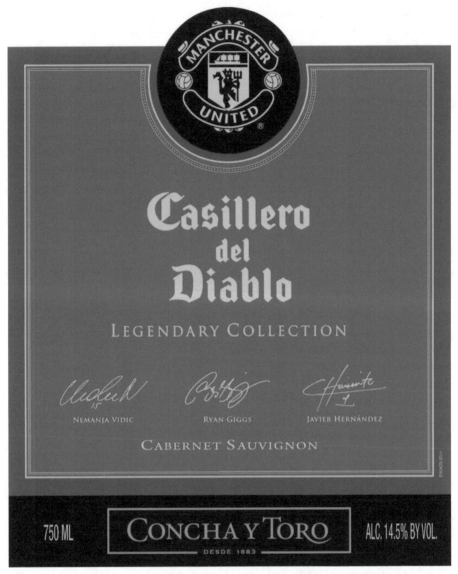

Fig. 2.1. Casillero del diablo label. Public domain, acknowledgment to Concha y Toro.

TARGET AUDIENCES

Casillero del Diablo's target audience is wide thanks to the different products that the brand owns. Segment audiences include those looking for wines at a lower price point and those looking for a higher-end experience. Price points range from the Reserva (the classic), which in Chile sells for US $ 6.31 per bottle; then the Devil's

Collection, US $ 7.34 per bottle; followed by Casillero del Diablo's Super Premium Reserva Privada, US $ 8.82 per bottle; and finally, Casillero del Diablo's Leyenda, an ultra premium wine, at $ 36.78 per bottle. This range of products enables the company to expand its range of services to reach more audiences not only in Chile but all over the world. Due to its large supply and volume of product available to supply global markets, similar prices and price-steps for its sub-brands and varietals are achieved in most of its global markets. It should be noted that in the wine business, the producer does not set or negotiate the retail price. It only negotiates the bulk or wholesale selling price to its distributors and retailers all over the world.

STRATEGY

The strategy was to position one brand and its family of wines- Casillero del Diablo- as a global brand destined for all global markets with a single message and marketing plan.

The wines are promoted through global campaigns with emphasis on the brand concept and its inherent value proposition. The idea is to convey the same message to all audiences, and based on this, appeal to a wide cross-section of consumers.

This strategy can be achieved through three pillars:

- *Quality* in the products, both with a broad portfolio of "cepas" (strains), and highlighting the awards that the brand has received due to the quality of its wines. In other words, it wants to be recognized as a "best buy" brand or by recognition to the value of the brand
- It is important to emphasize the concept of *Brand Building*. This can be achieved through campaigns that are 360°, turning everything to give Casillero del Diablo the best value, with strong Above-the-line (ATL) campaigns in the media and Below-the-line (BTL) campaigns, which favor direct engagement with the market as well as with a complete distribution of the products with affordable prices to consumers
- A brand with a *Global Approach*, not only to be present in 147 countries, but to maintain a consistent message in all countries where the company is present today, managing to reach our consumers with the same message-presenting economies of scale in campaign and creative costs which results in a strategic and competitive advantage.

TACTICS

To achieve global success Concha y Toro employs a wide range of tactics such as media campaigns, social media, event marketing, direct point-of-sale marketing and

sponsorship. For example, one of the Casillero del Diablo video spot on YouTube has over 1.3 million views and another over 600,000. One of the tactics that the company is most proud of is its sponsorship with the Manchester United football club.

Sponsorship of Manchester United

Pursuant to its global branding strategy, in 2010, Concha y Toro signed a deal with Manchester United Football Club, to have *Casillero del Diablo* become their official sponsor. Through this three-year agreement, the company hoped to further improve its brand reputation globally, with particular focus on the key markets of Asia, Latin America, and Eastern and Northern Europe where football is a dominant sport (Wilmore, 2015). "Our alliance with Manchester United has been much more than a sponsorship. It is a long-term partnership with mutual benefits between two global brands, both admired worldwide," stated Concha y Toro President, Alfonso Larrain. "Brand image and a consistent message was the key to unlock these markets for the brand. Our evaluation of this partnership is highly favorable, first due to its global scope: Our advertising reached a potential audience of 1.15 billion television viewers and we have held brand activations directed to our clients using the club's image" (Viña Concha y Toro S.A., 2011).

Since 2010, "Manchester United (ManU) has been a great platform for these purposes, because for us, it was the completion of a strategy that started back in 2001, when ManU decided to go for Casillero del Diablo as their sponsor brand," said Javier Brzovic who is in charge of Marketing Communications at Concha y Toro Winery (J. Brzovic, personal communication, October 21, 2016). It took almost a decade for the company to develop the partnership with Manchester United. Concha y Toro UK (CyT UK) set up business in Oxford to work closely with this important market in 2001. "From an initial team of two, the office has grown to over 60 strong in 2015," CyT UK documented ("Our History and Achievements," 2001).

Today, "ManU allows us to reach new consumers inculcating similar concepts that both Casillero del Diablo and the English soccer team have, such as globality, being a recognized brand, achievement sharing, and other similarities that both brands share," (J. Brzovic, personal communication, October 21, 2016).

An important component of Concha y Toro's growth strategy was its practice of closely managing its distribution network in its key markets and the sponsorship provides a platform for executing this element of the plan. This strategy also provided greater visibility for the company's brand worldwide, apart from bringing business objectives in key countries in line with those of the parent company in Chile. One of the toughest categories on supermarket shelves is wine. There are more labels out there than there are brands (Wehring, 2015). One of Concha y Toro's goals was to create a brand that consumers would consider for repurchase and the best way to do that was through brand building. By creating a campaign

with Manchester United, "Concha y Toro" could achieve visibility throughout the world and thereby enhance its position in the marketplace and in people's minds.

These are some of the distinctive characteristics of Casillero del Diablo described on the Manchester United's website:

- Its premium and super premium lines are prominent for their extensive range of wine varieties and excellent value for money, and are available in more than 135 countries
- Casillero del Diablo range includes more than 10 varieties, going from the more classic to the more exotic, delivering different experiences to our consumers: it is Chile's most complete range of wines
- There are many similarities between Casillero del Diablo and Manchester United—tradition, quality, work excellence and a renowned presence all over the world
- Casillero del Diablo wines are served in the VIP suites at Old Trafford, and those who attend a game will see the brand advertising on the digital boards.[1]

Key Messages for the Sponsorship

The *Wine Legend*, seal, and concept present in all Casillero del Diablo campaigns, that keep alive the origin of this brand which was born more than 130 years ago. In particular, these are some of the key messages used during the campaign that went from 2010 to 2015:

- Concha y Toro executives and British football club Manchester United iconic players and staff, agree to mutually strengthen both brands
- Casillero del Diablo is available in Old Trafford's bars and lounges during matches
- New television spot launched by Casillero del Diablo, receives plenty of praise and good reviews in the first few days it has been on air, after a year of being Manchester United's official wine
- Casillero del Diablo's excellent presence stands out once again during the English football team Manchester United's recent Asian tour in July 2013
- Casillero del diablo shines at the devil's match along with Manchester United in 2015.

EVALUATION AND MEASUREMENT

Per Sebastian Aguirre, the Casillero del Diablo Marketing Manager, the brand reaches a wide range of consumers in terms of age and nationality. On the one

hand, the style of the wine and its communication appeals to the young, but also connects with more traditional consumers through its legend and more classical packaging. This is the best example of how Concha y Toro manages to transform a local brand into one of a more global character, today present in 147 countries (Concha y Toro, 2014). Casillero del Diablo's competitive pricing and its wine distribution network and strategies are only two of the components that help with their public relations and brand reputation.

Casillero del Diablo's website is another tool the brand uses to help respond to the needs and tastes of a wide target consumer. The website is clean and highlights the wine legend campaign but also illustrates the main information of the wine through its "winemakers," "news," and "around the world sections. The website also includes links to their social media platforms.

Other forms of communication are the multi-Latina's social media platforms, especially their Facebook page,[2] in which campaigns are carried out permanently both with country-specific angles and with a global flavor. As of November 26, 2016, the brand's UK Facebook page had 11,885 likes.

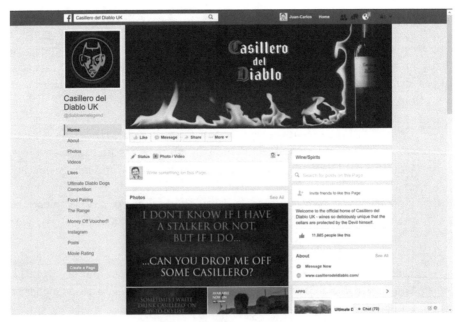

Fig. 2.2. Casillero del diablo Facebook page. Public domain, acknowledgment to Concha y Toro.

In addition to the photos posted by Casillero del Diablo on this social media platform, 813 photos have been posted by followers. One of the Casillero del Diablo—Manchester United TV spot uploaded on Facebook and YouTube has achieved 6.6k reactions, 315 comments, and 1.5m views.

The Twitter brand account (English) @DiabloWine follows 3,340 accounts and was followed by 9,008 Twitter users, as of November 25, 2016. For the same date, its Instagram (English) account had 322 posts, 5,937 followers, and 95 following. The posting of high quality of photos and videos on social media platform has been a priority for the company.

NOTES

1. http://www.manutd.com/en/Partners/Global-Partners.aspx?sponsorid=%7B21836B00-7803-4297-A252-BE004D805ED2%7D
2. https://www.facebook.com/casillerodeldiablo

REFERENCES

Banks, G., & Overton, J. (2010). Old world, new world, third world? Reconceptualising the worlds of wine. *Journal of Wine Research, 21*(1), 57–75. doi:10.1080/09571264.2010.495854.

Concha y Toro. (2014, March 14). Retrieved from http://www.conchaytoro.com/sala-de-prensa/concha-y-toro-world/casillero-del-diablo-is-chosen-one-of-the-worlds-most-admired-wine-brands/

Corporate Profile. (2014). *Viña Concha y Toro website*. Retrieved from http://www.conchaytoro.com/concha-y-toro-holding/investors-corporate-profile/

Ibáñez, G. (2012, August 17). *Chile's Viña Concha y Toro looks to revive U.S. Fetzer wines*. Retrieved from http://www.wsj.com/articles/SB10000872396390444508504577595350428087154

Moore, V. (2014). *Chilean wine: The devil's in the detail*. Retrieved from http://www.telegraph.co.uk/foodanddrink/wine/10635797/Chilean-wine-the-devils-in-the-detail.html

Our History and Achievements. (2001). *CyT UK website*. Retrieved from http://www.cyt-uk.com/about-us/timeline

Viña Concha y Toro S. A. (2011, October 4). *Concha y Toro celebrates first anniversary of Manchester united partnership by inviting MU legends and Barclays premier league to Chile*. Retrieved from http://www.prnewswire.com/news-releases/concha-y-toro-celebrates-first-anniversary-of-manchester-united-partnership-by-inviting-mu-legends-and-barclays-premier-league-to-chile-131064908.html

Viña Concha y Toro S. A. (2016, August 25). *VIÑA CONCHA Y TORO PRESENTA RESULTADOS CONSOLIDADOS AL SEGUNDO TRIMESTRE DE 2016* Retrieved from http://www.conchaytoro.com/wp-content/uploads/2016/08/Press-Release-2Q-2016-y-6M-2016-vs-2015-Español-VF.pdf

Wehring, O. (2015, January 23). *Just the answer Sebastián Aguirre, Concha y Toro marketing director for premium wines*. Retrieved from http://www.conchaytoro.com/wp-content/uploads/2015/01/just-the-Answer-Sebastian-Aguirre-Concha-y-Toro-Marketing-Director-for-Premium-Wines.pdf

Wilmore, J. (2015, January 6). *Casillero del Diablo to get UK push as Concha y Toro signs sky movies deal*. Retrieved from http://www.just-drinks.com/news/casillero-del-diablo-to-get-uk-push-as-concha-y-toro-signs-sky-movies-deal_id115794.aspx

Wine Spectator. (2011, March 2). *Concha Y Toro buying Fetzer for $238 Million*. Retrieved from http://www.winespectator.com/webfeature/show/id/44553

50 Wines You Can Always Trust. (2016). *Food & Wine*. Retrieved from http://www.foodandwine.com/articles/50-wines-you-can-always-trust

Case Studies IN Corporate Social Responsibility

Cargill's Indonesian Palm Oil Sustainability Program

ZIFEI FAY CHEN, DON W. STACKS, PH.D.,
YI GRACE JI, AND BO RA YOOK
University of Miami

EDITOR'S NOTE

The authors of this case study have applied excellence theory—what makes public relations excellent—to evaluate the Palm Oil Sustainability Program initiated by Cargill, a multinational food and agriculture company which serves as a supplier for many publicly-held consumer goods companies around the world. The case study examines how Cargill implemented, in Indonesia, a globally integrated corporate social responsibility (CSR) program that reached worldwide throughout the company and set agendas for key stakeholders and for future sustainability programs.

BACKGROUND

Sustainability has become a major business concern in the 21st century. Sustainability is the focus in fuel, power, environment, water, and food. In food particularly the tensions between environmental sustainability and profit are particularly turbulent. This case examines the program for one such project, palm oil sustainability in Indonesia. It looks at the efforts of one multinational food and agriculture company, Cargill, to provide a sustainable product at profit but without environmental damage. The Cargill palm oil sustainability program, although examined primarily

through the eyes of how it sold its palm oil sustainability plan in Indonesia, is also a portion of the larger Cargill sustainability program worldwide, but primarily in Southeast Asia. This chapter examines the Indonesian palm oil sustainability program from the Excellence Pyramid of Campaign Evaluation first advanced by Michaelson, Wright, and Stacks in 2012 and put to the test by Stacks, Wright, and Bowen in 2015 and again in this volume's chapter by Bowen, Stacks, and Wright.

METHODOLOGY

To analyze this case, two qualitative research methods were employed. First, secondary analysis was conducted by compiling reports on the Palm Oil Sustainability program both from Cargill's website and from related news reports. Second, interviews were conducted with Mr. Mike Fernandez, former Corporate Vice President of Corporate Affairs at Cargill and with Mr. Bruce Blakeman, Cargill's Vice President for Corporate Affairs in Asia Pacific.

THE PROBLEM

The need for sustained production and growth is a continuing problem worldwide. In particular, the economic and environmental impact of creating a sustainable crop that adds to a country's or region's economic benefit, especially in developing countries is tremendous. With every advance in sustainability, however, problems arise. In the case of genetically-engineered food for instance, problems focus on changes in the genome and potential down-the-road health issues. Renewable energy is another sustainability issue of late. Such problems have the potential to become corporate crises if not approached with a win-win or two-way symmetrical public relations program.

This case looks at a sustainability public relations program that has come to the world's attention in Southeast Asia—palm oil. Through an analysis of a public relations program created by Cargill that focused senior management on the relationship between profit and corporate social responsibility (CSR), this case examines how an integrated corporate program was put into place that reached throughout the company and set the agenda for key stakeholders and future sustainability programs. To better understand the problems Cargill faced, we first look at the food product—palm oil—and then a sustainability program and its economic impact on Indonesia, one of the largest countries in Southeast Asia. We then look in detail at Cargill as a company taking sustainability and CSR as corporate values leading to a mission that seeks to increase the world's population with safe and sustainable food products.

Palm Oil

Palm oil is an edible oil that is grown and processed primarily in Southeast Asia, particularly in Malaysia and Indonesia and is the most widely processed oil in the world. Palm oil is a vegetable oil, high in saturated fats from the fruit of the African oil palm tree, and grows in hot and humid climates. Around 87 percent of palm oil is grown in Malaysia and Indonesia (SBS World News, 2013). As such, it is the world's most popular edible oil, and is an ingredient in food, cosmetics, and toiletries, and is also gaining traction in the biofuel industry. Making palm oil even more popular is the fact that it has a longer shelf life than butter and other vegetable oils. Moreover, it is cheap to grow, harvest, and process. Oil palms produce more vegetable oil per hectare of land than other crops. As the Forum Nachhaltiges Palmöl (n.d.) notes:

> Palm oil is produced from the fruit of the oil palm (Elaeis guineensis). Originally native to West Africa, oil palms are now grown in almost all tropical regions of the world. The principal growing areas are Indonesia and Malaysia, but commercial cultivation is also increasing in South America and Africa.

> From their third year oil palms produce fruits which grow in large, dense clusters ... The yield stabilises after about four to six years, then production declines slowly from the 21st year onwards, and the old palms are replaced with new ones. A mature oil palm produces clusters of fruit of approximately 20 kg around fifteen times a year. This high productivity, besides other properties of palm oil and palm kernel oil useful to industry, has now resulted in the oil palm becoming the most successful of all oil plants. Of the oil plants the oil palm has by far the highest yield, at an average of 3.69 tonnes per hectare (t/ha); its yield is five times higher than that of soya (0.77 t/ha), four times higher than sunflowers (0.86 t/ha) and three times higher than rapeseed (1.33 t/ha).

Environmental Impact

Palm oil plantations are concentrated in Malaysia and Indonesia, where deforestation and less environmental regulation has led to indiscriminate forest clearing for the monoculture of oil palm crops, instances of illegal logging, and a dramatic impact on threatened and endangered local species. The environmental impact of the deforestation is huge. Thus, palm oil use has come under fire from environmental activists, companies who are sourcing it from suppliers, and concerned consumers.

Cargill

Founded in 1865, Cargill is the largest privately held corporation in the United States in terms of revenue and is based in Minneapolis, Minnesota. The company is specialized in providing food, agriculture, financial and industrial products and

services to the world. Cargill comprises more than 70 businesses organized around four major segments: agriculture, food, financial, and industrial. In the fiscal year of 2015, Cargill generated sales and other revenues of $120,393 million and earnings from continuing operations of $1,583 million.

The company gives great attention to corporate responsibilities. It focuses on four performance measures for success: engaged employees, enriched communities, satisfied customers, and profitable growth, claiming that "our performance measures recognize that high performance begins with engaged employees" (Cargill, 2015a p. 2).

Cargill's mission, vision, and values can be reflected in its "Our company-at a glance": *Together with farmers, customers, governments and communities, we help people thrive by applying our insights and 150 years of experience. We have 149,000 employees in 70 countries who are committed to feeding the world in a responsible way, reducing environmental impact and improving the communities where we live and work* (Cargill, 2016).

For corporate responsibility, Cargill's commitment has four focus areas: land use, water, climate change, and farmer livelihoods (Cargill, 2015b. For business operations, Cargill outlines seven guiding principles as its code of conduct: (1) we obey the law; (2) we conduct our business with integrity; (3) we keep accurate and honest records; (4) we honor our business obligations; (5) we treat people with dignity and respect; (6) we protect Cargill's information, assets and interests; and (7) we are committed to being a responsible global citizen (Cargill, 2012).

Overview of Cargill's Palm Oil Sustainability Program

The Palm Oil Sustainability Program is one of the major corporate responsibility programs led by Cargill. Addressing the focus area in land use and operating sustainable supply chains, the Palm Oil Sustainability Program aims at reducing deforestation and improving the sustainability of the palm oil industry in overall. As an early adopter, Cargill has been a member of the Roundtable on Sustainable Palm Oil (RSPO) since 2004.

In 2014, Cargill developed its new sustainable palm oil policy based on the inputs from stakeholders. At the same time, Cargill also joined The Forest Trust (TFT), a non-profit organization aiming to help companies deliver products responsibly. Cargill also signed the Indonesian Palm Oil Pledge at the 2014 United Nations Climate Summit to drive sustainable practices in Indonesia (Cargill, n.d.). The policy and commitment help Cargill to move toward its corporate social responsibility goals.

To "walk the talk," Cargill developed an action plan that helps guide implementation and monitor progress. The Palm Oil Sustainability Program is not a one-time commitment, but an ongoing process. Since November 2014, Cargill

has published six progress reports of the program in which actions taken and measurement indicators are specified and next steps are laid out. Some of the Cargill's accomplishments include establishing traceability of the mills, piloting the "High Carbon Stock" methodology, raising awareness and educating local communities on best fire prevention practices, and assisting smallholders to achieve RSPO certificates (Cargill, 2014). For example, in Indonesia, Cargill has pioneered effort in pledging of sustainability for the industry. Cargill keeps track of their smallholder farmers' production to make sure that all oil is produced sustainably (Kuhn, 2015). Concerns from multiple stakeholders are addressed in the program, including non-governmental organizations (NGOs), customers, suppliers, governments, communities, and even competitors to reach a shared belief regarding palm oil sustainability. Cargill's actions have helped set standards for other industry players such as Kellogg, Mars, Procter & Gamble, and Johnson & Johnson (Casey, 2014).

SITUATION ANALYSIS

The increased farming of palm oil has spurred concerns over habitat in Southeast Asia. Along with the tensions between environmental impact and profit, the sustainability requirements for companies, consumers, and NGOs around the world have been increasing. For instance, Unilever, one of Cargill's largest customers, sets out its vision that reads "Unilever has a simple but clear purpose—to make sustainable living commonplace. We believe this is the best long-term way for our business to grow" (Unilever, n.d.). Such requirement is in turn further advanced by NGO and consumer expectations. According to Fernandez (personal communication, June 17, 2016), large companies are expected to "make a big difference in saving the environment." The basic demands for large companies from NGOs, such as World Wildlife Fund (WWF) and Roundtable of Sustainable Palm Oil (RSPO), include requirements such as no to destroy forests, not to negatively impact wildlife like orangutans, and not to disrupt peatlands.

However, many companies still failed to source sustainable palm oil. A report by WWF in 2009 revealed that only 10 of 59 major retailers in Europe were showing progress in making their palm oil usage more sustainable (GreenBiz, 2009). The situation was further spurred when Nestle was criticized by Greenpeace in a global campaign for purchasing its palm oil from Sinar Mas, a supplier discovered to be damaging the habitat of orangutans. In Greenpeaces' campaign, Nestle's Kitkat was labeled as "Killer bars" (Greenpeace, 2010a). Under public pressure, Nestle finally announced it would stop sourcing products that would destroy rainforests (Greenpeace, 2010b).

The scope of the demand for sustainability reaches far beyond just the palm oil supply chain and envelopes a large number of commodities (M. Fernandez,

personal communication, June 17, 2016). In 2010, Jason Clay, Senior Vice President at WWF delivered a speech at TED Global, urging companies to save biodiversity (TED Global, 2010).

In the face of increasing demand, Cargill decided to *proactively* listen to and work with NGOs. In 2010, at the time when Fernandez was recruited, Cargill started to review its palm oil suppliers to track their progress toward sustainability with the help of WWF. It was reported that some of Cargill's palm oil plantations in Indonesia had already received or were in the process of receiving RSPO certification, and WWF would supervise Cargill's suppliers in Indonesia to track their progress toward implementing RSPO principles (GreenBiz, 2010). As noted, the Cargill's Palm Oil Sustainability Program is one of its major corporate responsibility initiatives. The Indonesian program is part of Cargill's larger global program.

CORE OPPORTUNITIES AND CHALLENGES

The increasing demand for environmental sustainability allows Cargill to explore opportunities to make a difference in saving the environment. After joining Cargill, Fernandez met with key representatives from NGOs including WWF, The Nature Conservancy, The Forest Trust (TFT), Greenpeace, Flora & Fauna International, Conservation International, and various others across the globe. Through two-way symmetrical communication, the conversations aimed building shared beliefs and actionable timelines and efforts as to what Cargill could do to support sustainable supply chains, which includes palm oil and other commodities such as cotton, soy, cocoa, and beef (M. Fernandez, personal communication, June 17, 2016). Since Cargill consists of more than 70 different business units across the globe, with each having its own environmental and sustainability efforts at the time, there was also the opportunity for Cargill's own businesses to coordinate their environmental and sustainability efforts through unified corporate sustainability initiatives. By naming Fernandez as its Senior Vice President of Corporate Affairs, Cargill had in place someone to integrate those efforts in a more holistic way.

However, the great opportunity was not without challenges. According to Fernandez (personal communication, June 17, 2016) and Blakeman (personal communication, June 15, 2016), the challenges were multi-faceted. While approximately two-thirds of all palm oil is consumed in Asia, most related activism came from the United States and a few countries in Europe, which consume less than 10 percent of palm oil globally. For Cargill, the biggest challenge is not from their own plantations, but *from the third-party supply chains whose activities that Cargill would become responsible for*, and about 90 percent of palm oil that Cargill processes comes from smallholder farmers. For smallholder farmers, the time and additional administrative work to comply with the sustainability standards were something

that caused them to question the need to continue to participate in the audit process. Thus, it created challenges for Cargill to "organizationally and operationally meet the desires of NGOs." In Cargill's corporate affairs organization, it was believed that a *common standard* should be implemented world-wide. However, the initial efforts had to start customer-by-customer and country-by-country as "the broad marketplace responded differently to the need for sustainable palm oil" (B. Blakeman, personal communication, June 15, 2016; M. Fernandez, personal communication, June 17, 2016).

GOALS AND OBJECTIVES

Being a part of Cargill's larger world-wide sustainability initiatives, the goal of the Indonesian Palm Oil Sustainability Program is to build a *traceable and transparent* palm oil supply chain, thereby *building and reinforcing mutually beneficial relationships* with its stakeholders including NGOs, policy makers, suppliers, customers, and communities. Specifically, Cargill set out to "work towards a 100% transparent, traceable, and sustainable palm supply chain by 2020" (2014). The sustainable palm supply chain needs to be firmly committed to:

- No deforestation of high conservation value (HCV) lands or high carbon stock (HCS) areas
- No development on peat
- No exploitation of rights of indigenous peoples and local communities (Cargill, 2014).

The goal entailed several objectives on the informational, motivational, and behavioral levels (Stacks, 2016). On the informational level, Cargill tries to reach mutual understanding between itself and multiple stakeholders to better establish a shared belief toward palm oil sustainability. On the motivational level, Cargill aims at building greater trust from stakeholders to obtain greater confidence in subsequent steps of the journey toward sustainability together (M. Fernandez, personal communication, June 17, 2016). On the behavioral level, Cargill sets out to move its suppliers "toward more sustainable practices, community investment and consultations," and to advocate its customers to act on their own sustainability strategies and policies (B. Blakeman, personal communication, June 15, 2016).

Research

An excellent public relations program cannot be achieved without research. On the communication side, the research conducted by Cargill for the Palm Oil

Sustainability Program was mostly qualitative through discussions with stakeholders. Conversations were held between Cargill and various stakeholders including corporate leadership, NGOs, policy makers, customers, and smallholders. Gap analysis (Stacks, 2016) was conducted in an environment where what NGOs thought Cargill was doing, what customers believed Cargill was doing and should be doing, what Cargill's own business units believed they were doing, and "where they thought the gaps were from what customers wanted and what NGOs desired" (M. Fernandez, personal communication, June 17, 2016). In addition, Cargill had been constantly engaging in environmental scanning to monitor what NGOs and its customers were saying to provide more evidence for the gap analysis (B. Blakeman, personal communication, June 15, 2016). Such conversations and environmental scanning were not only conducted prior to the implementation of the program, but throughout the whole process. Based on its gap analysis, Cargill was able to evaluate campaign progress and adjust strategies when necessary.

To further trace and evaluate its efforts toward goals and objectives, Cargill created quantitative measures to track its progress towards its objective of "a 100% transparent, traceable, and sustainable palm supply chain by 2020" (Cargill, n.d.). The measures include indicators such as *traceability* to mill status, *number of suppliers* on track with action plan commitments, and *number of field assessments* carried out and regions covered (Cargill, 2014). Since its first introduction of the updated palm oil policy, Cargill has published six progress reports, each detailing indicators measured against baselines and benchmarks to provide updated information for stakeholders.

Besides conversations and gap analyses with stakeholders as well as quantitative measures of the program's progress against its goals and objectives, some anecdotal evidence also helped to evaluate the program (M. Fernandez, personal communication, June 17, 2016). As Fernandez (personal communication, June 17, 2016) noted, the program helped cultivate a trusting relationship between Cargill and its stakeholders such as NGOs and customers. Environmental NGOs, previously critical towards Cargill, have been more willing to engage in conversations and partnerships with Cargill to help assess progress periodically, extending such efforts to other sustainability projects. Customers who were previously unsure about Cargill's capability have been satisfied with the progress and recognized its efforts. For example, Unilever gave Cargill its first "Visionary" Award in late 2014 for the help Cargill provided for them to meet their sustainability goals. Cargill has also been awarded the "Best of Sustainable Supply Award in 2014" by McDonald's, another large Cargill customer. In addition, Cargill's Palm Oil Sustainability Program has been recognized as a "best in class in managing its palm supply chain" by Carbon Disclosure Project (CDP) in its Global Forest Report 2015 (Carbon Disclosure Project, 2015).

KEY STAKEHOLDERS

Cargill's Palm Oil Sustainability Program involves engagement and relationship management with various stakeholders.

- **Customers:** As a business-to-business company, Cargill serves as the suppliers for many companies in different markets and geographies. Those companies, as Cargill's customers, are under increased pressures from NGOs and paying more attention to the environmental impact their suppliers have. Their own goal to achieve sustainability cannot be realized without Cargill's efforts, and Cargill's goal cannot be accomplished without customers' understanding and support. A shared belief between Cargill and its customers to co-create a vision in which long-term success is achieved through sustainable business conduct
- **NGOs:** NGOs play a significant role in urging sustainable conduct among large corporations. It is important to reach mutual understanding, create a shared belief, and obtain trust from NGOs. Cargill needs to actively listen to and engage NGOs to move its plans forward. Key organizations include WWF, Indonesia Palm Oil Pledge (IPOP), the Nature Conservancy, RSPO, the Wild Asia, The Forest Trust (TFT), Greenpeace, and Flora & Fauna International
- **Suppliers:** Without suppliers' compliance to the sustainability standards, goals and objectives cannot be achieved. Many program challenges are from suppliers among whom roughly 40 percent are smallholder farmers (Cargill, n.d.). According to Fernandez (personal communication, June 17, 2016) it was essential to build a trusting relationship with suppliers to assure them that "Cargill would not be requiring extra work only to leave them later." A win-win relationship needed to be built in which Cargill provides support for suppliers to comply with RSPO principles, "resulting in higher yields, better access to market, increased profitability and more reliable income streams" (Cargill, n.d.), and in return suppliers' compliance helps Cargill to achieve its goals and objectives, resulting in increased trust from various stakeholders and competitiveness in the long term
- **Cargill employees and leadership:** A program cannot be practically implemented without the efforts from its employees and support from leadership internally. At Cargill, dedicated staff are involved in managing and communicating the sustainability program with support from operations and corporate affairs team. Support from senior management was also obtained and has increased (B. Blakeman, personal communication, June 15, 2016; M. Fernandez, personal communication, June 17, 2016)

- **Communities around Cargill's plantations:** In the program, Cargill commits to "no exploitation of rights of indigenous peoples and local communities" (Cargill, n.d.). Sustainable operations in the plantations help protect the environment where the communities live in, which help build trusting relationships between Cargill and communities
- **Policy makers:** To build more trusting relationships with policy makers, Cargill needed to collaborate with policy makers and showcase its capability to successfully manage issues. As a result, policy makers do not need to get engaged in spaces that Cargill could manage on their own (M. Fernandez, personal communication, June 17, 2016).

KEY MESSAGES

The key message Cargill tries to deliver is that it is "working towards a 100% transparent, traceable and sustainable palm supply chain by 2020," and it "will work to ensure that all palm oil and palm products that Cargill produces, trades or processes are in line with" its commitments of "no deforestation of high conservation value lands or high carbon stock areas, no development on peat, and no exploitation of rights of indigenous peoples and local communities these commitments" (Cargill, n.d.). While communication is important to get across the key messages to stakeholders, what matters more is Cargill's *behavior*. According to Fernandez (personal communication, June 17, 2016), the corporate affairs team was "valued not just because they told the story, but because the team shaped and enabled the story to exist."

STRATEGIES AND TACTICS

According to Fernandez and Blakeman, the Palm Oil Sustainability program in Indonesia is far beyond simply a communication campaign. It is part of Cargill's *issues management initiatives to build and enhance trusting and mutually-beneficial relationships with stakeholders*. The strategies implemented during the program, in this regard, were relationship-focused.

First, Cargill set out its vision for the initiatives and developed its supply chain sustainability policy (B. Blakeman, personal communication, June 15, 2016). Cargill's Chairman and CEO David MacLennan proclaimed that Cargill wanted to be "the most trusted sustainable supplier" in the world. However, at the time Cargill had yet to have a unified sustainability program. In 2014, to further engage its internal stakeholders and senior management in the sustainability initiatives, Fernandez, together with Paul Naar, Cargill's leader of food and ingredient

solutions business platform and Christopher Mallett, Cargill's head of research and development, built a financial risk model that showcased how much money Cargill might lose if they did not have a more unified effort, tracing the impact commodity-by-commodity. The case Fernandez, Naar, and Mallett presented gained the attention of the senior management. An overarching vision and unified sustainability policy was then created company-wide (M. Fernandez, personal communication, June 17, 2016).

Based on this vision, and following the unified sustainability policy, Cargill reached out to NGOs in discussions on sustainability issues and proactively engaged them to build shared belief. From these conversations, Cargill obtained inputs from NGOs regarding critical issues as well as technical expertise and validation of the direction that Cargill was moving. An earlier member of the RSPO, Cargill also helped fund studies on critical issues for NGOs (B. Blakeman, personal communication, June 15, 2016).

The communication strategy of Cargill's palm oil sustainability program included narratives on how Cargill helps smallholders and conserving land. To engage with its various stakeholders, Cargill communicated stories through paid, owned, and earned media channels. On Cargill's corporate website, detailed information of the program was provided. A series of progress reports were made available on the website. Videos on some of Cargill's smallholder programs were created and uploaded to its website and YouTube channel. Featured stories of the program have appeared on outlets such as Bloomberg, National Public Radio (NPR), and WWF's "On Balance" blog, as well as through speech engagement at various summits and conferences. Cargill has also sponsored food stories focused on sustainability and food security in *National Geographic* which has a wide range of audiences in many countries.

CALENDAR/TIMETABLE

"The campaign in some ways started more than six years ago and continues today" (M. Fernandez, personal communication, June 17, 2016). In July 2014, Cargill announced its palm oil policy that "commits to building a 100% transparent, traceable and sustainable palm supply chain by 2020" (Cargill, n.d.). Each year, Cargill tracks its progress and delivers updates to its stakeholders. It is worth noting that this program *"was all about solving a long-term business program"* (emphasis added). As with Arthur W. Page Society's new model for activating corporate character and authentic advocacy (Arthur W. Page Society, 2012), Cargill is continually learning from its stakeholders to build a shared belief and adapt to a changing environment (M. Fernandez, personal communication, June 17, 2016).

BUDGET

The budget for the Palm Oil Sustainability Program included staff costs, RSPO membership ($5,000), NGO partnership and studies costs that ranged from $50,000 to $200,000 per year, and implementation of traceability and supplier risk assessment that cost more than $1 million per year (B. Blakeman, personal communication, June 15, 2016). Agreeing on the above costs, Fernandez (personal communication, June 17, 2016) further noted that "the effort is not a standalone, but is incorporated into everything we do," "if one were to add up every penny in service of the ultimate goal, it could be five times of what was listed". Essentially, the budget for "telling the story" is just the tip of the iceberg. According to Fernandez (personal communication, June 17, 2016), "What matters more were the behaviors driven by the plan."

EVALUATION AND MEASUREMENT

Excellence Campaign Pyramid

The Excellence Campaign Pyramid (Michaelson, Wright, & Stacks, 2012) is an object analysis of a public relations program that looks at more than just "success." The model, which parallels a Maslow's Hierarchy of Needs approach, establishes three levels with individual criteria that must be met to satisfy each level (see Figure 3.1). The first level is *basic* to any program and includes five criteria that must be met for a program to be successful. The second level, intermediate, demonstrates whether the program stood out among stakeholders and how that occurred. Finally, the third level, advanced, demonstrates that the program helps or sets the agenda for future or continuing programs.

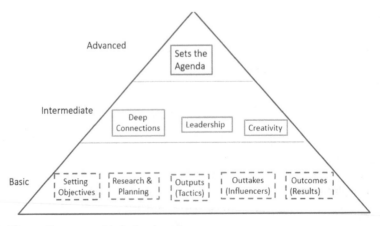

Fig. 3.1. The excellence pyramid. Authors' creation.

Evaluating Cargill's Palm Oil Sustainability Program at the Basic Level

Based on the preceding discussion of Cargill's palm oil research and strategy, it is clear that the program was and continues to be a success. The company early on set its goals and objectives, did the required research on the topic, countries, and problems that would be/could be encountered that produced a strategic communication plan to meet its goals.

Using baseline research Cargill developed its strategic initiatives by first establishing where in the communication lifecycle (Michaelson & Stacks, 2011) various issues existed. Based on this and previous research at the developmental program phase, informational objectives were identified as important to internal stakeholders, country stakeholders that included government, environmental activists/ NGOs, and smallholder farmers. From this they developed messages associated with moving stakeholders from simple awareness to advocacy on not only palm oil but also other sustainability issues through a multichannel message approach aimed at setting Cargill as one of the world's top sustainability companies.

The tactics employed created a holistic message that all stakeholders were responsible for environmental sustainability. A common theme was that Cargill is a transparent, traceable, and sustainable company that viewed sustainability as more than a one-issue/product and instead focused on the interrelationships between palm oil sustainability and environmental concerns across a number of issues (i.e., deforestation, habit endangers). The arguments were aimed at taking stakeholders from a simple awareness of the problem(s) and action(s) that Cargill was taking to alleviate problems by adding knowledge and sustaining relevance of sustainability over time (motivational objectives) and ultimately serving as company advocates among a variety of stakeholders (i.e., NGOs, employees, governmental offices, farmers). Cargill also targeted influencers across a variety of organizations to advocate their position and their history of environmental sustainability practices.

The program's outcomes were aimed at more than simple one-time behaviors but, as the term "sustainability" suggests, would continue into the future using this program as a model and baseline against which to continually measure "success" and provide a standard against which to measure other Cargill programs.

Intermediate Outcomes

Three criteria must be met to meet the intermediate level. First, the program must establish *deep connections* with stakeholders. In this regard Cargill focused its program on an inside-outside approach. The inside approach focused on making clear to Cargill employees and business partners that the company was and will continue to be an honest citizen, working for the betterment of the company, clients, and producers. The outside approach focused on becoming one of the

first companies to participate in environmental sustainability, working with NGO groups to ensure that sustainability was measured, reviewed, and shared among all stakeholders. The outside approach also included local and national governmental officials and offices and smallholder farmers who in the past practiced non-sustainable farming practices. Thus deep connections among various stakeholders were established, cultivated, and sustained for a long-haul program.

The second criterion deals with internal company *leadership* backing the communication function in such a way that it becomes part of the company's communication strategy across other projects and integrates that strategy across company functions. Clearly, Cargill's leadership embraced this campaign and internalized it as a major value for its mission and vision. The support from leadership can be showcased in the way Cargill's Chairman and CEO proclaimed that Cargill wanted to be "the most trusted sustainable supplier" in the world (B. Blakeman, personal communication, June 15, 2016). Furthermore, as Grunig and Grunig (2006) and Grunig, Grunig, and Dozier (2006) point out, the public relations/corporate communication function needs to gain a seat at the "management table" in order to achieve excellence. Cargill's sustainability programs have achieved excellence in terms of leadership support as Fernandez, as Corporate Vice President of Corporate Affairs who served as the Chief Communication Officer (CCO)'s role at Cargill was a member of the Cargill's Corporate Center, which consists of about 30 top executives at Cargill that help develop policies for the company (M. Fernandez, personal communication, June 17, 2016). The case Fernandez presented together with Naar, leader of Cargill's Food and Ingredient Solutions business platform, and Mallett, head of Research and Development obtained attention and support across the board at Cargill's Corporate Center, and helped set Cargill's vision to be the most trusted supplier of sustainable products, create a unified sustainability policy company-wide, and form a Sustainability Council.

The third criterion examines the *creative strategies* employed in the program. Cargill used a variety of channels in getting its messages out to stakeholders. These included social media, traditional media, and the use of NGOs to advance their arguments towards environmental sustainability above and beyond the palm oil issue.

Advanced Outcomes

Advanced campaign excellence is viewed as the influence the campaign has on the company, industry, and other stakeholder groups. In this specific case, Cargill's Palm Oil Sustainability Program has helped set the agenda for the company's own sustainability initiatives, other stakeholder groups, as well as the industry to a certain extent. How did this program influence the stakeholders and the industry? Fernandez (personal communication, June 17, 2016) noted:

Environmental NGOs who were previously critics meet with us on a periodic basis to assess progress and partner on other projects. Customers who were previously wary of our ability to meet their future requirements have recognized Cargill's efforts by purchasing more palm oil from Cargill and providing customer recognition for our efforts. In late 2014, Unilever recognized Cargill with its first "Visionary" Award for the organization that had most helped them to meet their sustainability goals; similarly, McDonald's gave Cargill its "Best of Sustainable Supply Award in 2014." More broadly the Carbon Disclosure Project (CDP), in its Global Forests Report 2015, cited Cargill as best in class in managing its palm supply chain. CDP was started by institutional investors in London who were motivated by cause investing, and in turn as they say have motivated "companies and cities to disclose their environmental impacts, giving decision makers the data they need to change market behavior." Cargill, though a privately-held company, was motivated to engage with CDP by its large, publicly-held customers.

In this regard, we evaluate that Cargill's Palm Oil Sustainability Program has reached the advanced level in terms of influence on the key stakeholders, as well as the industry in overall. Although a privately-held company, Cargill's program positively influenced its customers who are large, publicly-held companies such as Unilever and McDonald's for their sustainability goals. Being an earlier adopter of the RSPO, Cargill's pledge and actions to use only green palm oil have set standards for consumer goods companies such as Kellogg, Mars, Procter & Gamble, and Johnson & Johnson, who also adopted zero deforestation policies in 2014 (Casey, 2014). The program also had an impact on how communication and relationship management with stakeholders were viewed across Cargill's functional units. It is worth noting that some of this relationship-focused program's long-term goals are yet to be evaluated at this moment. Therefore, the long-term goals of this program, as well as other sustainability programs, need to be evaluated against the standards and benchmarks set as they continuously evolve. We will need to sit back and see how Cargill's stated long-term goals are met.

SUMMARY

This case examined the role of one large food company's environmental sustainability program. Cargill, a large international privately-held food company, developed an environmental sustainability program for palm oil—an important food product with world-wide implications—that was designed to meet the competing needs of sustainability, environmental policy making, and setting a company agenda for future programs. The program evaluated from a campaign excellence model, clearly met the first two levels (basic and intermediate) of the excellence pyramid, and also reached the advanced level as well. However, as the program continues to roll out, we will need to further evaluate the program's long-term goals that are yet to be evaluated at this point of time against the standards and

benchmarks it has set so far. Regardless, the Cargill Palm Oil Sustainability Program helped establish the communication and relationship management strategy of that and future programs. It serves a model for other environmental sustainability public relations campaigns and programs.

Authors' Note

The authors are indebted to two of Cargill's top communicators for their insights and analyses of the palm oil sustainability program: Mike Fernandez, former Corporate Vice President, Corporate Affairs, and Bruce Blakeman, Cargill's Vice President for Corporate Affairs in Asia Pacific.

REFERENCES

Arthur W. Page Society. (2012). *Building belief: A new model for activating corporate character and authentic advocacy*. Retrieved from http://www.awpagesociety.com/attachments/508b442e53cd 975472b3fa3f405c7c35f03cf6e5/store/ebe516e49e99af360d1e3ecdaa7271c33477365bc 62a016bf16fd96af540/Building-Belief-New-Model-for-Corp-Comms.pdf

Carbon Disclosure Project. (2015). *Global Forest Report 2015*. Retrieved from https://www.cdp.net/ CDPResults/CDP-global-forests-report-2015.pdf

Cargill. (2012, July). *Cargill's guiding principles*. Retrieved from http://www.cargill.com/wcm/groups/ public/@ccom/documents/document/na3064565.pdf

Cargill. (2014, July). *Cargill policy on sustainable palm oil*. Retrieved from http://www.cargill.com/ wcm/groups/public/@ccom/documents/document/palm_oil_policy_statement.pdf

Cargill. (2014, November). *Toward sustainable palm oil: Cargill sustainable palm oil action plan and progress update*. Retrieved from http://www.cargill.com/wcm/groups/public/@ccom/documents/ document/na31709187.pdf

Cargill. (2015a). *2015 corporate responsibility report*. Retrieved from http://www.cargill.com/wcm/ groups/public/@ccom/documents/document/na31881260.pdf

Cargill. (2015b). *2015 fact sheet*. Retrieved from http://www.cargill.com/wcm/groups/public/@ccom/ documents/document/na31749464.pdf

Cargill. (2015c). *Cargill 2015 annual report*. Retrieved from http://www.cargill.com/wcm/groups/ public/@ccom/documents/document/na31881261.pdf

Cargill. (2016). *Cargill at a glance*. Retrieved from http://www.cargill.com/wcm/groups/public/@ ccom/documents/document/br-cargill-at-a-glance.pdf

Cargill. (n.d.). *Smallholder programs*. Retrieved from http://www.cargill.com/corporate-responsibility/ sustainable-palm-oil/smallholder-programs/index.jsp

Cargill. (n.d.). *Palm oil sustainability program*. Retrieved from http://www.cargill.com/corporate-responsibility/sustainable-palm-oil/index.jsp

Cargill. (n.d.). *Sustainable palm implementation plan*. Retrieved from http://www.cargill.com/corporate-responsibility/sustainable-palm-oil/implementation-plan/index.jsp

Casey, M. (2014, December 17). Unilever, Cargill push to green their palm oil chain. *Fortune*. Retrieved from http://fortune.com/2014/12/17/palm-oil-deforestation-unilever-cargill/

Forum Nachhaltiges Palmöl. (n.d.). *The oil palm.* Retrieved from http://www.forumpalmoel.org/en/fonap.html

GreenBiz. (2009, October 28). *European firms failing to source sustainable palm oil.* Retrieved from https://www.greenbiz.com/news/2009/10/28/european-firms-failing-source-sustainable-palm-oil#ixzz0t7sRqWBm

GreenBiz. (2010, July 8). *Cargill to review palm oil suppliers' sustainability progress.* Retrieved from https://www.greenbiz.com/news/2010/07/08/cargill-review-palm-oil-suppliers-sustainability-progress

Greenpeace. (2010a). *Ask Nestle to give rainforests a break.* Retrieved from http://www.greenpeace.org/international/en/campaigns/climate-change/kitkat/

Greenpeace. (2010b, May 17). *Sweet success for Kit Kat campaign: You asked, Nestlé has answered.* Retrieved from http://www.greenpeace.org/international/en/news/features/Sweet-success-for-Kit-Kat-campaign/

Grunig, J. E., & Grunig, L. A. (2006). Characteristics of excellent communication. In T. A. Gillis (Ed.), *The IABC handbook of organizational communication* (pp. 3–18). San Francisco, CA: Jossey-Bass.

Grunig, J. E., Grunig, L. A., & Dozier, D. M. (2006). The excellence theory. In C. H. Botan & V. Hazelton (Eds.), *Public relations theory II* (pp. 21–55). Mahwah, NJ: Erlbaum.

Kuhn, A. (2015, April 21). Palm oil plantations are blamed for many evils. But change is coming. *NPR.* Retrieved from http://www.npr.org/sections/goatsandsoda/2015/04/21/396815303/palm-oil-plantations-are-blamed-for-many-evils-but-change-is-coming

Michaelson, D., & Stacks, D. W. (2011). *A professional and practitioners guide to public relations research, measurement, and evaluation* (2nd ed.). New York, NY: Business Expert Press.

Michaelson, D., Wright, D. K., & Stacks, D. W. (2012). Evaluating efficacy in public relations/corporate communication programming: Towards establishing standards of campaign performance. *Public Relations Journal, 6.* Retrieved from http://www.instituteforpr.org/wp-content/uploads/Michaelson-Wright-Stacks-PR-Journal-2012-Vol-6-No-5.pdf

SBS World News. (2013, March 26). *What is palm oil and why the controversy?* Retrieved from http://www.orangutans.com.au/Orangutans-Survival-Information/What-is-palm-oil-and-why-the-controversy.aspx

Stacks, D. W. (2016). *Primer of public relations research* (3rd ed.). New York, NY: Guilford Press.

Stacks, D. W., Wright, D. K., & Bowen, S. A. (2014). IBM's Smarter Planet Initiative: Building a more intelligent world. In J. Turk, J. Valin, & J. Paluszek (Eds.), *Public relations case studies from around the world* (pp. 3–20). New York, NY: Peter Lang.

TED Global. (2010, July). *Jason Clay: How big brands can help save biodiversity.* Retrieved from http://www.ted.com/talks/jason_clay_how_big_brands_can_save_biodiversity

Unilever. (n.d.). *Our vision.* Retrieved from https://www.unilever.com/about/who-we-are/our-vision/

Sharing "Made IN Italy"

Intesa Sanpaolo Bank's Cultural Communication around World Expo 2015

VALENTINA MARTINO
Sapienza University of Rome

ALESSANDRO LOVARI
University of Sassari

EDITOR'S NOTE

The significance of this case will become apparent to the reader, as you will learn how a smart strategy can serve multiple purposes. This case illustrates how an organization can leverage its "soft" reputational assets, align an international opportunity with its core values, exercise its role as a corporate citizen and provide win-win opportunities for its clients thereby producing a marketing benefit while sustaining economic growth. The case won several awards nationally and abroad. It relied on a solid strategy, creativity and brilliant execution to achieve its goals.

INTRODUCTION AND BACKGROUND

A strategic partnership sealed the collaboration between Intesa Sanpaolo Bank and *World Expo 2015*, hosted by Italy in Milan. The participation in such a global mega-event was supported by dedicated communication and public relations activities both on and offline, celebrating an innovative representation of the "Made in Italy" concept applied to the banking sector. Indeed, the partnership project can be considered the result of a long-standing corporate commitment in supporting and strategically communicating the most distinctive essence of the Italian character: arts and culture.

As an "official global partner" of World Expo 2015, Intesa Sanpaolo wanted to reinforce strategic relationships with its social and market stakeholders such as families, employees, public institutions, no profit organizations, and business partners. In particular, the bank dedicated its own pavilion space to host major public and private partners, among which four hundred small and medium companies representing the best of "Made in Italy".

Company Profile

Intesa Sanpaolo Bank is the result of a merger in 2007 between Intesa and the Sanpaolo IMI bank. It stands today as the leading banking group in Italy and one of the largest in Europe. The group's business has grown over time through several acquisitions and mergers (Bellavite Pellegrini, 2013) and inherits today the history of more than 250 banks in Italy and abroad,[1] some of which have roots that go back to the establishment of the Bank of Naples in 1539.

Legally established in Turin, in a new corporate skyscraper designed by the Italian architect Renzo Piano,[2] the executive headquarters is located in Milan. As of June 2016, the bank had approximately 11,1 million customers and 4,100 branches all over Italy. It also enjoys a significant presence in Central Eastern Europe and Middle Eastern-North African areas, with approximately 1,200 branches and 8,1 million customers belonging to the group's subsidiaries in 12 countries. Moreover, an international network of specialists in support of corporate customers spreads across 29 countries, in particular in the Middle East and North Africa and in those areas where Italian companies are most active, such as the United States, Brazil, India, China, and Russia.

Communication and CSR Policies

Intesa Sanpaolo Bank distinguishes itself by an innovative public relations strategy increasing corporate goodwill and relationships in the banking sector which, especially today in Italy, is experiencing a difficult reputational crisis as well as a strong push toward internationalization (Dell'Atti & Trotta, 2016). In particular, the bank invests in multi-channel communication and public relations activities, coordinated by the External Relations Department, dedicating special attention to private and corporate consumers, employees, public institutions, investors, media, and the development of local communities (Intesa Sanpaolo, 2016a, 2016b).

The group has cultivated, over time, an increasing integration of social and environmental issues into its own business strategy. This policy not only supports both issue and risk management, but proactively promotes the bank's corporate reputation and, thus, its profitability in the territories where it does its business. Faced with financial markets that are highly turbulent internationally, the group

has perfected a systematic reputational management model, based on the promotion of citizenship behavior and values recommended by the company's Ethical Code (Intesa Sanpaolo, 2012).

Furthermore, with a dedicated Cultural Heritage Department, Intesa Sanpaolo can be considered one of the most innovative contemporary participants in arts philanthropy and communication efforts to support stakeholders and local communities within the Italian context by making relevant investments in the banking system and in its own non-profit foundations, instituted by a specific Italian law in 1990 (ABI, 1997; ACRI, 2016; Civita, 2006; D'Orazio, 2016; Tosolini, 2013).[3]

Artistic Cultural Policies

Corporate commitment toward the artistic cultural sector is rooted in the philanthropic tradition carried on by the pre-existing banks the group absorbed over time.

Today, Intesa Sanpaolo's cultural policies evolve within a dedicated "Culture Project,"[4] representing the key asset of the bank's identity and public relations strategy. It combines several corporate approaches: among them, not only traditional patronage and sponsorship, but also strategic partnership with the major artistic institutions, and autonomous investment in promoting original cultural projects and in-house events (Bondardo Comunicazione, 2007; Martino, 2010; Martino & Herranz de la Casa, 2016).

On the one hand, the bank supports the preservation of Italian cultural heritage, by promoting, since 1989,[5] a restoration program entitled "Restitutions" which over almost two decades restored more than one thousand artworks and monuments all around Italy.[6] The project includes several activities that Intesa Sanpaolo carries on in collaboration with the competent public authorities, such as research and cataloguing of the art crafts, restoration, permanent exposition and events, loans, and educational and communication services. In 2016, for the first time, the project has extended outside the national boundaries, involving also the Slovakia Republic where the group conducts business.

The bank also supports the arts through strategic partnerships with the Italian national trust (FAI), the Teatro alla Scala in Milan, the International Book Fair of Turin, and many other cultural institutions and events all over the country, especially in the music and theatre sector. In 2015—the year of the World Expo—the bank financed the restoration of the house of writer Alessandro Manzoni in the centre of Milan, in collaboration with the National Centre of Manzonian Studies.

On the other hand, Intesa Sanpaolo sponsors several cultural projects, such as for example the Vox Imago multimedia project whose aim is to promote opera culture thorough a rich publishing and multimedia activity.[7] The group offers public access to the bank's art collections[8] and rich and varied architectural heritage in Italy. In particular, the "Galleries of Italy" project, dating back to 1999, created a

network among several corporate cultural locations and exhibits in Milan, Naples, and Vicenza.[9] In recent years, such cultural program of events and exhibits has extended also to the web, by means of virtual tours and other initiatives aiming to actively engage the public,[10] as well as to the major bank's branches all over the country, as part of a wider corporate project promoting from 2014 the development of a new friendlier banking service.

Intesa Sanpaolo participates with its own arts collections in the pilot group of partners contributing to the creation of a *Virtual Museum of Italian Banks* (Muvir),[11] promoted by the Italian national association of banks (ABI). In 2003, the bank also established its own historical archive, whose major site is located in Milan, conserving the group's corporate memory and also coordinating the local historical heritage of several absorbed banks (Pino, 2004; Pino & Mignone, 2016).

A strong educational mission animates the "Culture Project" and, in particular, the creation of a *Savings Museum* in Turin, opened to the public in 2012, which stands as unique in its genre in Italy. Also, since 2008, several educational activities were developed in collaboration with schools, universities, and research institutes all around the country, in order to promote a healthy economic and financial culture among young people and families.

Methodology

The following pages will focus on the special project concerning the corporate partnership with World Expo 2015, which Intesa Sanpaolo Bank supported by multi-channel communication and public relations activities both in the short and medium-long term. The case study has been developed thanks to the collaboration of the bank's departments of External Relations and Cultural Heritage, both providing the authors with documents and insights about the project.

The research used a multi-method approach including direct observations, informal meetings, and interviews with several company managers and public relations leaders. Furthermore, the context analysis examined several documental sources such as internal corporate materials, reports, publications, and communication documents related to the project.[12]

The study is also supported by a review of the academic literature on public relations and corporate communication (Argenti, 2009; Cornelissen, 2011; Fombrun & van Riel, 2004; Ki, Kim, & Ledingham, 2015; Goodman & Hirsch, 2010; Grunig, Grunig, & Dozier, 2002; van Riel, 1995). The theoretical framework includes publications and previous studies investigating corporate cultural communication, which emerges in Italy and abroad as a strategic form of corporate social responsibility and corporate shared value (Azzarita, De Bartolo, Monti, & Trimarchi, 2010; Martino, 2010, 2013; Martino & Herranz de la Casa, 2016; Wu, 2002).

SITUATION ANALYSIS

World Expo 2015 was held in Milan, Italy, from May 1st to October 31, in an area designed for exhibits located in northwest Milan. In spite of initial delays and public skepticism amplified by both the media and opinion leaders, the global exposition did not disappoint expectations for attendance and international visibility. Over 20 million people visited the pavilions representing more than 150 countries, and approximately 5,000 events took place on site within the 184-day-long exposition.[13]

World Expo 2015 can be considered the first World Expo taking place during the so-called "social web age". It was an extraordinary showcase for business and marketing of brands searching for a global exposure and visibility. The theme of this universal exposition was "Feeding the planet, energy for life". Many of the companies participating as partners or sponsors created controversy by their very presence, as their activities or image was perceived to be in contradiction with the ethical message supporting the theme.

The mega-event (Ritchie & Yangzhou, 1987; Roche, 2000; Yu, Wang, & Seo, 2012) provided for three different levels of partnership: Official Global Partner (the level chosen by Intesa Sanpaolo), Premium Partner, and Official Partner. Overall 28 companies responded to a public call from all over the world. There were 22 sponsors that supported the event and its communication, and five corporate pavilions were entirely dedicated to global leader corporations.

A situation analysis describing the partnership between World Expo 2015 and Intesa Sanpaolo Bank is summarized in Figure 4.1.

Strengths	Weaknesses
✓ Leadership in the national market ✓ Established artistic cultural policy ✓ Cultural heritage of the absorbed banks ✓ Service innovation ✓ Investment in strategic partnerships	✓ Young corporate origins ✓ Weak synergies between corporate and marketing communication ✓ Opaque brand image at the international level ✓ Business in the banking service, were not typically associated with "Made in Italy" concept
Opportunities	**Threats**
✓ Global visibility and internationalization of business ✓ Rebranding as "Made in Italy's bank" ✓ Growth in both B-to-C and B-to-B segments ✓ Cross-media storytelling ✓ Reinforce ethical message	✓ Financial and reputational crisis of the banking sector ✓ Delays and public debates against World Expo 2015 ✓ World Expo as a crowded communication context for partner and sponsor brands

Fig. 4.1. The strategic partnership with World Expo 2015: Intesa Sanpaolo Bank SWOT analysis. Source: Author's creation.

CORE OPPORTUNITY

Intesa Sanpaolo Bank will be remembered as one of the seven Official Global Partners[14] of World Expo 2015 due to its selection in the pool of leader corporations, which provided a top level of professional and technological support during the event.

As official partner in the banking sector, Intesa Sanpaolo guaranteed the supply of several financial services and resources at the event. Among them, the official ticketing service, offered both online and at the bank's branches; the distribution of prepaid "Flash Expo" cards, processing ticket payments as well as additional touristic and cultural packages; and of course, continuous banking and financial support to both international exhibitors and visitors, also by means of innovative electronic payment services.

Furthermore, to fully leverage its role as partner, Intesa Sanpaolo decided to actively participate in the event with a dedicated cultural program and exhibit space, expressing the bank's commitment for two major issues defining Italian identity: cultural heritage and business culture. The corporate pavilion was conceived as a multi-functional space where dedicated communication and networking activities could take place with strategic partners, most notably a selected group of small and medium-sized companies representing the tradition of "Made in Italy".

GOALS

From this scenario, Intesa Sanpaolo Bank chose to make the partnership with World Expo 2015 a key strategy to support its global ambitions. It chose this unique communication context to celebrate the company's affiliation with the cultural and entrepreneurial tradition of "Made in Italy" to re-enforce a distinctive and leading corporate identity both in Italy and abroad.

Intesa Sanpaolo's CEO Carlo Messina explained the strategy and its inherent opportunities during the launch event in Milan (November 5, 2014):

> The partnership with World Expo Milan 2015 represents a unique occasion in order to reinforce our commitment toward country, value the Italian business excellences, promote the vitality of both national economy and cultural heritage of which Italy is rich. Because Intesa Sanpaolo Bank believes in World Expo 2015 as a great occasion to re-launch the country and thus, from us, to offer a concrete support to Italian companies.[15]

As World Expo 2015 reproduced a scaled version of the contemporary global market, Intesa Sanpaolo wanted to contribute with a visible leading role in order to demonstrate that they are the "bank of Made in Italy" and stand for excellence. Gabriella Gemo, the manager responsible for the partnership project explained:

World Expo 2015 seemed to us the easiest and most immediate context where to demonstrate the presence of a bank integrated in the everyday real economy, together with families and companies that work [...]. To be part of such a global event has meant for us also to bear a responsibility and, indeed, to express an important message of trust for the country. (G. Gemo, personal communication, 2015)

OBJECTIVES

The partnership with World Expo 2015 was strategically played on an intense relational and networking activity, involving the established partners of the bank as well as all the other entities participating in the event: Italian and foreign visitors, public institutions, companies, non-profit organization, and the media.

By participating in the World Expo, Intesa Sanpaolo Bank not only demonstrated the quality of its own banking services, as evidenced by several innovative services supporting the event, but offered programmatically a corporate communication and public relations strategy that supported both the short and medium-long term objectives. Some of these strategies were to elevate the quality of international visibility for the group and the repositioning of its corporate identity as a leading "Made in Italy" brand, thus reinforcing of corporate reputation in the global market.

The key objectives of this project were to develop and qualify relationships and "partnerships" with all economic and social stakeholders, to improve financial value by increasing in the medium-long term the bank's market share both in the family and business segments.

KEY PUBLICS

The communication and public relations campaign supporting the partnership with World Expo 2015 was strategically driven by the specific stakeholder engagement approach developed by Intesa Sanpaolo according to international accountability principles (in particular, the AA1000APS standard) in order to promote symmetrical and long-term relationships, based on stakeholders listening and engagement (Intesa Sanpaolo, 2016b).

In detail, the bank's relational map (Intesa Sanpaolo, 2016b) identifies six major categories of stakeholders, further segmented internally as below:

- Employees (network and staff personnel, junior and senior employees, managers and top managers, trade unions);
- Customers (retail and household customers, financially vulnerable retail and household customers, SME customers, large corporation customers,

start-ups, consumer associations, public authorities and public administration, third sector, professional associations);
- Shareholders (small investors, foundations, institutional investors, socially responsible investors, shareholder associations);
- Suppliers (large and small-scale suppliers, trading partners, suppliers);
- Environment (environmental associations, scientific community, future generations);
- Community (associations, regulatory authorities, national and international public institutions, media).

KEY MESSAGES

An intense communication and public relations campaign supported the partnership between Intesa Sanpaolo Bank and World Expo 2015. It celebrated "sharing" as its own key concept, joining several communication activities promoted both online and offline (Bandirali & Gemo, 2016).

As reported some months after the conclusion of World Expo 2015 by Vittorio Meloni, Head of External Relations Department, during a launch event to promote new concepts in banking (Turin, April 13, 2016):

"The communication strategy of Intesa Sanpaolo puts in the center the idea of sharing: thus, the mission of a bank which is more and more open to the living forces of a society which wants to grow again by means of concrete projects."[16]

During the World Expo 2015, the concept of the project was defined in five thematic programs of initiatives:

- *Sharing Arts*, promoting Italian cultural heritage;
- *Sharing The World*, program of events animated by experts and famous scientists;
- *Sharing Creativities*, developing edutainment activities dedicated to families and young people;
- *Sharing Visions*, promoting business innovation and networking;
- *Sharing Stories*, valuing the experience and history of small and medium Italian companies.

This strategy leveraged the true value of World Expo 2015 as a relational platform,- one that is capable of improving existing connections with stakeholders and cultivate new ones, both at the corporate and marketing level-by developing strategic networking and communication activities. The pavilion space itself was conceived as a real incubator of stories, contents, and relationships connecting different players: indeed, the event became a unique occasion to develop shared

storytelling involving all the stakeholders of the bank, rather than a static representation of its own corporate identity.

STRATEGIES

The main strategy was to promote the bank's identity and reputation among stakeholders in a global context. The External Relations Department conceived the partnership project in continuity with a multi-year corporate communication strategy, which proclaimed: "A possible world" thereby emphasizing the contribution of the bank to make a better world.

At the same time, the communication and public relations strategy foresaw a marketing return. In particular, it integrates several on and offline platforms promoting the synergy between corporate and marketing relationships in order to involve existing as well as prospective clients of the banks, at both B-to-B and B-to-C levels.

Based on the core message of "sharing", the strategy supporting the participation in World Expo 2015 was incisively played on the opportunity of cultivating partnerships. Indeed, a symmetrical relationship involving cooperation and mutual exchange between the parties involved—even if different from their own role and mission—just by their "sharing" common values and goals (Austin, 2000; Grunig & Hunt, 1984; May Seitanidi & Crane, 2013; Riem Natale & Albarea, 2003). The participation of Intesa Sanpaolo Bank in World Expo 2015 celebrated the collaboration between the bank and the major players of the Italian economy and cultural life, as a source of "shared value" (Porter & Kramer, 2011) for the company and the country itself.

Indeed, the project offers an innovative example of the strategic business opportunities concerning the "Italian brand", especially for those companies competing in the global marketplace. Such a communication concept, traditionally applied by the most representative Italian productions (such as fashion, food, and design), is now adopted by other companies in the business and services sectors, in order to both reinforce international distinctiveness and to make communication more emotional and engaging.

TACTICS

A multiplicity of communication and public relations activities supported the official partnership with World Expo 2015 before, during, and after the event. Among the major initiatives, which are illustrated in detail in the following sections, there was a rich program of both internal and B-to-B communication; an integrated

advertising and media relations campaign addressed to a large public; and several projects and events promoted both in-house, as well as within the corporate pavilion, and on the web.

Internal Communication

The project was supported by continuous internal communication activity. Company management as well as the employees working in banking branches all over Italy were asked to contribute to the preparation of the event and to promote several local initiatives.

The internal campaign, launched in advance of the global exposition's inauguration, involved all the main tools and channels normally used for communicating with the bank's employees.

For example, "Mosaico", the company's house newsletter, published 21 articles concerning the partnership project. A special section dedicated to World Expo 2015 was created within the company's intranet to invite employees to share content and conversations about the event: the homepage reported 101 news items, in addition to 338 multimedia content units published in the internal pages. Several video interviews (17) with managers and personnel working in the corporate pavilion were delivered through the company's web television channel, including the conclusion of the event with a speech by the CEO Carlo Messina.

Advertising

An integrated advertising campaign was launched before the beginning of the event, in November 2014. It involved well-known personalities as well as some of the bank's partners.

Advertising tactics included both mass and specialized channels across several media (radio, television, daily and periodical press, billboards, and web), and were placed both at the national and local level. A corporate campaign in major media and television channels included this call to action: "Nominate your company". This same special project was promoted throughout communication activities on digital platforms as well in the bank's retail branches all over the country.

B-to-B Communication

The "Nominate your company" campaign promoted the selection, among the banks' clients, of 400 small and medium Italian firms, doing business in different Italian regions and in sectors which were aligned with the thematic components of the global exposition such as food, design, innovation, fashion, and hospitality.

Intesa Sanpaolo offered its business clients the opportunity to be part of World Expo 2015, by participating in the bank's exhibition area with different public relations opportunities: space that companies could use for organizing conferences, cultural events, business-to-business meetings, product launches, etc. In this way, the bank provided its partners the opportunity to interact with a range of publics, large or narrowly targeted, in order to promote to an international audience their own networking and communication activities.

Corporate Pavilion

The company's pavilion was named "The Waterstone". It will be remembered as the first pavilion set up within Expo's site. Designed and displayed in accordance with the corporate brand identity, it covered almost 1,000 square metres along the central route (*Decumano* street) crossing the exhibit site. The structure was designed by the well-known Italian architect Michele De Lucchi and inspired by natural elements evoking integrity and solidity, since it was built with wood and other eco-friendly and recyclable materials (Figures 4.2 and 4.3).

Fig. 4.2. The Waterstone pavilion in World Expo 2015: internal view. Source: © Ph. Maurizio Tosto—Intesa Sanpaolo EXPO Milano 2015.

Inside, the pavilion space was conceived as a suggestive representation of the "Made in Italy" concept, integrating iconic elements such as arts and culture, landscape, artisan tradition, and innovation. The ground floor (Figure 4.2) hosted

a technological branch of the bank, displaying innovative electronic and mobile payment services. It also exhibited some art crafts from their corporate collection (among which a painting designed by the famous futurist artist Umberto Boccioni in 1909). In addition, the pavilion space was animated by a multimedia installation, entitled "Horizons in motion". It consists of seven interactive scenarios celebrating both the Italian identity and the bank's responsiveness toward the economic and cultural development of the country, promoted in collaboration with the major public, private, and non-profit Italian organizations.

Fig. 4.3. The Waterstone pavilion: external view. Source: © Ph. Maurizio Tosto—Intesa Sanpaolo EXPO Milano 2015.

Events

The External Relation Department provided dedicated staff that were constantly present at the expo site, where it coordinated a multiplicity of in-house initiatives and collaborated with the reception staff.

The World Expo was the occasion for promoting an intense activity of international public and media relations, involving the key publics and opinion leaders in qualified contexts and events. The upper floor of the pavilion had a foyer and some meeting rooms which could be converted for different kinds of event, promoted either by the bank or their strategic partners: companies, non-profit associations, and public institutions including 30 major Italian cultural institutions, such as Teatro alla Scala in Milan, Regio Theatre in Turin, and San Carlo Theatre in Naples.

During the184-day-long World Expo 2015, The Waterstone pavilion was alive with non-stop events involving about 350 scientists, artists, and experts, of interest to both families and corporate partners. Among the initiatives, there were a total of 110 performances and edutainment events, 250 cultural events and conferences, in addition to many business meetings organized daily by the bank's corporate clients (chosen through the contest "Nominate your company").

The partnership with World Expo 2015 was also supported by several events and cultural exhibits taking place outside the exposition site and involving the bank's Galleries of Italy network in Milan and all over the country.

Media Relations

From the initial announcement in October 2012, the launch, execution, and conclusion of the project were supported by an intense media relations activity, addressed to the national and financial press.

Media relations tactics intensified and became continuous from November 2014, when the partnership project and its distinctive contents were officially presented. A dedicated newsroom was set up in the company's headquarters in Milan in order to support journalists. During and just before/after the event, from February to November 2015, overall 85 news releases were issued highlighting the salient moments of the event. This places Intesa Sanpaolo Bank, followed by the Enel energy corporation, as the most active company among all the World Expo's sponsors and partners.[17] Furthermore, strategic media partnerships were cultivated with several television channels and national newspapers, notably "Il Sole24Ore"—the media group with the most economic prestige in Italy.

Digital Communication

The participation of Intesa Sanpaolo in World Expo 2015 was supported by a comprehensive digital communication campaign. It involved both the corporate website http://www.intesasanpaolo.com and official social media profiles, where all the news and content concerning the partnership were published. Of note, a rich video of the event was posted on the company's YouTube channel, where overall 112 videos concerning corporate events and initiatives were uploaded during the period of the expo. Furthermore, the bank's participation in the event was cross-promoted on a dedicated corporate page on the World Expo 2015's official portal, as well as on the specific website "Un mondo possibile" supporting the multi-year corporate communication policy of the bank.

The partnership was also an ideal springboard for a new B-to-C and B-to-B e-commerce portal (originally entitled "Created in Italia"[18]), which the bank launched in September 2014. The project, dedicated to the excellence of Italian

business, aimed to promote the internationalization of small and medium firms by developing their presence in a virtual marketplace entirely dedicated to the most distinctive "Made in Italy" productions.

CALENDAR/TIMETABLE

The partnership with World Expo 2015 was formalized on October 16, 2012, after Intesa Sanpaolo Bank had responded to a call for proposals on October 8, 2012.

The corporate communication campaign for World Expo 2015 started from the public announcement of the partnership, almost two years before the May 1st, 2015 start of World expo. Three major campaigns can be identified:

- *Pre-event campaign*: September 2013–April 2015
- *During-event campaign*: May–October 2015
- *Post-event campaign*: November 2015–2016

In September 2013, the first public relations and communication activities were promoted in Milan and Turin, which are the major hubs of the bank in the country. Later, in April 2014, a wider internal communication campaign began involving all the bank branches in Italy.

Before the opening event, one of the first external communication activities was the public call dedicated to small and medium Italian companies, which was supported by a teaser advertising campaign in November 2014. The partnership project was highlighted during a public event in the Gallery of Italy's in Milan on November 5, 2014, followed by a press conference which was organized in the corporate pavilion on March 25, 2015, about one month before the official inauguration of the World Expo.

During the World Expo (May 1st–October 31, 2015), several communication and public relations activities (which have been summarized in the previous sections) were developed both on and offline, in order to support the many events and activities promoted daily within the bank's corporate pavilion as well as outside the expo site.

After the conclusion of World Expo 2015, a new strategic stage began for the company, aimed at managing the post event period and its legacy. Several initiatives have been promoted in order not only to assure the indispensable reporting and follow up activities, but also to communicate the relevant results from the partnership project and moving forward.

In particular, the "Made in Italy" e-commerce portal dedicated to the small and medium enterprises is one of the most valuable legacy of the World Expo for

the bank. After the event, this initiative continued its growth and enriched itself with a new cultural offering by moving to the web portal "Mercato Metropolitano" in December 2015 while continuing other non-web activities.[19] Finally, on October 2015 a book on the challenges surrounding global ethics was published by the Italian publisher Laterza, which collected contributions by several intellectuals involved in the series of conferences for World Expo 2015 (Cogoli, 2015).

BUDGET

The bank supported an overall investment largely exceeding the minimum threshold of the request for proposals set at 20 million Euros by the organizer company Expo 2015 S.P.A. The company's investment in the event included both the cash costs stated by the partnership agreement (22.462.639 Euros, VAT excluded) and the additional "value in kind" (VIK) related to the many banking services offered during the global exposition (11.175.586 Euros).

Additional costs were also supported in order to finance the many cultural and communication activities promoted both in and outside the expository site. These expenditures, reported publicly at between 1 and 5 million Euros, were absorbed within the annual communication budget, by leveraging and re-directing the existing marketing programs in order to maximize results.

Furthermore, at the invitation of the European Central Bank, Intesa Sanpaolo also set aside a 15 billion Euros fund for the development of Italian small and medium firms.

EVALUATION AND MEASUREMENT

The results of the partnership with World Expo 2015 were tracked before, during, and after the execution of the event with timely reports. The External Relations Department promoted a continuous in-progress and ex-post monitoring of the outputs guaranteed by different kinds of communication and public relations initiatives. Moreover, the desired outcomes of the project—the reinforcing of corporate reputation in the national and global market by repositioning as a leading "Made in Italy" brand—were evaluated in both the short and the medium term by using different tools, such as surveys and web opinion mining.

Measurement activities included counts of major outputs: number of events, partners, services assured during the event, visitors, etc., media coverage monitoring, as well as techniques more adapted to measure outcomes such as brand reputation and equity, which Intesa Sanpaolo tracked at the mid-event period and continues today on a regular basis.

The evaluation revealed the following results:

- 700,000 visitors to the corporate pavilion and 50,000 spectators for events and artistic performances;
- 530 companies and 35 start-ups hosted in the corporate pavilion, among which 400 client companies selected from about 1,000 candidates from all over the country;
- 650,000 expo tickets sold by the bank's branches and online platform;
- 60,000 "Flash Expo" cards distributed;
- 2 million banking transactions with credit and pay cards;
- 130 million banking transactions supported within the expo site.

Web analytics were also tracking positive results. In particular, during the entire event, the corporate webpage on the World Expo's official site obtained more than one million views. In the same period, the bank's Facebook page fan-base increased by 450 percent, and reached 312,000 "likes" in Italy after the event. Furthermore, the video story of the event posted on the web obtained over 15 million views and 4,000 users registered to the corporate YouTube channel.

Finally, the e-commerce portal "Created in Italia" saw relevant growth after the event with approximately 900 companies and 27,000 users registered as of February 2016.

Media Coverage

Intesa Sanpaolo's participation in World Expo 2015 received widespread domestic and international media coverage, with a total of 4,500 stories in addition to significant television and radio reportages. In Italy alone, for the ten months beginning in January and ending in October 2015, the press review counted 1,227 newspaper articles (331 of which were in national newspapers), 66 magazines articles, and 412 mentions on the web. Broadcast coverage shows 128 stories delivered during 2015 by both local broadcast and the major radio-television channels, with special interest in the many initiatives and events promoted in collaboration with the partner companies invited in the bank's pavilion.

Domestic media coverage skyrocketed in the first week of May 2015, driven by the official opening of the World Expo, and at the end of October 2015, during the final stage of the event. Before and during the global exposition, a decisive contribution to media visibility was offered by the media partnerships strategically promoted by the bank, highlighted by the economic publisher "Il Sole 24Ore" publishing 72 stories on both the newspaper and online channels from January to October 2015.

Brand Reputation and Equity

Intesa Sanpaolo Bank conducts annual brand tracking to continuously monitor the group's image and reputation in collaboration with the Italian research institute IPSOS.[20]

Among both market and social stakeholders, the quality of the bank's corporate image registered a steady increase in 2015, despite a new dramatic scandal hitting the Italian banking sector (the "four banks" scandal, following the crash of the Monte dei Paschi di Siena Bank in 2013). Per IPSOS' monitoring, the group obtained positive reputational results among both visitors and non-visitors of the World Expo: 43 percent of Italian citizens indicated that their perception of Intesa Sanpaolo had improved, and this percentage rose to 55 percent among visitors of the event and further to 61 percent among the bank's clients (IPSOS, 2015).

After the conclusion of the event, Intesa Sanpaolo also gathered the opinions expressed by small and medium enterprises which were invited within the corporate pavilion: they expressed a general level of satisfaction and thankfulness for having the chance to live as protagonist of "a day in World Expo 2015". Indeed, they all appreciated the alliance with such a special organization as the Intesa Sanpaolo Bank, offering them free prestigious space and visibility opportunities. They said they could not have achieved this on their own (IPSOS, 2015).

Furthermore, Intesa Sanpaolo emerged as the first brand in a non-food sector spontaneously remembered by the public, as well as the first non-food company to be perceived as more capable to support the execution of the event (Intesa Sanpaolo, 2016a). In 2015, the research group Doxa ranked Intesa Sanpaolo amongst the first five banking players for the number of conversations on the web with a positive sentiment about corporate solidity and integrity.

Awards

The campaign supporting the participation of Intesa Sanpaolo Bank in World Expo 2015 was honoured internationally with several acknowledgements.

In Italy, the project won second place at the 2015 edition of BEA—Best Event Awards competition for the category "Event in Expo". In the same competition, it gained a special prize for the event execution, curated by the FilmMaster Event agency.

Furthermore, the annual *Cultura + Impresa Award 2015* included the cultural program of events proposed by the bank within World Expo 2015 in the shortlist dedicated to the best corporate cultural investments promoted by Italian companies. Among them, Intesa Sanpaolo received a special mention for the "The Waterstone experience" project.

In UK, the project received the Bronze Price in the category "Education and training event" at the EVCOM Live Award 2015, organized by the Event & Visual Communication Association.

CONCLUSIONS

Before and after the participation in World Expo 2015, Intesa Sanpaolo Bank's case can be considered unique in its genre, because of both the relational commitment animating corporate communication policies and the will to invest in the "Made in Italy" brand heritage and reputation.

On the one hand, the bank's multi-year cultural policies have arisen over time as the most distinctive asset of its corporate identity and public relations strategy, preparing the field for a very proactive participation in World Expo 2015. The major strength of the bank's "humanistic" approach to business resides in the combination of both prestigious partnerships and original in-house projects promoted all over the country: this opportunity distinguishes Intesa Sanpaolo's strategy from the philanthropic tradition carried on by the other major banks in Italy and worldwide (Civita, 2006; D'Orazio, 2016; Tosolini, 2013). Indeed, this second and more conventional approach to arts and culture is based, in general, on the ownership of huge collections and historical sites which most banks continue to treasure, while only rarely made available or shown to stakeholders, thus valued as a form of "relational capital".

On the other hand, the significant public relations and communication investment in World Expo 2015 supports corporate rebranding as the "Made in Italy's bank", taking advantage of the "potential for regeneration" ascribed to mega-events (Ritchie & Yangzhou, 1987; Roche, 2000) and, specifically, of the enormous narrative potential residing in the communication of Italian style and heritage (Bettiol, 2015; Bucci, Codeluppi, & Ferraresi, 2011; Calabrò, 2015; Ferraresi, 2014; Martino & Lovari, 2016). To this end, the several initiatives associated with the World Expo aimed firstly to elevate the value of the bank's connection with the arts and culture, widely recognized as the most distinctive essence of Italian identity (Martino, 2013, 2015), by means of a refined offering of events, which could stand out amidst the vast World Expo. Secondly, the project leveraged the huge marketing potential arising from the aggregation of the highly fragmented small and medium Italian businesses (Symbola Foundation, 2015), by providing them with new dedicated communication platforms both on and offline.

As Intesa Sanpaolo's Head of External Relations Vittorio Meloni explained:

> The corporate pavilion stood as a *trip into Italian identity*; indeed, an unique point of meeting among culture, arts, and business, joining a multitude of players which with difficulty could have met both each other and the large public otherwise. [...] The results for us were

remarkable: probably we were the most active hub of communication within the entire World Expo, since every day we promoted several events and narrated them also outside the expo site, on both digital and traditional platforms. Doing this, indeed we tried to be a mirror of the country: probably, we offered the major place where Italy could express itself with eloquence, representing to the world through its own business excellences as well as the major players of cultural life, which were both guests of the bank. (V. Meloni, personal communication, 2016)

Furthermore, the "Made in Italy" communication activities promoted by the bank illustrate a decisive application of a strategy aiming at "creating shared value" (Porter & Kramer, 2011) and, thus, providing mutual benefit for all the parts collaborating to a common goal. This ethical approach seems to be decisive in front of an international scenario in which, especially since the 2008 economic crisis, banks have faced a dramatic financial and reputational crisis (Dell'Atti & Trotta, 2016).

In this regard, the campaign for World Expo 2015 celebrated especially the value of partnerships (Austin, 2000; May Seitanidi & Crane, 2013), by conceiving a corporate pavilion itself as a strategic incubator of projects and business relationships (Bandirali & Gemo, 2016). Indeed, the numbers of collaborations were not simply possible marketing opportunities, but a source of ideas and quality content for future communication. The same innovative idea of "sharing" animated also the new communication campaign promoted in 2016: the campaign slogan, "Sharing ideas", continues to underline the opportunity to support corporate competitiveness by improving, at the same time, the economic and social conditions of the community among which the bank does its business (Porter & Kramer, 2011).

From all these points of view, Intesa Sanpaolo's experience in the most recent World Expo illustrates some extraordinary business and communication opportunities connected to the most authentic essence of "Made in Italy", which has deep relational and emotional connection. The execution of this strategy went beyond the rhetorical, which is more commonly seen in traditional brand image campaigns competing in the global market, but rather capitalized on an inestimable set of values and relationships formed over time. For Intesa Sanpaolo Bank, indeed, it stands as a durable legacy of World Expo 2015 to be spent in the long term, after the lights on the mega-event were turned off.

AKNOWLEDGMENTS

For their professional help gathering facts and support, special thanks go to: Vittorio Meloni, Head of External Relations at Intesa Sanpaolo Bank; Michele Coppola, Head of Cultural Heritage Department; Gabriella Gemo, manager responsible for the partnership project with World Expo 2015; Elena Jacobs, Corporate Image Executive; Milena Lazza, Identity and Community Relationships' coordinator.

We also thank Raffaele Lombardi, Concetta Monte, and Emanuela Ventola for their contribution to data analysis and interviews.

NOTES

1. For a historical map of the group, see the dedicated section on corporate website http://www.intesasanpaolo.mappastorica.com.
2. The building, which represents a cultural and entertainment center, was inaugurated in 2015 (http://www.grattacielointesasanpaolo.com).
3. Indeed, in order to value their own roots and responsibility toward territory, these organizations promote projects benefiting local communities especially in the artistic sector, which, in 2014, represented almost a third of the whole investment in Italy (ACRI, 2016).
4. See the website dedicated to the project: http://www.progettocultura.intesasanpaolo.com. Cultural sector, representing the major area of social intervention by the bank, absorbed in 2014 the 50 percent of its overall contribution to community and has increased for amounting of the investment over the years (Intesa Sanpaolo, 2015).
5. The project was launched by the preexisting Catholic Bank of Veneto, later absorbed by Intesa Sanpaolo Group.
6. See the website dedicated to the project and cataloguing all the restored artworks: http://www.restituzioni.com.
7. See the website of the project: http://www.voximago.it.
8. The bank's cultural heritage includes approximately 20,000 artworks, stretching from archaeology to modern arts.
9. The first expository gallery was opened in Vicenza (1999), followed by the ones in Napoli (2007), and Milan (2011). The gallery in Milan, hosted by the historical palace of Commercial Bank of Italy at piazza Scala, includes also a bookshop and a coffee shop, in addition to several didactic and communication services. From November 7, 2015, to February 21, 2016, it hosted a successful exhibition presenting 120 paintings by the well-known artist Francesco Hayez (among which a version of the iconic "Kiss"): the event, launched by a dedicated flash mob in the World Expo's site, counted a public of overall 80,000 visitors.
10. For example, the special contest "Curator for a day", launched in occasion of World Expo 2015 and supported by the dedicated website http://palco.intesasanpaolo.com/browse/category/curator.
11. See the website of the project: http://www.muvir.eu.
12. The case study applies the 12-level model suggested by the updated version of the "RACE" scheme, analysing public relations and communication campaigns (Wilson & Ogden, 2010).
13. See the official website http://www.expo2015.org.
14. The others were Accenture, Enel, Fiat Chrysler Automobiles and CNH Industrial, Samsung, Selex ES, and Telecom Italia.
15. See the press release on the website: http://www.group.intesasanpaolo.com.
16. See the press release on the website: http://www.group.intesasanpaolo.com.
17. Provided by a research study, coordinated by the Department of Communication and Social Research at Sapienza University of Rome, investigating the communicative behaviors of all the companies participating as sponsors or partners in World Expo 2015.
18. Since the end of 2015, the web portal has been integrated to the "Mercato Metropolitano" project, launched in connection with World Expo 2015 for creating a typical Italian food market in Turin. See the website: https://www.mercatometropolitano.it.

19. See footnote 17.
20. Interviews are collected by different groups of stakeholders and measured by means of a reputation scale expressing different levels of appreciation. Stakeholders' perceptions are also valued in economic terms in order to track the group's brand equity over time, according to the major international standards and in collaboration with several research agencies (IPSOS, 2015).

REFERENCES

ABI. (1997). *Ricerca sulle sponsorizzazioni culturali delle banche.* Roma: Bancaria Editrice.
ACRI. (2016). *Ventunesimo Rapporto sulle Fondazioni di origine bancaria. Anno 2015,* Roma.
Argenti, P. A. (2009). *Corporate communication.* Boston, MA: McGraw-Hill 1994.
Austin, J. E. (2000). *The collaboration challenge. How non-profits and businesses succeed through strategic alliances.* San Francisco, CA: Jossey-Bass.
Azzarita, V., De Bartolo, P., Monti, S., & Trimarchi, M. (2010). *Cultural social responsibility. La nascita dell'impresa cognitiva.* Milano: Franco Angeli.
Bandirali, F., Gemo, G. (Eds.). (2016). *Diario di un'esperienza condivisa. Intesa Sanpaolo per Expo Milano 2015.* Milano: Intesa Sanpaolo.
Bellavite Pellegrini, C. (2013). *Una storia italiana. Dal Banco Ambrosiano a Intesa Sanpaolo.* Bologna: il Mulino.
Bettiol, M. (2015). *Raccontare il Made in Italy.* Venezia: Marsilio.
Bondardo Comunicazione. (Ed.). (2007). *Impresa e cultura in Italia. Itinerari alla scoperta dei protagonisti dell'investimento in cultura.* Milano: Touring.
Bucci, A., Codeluppi, V., & Ferraresi, M. (2011). *Il Made in Italy.* Roma: Carocci.
Calabrò, A. (2015). *La morale del tornio. Cultura d'impresa per lo sviluppo.* Milano: Bocconi.
Civita. (Ed.). (2006). *Fondazioni bancarie e cultura: un impegno di valore.* Milano: Sperling & Kupfer.
Cogoli, G. (Ed.). (2015). *Un mondo condiviso.* Roma-Bari: Laterza.
Cornelissen, J. (2011). *Corporate Communication: Theory and Practice.* London: Sage.
D'Orazio, C. (2016). *La cultura delle banche oggi. Viaggio attraverso un anno di iniziative.* Bologna: il Mulino.
Dell'Atti, S., & Trotta, A. (Eds.). (2016). *Managing reputation in the banking industry. Theory and practice.* Cham: Springer.
Ferraresi, M. (Ed.). (2014). *Bello, buono e ben fatto. Il fattore Made in Italy.* Milano: Guerini Next.
Fombrun, C. J., & Riel, C. B. M. van (2004). *Fame and fortune: How successful companies build winning reputations.* Upper Saddle River, NJ: Prentice Hall Financial Times.
Goodman, M. B., & Hirsch, P. B. (2010). *Corporate communication: Strategic adaptation for global practice.* New York, NY: Peter Lang.
Grunig, L. A., Grunig, J. E., & Dozier, D. M. (2002). *Excellence in public relations and communication management: A study of communication management in three countries.* Mahwah, NJ: Lawrence Erlbaum Associates.
Grunig, J. E., & Hunt, T. (1984). *Managing public relations.* New York, NY: Holt, Rinehart and Winston.
Intesa Sanpaolo. (2012). *Ethical code.* Retrieved from http://www.group.intesasanpaolo.com
Intesa Sanpaolo. (2015). *Sustainability Report 2014.* Retrieved from http://www.group.intesasanpaolo.com
Intesa Sanpaolo. (2016a). *Sustainability Report 2015.* Retrieved from http://www.group.intesa-sanpaolo.com

Intesa Sanpaolo. (2016b). *Stakeholder engagement 2015 and improvement objectives 2016.* Retrieved from http://www.group.intesasanpaolo.com

IPSOS. (2015). *Osservatorio immagine Intesa Sanpaolo.* Internal Report.

Ki, E.-J., Kim, J.-N., & Ledingham J. A. (Eds.). (2015). *Public relations as relationship management. A relational approach to the study and practice of public relations* (2nd ed.). New York, NY: Routledge.

Martino, V. (2010). *La comunicazione culturale d'impresa.* Milano: Guerini.

Martino, V. (2013). *Dalle storie alla storia d'impresa.* Acireale-Roma: Bonanno.

Martino, V. (2015). Made in Italy museums. Some reflections on company heritage networking and communication. *Tafter Journal, 84.* Retrieved from http://www.tafterjournal.it

Martino, V., & Herranz de la Casa, J. M. (2016). Arts and strategic communication in Italy and Spain: from sponsorship to corporate responsibility. *Tafter Journal, 86.* Retrieved from http://www.tafterjournal.it

Martino, V., & Lovari, A. (2016). When the past makes news: Cultivating media relations through brand heritage. *Public Relations Review, 42*(4), 539–547.

May Seitanidi, M., & Crane, A. (2013). *Social partnerships and responsible business: A research handbook.* New York, NY: Routledge.

Pino, F. (Ed.). (2004). *L'archivio storico di Banca Intesa. Per una storia al plurale.* Milano: Banca Intesa.

Pino, F., & Mignone, A. (Eds.). (2016). *Memorie di valore. Guida ai patrimoni archivistici di Intesa Sanpaolo.* Milano: Hoepli.

Porter, M. E., & Kramer, M. R. (2011). Create shared value. *Harvard Business Review, 89,* 62–77.

Riel, C. B. M. van (1995). *Principles of corporate communication.* London: Prentice Hall.

Riem Natale, A., & Albarea R. (Eds.). (2003). *The art of partnership. Essays on literature, culture, language and education towards a cooperative paradigm.* Udine: Forum.

Ritchie, J. R. B., & Yangzhou, J. (1987). The role and impact of mega-events and attractions on national and regional tourism: A conceptual and methodological overview. In AIEST (Ed.), *Proceedings of the 37th Annual Congress of the International Association of Scientific Experts in Tourism.* Calgary.

Roche, M. (2000). *Mega-events and modernity: Olympics and expos in the growth of global culture.* London: Routledge.

Symbola Foundation, Unioncamere & Edison Foundation. (2015). *I.T.A.L.I.A. Geografie del nuovo Made in Italy.* Retrieved from http://www.symbola.net

Tosolini, M. M. (2013). *Fondazioni bancarie e nuova economia della cultura.* Venezia: Marsilio.

Wilson, L. J., & Ogden, J. (2010). *Strategic communications planning for effective public relations and market.* Paperback.

Wu, C.-T. (2002). *Privatizing culture: Corporate art intervention since the 1980s.* London: Verso.

Yu, L., Wang, C., & Seo, J. (2012). Mega event and destination brand: 2010 Shanghai Expo. *International Journal of Event and Festival Management, 3,* 46-65.

Cases IN Public Diplomacy

Japan Is Back

The International Public Relations of the Second Abe Administration

KOICHI YAMAMURA, PH.D.
Waseda University

MASAMICHI SHIMIZU
Corporate Communication Initiative

NANCY SNOW, PH.D.
Kyoto University of Foreign Studies

EDITOR'S NOTE

The government of Japan has, since the trauma of World War II, been hesitant to extend its public diplomacy efforts beyond international cultural and personal exchanges. This case study examines the efforts of Japan's prime minister Shinzo Abe to accelerate the country's global public relations efforts, focusing on expanding the understanding of Japan's basic positions and policies, establishing and enhancing Japan as a nation brand, and effectively and efficiently communicating the public diplomacy messages of the Japanese government.

BACKGROUND

When World War II ended, Japan needed to wipe out its pugnacious image and present itself as a peace-loving democratic country. Due to lack of resources, coupled with the trauma associated with wartime aggression, Japan's public diplomacy efforts were focused primarily on Japan's culture and exchange of persons. As Japan's economy grew, the government of Japan began spending a huge sum

of money on official development assistance (ODA), in particular, to neighboring countries in Asia. However, Japan's postwar development aid, substantial as it was, was not well recognized by the general public in receiving countries. By the time of the Gulf War (1990–1991), at a time when Japan was still viewed as an economic superpower in second place behind its closest ally, the United States, Japan became aware that monetary support alone, so-called chequebook diplomacy, was not enough to earn appreciation and stature in world public opinion. The Gulf War "shock" led to the passage of the International Peace Cooperation Law in 1992, which allowed limited participation by Japan's Self-Defense Forces in United Nations peacekeeping operations. By the late 1990s, the government of Japan recognized the importance of policy communication with global publics, first with the installment of a Cabinet Public Relations Vice Secretary in 1998 (Kaneko, 2014) and then with the high-profile Office of Global Communications (hereafter OGC) in the Prime Minister's Office, officially recognized in 2012, but informally in operation right after the Great East Japan Earthquake in March 2011 (N. Shikata, personal conversation, June 30, 2016).

In September 2006, Shinzo Abe became the Prime Minister of Japan as president of the Liberal Democratic Party (LDP), succeeding Junichiro Koizumi, who held the office for five years and five months, the third longest in the post-World War II period. After only one year, in September 2007 Abe had to resign due to stomach illness. Two more LDP Prime Ministers took office, each for a short one year, and the public's loss of confidence in the LDP led to the birth of the Democratic Party of Japan's (DPJ) government with a landslide victory in the July 2009 general election.

The DPJ's failure in reviving the economy, coupled with its mishandling of the post-March 2011 earthquake incidents and recovery, resulted in an LDP comeback as ruling party of Japan in December 2012 election. Shinzo Abe, who had recovered from his illness and was the president of LDP at the time, once again became the Prime Minister of Japan.

SITUATION ANALYSIS

Once the second largest economy in the world, Japan's economy stagnated after the collapse of the economic bubble in 1991. The following two decades that Japan struggled to revive its economy were known as the "lost decades." In 2010, China took over the No. 2 position in the global GDP ranking. In the same year, a Chinese fishing boat intentionally hit a Japan Coast Guard patrol boat off the coast of Senkaku Islands, intensifying the tension between the two countries. On March 11, 2011, the Great East Japan Earthquake hit the country, leaving the country with dire needs to communicate the situation about the Fukushima Daiichi

Nuclear Power Plant, atmospheric radiation and food safety, among other public worries. The growing public dissatisfaction with the Democratic Party of Japan's (DPJ) handling of the triple disaster known as 3/11 may have been the key factor behind the Liberal Democratic Party (LDP)'s election victory in December 2012, regaining control of the government from DPJ after three years. LDP president Shinzo Abe, who had resigned as Prime Minister in September 2007, once again became the Prime Minister of Japan. Abe's return to the highest echelon of government after successful treatment for chronic ulcerative colitis seemed to secure his resolve to make Japan matter again in the eyes of the world.

In his inaugural press conference on December 26, 2012, Prime Minister Abe pointed out three areas to which he wanted his cabinet members to dedicate their greatest efforts: economic revival, reconstruction in particular of the earthquake hit regions, and crisis management including natural disaster and diplomatic tensions (Abe, 2012).

CORE OPPORTUNITY

Although many of the news reports were negative, the Great East Japan Earthquake on March 11, 2011 certainly drew the attention of the overseas media to Japan. Less than two years after the earthquake, with the outcome of the nuclear power plant failure in 2011 still unclear, Japan's recovery efforts were quite newsworthy.

Abe's comeback as prime minister and LDP's resurgence as ruling party were also of significant interest to domestic and global media. Abe was a grandson of Shinsuke Kishi, a former prime minister and one of the founders of the Liberal Democratic Party (LDP) of Japan, the dominant political party created in the 1950s. Abe's father, Shintaro Abe, was also a powerful politician—the longest serving foreign minister—and he led a major faction of the LDP. Abe's comeback caught media attention from three aspects: Had Abe really recovered from his illness?; how does Abe, a nationalistic politician, cope with neighboring countries of China and Korea, who were in terms of economic power much stronger than during Abe's first term in office and had disputes over small islands with Japan?; and how was he going to revive Japan's economy?

GOALS

As introduced earlier, Abe listed three goals of his cabinet in his speech during his inaugural press conference. The three goals were: economic revival, reconstruction and crisis management. During the press conference, he made a remark that indicated his resolve to accelerate Japan's diplomacy efforts. He said, "We must also restore proactive diplomacy that defends our national interests" (Abe, 2012).

OBJECTIVES

The objectives of the OGC were: (1) to expand the understanding of Japan's basic positions and policies, (2) to establish and enhance Japan as a nation brand, and (3) to effectively and efficiently communicate the messages issued by the Japanese government. The key aspects of Japan's stance and policies that needed to be communicated were earthquake disaster reconstruction; Abenomics (Abe's policies for economic recovery); regional revitalization; proactive contributions to peace, and a society in which women shine (increasing the number of women in executive and management position); and dynamic engagement of all citizens. The priority of these messages and wording for each message to be applied for actual use did change from time to time to reflect the situation at the time (M. Fukuchi, personal communication, June 29, 2016).

Regarding the Japan brand, the OGC was concerned with creating a foundation for building a positive image of Japan. The aspects that they wanted to convey to the world included the image of a secure and stable society, high value-added Japanese products, a forerunner in solving problems, a leader in culture and tourism, and an international contribution during the post-WWII period.

KEY PUBLICS

For the OGC, the key publics were current and potential opinion leaders and media that could influence opinion leaders. Of course, the understanding from general publics was of paramount importance. The media that the OGC focused on were primarily global media with branch bureaus in Tokyo, such as the Financial Times, Wall Street Journal, Washington Post and New York Times. These media were influential and had a global network. However, when the OGC conducted group briefing sessions, in principle all the international media stationed in Tokyo were invited. Whenever Prime Minister Abe traveled abroad, these media in Tokyo would contact their counterparts in the respective regions to make arrangements for possible coverage. If a trip was an official state visit, the receiving country would make arrangements for press coverage by the local media.

KEY MESSAGES

While there appeared to be different messages for different audiences at different occasions, the OGC did not seem to set any key message to focus on. However, there were two phrases that eventually were treated by media as key phrases. One was "Japan is back," the title of a speech Prime Minister Abe gave at the Center

for Strategic and International Studies in Washington D.C. in February 2013, two months after his assumption of his second term in office. The phrase was used in the subtitle of his new growth strategy issued in June 2013: "Japan Revitalization Strategy-Japan is Back". The other was "Abenomics," a phrase that Prime Minister Abe used to describe his policy package intended to revive the Japanese economy. The three pillars of Abenomics were aggressive monetary policy, flexible fiscal policy and new growth strategy.

In his speech at the Center for Strategic and International Studies in February 2013, Prime Minister Abe cited a paper published in 2012 by Richard Armitage and Joseph Nye, that asked if Japan would end up becoming a tier-two country. In response Abe said, "Secretary Armitage, here is my answer to you. Japan is not, and will never be, a tier-two country. That is the core message I am here to make. And I should repeat it by saying, I am back, and so shall Japan be" (Abe, 2013).

There were certain messages that the OGC consciously used to present a consistent image. "Sharing tomorrow" was the phrase that was used on various occasions to represent an idea that "Japan and the World walk together hand in hand." This phrase and the accompanying logo were used with the TV advertisements that the OGC produced and aired overseas, on the back cover page of the publication "We are *Tomodachi*," and with certain advertorial articles in global newspapers. Other phrases such as "Abenomics is progressing," "regional revitalization" and "society in which all women shine" also were used. However, there was no overarching message that unified communications of the OGC.

STRATEGIES

Noriyuki Shikata, a director of the Personnel Division of the Ministry of Foreign Affairs (at the time of the interview) and director of the International Press Division of the Ministry of Foreign Affairs during Abe's first Administration from 2006 to 2007, said that Abe was mindful of international public relations (personal conversation on June 30, 2016). Before his second appointment as prime minister, Abe was using Facebook and Twitter for disseminating his messages (Ono, 2014). It was only natural that Abe would be the main spokesperson for his own cabinet. A former journalist and Deputy Press Secretary of the Ministry of Foreign Affairs during Abe's first administration, Tomohiko Taniguchi, was brought in as Special Advisor to the Cabinet and acted as Abe's speechwriter on key occasions.

For the OGC, the first priority was to communicate to the international community the fundamental stance and policies of Japan, including the economic status and economic policies, proactive pacifism, promotion of dynamic engagement of all citizens and territorial issues. The second was to build and enhance Japan as

a nation brand. It was to nurture a positive image of Japan by communicating the allure and strength of Japan in order to build a strong foundation for economic and diplomatic activities.

These communications were carried out through three channels. The first was the speeches and interviews by the Prime Minister himself on various occasions and through daily press briefings by the Chief Cabinet Secretary. The second was the information dissemination through websites. The third was the use of social media such as Facebook and Twitter.

TACTICS

Communications by Prime Minister Abe

In the period since he assumed office in December 2012 through June 21, 2016, Prime Minister Abe gave 90 interviews to foreign press reporters. Of these 90 interviews, 31 were conducted face-to-face, including 11 TV interviews. Fifty-nine were pen and paper interviews. Some interviews were conducted in Tokyo and others were conducted abroad during Abe's overseas trips. The media that conducted interviews included the *Wall Street Journal* (U.S.A), *Washington Post* (U.S.A), *Financial Times* (UK), *Economist* (UK), AFP (France), Russian News Agency TASS, CNN (U.S.A.) and Al Jazeera (Qatar).

Prime Minister Abe also gave public speeches on various occasions. In many cases he gave the speech in English, which was quite unusual for a Japanese politician. Some of the speeches he gave in English were the following:

- February 22, 2013: "Japan is Back" at the Center for Strategic and International Studies (U.S.A.)
- September 7, 2013: "We are ready to work with you" at the general assembly of the International Olympic Committee (Argentina)
- September 25, 2013: "Buy my Abenomics" at New York Stock Exchange (U.S.A.)
- January 22, 2014: "It is not twilight, but a new dawn that is breaking over Japan" at World Economic Forum (Switzerland)
- April 29, 2015: "Toward an Alliance of Hope" at a joint meeting of the U.S. Congress (U.S.A)

Abe may not have been fluent in English, but his confident posture and the script that was beyond mere translation from Japanese seemed to resonate well with the audiences. Abe also contributed articles on newspapers, magazines and journals. The articles Abe has contributed include the following:

- May 2013: "Japan is committed to Africa's development" in the *Wall Street Journal*
- September 2013: "Unleash the power of women" in the *Wall Street Journal*
- September 2013: "Japan's strategy for global health diplomacy: why it matters" in The *Lancet*
- June 2014: "My 'third arrow' will fell Japan's economic demons" in the *Financial Times*
- November 2014: "Stronger Japan a better friend" in *Australian Financial Review*
- June 2015: "3 big challenges facing the world" in CNN.com (Ministry of Foreign Affairs of Japan website: http://www.mofa.go.jp/announce/cai/index.html retrieved on August 8, 2016)

Website

The English version of the "Prime Minister of Japan and His Cabinet" website launched in April 2000 and a Chinese version launched in February 2012. In April 2014, a website named "JapanGov" launched as a portal site for all the Japanese government branches and activities. As of August 2016, the website included the following information and links:

- Key Initiatives: includes information such as "TICAD VI (Tokyo International Conference on African Development)," "G7 Japan 2016 Ise-Shima," "Abenomics is progressing," "unleashing the power of women," "regionalism revitalizes Japan," "walk in U.S, talk on Japan," and so on.
- Visual gallery: includes photos of world heritage in Japan, Japanese crafts, Japan's natural beauty, technologies of Japan, and the Prime Minister in action. It also includes links to e-Museum, Japan photo library, web camera images of national parks and wildlife, and so on.
- Publications: includes online magazines "JapanGov Weekly" and "We are *Tomodachi*," and introduction of a series of books called "Japan Library" to help overseas researchers learn more about Japan. It also has online versions of magazines and newsletters published by various ministries and other government agencies.
- This is Japan: includes "facts about Japan," "Japanese culture," and "visiting Japan." It also has a link to the app store to download "JapanGov App," a mobile application to access JapanGov with ease.
- Government Directory: includes links to websites of the cabinet, various government ministries and agencies, the Diet, the Supreme Court, and other governmental agencies.

- JapanGov application: offers a mobile friendly application that provides location information related to the articles, photos, and videos in JapanGov. In addition, by registering to subscribe to JapanGov, viewers receive notification when new information is uploaded. As of June 2016, there had been 6,032 downloads including iOS, Android and kindle.

Since its launch in April 2014, the OGC had been trying to enhance JapanGov's content step by step, and senior coordinator of the OGC Mami Fukuchi acknowledged that there was still more work to be done to improve the JapanGov site (Mami Fukuchi, personal conversation on June 29, 2016).

The "Prime Minister of Japan and His Cabinet" website was also enhanced after Abe took office for the second time. In addition to the earthquake-related information placed in August 2011, "information on contaminated water leakage at TEPCO's Fukushima Nuclear Power Plant" was added in September 2013, "'Abenomics' is progressing!" was added in March 2014, and "Japan's contribution to international efforts to halt the Ebola outbreak" was added in November 2014. The Chinese version of the "Prime Minister of Japan and His Cabinet" website launched in February 2012 under previous administration and the Chinese version of the Kids page that introduced and explained Japanese political systems was added in July 2013 (Ono, 2014).

Social Media

The Prime Minister's Office of Japan (PMO) English-language Facebook and Twitter accounts were launched in March 2011 in response to the Great East Japan Earthquake. They were originally intended to disseminate information regarding the earthquake to foreigners in Japan and then to overseas audiences. The majority of the content was the Chief Cabinet Secretary's press conferences and Japan news contents on the English website (Ono, 2014).

Under Prime Minister Abe, the Japanese language Facebook page launched in January 2013 and the content of the English language Facebook page was enhanced, reflecting the contents of the Japanese language site. The Prime Minister's daily activities with photographs that convey the prime minister's thoughts were posted (Ono, 2014). As of June 2016, the PMO Facebook account had about 110,000 likes and the PMO Twitter account had about 180,000 followers. In April 2014, the JapanGov Facebook page launched. The page was positioned as an official Japanese government page that includes a wide range of content from Japanese cultural heritage and crafts to policies, and the page was renewed on a daily basis. The Google+ page with the same content also started at the same time. As of June 2016, the JapanGov Facebook page had about 1.42 million cumulative likes.

In April 2014, at the same time as the Facebook JapanGov page launched, the official Japanese government Twitter account @JapanGov launched. The content, as with Facebook, was posted on Twitter along with links to corresponding content. In March 2015, @Japan Twitter account with the same content also launched to improve accessibility. As of June 2016, there were about 133,000 @JapanGov followers.

In November 2013, under Prime Minister Abe, a PMO YouTube account launched to broadcast Prime Minister Abe's speeches globally, to inform the world about Japan's charm and international contributions. As of June 2016, the You-Tube account had 6.54 million cumulative views.

In other social media, Prime Minister Abe was invited by LinkedIn as one of the 500+ influencers in 2013. His overseas addresses and some of his policy initiatives were posted. As of June 2016, there were about 220,000 followers. Prime Minister Abe also posted his opinion on Huffington Post regarding his economic policy on July 3, 2013.

For the G7 Ise-Shima Summit held in May 2016, the OGC handled the G7 Twitter account. The account was handed over to Japan from the government of Germany, and unless the Italian government chooses not to, the Japan account will be handed over in preparation for the G7 2017 in Taormina, Sicily.

TV Advertisements

The OGC produced TV advertisements that featured Japanese people who were actively contributing to local societies. These TV advertisements were aired in countries where Prime Minister Abe visited, or where important international conferences were being held. One of the films, "South Sudan, Peace Keeping Activities," featured peacekeeping operations by Japan's Self Defense Force (SDF), where, as of June 2016, 2,500 SDF members were dispatched. Another film titled "Around the world water purification" featured the activities of Nippon Poly-Glu Co., Ltd. that manufactures and sells organic water purifiers. The company not only solves water supply issues but also creates business opportunities for local people. Some of the other TV advertisements produced were as follows.

- Panama, environmental education
- Indonesia, sewer work
- Myanmar, pediatric practice
- China, tree planting
- Germany, medical robot
- India, Delhi metro
- U.S.A., New York metro
- Natural disaster affected area, temporary buildings
- Malaysia, social participation of handicapped

In 2015, the TV advertisements were broadcast in areas of the country where certain events were held

- March: UN World Conference on Disaster Reduction in Sendai, Japan
- April—May: Bandung Conference in Bandung, Indonesia
- April—May: Prime minister Abe's visit to the U.S.A.
- April—May: Pacific Islands Leaders' Meeting in Fukushima, Japan
- June: G7 Summit in Germany
- July: Milan World Expo in Italy
- September: UN General Assembly in the U.S.A.
- November: G20 Summit in Turkey
- November: APEC Economic Leaders' Meeting in the Philippines
- November: East Asia Summit in Malaysia

The TV advertisements aimed to enhance understanding and favorability of Japan by the local community (Fukuchi, personal conversation, June 29, 2016).

We Are *Tomodachi*

In November 2013, the OGC started publishing a publicity magazine titled "We are *Tomodachi*." The magazine includes articles on Japanese culture and sceneries from around Japan, major events, Prime minister Abe's actions and speeches, Japanese individuals contributing worldwide, various regions in Japan, active foreigners in Japan and the introduction of a work-stay program for foreigners. As of June 2016, the magazine was published in English, French and Spanish.

The OGC hoped to make the "We are *Tomodachi*" magazine appealing, like in-flight magazines, and tried to strike a balance between "what the government wants to convey" and "fun read." Their idea was to make the magazine perceived as "easy to understand and easy to use for explanation." Five or six issues were published each year, and by June 2016, 16 issues had been published. Each issue was available on the JapanGov website in E-Book format, PDF or Kindle format, except the very first issue which was only available in PDF and HTML format. The Kindle version was started in July 2014, and it can be obtained free of charge. By June 2016, there had been about 660,000 cumulative website visits to access "We are *Tomodachi*." "We are *Tomodachi*" also was printed as hard copy and distributed to media, and the members of the foreign governments and organizations when the prime minister visited foreign countries, and to those participating in the major international events in which Japan was involved. Five thousand copies in English and a few hundred copies in French and Spanish were printed for each issue between November 2013 and June 2016.

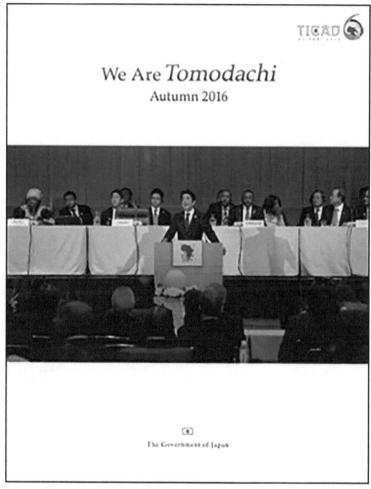

Fig. 5.1. We Are *Tomodachi*. Credit: Government of Japan.

Walk in U.S., Talk on Japan

"Walk in U.S., talk on Japan" was a program to send Japanese people in groups to various regions of the U.S. to act as goodwill ambassadors by visiting and interacting with various groups of people in U.S. local communities. The program launched in June 2014 and in two years, 14 groups with 49 participants had visited and exchanged opinions with about 7,000 people in 27 states in the U.S.A. The Japanese people from a wide variety of walks of life in ages ranging from 18 to 82 capable of communicating in English had participated in the "Walk in U.S., talk on Japan." Each team was led by a former Japanese diplomat to allow for a

smooth arrangement of visits and discussion meetings to exchange opinions and ideas about issues related to the U.S.-Japan relationship at a grassroots level. The organizations that the teams visited included universities, schools, chambers of commerce, city councils and local community groups. The visits often were covered by local media and some of the "Walk in U.S., talk on Japan" groups were invited to talk on U.S. local radio programs. Three groups of Japanese were scheduled in 2016 to visit eight U.S. states and British Columbia, Canada.

Japan Library

In 2014, the OGC started a program to support translation and publication of Japanese books in English. Because of the language barrier, only a small portion of Japanese books were translated into foreign languages and published overseas. Only a handful of bestsellers such as the works of Haruki Murakami, the recipient of the Frantz Kafka Prize and the Jerusalem Prize and one of the 2015 TIME 100 list of the most influential people, or anime comics such as Doraemon, Dragon Ball and Pokemon had been translated and published overseas and many of the good books on genres such as culture and history were left out with little chance of being introduced overseas. The newly-created Japan Library was an effort to help foreigners and scholars better understand Japan by subsidizing the cost of translation and distributing the translated books to key institutions overseas free of charge. In March 2015, five books were translated and published. The titles were:

- Flower petals fall, but the flower endures: The Japanese philosophy of transience
- Listen to the voice of the earth: Learn about earthquakes to save lives
- Tree-ring management: Take the long view and grow your business slowly
- If there were no Japan: A cultural memoir
- Saving the mill: The amazing recovery of one of Japan's largest paper mills following the 2011 earthquake and tsunami

In March 2016, five other books were published. The titles were:

- The building of Horyu-ji: The technique and wood that made it possible
- Fifteen lectures on Showa Japan: Road to the Pacific War in recent historiography
- The people and culture of Japan: Conversations between Donald Keene and Shiba Ryotaro
- Essays on the history of scientific thought in modern Japan
- Kabuki, a mirror of Japan: Ten plays that offer a glimpse into evolving sensibilities

These books had been donated principally to universities, research institutions and public libraries in 41 countries and regions including the U.S.A., England, Canada, Germany, Australia, New Zealand and Assembly of South East Asian Nations (ASEAN) countries. With the exception of two titles published in 2014, they were available for purchase as e-books. The hard copies were available at online bookstores and at certain Japanese bookstores overseas.

With more titles in the pipeline, 15 or more titles altogether are expected to be published by March 2017. This program had just begun and the outcome has yet to be evaluated. (Fukuchi, personal conversation).

JapanGov Weekly

JapanGov weekly was a weekly online magazine published on JapanGov website and it compiled information which concerns, involves and might be of interest to international audiences that was disseminated by various government ministries and agencies. The first issue of the JapanGov weekly was published on November 6, 2014.

Abenomics Is Progressing

One of the pillars of Abe's policies was the plan to revitalize the Japanese economy that Abe called "Abenomics." Key features of Abenomics and its progress were summarized in a brochure titled "Abenomics is progressing." Included in it were data such as macro-economic status, financial condition of the government, status of policy measures to support corporate activities, status of regional growth measures including tourism, labor market reform, regulatory reform and encouragement of foreign direct investment. The brochure was revised from time to time to reflect the up-to-date situation of the policy initiatives and Japan's economy. The brochure could be downloaded from the JapanGov website and hard copies were distributed to media and parties concerned when prime minister and other key ministers go abroad.

Media Relations

One of the changes under the second Abe administration was the increase in the number of persons who handle international media relations. For instance, at a media briefing session during Prime Minister Abe's visit to Russia and Middle East in May 2013, five briefers were on stage responding to questions from media. They were: the press secretary and director-general for press and public diplomacy of the Ministry of Foreign Affairs; assistant press secretary and director of

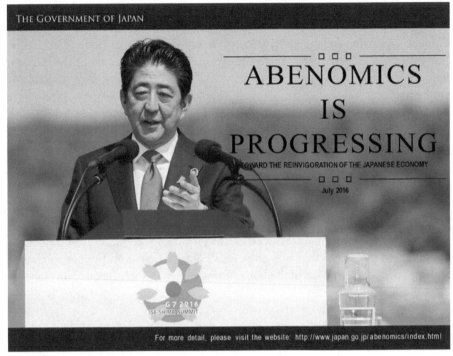

Fig. 5.2. Abenomics is progressing. Credit: Government of Japan.

the International Press Division of the Ministry of Foreign Affairs; deputy press secretary of the Cabinet Office; cabinet councilor (a deputy press secretary of the Ministry of Foreign Affairs during the first Abe administration); and special advisor to the cabinet who advised the prime minister on Abenomics). The increased number of senior staff who were capable of handling international media relations allowed for detailed responses to reporters in a timely manner (Ono, 2014).

Prime Minister Abe held press conferences from time to time and they were simultaneously translated into English to allow foreign reporters to participate. The chief cabinet secretary, who is a spokesperson for the Cabinet, in principle holds two press conferences a day, one in the morning and another in the afternoon. These were simultaneously translated. These press conferences were uploaded onto relevant websites so that foreign reporters could see and listen without much delay.

CALENDAR/TIMETABLE

The public relations efforts of a government are ongoing in nature and there is no beginning or ending. Of course the OGC was bound by the annual government

budget system, thus forcing the OGC to work within yearly government budgeting and reporting schedules. However, what was more important in terms of schedule were international conferences and the prime minister's visits to other countries. When planning the content of "We are *Tomodachi*," the OGC would consider the country/countries the prime minister would be visiting around the time of publication. The airing of TV advertisements for overseas use would also be tailored to the country being visited so that the viewers in that particular country would be comfortable watching. If they could identify some Japanese who were active and well-received in that country, those Japanese would most likely be covered in the localized issue/TV advertisement.

BUDGET

The government public relations budget including supplementary budget in the past 10 fiscal years (from April 2006 until March 2015) were as follows. The figures are in Japanese Yen million and US dollar value (converted at the exchange rate as of March 31, 2016, 1US dollar at 112.68 Japanese Yen) is in parenthesis.

	International PR budget	Domestic PR budget
FY2006	JPY 730million (US$ 6.48million)	JPY 9.32billion (US$ 82.71million)
FY2007	JPY 680million (US$ 6.03million)	JPY 8.86billion (US$ 78.63million)
FY2008	JPY 300million (US$ 2.66million)	JPY 8.93billion (US$ 79.25million)
FY2009	JPY 260million (US$ 2.31million)	JPY 8.80billion (US$ 78.09million)
FY2010	JPY 160million (US$ 1.42million)	JPY 4.82billion (US$ 42.78million)
FY2011	JPY 460million (US$ 4.08million)	JPY 4.93billion (US$ 43.75million)
FY2012	JPY 400million (US$ 3.55million)	JPY 3.67billion (US$ 32.57million)
FY2013	JPY 1.66billion (US$ 14.73million)	JPY 4.55billion (US$ 40.38million)
FY2014	JPY 2.40billion (US$ 21.30million)	JPY 6.60billion (US$ 58.57million)
FY2015	JPY 4.58billion (US$ 40.65million)	JPY 6.54billion (US$ 58.04million)

The first Abe Administration was in office from September 2006 until August 2007. The Democratic Party of Japan (DPJ) took over the government from the Liberal Democratic Party (LDP) in September 2009, but the LDP regained power in December 2012 with Abe as the Prime minister. Japan's fiscal year begins in April and ends in March of the following year, and the core portion of the government budget was determined by the end of the previous year. The 2007 to 2009 budget figures imply that, compared to his LDP successors, Abe had already recognized the importance of international public relations. The 2010 to

2012 budget figures also imply that the DPJ did not see public relations, whether international or domestic, as important as their LDP counterparts did. Even so, the increase in the international public relations budget in 2011 and 2012, though modest, indicates that the DPJ government saw the need to improve Japan's image in response to the decrease in inbound tourists, widespread concern over safety in Japan, in particular the nuclear radiation caused by the Fukushima nuclear power plant failure, and concern over a potential decrease in foreign to domestic investment. On the contrary, the rapid increase in the international public relations budget from 2013 to 2015 clearly shows the importance Abe places on international public relations activities.

EVALUATION AND MEASUREMENT

The OGC evaluated its own activities from several aspects. A key indicator was the favorability survey. The survey was conducted once a year in six major countries in Europe, America, and Asia. However, the senior coordinator of the Office of Global Communications, Mami Fukuchi acknowledged, that it seemed to be difficult to link causation between public relations activities and favorability. The results of the survey also seemed to be sometimes influenced by external factors (Fukuchi, personal conversation, June 29, 2016). The members of the OGC found it worrisome that, unlike marketing products and services, it was difficult to quantitatively evaluate the outcome of public relations activities and they had to rely on qualitative methods when trying to determine the effectiveness of their activities. For instance, when a TV advertisement was produced, a small number of research participants were exposed to the advertisement footage and the changes in their attitudes were qualitatively evaluated. This was done in addition to routine favorability surveys.

The OGC also retained an outside public relations firm to conduct tone analyses of articles of major global media to check and see if articles covering Japanese government activities were positive or negative. They analyzed articles in newspapers such as the *Financial* Times, the *Wall Street Journal*, and the *New York Times*. Major magazines such as the Economist and *Time* also were covered. The tone analyses were reported biweekly to the OGC. When there were events such as major announcement or major international conference, the tone analyses were conducted before and after the event. The analysis before the event was utilized for crafting public relations strategy, and the analysis after the event was utilized to evaluate the public relations activities. On the web, the OGC monitored a variety of things such as how often certain topics were tweeted and how messages spread on Facebook.

Regarding its own contents, senior coordinator Fukuchi thought that it was important to have the audiences share the information concerning Japan. For

website content, they would look at the number of people who accessed the website for view and download. For social network sites, in addition to the number of access, the OGC would look at engagement activities such as actions in response to a post, likes, and sharing Twitter comments (Fukuchi, personal conversation, June 29, 2016).

The OGC found that, after watching the advertising footage, the qualitative research participants' favorability rating of Japan and its government improved. When the prime minister's speech was translated, and uploaded in a timely manner, there were more viewers, as was the case when Prime Minister Abe's press conference at the G7 summit 2016 was broadcast via live streaming.

There was a remarkable response when the Prime Minister Abe gave a speech in English to a joint meeting of the U.S. Congress in May 2015. The public relations firm that monitored media reporting for the OGC had reported that the content of media reports on Abe had changed. Prior to the speech, there had been many reports that seemed to be written based on misunderstanding of some sort, whether of his political stance or of his personal issues. After the speech, there seemed to be fewer articles based on blind assumptions.

Fukuchi of the OGC thought that having a strong economy was essential in promoting the country. She said:

> I think that the better the economy, the more people will view the content the country provides. Some people would view content seeking merit, which means that if they think it would be beneficial to do business with Japan, they would be more likely to view the contents we provide. Even when the economy is not visibly improving, if we can convey that Japan is trying something new, that it is undergoing structural reform, or that the country is trying to do something with a firm stance, it would result in more people viewing the content. And if more people view the content, it would in return create more content to tell, resulting in a virtuous cycle. It would then lead to more media coverage. (Personal conversation, June 29, 2016)

CONCLUSION

The efforts made by the second Abe administration, more aggressive in comparison with previous administrations, seemed to have brought Japan's global public relations on track by speaking out that "Japan is back." A country with a rather uniform cultural background and the burden of international business and cultural exchanges borne by only a portion of the population, and the country of Japan as a whole, whether private of public, did not seem to have felt the need to speak loudly to the world. Abe's administration was the first to make concerted efforts to communicate the current situation and future ideals of the country to the world.

In order for Japan to gain support from the global community and succeed in organizing the next summer Olympics in Japan in 2020, it is essential to continue to disclose and disseminate information in a transparent manner. Japan also needs to go beyond the commonly held images of the country—technology savvy economic power and cultural heritages of Buddhist temples and shrines—and blend them with the fun and excitement that exist alongside the daily lives of common Japanese people.

The introduction of Japan as the next Olympic host following the flag handover ceremony at Rio de Janeiro demonstrated a brilliant image of in areas where Japan excels. Featured in the performance and video were robots, Tokyo's city landscape, current and future top athletes, a bullet train, a temple, animation characters, world famous game character Mario, and Prime Minister Shinzo Abe. Abe as Super Mario jumps into the pipe linking Tokyo to Rio de Janeiro, and when the video ends, Abe in the Mario costume appears in the middle of the stadium. The participation of Abe, a mainstream politician, in this cutting-edge demonstration showed that Japan is flexible and fun enough to communicate with a savvy, social-media friendly global audience.

REFERENCES

Abe, S. (2012). *Speeches and Statements by the Prime Minister.* Prime Minister of Japan and His Cabinet. Retrieved July 26, 2016 from http://japan.kantei.go.jp/96_abe/statement/201212/26kaiken_e.html

Abe, S. (2013). *"Japan is Back", Policy Speech by Prime Minister Shinzo Abe at the Center for Strategic and International Studies (CSIS).* Ministry of Foreign Affairs of Japan. Retrieved July 26, 2016 from http://www.mofa.go.jp/announce/pm/abe/us_20130222en.html

Armitage, R. L., & Nye, J. S. (2012). *The U.S.-Japan alliance* (2012). Retrieved from Center for Strategic & International Studies website: https://csis-prod.s3.amazonaws.com/s3fs-public/legacy_files/files/publication/120810_Armitage_USJapanAlliance_Web.pdf

Kaneko, M. (2014). Nihon no public diplomacy no zentaizo [The overall picture of public diplomacy in Japan]. In M. Kaneko & M. Kitano (Eds.), *Public diplomacy strategy* (pp. 185–226). Tokyo: PHP Institute.

Ministry of Foreign Affairs of Japan. Retrieved August 8, 2016 from http://www.mofa.go.jp/announce/cai/index.html

Ono, H. (2014). Kantei ni okeru kokusai koho no genjo to kadai [The current status and objectives for the global public relations in the Cabinet Office]. In M. Kaneko & M. Kitano (Eds.), *Public diplomacy strategy* (pp. 185–226). Tokyo: PHP Institute.

"Ukraine: Open FOR U"

A Promotional Campaign and Nation Re-branding After the Euromaidan

DARIYA ORLOVA
National University of Kyiv-Mohyla Academy
School of Journalism

KATERINA TSETSURA
University of Oklahoma, Gaylord College

EDITOR'S NOTE

This case caught our attention because of the dramatic events that took place in the Ukraine in 2013 to 2015. Normally, a single video would not warrant discussion in an academic case study book. However, because of the context in which it was produced (post-invasion and post-reforms), and its unintended effect on the local population, it shows that interesting positive results can happen even without a clear strategy. Indeed, the video might have achieved its modest initial goals but the real result was the residual pride it instilled in the local population who, no doubt, could use good news.

INTRODUCTION

Country promotion has long been a focus of public relations and public diplomacy scholarly work (Kunczik, 1997). Country promotion is interdisciplinary and has recently emerged within public relations by integrating ideas from public diplomacy, public relations, nation branding, and international relations (Dolea, 2015). International relations scholars traditionally consider various types of power in terms of the size of the country, its military and financial resources, wealth, etc.

(Gilboa, 2008). Recent discussions, however, have concentrated around soft power as a way to understand the attractiveness, or appeal, of the country, to others (Nye, 2008). Building on the idea of soft power, public relations scholars have offered a theoretical framework of country promotion that integrates public diplomacy, nation branding, and public relations (Buhmann & Ingenhoff, 2015; Fitzpatrick, 2007; Szondi, 2010).

Often, country promotion is seen only as a public issue for post-communist countries because of their transition and search for and "redefinition of national identity" (Dolea, 2015, p. 283). Country promotion is often associated with efforts by the country's government to attract foreign investments and develop tourism (Dolea, 2015).

The case study of the "Ukraine. Open for U" campaign, discussed here, highlights the major trends in country promotion, country branding and public diplomacy: the campaign, supported by the government of Ukraine, was designed and produced in close collaboration with non-state actors and ended up being more attractive to publics beyond those originally intended. This campaign demonstrates how government and non-state actors should work together to address challenges of non-strategic approach to country promotion and how country promotion campaigns can often become auto-communication campaigns for internal publics, intentionally or not.

The case study begins with an overview of the context in which the Ukrainian campaign was launched, discusses the very campaign and proceeds with a critique of the campaign in terms of strategy development. Finally, the case study illustrates how this campaign ended up being an example of auto-communication, or country auto-promotion, rather than of public diplomacy.

BACKGROUND

EuroMaidan[1] protests that broke out in Ukraine in late November 2013 and lasted until February 2014 dramatically changed the Ukrainian political and social landscape and triggered significant transformations throughout the nation. What had started as a spontaneous rally of those outraged by the Ukrainian President's last-moment decision to suspend the signature of an Association Agreement with the European Union eventually turned into a massive popular uprising against a corrupt regime.

The very name of the protest movement, EuroMaidan, indicated 'European' aspirations of the protesters and referred to the Maidan Nezalezhnosti square as a major site of protests, which had been established as such during previous Ukrainian "revolutions"- the so-called "Revolution on the granite" of 1990 and the "Orange revolution" of 2004.

Pro-European rallies that took place across Ukraine and even abroad (Global Voices, 2013) in late autumn of 2013 attracted many people dismayed at the prospects of halting the planned European integration. Frustration over thriving corruption and increasing authoritarianism had also been key drivers behind the initial protests (Onuch, 2014; Rachkevych, 2013). Peaceful protests, however, saw a violent response from the government on the tenth day of protests when riot police units brutally dispersed protesters, most were young, on the Maidan at dawn (Balmforth & Grove, 2013). Those brutal assaults prompted hundreds of thousands of people to join the next-day rally demanding the resignation of then-President Viktor Yanukovych and new elections (BBC, 2013).

Tense, yet relatively bloodless, standoff situations between protesters and government lasted until late January 2014, when one of the situations deteriorated as a pro-presidential majority in the parliament adopted several laws that restricted freedom of speech and introduced criminal penalties for various kinds of unsanctioned protests. The fact that Yanukovych signed these legislations fueled tensions between the police and protesters. Violent clashes erupted on 19th of January 2014 when protesters tried to get close to the Parliament and were met by police cordons (Kramer, 2014). Five protesters were killed and more than 100 people injured in the fierce clashes during several days. The escalation of conflict was followed by a wave of arrests, attacks, beatings, and kidnappings of Maidan activists. The situation escalated further in February when protesters moved toward the parliament to demand constitutional changes that would weaken the authority of the president, as it had been negotiated between the opposition leaders and the government. Ferocious clashes broke out on 18th of February, lasted three days and left dozens of people dead and hundreds injured. The standoff culminated on February 20 in the morning, which became known as a *snipers' massacre* that killed more than 50 protesters and three policemen (Gatehouse, 2015). Investigation of the massacre has not been completed and various speculations of who exactly had stood behind the killings have circulated (Gatehouse). It was clear, however, that the bloodiest day of protests marked the beginning of Yanukovych's regime fast downfall.

Yanukovych immediately fled the country, and the Ukrainian parliament created a new coalition, appointed a new government and called for presidential elections that eventually took place on May 25, 2014. Ukrainian society, which had not yet recovered from the devastating tragedy in the heart of the capital now faced many new challenges, both internal and external ones. Right after the Yanukovych escape, pro-Russian gunmen seized the key buildings and parliament of Crimea, a Ukrainian peninsula in the Black Sea inhabited by a Russian-speaking majority. Military men without insignia occupied Crimea. The dubious and internationally unrecognized referendum to include Crimea into Russia was held on March 16, 2014, and Russia formalized its annexation of Crimea just two days later (BBC,

2014a, 2014b; Herszenhorn, 2014). Russian president Vladimir Putin later admitted the presence of Russia's military in Crimea in February and March 2014, as well as plans to annex Crimea in a TV documentary (BBC, 2015).

The situation deteriorated in other parts of the country, especially in the industrial region of Donbas, when Russia-supported militants seized governmental buildings in some parts of Donetsk and Luhansk oblasts following the *Crimean scenario* and created so-called Donetsk and Luhansk People's Republics in May 2014 (Kirby, 2015). Unlike in Crimea, the conflict turned into a full-fledged war involving the Ukrainian army, separatist forces, and the Russian troops, as numerous reports suggested (Bellingcat, 2016; Urban, 2015; Vice News, 2015). The biggest escalations took place in the summer of 2014 and winter of 2015, and the ceasefire agreements were signed in Minsk on 5 September 2014 and 12 February 2015 respectively. The conflict that already killed over 9,000 people as of March 2016, (Cumming-Bruce, 2016) has still today not been settled although conditions in the conflict area improved. Occasional skirmishes continue adding to the death toll, but, so far, no large-scale battles are being fought. Part of Ukraine's territory remains under control of the pro-Russian separatist forces and Crimea was annexed by Russia.

There were several external challenges complicating Ukraine's transition to peaceful co-existence after the EuroMaidan. A severe economic crisis caused by the state's massive debts and the cost of waging war (BBC, 2014; Stewart, 2016), political instability and malfunctioning state institutions all contributed to an extremely challenging environment in post-Maidan Ukraine. In addition, a legacy of deep-rooted pervasive corruption further complicated Ukraine's transformation into a well-functioning democracy. On the bright side, civil society got an unprecedented boost after a show of successful resistance during the EuroMaidan. The war in the Donbas region caused further strengthening of civic activism, with thousands of new activists launching various initiatives to help the Army and displaced people. The so-called third sector[2] has also been a major force behind attempts to launch reforms in many areas of public life and governance.

In early 2015, after parliamentary elections that brought a new coalition into the Parliament, the new government embarked on a set of reforms in response to the pressure coming from both the civil society inside the country and its Western creditors. The situation in the conflict area was stabilized to some degree after the second Minsk agreement as the urge for reforms became stronger (Herszenhorn, 2015). The new government attracted a wave of newcomers, mostly young reform-minded professionals from the business sector, in a striking contrast to previous governments (Romanyshyn, 2015). Top-priority areas for reforms included deregulation and increased transparency, fighting corruption, police reform, and tax reform. Boosting Ukraine's attractiveness for investment was also declared as one of the goals for the government.

SITUATION ANALYSIS

As part of the efforts to increase Ukraine's attractiveness to foreign investment, Ukraine's Ministry of Economic Development and Trade started a promotional campaign aimed at demonstrating and emphasizing Ukraine's advantages for investment. The main tactic of the campaign was a promotional video clip titled "Ukraine. Open for U" (available on YouTube https://www.youtube.com/watch?v=jdSQuanI8Z8), was released and posted in July 2015, on the eve of the first US-Ukraine Business Forum. As described in the background section, the broader context in which this campaign was launched suggested that Ukraine faced numerous challenges in its promotional efforts to attract foreign investors. The economy in the country was still in decline after various shocks it experienced less than 12 months before the promotion campaign. Potential investors, and even those foreign businesses that were already operating in Ukraine, were discouraged by threats and risks brought by the armed conflict in the Eastern part of the country. The pace and quality of reforms received mixed evaluation from experts and observers, especially with regard to anti-corruption efforts (Herszenhorn, 2015; Kononczuk, 2016; Ukraine Reform Monitor, 2015).

Ukraine slightly improved its performance in the ranking measuring conditions for "doing business" by the World Bank, from the 96th place in 2014 to 87th in 2015 (World Bank, 2014, 2016). The Corruption Perception Index also saw a positive trend, with Ukraine moving up from the 142th place in 2014 to the 130th in 2015 (Transparency International, 2014, 2015). However, the country's image as corrupt and dysfunctional was not effectively contested. Furthermore, such an image has been cultivated by the Russian propaganda that targeted Ukraine since EuroMaidan and particularly following the annexation of Crimea (Kendall, 2014). Indeed, portraying Ukraine as a failed state has been one of the central narratives promoted by Russia (Riabchuk, 2014).

At the same time, the campaign could benefit from increased attention and largely sympathetic media coverage of Ukraine in the Western media since the Maidan events. As Western donors have been supporting various reforms in Ukraine and monitoring the progress in implementing these reforms, a promotional campaign could be expected to receive attention of various foreign stakeholders.

CORE OPPORTUNITY

EuroMaidan, the annexation of Crimea and the armed conflict in the East put Ukraine into the spotlight of the media around the world. The Ukrainian state, however, lacked experience and instruments for communication with external

actors and was totally disoriented during the first months after the Maidan events. In 2015, Ukraine needed a new approach to communication, not just proving that the country was a victim of neighboring country's invasion, but re-establishing itself as a new nation seeking development, reforms and ready to break up with the dysfunctional and corrupt institutional framework. Close collaboration between the new government and the third sector entities could serve as a proof of changes taking place in Ukraine.

GOALS AND OBJECTIVES

The goal of the campaign was to show Ukraine's attractiveness to foreign investment, its potential for economic growth in the new, post-Maidan context, and its people in the effort to change perceptions of Ukraine. The promotional video was produced specifically for the first US-Ukraine Business Forum and aimed at presenting a vision of a new Ukraine, which is open for investment and has several core strengths. The target audiences were United States of America business and political elites, and subsequently investors from other countries. In personal communication with campaign managers Maryana Kahanyak from the Ministry of Economic Development and Trade of Ukraine, and with Oleg Shymanskyi, director of communications for the Minister of Economy at the time of campaign, they both acknowledged that they wanted to confront the image of Ukraine as a corrupt, backward, and war-torn country and instead show its other face, modern, educated, and ready for business breakthroughs (personal communication, 2016). The promotional video was designed as a communication instrument, to support the government reforms and measures and steps to attract investors in a general way, that were part of the agenda for the Ukraine business forums in the USA and other countries.

KEY PUBLICS

Per the initial plan of the campaign, its primary target audience included foreign companies, businessmen and investors, and, to some degree, foreign policy makers. Campaign managers also planned to disseminate the video in social media to reach general public. In reality, the response from the local audience was much more pronounced and positive and the local publics were much more engaged by it, than it was initially expected. It instilled pride in the population. This turn of events, although unplanned, made the general public one of the unexpected key publics and beneficiaries of the campaign.

Fig. 6.1. Screen shot of promotional video. Public domain.

KEY MESSAGES

The promotional video clip focuses on various facets of Ukraine's attractiveness for business development and portrays the country as a perfect place to host IT operations and to offer agricultural companies new opportunities. It also praises the country's well-developed infrastructure, fertile soil, and skilled human resources. It provides a myriad of useful statistics that were surprising to Western viewers. The video is not so much about Ukraine, but rather about the Ukrainians who are young, intelligent, and promising professionals. The choice of visuals used in the video is clearly strategic as the images depict Ukrainians as primarily young and well educated, highly skilled, and success-oriented. The entire aesthetics of the video is centered on a hip imagery of both people and the country. Young people appear tech-savvy, and the technological advanced of the country, presented in the video, look modern and appealing. In short, the whole country look as it is open to innovation and prime for investment.

The emphasis on young Ukrainians is explicit not only through visuals. The clip, in fact, opens with the titles "Ukraine reborn" and "Driven by the new generation," accompanied with images of huge crowds of people waving hands, which is a clear reference to the recent EuroMaidan experience. The video shows the image of a new Ukraine that is expected to contrast with common stereotypes of the country promoted recently by the Russian media as a backward, corrupt, dysfunctional, and doomed to failure society (Kendall, 2014). One of the representatives

of the team that worked on the project, Iryna Ozymok of the Western NIS Enterprise Fund confirmed the intention to fight negative stereotypes through this video in a personal interview on March 11, 2016:

> We wanted to) challenge myths because Ukraine is associated with negative things to a large extent ... Chernobyl, Maidan, a few famous personalities and corruption—these are clichés about Ukraine. In our first video we wanted to show that there are many young and active people in Ukraine; we are also a country of start-ups even though we have fewer of them than in the West; and that the IT industry is developing fast.

Thus, the two major messages of the campaign could be summed up as follows: (1) Ukraine is a land of opportunity for investment and (2) Ukraine has reinvented itself as a nation that strives for success.

STRATEGIES

Campaign managers acknowledged that promotional videos have a limited capacity to influence real investment activities; yet, their significance is explained by their capacity to change public perceptions. Oleg Shymanskyi, who worked as a director of communications for the Minister of Economy at the time of the campaign, said that business forums could hardly be estimated in millions of investments. "The goal of such business forums is to attract attention and change perception of Ukraine among investors from 'it's an impossible country (to do business)' to "we are interested, let's move on" (personal communication with Oleg Shymanskyi, 2016). Thus, the campaign primarily sought to reach foreign stakeholders and present to investors a new vision of Ukraine that would potentially convince them to consider exploring investment opportunities in the new country.

Due to various reasons, including scarce financial, human resources, and a lack of efficient institutions and established policies for strategic communication campaign planning and implementation, the campaign lacked a comprehensive strategy. It was rather an ad-hoc campaign, which consisted of several tactics (video messages). It was designed to fill the gap of Ukraine's self-promotion abroad in the run-up to the big event, US-Ukraine Business Forum. Developments in the campaign were driven by the response of public and various stakeholders instead of a well-researched and well-developed strategy; yet, the campaign was attractive to local audiences and was welcomed with interest.

TACTICS

The initiative to create the original promotional video came from the Ministry of Economic Development and Trade. However, the Ministry itself could not fund

the production of the video clip due to its very limited resources. Thus, the Ministry had decided to approach potential sponsors to finance the costs of the video. As a result, the video was produced with the funds from the Western NIS Enterprise Fund, a regional private equity fund funded by the United States Agency for International Development (USAID). The Fund has recently sold its assets and investments and has turned into a donor organization with a focus on transformational projects in post-Maidan Ukraine. The concept of the clip was also developed in close cooperation with the Horizon Capital, a private equity fund in Ukraine with strong links to the Western NIS Enterprise Fund. Filming and production was done by the Titanium Presentations Company. Apart from the video clip, the promotional brochure and leaflet "Invest Ukraine Open for U" were designed and produced for subsequent distribution at business forums.[3]

Fig. 6.2. Ukraine promotional brochure. Public domain.

While the campaign lacked a comprehensive strategy, its implementation was quick and effective, per campaign managers (personal communication with Maryana Kahanyak, campaign manager at the Ministry, 2016; personal communication with Oleg Shymanskyi, 2016). It took just a few weeks between the decision to create a clip and to release it on the eve of the US-Ukraine Business Forum, a media report suggested (Business Ukraine, 2015).

Once released, the video was widely circulated and promoted through online and social media, in particular YouTube and Facebook. The release of the video was widely reported by the Ukrainian mainstream media with all major online news media and TV channels covering the campaign and showing the video, in part or fully. In addition, the video has been repeatedly shown on big screens at the Kyiv Boryspil Airport,

a major air transport hub in Ukraine, and on screens of the high-speed inter-city trains en route between Ukraine's biggest cities: Kyiv, Odessa, and Lviv.

Success of the first promotional video prompted other government agencies to initiate the production of similar video clips for various industries, including tourism, infrastructure, agriculture, and energy. In particular, a clip about Ukraine as an attractive tourist destination, titled "Experience Ukraine! We are open for Tourism" (https://www.youtube.com/watch?v=qZMMJo7jOTQ), enjoyed a similar, if not bigger success among Ukrainian audiences (Shevchenko, 2015). Eventually, video clips and promotional leaflets were translated into other foreign languages, in addition to English (personal communication with Maryana Kahanyak, 2016).

Campaign managers Kahanyak and Shymanskyi also said that various private companies, including private equity funds, approached the Ministry and asked for permission to use the video for their internal presentations to potential clients, members of board from other countries etc. After receiving positive feedback, campaign managers also encouraged Ukraine's Ministry for Foreign Affairs to promote the video across the world through the network of Ukrainian embassies.

CALENDAR/TIMETABLE

The initial idea was developed several weeks before the US-Ukraine Business Forum that had been scheduled for 13 July 2015. The promotional video "Ukraine. Open for U" was posted on YouTube on 9 July, a few days before the Forum. It was also simultaneously posted on other platforms, such as websites of governmental agencies, as well as on various social media pages.

The video was also used for presentational purposes at several subsequent business forums: Germany-Ukraine in October 2015, Netherlands-Ukraine in March 2016 and Canada-Ukraine in June 2016. At the time of interviews, campaign managers said the Ministry planned to expand this type of activity and organize business forums in several other countries.

BUDGET

The information on the campaign's budget was not disclosed.

EVALUATION AND MEASUREMENT

Evaluation of the discussed campaign's success is a challenging task, given that its goals were set quite broadly. There was no set measurement outcomes metric other

than to raise awareness. Many other variables can impact investment attractiveness and image of the country and thus one campaign cannot be alone be responsible for any changes. It is also quite difficult to estimate the overall reach of the video, given its diverse channels of distribution. In one year after its release, the video has attracted over 424 thousand views on the official YouTube channel of the Ministry of Economic Development and Trade of Ukraine (Ministry of Economic Development and Trade of Ukraine, 2015). However, other users on their YouTube pages have uploaded the same clip, and the total number of viewers could be significantly larger. In a similar vein, although the direct link to the clip on YouTube has been shared slightly more than one thousand times on Facebook, many more Facebook users reposted the video from other users and not directly from YouTube. In addition, the video has been viewed through Facebook and Twitter, which substantially increases the number of views. On top of that, online media embedded video directly into their pages, which again added to the number of views.

It seems plausible to suggest that the promotional video, "Ukraine. Open for U," has reached several hundreds of thousands of Internet users. How significant was that? And what impact could this media exposure have on boosting Ukraine's investment attractiveness? Organizers of the campaign have been quite reserved when they were asked about estimated potential influence on the actual investment activities. They acknowledged that the initial idea was driven by a mere demand for decent-quality promotional materials that had been lacking in post-Maidan Ukraine. They also demonstrated an awareness of the limited potential of such video clips when it comes to real investment activities. However, they admitted that the responses to the video from foreign investors, businesspeople, and policy makers at business forums have been very positive. The response from internal stakeholders in Ukraine (such as other ministries that later requested production of similar video clips for their agencies, and the general public in the country) has been very positive. Many top officials posted a link to the video on their official social media channels. Even Ukraine's President Poroshenko posted a video and wrote, "Please share this video to let the world learn about Ukraine's potential!" (Poroshenko, 2015).

The media coverage was also extensive and predominantly favorable. All major online media in Ukraine posted a link to the clip and at least a brief statement. Some TV channels also made reports about the video. An example of such favorable coverage could be found in the Ukrainian English-language publication *Business Ukraine*: "[the video] was widely hailed as the most successful promotional video produced since Ukraine achieved independence in 1991" and "proved an online hit, garnering enthusiastic comments from all over the world and generating no small amount of pride among Ukrainian viewers thrilled to see their country finally depicted to international audiences in a positive and fresh light" (Business Ukraine, 2015).

Campaign managers explained a largely enthusiastic response to the video among Ukrainians by a need for a positive representation of the country, which has been struggling hard to transform itself into a prosperous and democratic nation state (personal communication with Maryana Kahanyak, 2016). Thus, the "Ukraine. Open for U" campaign has unintentionally served an internal audience, that is, the Ukrainian citizens, in a much more effective way than it did its originally intended audience, the Western investors.

Not all commentaries on the video were positive. There were over 1,000 dislikes on YouTube versus more than 4,000 likes. Some users questioned the content of the video, pointing that the reality in Ukraine is still distant from the attractive images used in the clip. Although there is a lack of quantitative data that would measure attitudes toward the video among the general public, campaign managers concluded that a positive response from the Ukrainian stakeholders was to a large degree in line with broader public's positive reception of the video.

CRITIQUE OF THE CAMPAIGN

This campaign is a good example of what we call a country auto-promotion campaign. In this case study, the authors introduce this term *auto-promotion campaign* to reflect the auto-communication nature of the country's promotion campaign, in which, intentionally or unintentionally, internal audiences (i.e., a country's own citizens) become the main recipients of the communication campaign's messages (Christensen, 1997). This case demonstrates how auto- communication can be manifested in country promotion communication campaigns and why country auto-promotion efforts are important to investigate in studies of public diplomacy. The implications of such country auto-promotion are clear: countries that produce country promotion campaigns should be aware that their own citizens will consume the messages and will be exposed to these campaigns, via legacy media, social media, and other citizens' channels. Countries should realize the consequences of such exposure and perhaps may choose to purposefully engage in auto-communication. Thus, countries, especially the ones that go through transformational processes (and/or face national security, economic, and/or societal challenges), may choose to explore the need and desire for country branding among their own citizens and may want to examine whether key messages of their country promotion campaigns resonate with internal audiences as well as with external—with the understanding that these country promotion campaigns can auto-communicate and become country auto-promotion campaigns as much as they are country promotion campaigns.

Incorporating those auto-promotion messages in country promotion campaigns may also be a useful strategy for countries that seek to establish and/or

support these nations' pride and brand internally and externally. In the case of Ukraine, the "Ukraine. Open for U" campaign was a country promotion and auto-promotion effort by the Ukraine government to restore investor and public confidence after Ukraine's borders had been violated.

The "Ukraine. Open for you" campaign showed that the Ukraine government's understanding of the importance of country promotion to the outside world also reached various parties in the country itself. However, no comprehensive strategy of communication has been developed in this campaign to present post-Maidan Ukraine to the world. The discussed video has been an outcome of an ad-hoc, situational cooperation between governmental staff and third-sector organizations, and has turned out to be one of a few isolated projects aimed at improving the image of Ukraine among Western investors. Sadly, it was not a part of a larger country promotion strategy, a bigger program, or a framework. On the bright side, this campaign did become an exemplar case for successful cooperation between the government, civil society, and business community in Ukraine in the turbulent and challenging environment.

While the campaign lacked a strategic dimension, video clips produced in the framework of the campaign turned to be more than simple commercials. Their narrative signaled attempts to re-brand the country. These videos were used to auto-communicate with Ukraine's own people to help support the idea of new post-Maidan Ukraine. The idea of promoting Ukraine to its own citizens was welcomed by many young Ukrainians, per Ozymok, but had little impact on the change in Western investments in the country (personal communication with Iryna Ozymok 2016). However, the demonstration of Ukraine as a modern, prosperous, and ready for business country was a message that was much needed in war-torn Ukraine. Ukrainians welcomed this message by watching the videos and forwarding them via social media.

CONCLUSION

The ability of Ukraine's state institutions to fund, organize, and manage projects that would strengthen country promotion efforts has been remarkably weak due to a lack of strategic vision, experience, and resources. While there is an increasing understanding in Ukraine of the importance of public diplomacy and country promotion in the post-Maidan and post-annexation of Crimea, neither comprehensive public diplomacy nor country branding strategy has been developed thus far. Instead, a significant number of smaller initiatives that were aimed at improving communication of the country and its perception abroad have been launched primarily by non- governmental sources from the third sector or in a close cooperation with the third sector. The campaign discussed here was no exception. Most of

these efforts served as auto-communication within the country to support the idea of a new Ukraine among its own citizens. The interest in this campaign among Ukrainian citizens demonstrates that the campaign worked more as country auto-promotion rather than as a country promotion to Western investors.

NOTES

1. EuroMaidan is a word that is used to describe the social protests in Ukraine during late 2013-early 2014 against the pro-Russian government of Ukraine at the time and for the European reforms in Ukraine. Maidan is a word that means a square, a place of gathering of people, which quickly became popular in Ukraine after the 2005 social protests as a word that describes any social protest or public societal discussion gathering.
2. The third sector is a term widely used in development communication to describe the work of non-government organizations of the society, usually nonprofits, including activist, educational, and voluntary institutions.
3. Leaflets can be found on the Ministry's account page on ISSUU
 https://issuu.com/mineconomdev/docs/medt_leaflet_view__d293561c974666
 Another, more extended brochure for the US-Ukraine Business Forum can be found here
 https://issuu.com/mineconomdev/docs/medt_brochure_a4_view

REFERENCES

Balmforth, R., & Grove, T. (2013). Ukraine police smash pro-Europe protest, opposition to call strike. *Reuters*. Retrieved August 23, 2016 from http://www.reuters.com/article/us-ukraine-protest-idUSBRE9AT01Q20131130

BBC. (2013, December 1). Clashes amid huge Ukraine protest against U-turn on EU. *BBC News*. Retrieved August 23, 2016 from http://www.bbc.com/news/world-europe-25176191

BBC. (2014a, March 16). Crimea referendum: Voters "back Russia union". *BBC News*. Retrieved August 25, 2016 from http://www.bbc.com/news/world-europe-26606097

BBC. (2014b, March 21). Ukraine: Putin signs Crimea annexation. *BBC News*. Retrieved August 25, 2016 from http://www.bbc.com/news/world-europe-26686949

BBC. (2014c, May 1). Ukraine economy: How bad is the mess and can it be fixed? *BBC News*. Retrieved August 25, 2016 from http://www.bbc.com/news/world-europe-26767864

BBC News. (2015, March 9). Putin reveals secrets of Russia's Crimea takeover plot. *BBC News*. Retrieved August 25, 2016 from http://www.bbc.com/news/world-europe-31796226

Bellingcat. (2016, August 31). Russia's War in Ukraine: The Medals and Treacherous Numbers. *Bellingcat*. Retrieved August 31, 2016 from https://www.bellingcat.com/news/uk-and-europe/2016/08/31/russias-war-ukraine-medals-treacherous-numbers/

Buhmann, A., & Ingenhoff, D. (2015). The 4D model of the country image: An integrative approach from the perspective of communication management. *The International Communication Gazette, 77*(1), 102–124.

Business Ukraine. (2015, October 1). Viral video promotes new Ukraine. *Business Ukraine*. Retrieved August 31, 2016 from http://bunews.com.ua/investment/item/viral-video-promotes-new-ukraine

Christensen, L. T. (1997). Marketing as auto-communication. *Consumption Markets & Culture, 1*(3), 197–227.

Cumming-Bruce, N. (2016, March 3). Death Toll in Ukraine Conflict Hits 9,160, U.N. Says. *New York Times.* Retrieved August 27, 2016 from http://www.nytimes.com/2016/03/04/world/europe/ukraine-death-toll-civilians.html

Dolea, A. (2015). The need for critical thinking in country promotion: Public diplomacy, nation branding and public relations. In J. L'Etang, D. McKie, N. Snow, & J. Xifra (Eds.), *Routledge handbook of critical public relations* (pp. 274–288). New York, NY: Routledge.

Fitzpatrick, K. (2007). Advancing the new public diplomacy: A public relations perspective. *The Hague Journal of Diplomacy, 2*(3), 187–211.

Gatehouse, G. (2015). The untold story of the Maidan massacre. *BBC News.* Retrieved August 23, 2016 from http://www.bbc.com/news/magazine-31359021

Gilboa, E. (2008). Searching for a theory of public diplomacy. *The Annals of the American Academy of Political and Social Science, 616*(1), 55–77.

Global Voices. (2013, November 24). Interactive Map of #Euromaidan Protests in Support Ukraine's EU Integration. *Global Voices Online.* Retrieved August 22, 2016 from http://globalvoicesonline.org/2013/11/24/interactive-map-of-euromaidan-protests-in-support-ukraines-eu-integration/

Herszenhorn, D. (2014, March 16). Crimea Votes to Secede from Ukraine as Russian Troops Keep Watch. *The New York Times.* Retrieved August 25, 2016 from http://www.nytimes.com/2014/03/17/world/europe/crimea-ukraine-secession-vote-referendum.html?_r=0

Herszenhorn, D. (2015, May 17). In Ukraine, corruption concerns linger a year after a revolution. *The New York Times.* Retrieved August 27, 2016 from http://www.nytimes.com/2015/05/18/world/europe/in-ukraine-corruption-concerns-linger-a-year-after-a-revolution.html

Kendall, B. (2014, June 6). Russian propaganda machine "worse than Soviet Union." *BBC News.* Retrieved August 28, 2016 from http://www.bbc.com/news/magazine-27713847

Kirby, P. (2015, February 18). Ukraine conflict: Why is east hit by conflict? *BBC News.* Retrieved August 27, 2016 from http://www.bbc.com/news/world-europe-28969784

Kononczuk, W. (2016). Ukraine's reforms: Promises still unfulfilled. *Aspen Review Central Europe.* Issue 1. Retrieved August 28, 2016 from http://www.aspeninstitute.cz/en/article/1-2016-ukraine-s-reforms-promises-still-unfulfilled/

Kramer, A. (2014, January 20). Police and protesters in Ukraine escalate use of force. *The New York Times.* Retrieved August 23, 2016 from http://www.nytimes.com/2014/01/21/world/europe/ukraine-protests.html?_r=0

Kunczik, M. (1997). *Images of nations and international public relations.* Mahwah, NJ: Lawrence Erlbaum.

Ministry of Economic Development and Trade of Ukraine. (2015, December 4). Experience Ukraine! We are open for Tourism. [Video file]. Retrieved August 23, 2016 from https://www.youtube.com/watch?v=qZMMJo7jOTQ

Ministry of Economic Development and Trade of Ukraine. (2015, July 9). Ukraine. Open for U. [Video file]. Retrieved August 26, 2016 from https://www.youtube.com/watch?v=jdSQuanI8Z8

Nye, J. S., Jr. (2008). Public diplomacy and soft power. *The Annals of the American Academy of Political and Social Science, 616*(1), 94–109.

Onuch, O. (2014). Who were the protesters? *Journal of Democracy, 25*(3), 44–51.

Poroshenko, P. (2015, July 9). Facebook post. Retrieved August 31, 2016 from https://www.facebook.com/petroporoshenko/posts/647057212095341

Rachkevych, M. (2013, December 6). How the social drivers of EuroMaidan differ from the Orange Revolution. *Kyiv Post.* Retrieved August 23, 2016 from http://www.kyivpost.com/content/ukraine/how-the-social-drivers-of-the-orange-revolution-differ-from-euromaidan-333171.html

Riabchuk, M. (2014, April 11). Ukraine: Russian propaganda and three disaster scenarios. *Al Jazeera News*. Retrieved August 28, 2016 from http://www.aljazeera.com/indepth/opinion/2014/04/ukraine-russia-propaganda-thre-201441112542990923.html

Romanyshyn, Y. (2015, August 13). Western-educated Ukrainians seeking to transform government from key posts. *Kyiv Post*. Retrieved August 23, 2016 from http://www.kyivpost.com/article/content/ukraine/western-educated-ukrainians-seeking-to-transform-government-from-key-posts-395711.html

Shevchenko, D. (2015, December 12). Tourism promo video for Ukraine goes viral. *Kyiv Post*. Retrieved August 31, 2016 from http://www.kyivpost.com/article/guide/travel/tourism-promo-video-for-ukraine-goes-viral-404025.html

Stewart, P. (2016, January 17). Ukrainians prepare for further economic hardships. *Al Jazeera News*. Retrieved August 28, 2016 from http://www.aljazeera.com/indepth/features/2016/01/ukrainians-prepare-economic-hardships-160114102732811.html

Szondi, G. (2010). From image management to relationship building: A public relations approach to nation branding. *Place Branding and Public Diplomacy*, 6(4), 333–343.

Transparency International. (2014). Corruption Perceptions Index 2014. Retrieved August 28, 2016 from https://www.transparency.org/cpi2014/results

Transparency International. (2015). Corruption Perceptions Index 2015. Retrieved August 28, 2016 from http://www.transparency.org/cpi2015

Ukraine Reform Monitor. (2015, August 19). Ukraine Reform Monitor: August 2015. Carnegie Endowment for International Peace. Retrieved August 28, 2016 from http://carnegieendowment.org/2015/08/19/ukraine-reform-monitor-august-2015-pub-60963

Urban, M. (2015, March 10). How many Russians are fighting in Ukraine? *BBC News*. Retrieved August 27, 2016 from http://www.bbc.com/news/world-europe-31794523

Vice News. (2015, June 16). Selfie Soldiers: Russia Checks in to Ukraine. *Vice News*. Retrieved August 27, 2016 from https://news.vice.com/video/selfie-soldiers-russia-checks-in-to-ukraine

World Bank. (2014). Doing Business in Ukraine: Ukraine Continues to Improve its Regulatory Environment for Entrepreneurs Despite Turmoil. Retrieved August 28, 2016 from http://www.worldbank.org/en/news/press-release/2014/10/29/doing-business-ukraine

World Bank. (2016). Doing Business. Ukraine. Retrieved August 28, 2016 from http://www.doing-business.org/data/exploreeconomies/ukraine

Cases IN Measurement AND Reputation Research OF Public Relations

A Real-time, Integrated AND Actionable Measurement System

KATIE DELAHAYE PAINE
CEO, Paine Publishing, LLC

EDITOR'S NOTE

Measuring the results of campaigns is today's Holy Grail of public relations. This case study provides details of how a coalition of Atlantic City businesses and state and local government, in the context of declining casino gambling revenues, launched a public relations campaign to promote all of the non-gaming related delights of the famed, but fading, city known as the "Las Vegas of the East"—and used a sophisticated measurement program that integrated survey research, web analytics, qualitative and quantitative media analysis and social analytics to document success of the campaign.

BACKGROUND

In the years immediately following the launch of the Barcelona Principles, most of the public relations (PR) profession either did not know (or did not care) about the principles of best PR measurement practices that hundreds of communications professionals had agreed to in Barcelona in 2010. At the time, PR professionals thought the Barcelona Principles would provide that Holy Grail of measurement— a simple set of metrics that provided consistent, accurate, and actionable data at the click of a mouse.

They didn't and never will.

The Barcelona Principles were essentially the PR equivalent of the Declaration of Independence—a great statement, but lacking the rules and structure of a Constitution. Those rules and structures are just now coming into focus.

And since PR hasn't had a Supreme Court to adjudicate the right way or wrong way to measure PR, clients have been navigating their own way through the jungle of bad data, entrenched structures and old habits and beliefs that no amount of evidence seems able to dispel. This is the story of one of those journeys.

In 2012, when Hurricane Sandy drowned much of New York City, it also wiped out a number of beach communities along the New Jersey shore. As it happens, the most famous of those towns—Atlantic City (AC)—was not badly damaged. However, media reports and photos got that detail wrong and incorrectly attributed pictures of destroyed boardwalks to Atlantic City. As a result, tourism plummeted. But that was only one of many unfortunate things to happen to the legendary beach town that year.

In the wake of the recent Great Recession, gambling revenues were down, and thanks to numerous competitors cropping up in Connecticut, Pennsylvania and Maryland, Atlantic City no longer had exclusive access to gambling east of Las Vegas. These new casinos were all within an easy driving distance for Atlantic City's primary revenue source—New Yorkers. Rumors began to circulate around about the post-storm imminent closing of various casinos.

Atlantic City's leadership, including the people who had the most to lose—the hotel and casino owners—knew they needed a new strategy to bring people to their town. So they created the Atlantic City Alliance (ACA), a marketing organization tasked with attracting visitors who wanted to enjoy Atlantic City's (AC's) many non-gambling attributes.

Lost in all the gambling hype and "East Coast's Las Vegas" image it had fostered for years were Atlantic City's other attractions including a gorgeous beach, the boardwalk, a wonderful performance space (Boardwalk Hall), celebrity chefs offering first-class dining and a high-end mall located right on the beach. It also had a legacy of love from people who grew up playing around the boardwalk. The city just needed to get the word out about these various attractions being open, and ready for business.

A budget was established that included paid media in New York, Philadelphia and Baltimore, some social and digital advertising and a number of local specialty PR firms to push AC's messages out to the media in the targeted cities. Additionally, revenue was set aside in the PR budget to support programs and events in 2012 highlighting the beach and its legacy of entertainment. These events included:

- The return of the Miss America pageant to its city of origin
- An LGBT alternative to Miss America known as Miss'd America

- Concerts on the beach with Blake Shelton, Lady Antebellum, and Maroon 5
- Fireworks
- Volleyball competitions
- Sand sculpting competitions
- Wine tastings
- Airshows
- World class art exhibits dubbed "Artlantic"

Unsurprisingly, given the public-private partnership funding the effort, high-quality metrics were required. So a significant portion of the budget was set assigned for research and measurement. In the end, of all the facets of the program, it was the research funds that provided the most value to the organization's survival.

SITUATION ANALYSIS

Relative to the budget, the ACA staff was tiny. Two people managed PR, events and measurement; one person oversaw all communications, and the executive director was the "face" of the organization. Additionally, ACA hired several regional PR agencies to do local outreach while the communications agency Havas managed the paid media campaign. ACA was governed by a board of directors that was primarily made up of casino and hotel owners who had contributed the funding.

Given the political nature of their charge, the communications director, Jeff Guaracino, knew that measurement would be critical. Although in the past both he and his "Measurement Sherpa" Melanie Sole had relied on Advertising Value Equivalency (AVE) to measure results, they were committed to adhering to measurement best practices and realized they needed more insight than they had in the past.

CORE OPPORTUNITY

The core opportunity was to put the Barcelona Principles to the test, bringing all the best practices to bear so the ACA could show the value that PR added to the marketing mix. A year after the measurement program began, numerous casinos closed, and the ACA became target #1 as politicians were looking for expenses to be cut. Instead, the ACA's efforts proved to be a bulwark against the tsunami of negative news. While the budget was substantially cut and paid media was virtually eliminated from the plan, PR activities such as events and retaining PR

agencies in key cities from whom casino visitors came were maintained to generate earned media results and because it had solid metrics to prove its effectiveness.

GOALS

- Increase non-gambling revenue
- Attract more visitors
- Dispel the myths that Atlantic City was just for gambling, in decline, and that the Boardwalk had been destroyed by Hurricane Sandy

OBJECTIVES

For the PR program:

- Increase high-quality media coverage of Atlantic City. (High-quality meant that coverage contained the messages and key elements that would increase consideration of Atlantic City as a destination.)
- Increase consideration and preference of Atlantic City as a destination for LGBT tourists
- Increase consideration and preference of Atlantic City as a destination for Bachelor/Bachelorette parties and other similar celebrations
- Increase consideration and preference for Atlantic City as a destination for food and wine enthusiasts

For the measurement program:

- Determine if ACA's earned media coverage was effective in changing perceptions of Atlantic City
- Discover which media/influencers and issues are driving content
- Characterize the sentiment expressed by the media toward the initiatives
- Identify what was working and not working in the program, where more resources were needed and where resources might be redeployed towards new initiatives

KEY PUBLICS

- Potential visitors in the region, specifically from New York, Baltimore/Washington, D.C., and Philadelphia

- Travel influencers
- Business conference decision-makers
- Regional media reaching potential visitors from adjoining regions, specifically New York, Baltimore/Washington, D.C., and Pennsylvania
- Atlantic City and New Jersey elected officials

KEY MESSAGES

- Atlantic City is a clean and safe place to visit
- AC is making a comeback
- AC offers more than just gaming
- AC has something for everyone, with a variety of great activities
- AC is a year-round destination spot
- AC Boardwalk is open
- AC is a place for business meetings

Because the ACA was tasked with dispelling myths, it also tracked negative messages, specifically:

- Atlantic City is dirty/full of crime
- AC is in decline/not making a comeback
- AC is only for gamblers/only about gaming
- AC is only a summer destination
- AC Boardwalk is closed
- AC is not a place to hold business meetings/conventions

STRATEGY

This case study focused on the measurement of results of the PR program, not on individual activities conducted as part of the Atlantic City campaign.

The strategy for measuring/evaluating results focused on answering the following questions:

What specific benefits or attributes made members of the target audiences consider and then plan to visit Atlantic City?

To what extent were those benefits or attributes (in the form of key messages) being seen by the target markets via paid and earned media?

To what extent was communications driving demonstrable consideration in the form of web access to the visitor guide and other calls to action on the website?

Measurement was conducted via:

a. Quarterly waves of phone surveys to find out what made people in the target geographies New York, Philadelphia and Baltimore/Washington, D.C. consider visiting Atlantic City, and what would make them prefer Atlantic City.
b. Quarterly waves of phone surveys to find out how effective the paid media. campaign was, and whether the target publics had seen or remembered any earned media.
c. Continuous media monitoring and analysis of all earned traditional media.
d. Continuous monitoring of social media.

TACTICS

Defining Acceptable Proxies for "Visits"

The measurement system design process started with a meeting between the measurement firm, the staff, the executive director and several of ACA's board members. The discussion resulted in an agreement that while it was impossible to track actual visitors to Atlantic City (never mind attributing their arrival or spending to a specific communications effort) everyone agreed that getting traffic to the "Visitor Guide" page on the website was an acceptable proxy for intent to visit.

Defining "Good Press"

After Hurricane Sandy and numerous casino closings, PR's mission was to "get better press," but the team first had to define what "good" and "bad" media looked like. In the same initial discussion, the team also agreed that the appearance of key messages and certain other quality criteria were measures of success for earned media. The discussion was based on this question: What drives visitors to consider or prefer Atlantic City as a destination? The discussion provided the answers:

- Communication of key messages around Atlantic City as a fun place to go with friends and family, and other tested messages.
- Desirable visuals
- Endorsements and recommendations by key influencers
- Exposure to programs designed to draw in specific demographics

From that discussion, the team developed a detailed, specific definition of quality media which it then weighted according to the influence it had on visitor preferences as well as internal priorities. The result was an "Optimal Content Score" (OCS) detailed below. To reflect the potential negative portrayals of ACA and Atlantic City, the team also defined and weighted key elements that might leave a message consumer less likely to visit Atlantic City.

The OCS looked like this:

Desirable Criteria	Score	Undesirable Score	Score
Positive Sentiment	1	Negative Sentiment	-2
Contains one or More Positive Messages	3	Contains one or more Negative Messages	-3
Event/Program is mentioned	2	No Event/Program is mentioned	0
Appears in Tier1 Media	2	Negative Mention in Tier1	-1
Third Party Endorsement	1	Recommends competition	-2
Contains a desirable visual	1	Contains undesirable visual	-2
Total Score	10	Total	-10

Fig. 7.1. OCS scorecard. Author's creation.

Each item of earned media content that appeared in key media was evaluated according to the six criteria listed above and given a score. The Optimal Content Scores were averaged over time, by program, topic, geography, media type, etc.

Defining Consideration and Preference

ACA had already commissioned quarterly survey research to measure actual intent, awareness and preference. In order to isolate the earned media contribution, the team inserted a question in the survey to enable filtering for people who had heard news via earned media versus paid. The team was then able to track the extent to which people who had seen destination-related news in key markets were influenced to perceive the city as a fun place to go with friends—an identified key driver of actual visits.

Social Media Measurement

Monitoring of social media engagement was conducted via Simply Measured and set up to track Facebook, Twitter, YouTube and Instagram. There was no content analysis of social media due to the fact that Simply Measure's automated sentiment was unacceptably inaccurate and there was not a budget for human coding.

EVALUATION METHODOLOGY

Initial Measurement Program Design

The single biggest factor in successful measurement program design is always the discussion with senior leadership that determines the criteria for success. The ACA was no different. The initial formative meeting brought together the communications team, the agencies, the executive director, and marketing representatives from the governing board. After an overview of basic PR measurement philosophy and a brief discussion of the Barcelona Principles, the team discussed what would be measured, the target audiences and what success would look like from a business perspective. A subsequent discussion achieved consensus on how PR would contribute to the business outcome and what metrics we would use to calculate success. The results were:

Business Impact	PR's Contribution	Metric
Increase non-gaming revenue for the city	Increase exposure to, and belief in key messages to target audiences in New York, Philadelphia, and Baltimore. Increase consideration and preference of Atlantic City as a destination for non-gaming visitors.	% of earned media that contained key messages. % of earned media that left readers more likely to visit Atlantic City. % increase in OCS Score (coverage contained the messages and key elements that would increase consideration of Atlantic City as a destination.) % increase in aided and unaided awareness of Atlantic City's non-gaming attributes. % increase in consideration and preference of Atlantic City.

Business Impact	PR's Contribution	Metric
Attract more visitors to Atlantic City as a whole (not just the casinos.)	Dispel the myths that Atlantic City was just for gambling, in decline, and that the Boardwalk had been destroyed by Hurricane Sandy. Increase high-quality media coverage of Atlantic City that left people more likely to consider or prefer Atlantic City as a tourism destination.	% reduction in coverage of "myths." % increase in traffic to the "request visitor guide" page on www.atlanticcitynj.com % increase in aided and unaided awareness of Atlantic City's non-gaming attributes. % increase in consideration and favorability of Atlantic City.

Fig. 7.2. Results table. Author's creation

Data Collection

Fortunately, most of the data was already available—or so the team thought. Google Analytics had been set up for the website and media coverage was being collected by the agency. Unfortunately, the team could not be confident that it had been collecting from the entire universe of key target media. There was no documented valid collection methodology, so the data was essentially unusable.

To measure awareness, consideration and preference, a survey research firm was hired to conduct quarterly surveys via online panels of 900+ fun-seeking consumers aged 21–65 who enjoy unique aspects of life, like short trips, and some combination of shopping, fine dining, the spa, the beach or gambling. They were asked a series of questions designed to establish levels of awareness, favorability and preference.

The only missing measurement piece was a valid system to evaluate earned media's contribution. The Optimal Content Score required human coding of each key article for the following criteria:

- Which, if any, positive messages did it contain?
- Did it mention any of the "myths" or negative messages?
- Which ACA programs were mentioned in the item?
- Were any ACA designated spokespeople quoted?
- How prominently was ACA mentioned?
- Did the item leave the reader more or less likely to visit Atlantic City? Or did was it neutral or balanced in tone?
- Did the author recommend visiting Atlantic City or one of its competitors?

The solution was to hire a media measurement company to collect, code, and analyze all the earned media in traditional top tier media outlets. Social media was monitored in-house because there was not a budget at the time to add it to the analysis.

Spelling Out the Details

To ensure consistent coding, a detailed definitions and methodology document (DMD) was created. See Appendix 1 for the complete Detailed Definitions and Methodology Document.

Tweaking the Coding

Coders were trained on the DMD and intercoder reliability tests were conducted to ensure consistency. After a month or so and a number of tweaks, the data went live in ACA's dashboard and reporting commenced.

The first major issue encountered was a tsunami of mentions of Atlantic City—including police reports from "Atlantic City Boulevard." The team solved the problem by narrowing the key media list further, so only truly significant media were analyzed. The team also decided to only code a mention if one of the brands were mentioned: Atlantic City (the actual metropolis, not all the stores, sports teams, and roadways) and Atlantic City Alliance (or both).

The second major coding controversy came when Baltimore Ravens Running Back Ray Rice decided to beat up his girlfriend in an elevator in Atlantic City. The scene was captured on video and went viral. The story made headlines around the country since it raised the issue of domestic violence within the NFL.

For those on the measurement side, the question was this: Is coverage of Ray Rice negative? Specifically, did the stories leave potential tourists less likely to visit the city? The team could find zero evidence that misbehavior on the part of a sports figure had decreased tourism, but ACA felt that because it contradicted their "safe, clean, and family-friendly" messaging, all the Rice coverage should be considered negative and tagged with a negative message. They argued that if an equally well-known celebrity had chosen to celebrate his wedding vows in Atlantic City, it would have been included as a positive message.

The team compromised and agreed that stories mentioning the beatings were negative for AC's image, but unless the story specifically implied that that a visitor might not be safe in Atlantic City or one of the hotels, it would not be coded as a negative message.

Reporting

Not surprisingly, early reports required significant tweaking, particularly around which programs were which and how to interpret messages. Once the quarterly

report was approved, the team began to integrate the media data with the survey research data. However, the team quickly realized it had to add a question to identify how the recipient was getting information about Atlantic City—via print ads, TV ads or the news? That way the team was able to isolate the people who had heard of Atlantic City on the news. It turned out that those who had seen earned media were, in fact, significantly more likely to believe the message that "Atlantic City is a fun place to go with friends"—which in turn was the most important element in respondents' willingness to consider and prefer Atlantic City as a destination.

The biggest "aha!" moment came, however, when the team was able to run correlations between traffic to the "Visitors Guide Page" (one of the core measures of success) and three key metrics:

(1) Volume of coverage
(2) Volume of positive coverage
(3) Optimal Content Score.

While the team was pleasantly surprised to find a slight positive correlation between the numbers of positive stories with traffic to the "Visitors Guide Page," it was even happier to find significant correlation when Visitor Guide traffic was paired with the Optimal Content Score—essentially validating a hunch that the elements in the score were driving consideration and preference.

Testing Patience as Well as Validity

In the middle of the program, the media measurement company that had been providing the analysis of earned media data was sold to an overseas corporation. In the consolidation, ACA was deemed two small an account for the new company, so the vendor resigned the account leaving ACA with no monitoring and no media analysis.

After a brief scramble, a new supplier was identified, but while the new supplier had the ability to collect and code clips, it did not offer the detailed reporting and analysis ACA required. So ACA retained this author to provide quarterly and ad-hoc reports.

It was in the course of producing those reports that data quality problems with the new vendor emerged. For example, two identical wire stories were coded completely differently—suggesting that multiple coders were being used and indicating that there was insufficient supervision of the results.

To confirm client suspicions, the ACA team worked with this author to conduct an intercoder reliability test of the data using a team of three independent coders. Two hundred stories were randomly selected from the incumbent vendor's original data. The panel of trained human coders familiar with the ACA

and its requirements was given the most recent ACA coding instructions. They were trained and then instructed to code the 200 stories according to the coding instructions. Their results were frankly disturbing.

More than half the items were found to have been incorrectly scored on sentiment by the most recent vendor. Even criteria as basic as the subject of the article or if a program was mentioned were miscoded a majority of the time. Of the 200 articles, messages in 46 percent of them were misidentified and shown to inaccurately identify which spokesperson was quoted in half the articles.

Clearly the new vendor wasn't following the coding instructions. After some discussion about more detailed training, the contract was terminated and another vendor was found.

Putting the Data to Work to Mitigate a Crisis

Fortunately, this time around, the transition went smoothly, which was particularly fortuitous because in the summer of 2014, solid data was more essential than ever. All the predictions of casino closings came true. Four casinos closed, including some of the most well-known. Thousands of workers were laid off and subsequently took to the streets to protest against unfair labor practices. To make things worse, Donald Trump added to the negative headlines by suing to remove his name from his former casino. Despite all the bad news, the data showed that because of ACA's programs and events, coverage was significantly better quality and more positive than it would have been without ACA's help.

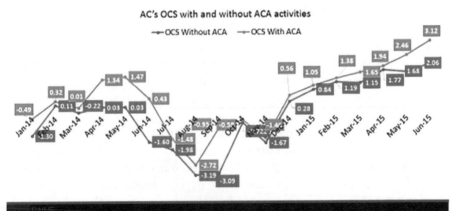

The lift from ACA messaging and programs was dramatic this month. AC's OCS reached its highest level since 2013, but would have been a full point lower without ACA's efforts.

Fig. 7.3. Evolution of scorecard. Author's creation

But the ACA PR team wasn't content to just prove its worth. It used the data to both prep for media calls as well as to determine a crisis mitigation strategy going forward. Using data on what media were most likely to pick up messages and desirable photographs, the ACA PR team was able to change the visuals and messaging on a number of stories.

It also bypassed the skeptical local and national media with ramped up social media that photographed and amplified the messages from the ACA-organized events on the beach. It used the data almost weekly to make decisions about how to allocate resources to mitigate the damage most efficiently. For example, one data point suggested that the worst quality coverage originated in broadcast news, primarily due to poor visuals. ACA rectified the situation with direct outreach to local TV outlets with opportunities to film interesting (and attractive) footage. As a result, by the end of 2015, some of the most positive, high-quality coverage was appearing on broadcast TV. This chart shows how the trend was turned around:

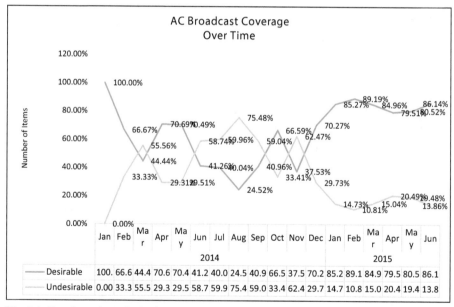

Fig. 7.4. Broadcast chart. Author's creation.

Ultimately, the analysis showed while they could not make the bad news go away, the proactive PR efforts significantly mitigated the damage.

CALENDAR/TIMETABLE

2011:	Atlantic City Alliance created
2012:	Superstorm Devastates the New Jersey Shore—Atlantic City Alliance Responds
January 2013:	Integrated "DO AC" Marketing program launched and Measurement Program begins
Spring 2014:	Casino closing news breaks
Summer 2014:	ACA Free Beach Concerts launched
Fall 2014:	More casinos close
	Added "Meet AC" campaign to attract new convention business to Atlantic City
December 2015:	Measurement Program Ends

BUDGET

Media measurement costs were capped at $40,000 a year for the January 2013–June 2015 duration of the project. Survey research was in the six-figure range, but exact amounts are not available. Social media monitoring was $2,000 a month.

EVALUATION OF THE MEASUREMENT PROGRAM

Using the data that the measurement program provided, ACA was able to show that media quality index (Optimal Content Score) correlated more closely with traffic to their destination website (the agreed-upon proxy for actual visitor counts) than paid advertising.

It also used the quarterly survey research to determine the impact PR was having on awareness and preference for Atlantic City. Once again, the data showed that people who had seen the earned media messages were more likely to perceive Atlantic City as a fun place to go with friends—the number one driver of consideration and preference.

As a result, when revenues dropped and budgets were cut, paid media were among the first to go. The PR program was retained for an additional two years. Even more importantly, during 2014, a summer of overwhelmingly bad news, ACA efforts were proven effective and the data proved invaluable when making decisions about resource allocations and budget cuts.

To sum up, the ACA team embraced the Barcelona Principles standards, set up a best-in-class measurement program and then took the whole thing to the next level by putting data to work to help IT make better decisions. As a result, the PR budget was maintained when all others were eliminated.

Appendix 1
Detailed Methodology and Definitions
(DMD) for ACA

General Restrictions

The following items will be removed and not coded:

- Obituaries
- Wedding announcements
- Birth announcements
- Police blotters
- Community Calendar: If item is a full write-up outlining in detail what the event is about and who is sponsoring, it is qualified; if it a listing of an event with no further explanation then it is not qualified
- Do not code items that are Classified Ads or Help Wanted Ads
- Duplicates: If an item appears twice, then one would be qualified and the other a duplicate. Items will be marked as a duplicate if any of the following criteria are met:
 - URL is identical
 - Items with the same outlet on the same date with identical content
 - Items posted in less than 7 days of each other that are identical in content and URL
- Spam Sites/Content Farms: Any item that comes from a known content farm or spam site will be immediately disqualified no matter the content posted to it.

Brands

Each collected item will be analyzed to determine which brand or product the item references. All subsequent coding will proceed from this point. The brands are:

- Atlantic City Alliance—mentions of ACA and/or a program
- Atlantic City
- Casino Reinvestment Development Authority (CRDA)
- Atlantic City Convention & Visitors Authority (ACCVA)

Media Tiers

Media will be classified as Tier 1 for NY/North Jersey, Baltimore & Philadelphia; select national and ACCVA outlets, and Tier 2 according to lists provided by ACA.

Markets

Each media outlet will be categorized by the market it services. Key markets are:

- New York
- Philadelphia
- Chicago
- Houston
- Baltimore
- National

Date

For each item, we will note the date and time it was posted.

Media Source and Author

For each item, our system will note the date it appeared, the publication or media outlet in which it appeared and the author/reporter/publisher/blogger who authored or posted the item.

Reach (Opportunities to See)

Opportunities to See (OTS) are calculated per media type and are used to calculate the quantity of exposure that brand receives. Print OTS represents the audited circulation figures for the media outlets in which the story/item appeared. Online News' OTS is the estimated number of unique visitors per month determined by Compete. If an OTS figure could not be determined, the mention was assigned a one. For the most part it is not possible to accurately calculate the OTS for many blogs, in which case they will be given a 1.

Desirability/Sentiment

Read and assess each item to determine the tone in which it discusses Atlantic City.

Message Presence

We will specifically search for the presence of ACA's key messages. For each item that mentions Atlantic City, we will analyze its content and determine if

Positive	An item that leaves the reader more likely to visit or consider visiting Atlantic City.
Neutral	An item that contains no sentiment at all.
Mixed	An item that contains both positive and negative sentiment.
Negative	An item that leaves the reader less likely to visit Atlantic City.

Fig. 7.5. Tone chart. Author's creation.

it contains one or more occurrences of these specific messages. Typical messages might be:

AC offers more than just gaming.	Will mention things about going to AC for other activities other than gambling (the word gambling doesn't need to be in there, can be inferred) AC Program mentions.
AC has something for everyone, with a variety great activities.	Mentions: New Events, New Activities, New Launches, New Casinos, New things happening in AC and AC Program mentions
AC is a year-round destination spot.	~ Mentions AC as a quick spontaneous getaway spot. ~ Mentions AC as a getaway spot anytime of the year ~ Mentions going to AC on vacation or going there for the weekend or going there over a holiday weekend, or to celebrate a holiday in AC, etc.

Negative/Opposite Messages

Atlantic City is dirty/full of crime.	~ Criminal activity in AC ~ Run down hotels or dirty streets ~ City in disrepair ~ Mention of AC not being a visually pleasing location ~ Mention of fear of AC due to lack of security or safety precautions
AC is in decline/ not making a comeback.	~ Any mention of a stagnant (no growth or development) in AC ~ Mentions of AC not being a destination spot ~ Mention of AC falling apart around ~ Mention of lack of improvements in AC ~ Mention of lack of improvement in the appearance of AC

AC is only for gamblers/only about gaming.	Will portray AC as a gambling city, no reference to other Events/Activities happening in the city.
AC is only a summer destination.	Will reference AC as a summer getaway, does not account for visiting AC any other time of the year.
AC Boardwalk is closed.	Mentions of the boardwalk being closed, rows of closed casinos on the boardwalk, business closing down on the boardwalk.

Effectiveness of Thought Leaders

Each item will be analyzed to see which, if any, members of ACA's leadership team are mentioned and whether the item in which they are quoted contains a key message.

Prominence/Visibility

Each item will be analyzed to see how prominently the brand is mentioned, thereby assessing the likelihood that a reader will remember the brand. If a brand is mentioned in the headline, photograph, or call out, it is far more likely to be remembered. We will classify such items as high prominence. We will rate each item to determine if it has high prominence, medium prominence, or is just a minor mention.

Each article or item that we receive will be categorized by the brand that is the primary topic of the item. The brand category is the overall "bucket" that will enable ACA to understand where the conversation in the media is occurring. By categorizing each item according to its brand, ACA will be able to understand the relationship between its efforts and each brand. Additionally, each brand will also have its own "Kick Butt Index" or Optimal Content Score.

Casino Names

The item will be analyzed for mentions, if any, of the following casino(s):

- The Borgia Hotel Casino & Spa (Borgata)
- Tropicana Casino & Resort (Tropicana)
- Trump Taj Mahal
- Trump Plaza
- Atlantic Club Hotel & Casino (Atlantic Club)
- Golden Nugget Atlantic City (Golden Nugget)

- Resorts Casino Hotel (Resorts)
- Revel Entertainment (Revel)
- Harrah's Resort Atlantic City (Harrah's)
- Showboat Atlantic City (Showboat)
- Bally's Atlantic City (Bally's)
- Caesars Atlantic City (Caesars)
- The Chelsea—this is a hotel along the Boardwalk that does not contain a casino
- Sheraton Atlantic City Convention Center Hotel

Programs

Any stories mentioning ACA programs should be automatically coded for the brand ACA. Programs include:

Programs	Examples/Definition
Public Arts Initiative/ ARTLANTIC	Program to bring top artists to Atlantic City and display their work in a conspicuous location close to the Boardwalk.
Do AC Boardwalk Wine Promenade	Mentions of Wine Flight or Wine Promenade
Winter Sweet/Duality/ Boardwalk Beat/AC'Dreamin/ Boardwalk Hall Light Show/ Moment Factory	Mentions of the Winter Sweet, or Duality. This is a show put on by the Moment Factory
Miss America	Miss America Pageant held in AC or mentions of Miss America in AC
World Championship of Sand Sculpture or DO AC Sand Sculpting World Cup	World Championship Sand Sculpting contest held in AC
AC Pro Beach Volleyball Tournament	Atlantic City Pro Beach Volley Ball Tournament
World's Largest 3D Chalk/Paint Installation	3D Chalk designs or similar attractions in AC
American Palio	Horse Race held in AC
The Bachelorette	The Bachelorette (TV show) that was filmed in AC
Airshow	Atlantic City Airshow
DoAC	Any mention of the DoAC campaign, ad program, or DoAC related activities.
July 4th Fireworks	Atlantic City's 4th of July fireworks show

Programs	Examples/Definition
Play AC Golf	Any mention of visiting Atlantic City to play golf
Phillies at the Beach	Phillies game viewing party on the beach in AC
Miss'd America Pageant	Drag queen pageant
Boardwalk Rodeo	Rodeo held in Atlantic City
Show Us Your Bling	Social media contest for bachelor & bachelorettes
DO AC Nightlife	Campaign to promote nightlife offerings in AC
Taste of Summer	Campaign to promote summer-like activities/amenities in AC in the middle of winter

Fig. 7.6. Programs table. Author's creation.

Subjects

Subjects are the overall organizational priorities that the item discusses. All items will be categorized as one or more of the following priorities:

Subject	Definition
Casinos/Resorts	Discussion is about casinos and the role they play in AC
Shopping	Discussions about shopping in AC, new stores coming to AC
Fine Dining	Discussions about the fine dining establishments in AC, new restaurants opening
Public Arts	Discussions about the Public Arts in AC (i.e. art galleries, Atlantic, theatre, art in the park)
Entertainment/Nightlife	Discussion about entertainment &nightlife (i.e. nightclubs, movies, concerts)
The Boardwalk	Discussion about the world-famous boardwalk. Can be about events, history, casinos, activities, and people giving speeches on the boardwalk.
Attractions/Events	Any activity that is happening in AC that would draw in tourists (i.e. Miss America Competition, concerts, all ACA program mentions)
Ocean and Water Activities & Beach	Discussion about going to the beach, the ocean, fishing, swimming, and water sports
Gaming Revenue Figures	Discussion about gaming revenue figures
Economic Metrics	Discussion about occupancy, parking, and luxury tax
Marketplace/Economic Development	Investment in the marketplace or economic development

Fig. 7.7. Subject listing. Author's creation.

The Impact OF Corporate Reputation ON Behavior

AkzoNobel and Zurich Insurance

SANDRA MACLEOD
Mindful Reputation

JOHN A. McLAREN
Formerly Akzo Nobel

KEVIN MONEY
The John Madejski Centre for Reputation,
Henley Business School

EDITOR'S NOTE

Reputation measurement and management is one of the more recently identified functions of an organization's public relations staff. And while many organizations focus on the challenge a crisis poses to reputation, others—like AkzoNobel and Zurich Insurance Company Ltd—believe that the reputation of the organization behind its brand matters and adds value no matter the context. AkzoNobel, arguably the world's most famous paint company, conducted both quantitative and qualitative research to comprehensively audit corporate brand awareness and reputation. Zurich, a leading global insurance group, set up its first integrated reputation measurement and analysis program across selected markets which involved harnessing and aligning its many existing studies and providing missing insights through new research to address gaps in some of the key stakeholder knowledge. The format of this case study differs from our standard template in order to allow flexibility in discussing the research findings from a management perspective.

BACKGROUNDER

As communication leaders are asked to step up to greater strategic proactivity that has a demonstrable impact on tangible business outcomes insights by way of research and evaluation increasingly are recognized as the most significant natural resources to be drawn upon. These two case studies demonstrate how different organizations have embraced best practices in measurement to demonstrate the value of reputation at the corporate level—across markets, brands and key audiences. They illustrate how benchmarking research sets the baseline for effective evaluation and how building evaluation metrics into public relations/corporate communications programs from the start can establish an evidence base to help influence wider business discussions and decision-making. In a word, research is the key to strategic communications and reputation management.

SITUATION ANALYSIS: AKZONOBEL—*IS HAVING A FAMOUS PRODUCT BRAND ENOUGH?*

Is having the world's most famous paint brand enough, or does the reputation of the corporate organisation behind the brand actually matter?

For many people around the world, the Dulux dog comes to mind when Akzo-Nobel is mentioned. For others, it's the specialty coating in Formula One. Others praise its anti-malaria paint, saving lives across India. However, few think Akzo-Nobel the corporation is synonymous with these well-known and well-regarded products. The question posed to the company's executive team by the AkzoNobel board was: "*does this actually matter? Is there real material advantage to be gained by building corporate reputation?*"

AkzoNobel is one of the world's largest paints and coatings companies and is a leading producer of specialty chemicals. The organisation has a long and distinguished history dating back hundreds of years, with the last two decades seeing the merger of Akzo and Nobel as well as the acquisition of two high-profile companies, Courtaulds and Imperial Chemical Industries (ICI). Today, with operations in more than 80 countries and about 47,000 employees, AkzoNobel has transformed from a diversified conglomerate into a focused chemicals and coatings company.

Despite owning Dulux, one of the world's best-loved paint brand, and being responsible for ground-breaking innovations, from fire-retardant coatings for the Apollo space missions to high performance finishes for McLaren Formula One cars, AkzoNobel as a corporate entity is little known outside of its home market of The Netherlands.

It was with this in mind that AkzoNobel partnered with Mindful Reputation to conduct the most comprehensive audit of corporate brand awareness and reputation ever undertaken by the company.

CORE OPPORTUNITY

For AkzoNobel's Corporate Communications Director the starting point was: "*If we are going to have our future license to exist as mega corporations, society will increasingly say 'I know I can buy your product but what do you stand for? Do I like you?'*"

RESEARCH BRIEF

The reputation research brief aimed to measure corporate brand awareness by market, stakeholder audience, segment and product brands; understand drivers of trust and behavior, and assess the relationship between the corporate brand and the product brands. The program had to:

- provide a baseline to track progress over time, benchmarked against a host of international competitors
- develop an integrated Reputation Scorecard for the AkzoNobel board of directors, and
- deliver actionable, evidence-based insights for the company's leadership and communications teams.

Priority markets were identified as the traditional "home" markets of The Netherlands and the United Kingdom (UK) and also fast-growing and hugely important emerging markets such as Brazil, India and China.

RESEARCH APPROACH

The research team sought to determine the alignment (or lack thereof) between how AkzoNobel sees itself, how the outside world experiences it and expects it to be, and how AkzoNobel's owned, earned and paid for communication positions the group from Brazil to China.

Given the scope of what was needed, the research conducted was both quantitative to provide key performance indicators (KPIs) and drive insights for the business, and qualitative to get behind the "why" and "why not" questions.

As part of the planning stage, the AkzoNobel leadership from a variety of functions in each of the target markets explained how they saw the organization.

This was used to frame the questionnaire for the external phase as well as providing a snapshot of AkzoNobel's identity.

AkzoNobel is a highly complex business with both a B2B (business to business) and B2C (business to consumer) focus. The research included external audiences consisting of three main groups:

- consumers
- business customers (by setting sample quotas across each business segment from automotive to industrial), and
- opinion formers: media, the financial community, government, NGOs and industry experts.

The research method and materials were adapted to each of these three groups. An online survey was recommended for consumers while business customers and opinion formers were expected to respond best to a semi-structured telephone interview. Importantly, each of the AkzoNobel business leaders were involved in the targeting and research process which proved essential in sharing the findings and ensuring that they were the basis for future action.

Finally, as most organizations only have some 30–50 external publications that actually "drive" their brand and reputation, the team worked with the AkzoNobel country representatives and business leaders across the group to focus on only the top tier print, online and social media to benchmark AkzoNobel's profile and relationships against chosen competitors across each market.

FINDINGS

The findings provided statistically robust evidence that AkzoNobel, as a corporate entity, was little known by consumers outside its home market of The Netherlands. However, AkzoNobel enjoyed an excellent reputation among those consumers, business customers and opinion formers who know the group.

The corporate brand endorsement strategy was validated by findings that consumers and business customers who knew AkzoNobel were more likely to purchase a product if AkzoNobel is known as the manufacturer. A direct result of this was CEO approval of proposals by the corporate brand team for more consistent and prominent corporate logo placement across the entire product portfolio, and broader corporate brand stories focusing on innovation and excellence to generate greater recognition of AkzoNobel's strong reputation.

Findings on AkzoNobel's "employer attractiveness" among the sub-groups of potential employees and students of chemistry, engineering and business, were

used by AkzoNobel's global recruitment HR team to feed into their strategy for further developing the employer brand.

AkzoNobel's corporate communications and media relations teams applied the research insights in planning future communications, including a renewed focus on story-telling and messaging around innovation and sustainability and an enhanced corporate social media presence.

The storytelling and messaging was also being driven by the company's global Human Cities initiative, launched in June 2014. It built on the fact that a significant percentage of AkzoNobel's business comes from products and services that are linked to the urban environment. Designed to help cities become more inspiring, energizing and vibrant, it is focused on six main pillars: color, heritage, transport, education, sport and leisure, and sustainability. The initiative also involves partnering with major organizations such as The Rockefeller Foundation. A key reputation driver, Human Cities plays a vital role as it links the company to an important global issue—the challenge posed by rapid population growth in urban areas—and is an ideal platform for AkzoNobel to explain why its products are so relevant to today's world. AkzoNobel has since restructured its corporate communications team to facilitate both the research findings and the new focus on Human Cities.

RESULTS

The results of the benchmark research and the media tracking can be seen in the chart below.

One top-line scorecard was produced to capture the key findings from the various studies: brand awareness (business vs consumers, and by key market), "outcome scores" on likelihood to purchase among business customers and consumers, and advocacy among opinion formers, share of media voice vs competitors and favorability, "one" reputation score per key group, level of endorsement among each and by market, and finally for overall influence—key global media attention and sentiment.

Ongoing media analysis showed an improvement in AkzoNobel's proactively generated media profile. More broadly, the research benefitted multiple internal stakeholders at a country and global level and set a baseline for tracking progress over time.

Not least, presentations to AkzoNobel's CEO and Executive Committee and the AkzoNobel Board focused on the evidence of materiality and where "*money was being left on the table*" as the research demonstrated the impact of corporate brand awareness (or lack thereof) on likelihood to purchase product. This put

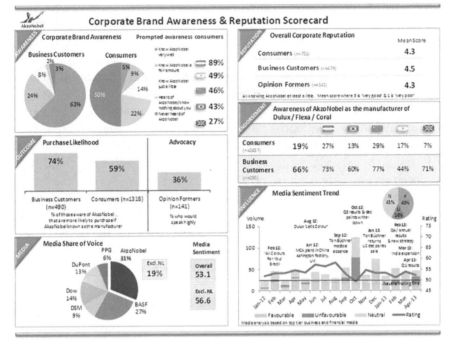

Fig. 8.1. Results chart. Used with permission of John McLaren, AkzoNobel.

AkzoNobel's corporate reputation and communications engagements at the center of the group's growth strategy.

SITUATION ANALYSIS 2 ZURICH INSURANCE—*BUILDING AN INTEGRATED REPUTATION MEASUREMENT PLATFORM (DASHBOARD)*

Complex organizations with multiple stakeholders, lines of business, markets, competitors and regulators are challenged when considering reputation holistically. Where to focus? What to focus on? How to present findings in a meaningful and actionable way? Where to start?

For a business, as complex and risk-rich as the Zurich Insurance Company, taking a data-driven approach to reputation management in today's "always-on" communications environment is vital to provide objective feedback and help with prioritization. A professional focus on reputation is also part and parcel of Zurich's commitment to its many stakeholders around the world.

As one of the leading global providers of general and life insurance, Zurich operates across issue-dense multi-line insurance with a global network of subsidiaries and offices in 170 countries, supporting the spectrum from individuals' needs to multinational corporations' requirements. To thrive and grow in its competitive and changing markets, it is business-critical that the company is aware of the causes and consequences of its reputation among its key stakeholders. By arming itself with objective and genuinely actionable insights, it aimed to address both operational and communication imperatives with clarity and certainty.

CORE OPPORTUNITY

"At Zurich, we have set out on a journey to become the best global insurer as measured by our customers, employees and shareholders, and by our contribution to the communities in which we live and work." (Zurich Insurance Group, Annual Review 2012, Living our Strategy)

In line with this stated public commitment, Zurich decided to step up its reputation measurement, analysis and management. The primary objective of the program was to enable Zurich to better understand, appreciate and manage its reputation among its varied key audiences in selected markets.

RESEARCH BRIEF

The following brief was developed by Zurich to direct its reputation measurement requirements:

- Overall approach towards measurement must be robust and replicable based on quantitative research methodologies (where feasible)
- Approach should include benchmarking vs key competitors
- Approach should use one common and clear "currency" for measuring reputation
- Approach should be applicable locally and globally
- Approach should use one approach to identify drivers of reputation (drive to defend, to learn, to acquire, to bond and drive to have purpose/meaning as described in the Better Balance Model (Money, Pain, & Hillenbrand, 2014)
- Approach must understand performance on Zurich's company/brand promise
- Reputation management program must be relevant across all of Zurich's business critical audiences
- Propose a sound approach towards quantifying the value of reputation

Expected and delivered outcomes included:

a. A strategic, truly integrated approach to reputation measurement aligned with Zurich's strategic brand objectives
b. Delivery of actionable insights for Zurich's management teams across Zurich's most important audiences
c. Guidance to enable focus of resources on the audiences which matter and have the greatest influence on Zurich's reputation. The pilot followed the framework guidelines developed during an earlier assessment stage where business-critical audiences, ranging from customers and prospects to intermediaries, employees, investors, NGOs and regulators/ politicians, were identified.

Mindful Reputation suggested that other influencers such as media, analysts, the wider community and future employees also be considered.

The reputation management pilot research had to help make a tangible contribution to the priorities of Zurich at corporate, business unit and regional levels, through the insightful analysis, interpretation and implementation of research data from a variety of sources. This entailed:

• Review of existing research efforts and findings
• New research methods
• Expert counsel and guidance
• Zurich in-house expertise (e.g. investor relations, Public Affairs, marketing, communications, program managers)

In reviewing and recommending research methods and findings, the following were taken into consideration:

• Are the methodologies and findings sound and robust?
• Are they cost-effective?
• Do they maintain consistency with previous and/or future research?
• Do they support analysis and reporting that is diagnostic (e.g. to drivers and consequences) and provide insights that are actionable?
• Do they provide both in-depth qualitative insights (e.g. into "hot topics" and sentiment) and robust quantitative data to support ongoing benchmarking of key metrics?
• Are they replicable, scalable and track-able over time (e.g. to allow the addition of other markets or audiences in subsequent years)?

Mindful Reputation recommended that insights be targeted specifically to each of Zurich's key internal customers, from the corporate executive level to

specific functional or country leadership, to maximize their value and relevance to Zurich. In this way, the program could contribute to each of the disciplines through which Zurich is able to enhance perceptions of the company in the marketplace: stakeholder engagement, communications and messaging, competitive positioning and differentiation, and the development of a cohesive and compelling corporate reputation narrative.

RESEARCH APPROACH

The Mindful Reputation team introduced the concept of "Reputation for what; among whom; and to what purpose" to frame the challenge and discovery ahead.

Reputation among WHOM- identifying the following as key stakeholders:

Consumers

- Retail (general insurance (GI) and general life (GL) Users
- Retail (GI & GL)—NON-Users
- B2B(GI)

Employees

- Zurich
- Prospects

Investors

- Zurich
- Insurance Sector

Influencers

- Journalists
- Politicians

Regulators

- Financial Analysts
- NGOs

After auditing existing research and insight vehicles and discovering a mix of approaches, techniques, areas of questioning and foci used in the past, it was clear that making sensible comparisons across insights would not be easy, efficient

or cost-effective. As such, the team developed a set of key INDEX Questions which it recommended be common to all research going forward as well as CORE Questions which should be added to any research to uncover the key drivers of reputation and key consequences of reputation (manifested in terms of supportive or unsupportive stakeholder behavior).

Reputation for WHAT—applied consistently and holistically via *PSYCHO-LOGICAL DRIVER QUESTIONS*—These included questions to understand the fundamental motivations of stakeholders and what psychological benefits they perceived Zurich was providing them and/or their communities. These included the extent to which Zurich was seen to defend and protect what is important to communities, the extent to which Zurich was seen to be an aspirational organization for stakeholders to be associated with, the extent to which Zurich was seen to be continually learning from its activities and the extent to which Zurich was playing a positive role in facilitating positive community relationships. Finally, it included measures that related to the extent to which Zurich was seen to deliver its core purpose beyond its own financial success: the genuine care it shows to customers, employees, shareholders, communities and wider stakeholders.

INDEX QUESTIONS—These included questions that measured stakeholders' general feelings towards Zurich. Important components of this scale included the extent to which stakeholders trusted, respected and believed that Zurich kept its promises.

CORE QUESTIONS—These included questions that more specifically addressed stakeholder experiences of Zurich as an organization. Measures included the extent to which Zurich is seen to operate in the best interest of customers, employees, shareholders and communities, as well as being responsible, financially stable, having strong leadership and being socially responsible.

Reputation for WHAT PURPOSE—this aspect of the questionnaire sets out to identify the consequences corporate reputation and its drivers has in terms of the specific supportive and unsupportive behaviors of different stakeholder groups (See the *RELATE* model, Money & Hillenbrand, 2006; Money, Pain, & Hillenbrand, 2016; Money et al., 2015. The team added questions related to behavioral outcomes:

CONSEQUENCES QUESTIONS—This included behavioral outcomes and most explicitly the extent to which stakeholders were prepared to recommend and defend Zurich as an organization.

The research built upon best practice in behavioral prediction. This was conducted in three key stages and involved:

1. Ensuring data conforms to properties appropriate for analysis
2. Understanding underlying themes in the data (this includes data reduction techniques such as factor analysis and scale creation)

3. Understanding causal links in the data ((this involves using the Reputation Framework and *RELATE* model to guide the application multivariate techniques such as regression and structural equation modeling).)

In addition to mapping through existing studies and questionnaires, the team conducted original research to address gaps in stakeholder data. Prospective employees (also tomorrow's future leaders) were canvassed via omnibus online surveys in each of Zurich's key markets, and compared/contrasted to current employee views and attitudes. Influencers such as regulators, politicians, media, NGOs and analysts were closely identified and reached via one-on-one telephone interviews. In all instances, to secure the right level of participation, questions about the knowledge of Zurich were used to screen out those with little awareness of the group or its activities. Of note, any significant lack of awareness among target audiences was captured closely as a finding in of itself in relation to the group's relationship building programs. Participation was secured among the influencer audience by committing to revealing the sponsor of the research and sharing the resulting "white paper" on the future of the industry globally and key issues as perceived by fellow opinion leaders. As all research communicates and can be a valuable vehicle of listening and engagement in of itself, this white paper was accompanied by a follow up thank you from Zurich itself that promised to respect the participation of each individual, and help further develop an open and transparent relationship going forward.

In terms of the financial impact of Zurich's reputation, the international British-based firm Reputation Dividend was retained to assess and benchmark the confidence inspired by Zurich's reputation above and beyond stated financials and a host of other tangible factors such as dividends and forecasted earnings as a precise and defined economic contribution to Zurich's market capitalization. This analysis was trended over several years to demonstrate the direction of travel of Zurich's reputation and was benchmarked against that of its leading global peers.

RESULTS

Through this program, Zurich was able to develop its first fully Integrated Global Reputation Dashboard featuring:

- *Reputation contribution to market capitalization*: five-year trend against four leading global competitors
- *Reputation value:* year-on-year, over the same five years
- *Total Zurich reputation score*: combining all scores for T

- *Trust,* admiration and reliability across all analyzed stakeholders, brands and markets
- *Stakeholder benchmarks*: specific competitively benchmarked scores for how well Zurich was doing versus its leading competitors among customers, employees, investors and opinion formers
- *External measures of corporate responsibility* drawn from the Dow Jones Sustainability Index

Behind this one-page graphic overview designed for the Executive Committee, further scorecards and analysis were prepared for each market and stakeholder for greater granularity and consideration. Critically these could provide insights not only into the reputation of Zurich but its causes (drivers of reputation) and its consequences (stakeholder behaviors). As such the scorecard was designed to provide leaders and managers with information to both the practice and strategy related to stakeholder engagement across the group as a whole and with specific stakeholders in different markets.

By way of illustration, Zurich's Reputation Value was assessed by Reputation Dividend to be significantly above the Fortune 500 average, and supported the share price through the last economic downturn. The stakeholder-related research indicated the issues on which this value is based and what activities should be stopped, enhanced or maintained to simultaneously enhance the trust of stakeholders and the value of the business (Ghobadian, Money, & Hillenbrand, 2015).

Tracking the contribution of its corporate reputation to the market cap of Zurich over five years highlighted the significant value and strength of the asset.

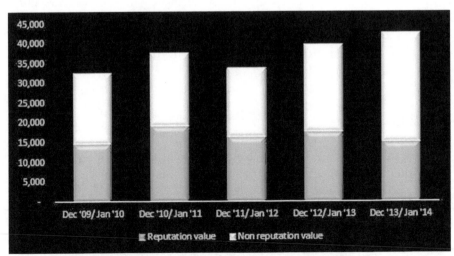

Fig. 8.2. Analysis chart. Used with permission of Reputation Dividend Ltd.

OTHER FINDINGS

- Both B2C and B2B customers will be stronger advocates of Zurich if the group can demonstrate that it is genuinely committed to its purpose beyond its immediate financial success (I.e. Zurich putting its purpose as the key of its offering).
- Zurich employees can be powerful ambassadors for Zurich's purpose and are key influencers of consumer behavior.
- Lack of responsiveness/awareness among politicians demonstrates importance of enhancing public affairs and engagement efforts.
- Similarly, the international NGO community (notably around climate change/environment/sustainability) do not see the inherent value of engaging with the insurance sector, so this needs addressing and presents opportunity for Zurich.
- Listening followed by communication on stakeholder relevant issues is key. Strategic profile raising and improved stakeholder engagement will deliver business benefit and can be delivered through employee ambassadors where possible.

KEY POINTS ABOUT THESE TWO CASES

- Setting research-based benchmark is the key to rigorous evaluation.
- Applying a framework that measures not just reputation, but its causes and consequences allows research to inform both the strategy and practice of stakeholder engagement
- On-going monitoring and evaluation provides key insights on how existing activities should be adjusted and fine-tuned. It can also provide useful information about ROI and provide value of the communications function to the business.
- On-going monitoring and evaluation provide evidence of new and unexploited opportunities.
- Providing evidence allows communication to position itself as a strategic asset for the organization and secure on-going resources for its activities.
- Through the persuasive evidence of research and evaluation, the communication department can place itself at the heart of business strategy.
- Rigorous research generating an evidence base is taken seriously by senior management and boards of directors.
- Properly done, Reputation Dashboards connect management with the insight and intelligence to be more effective, bringing clarity to an otherwise confused and complex picture.

REFERENCES

Ghobadian, A., Money, K., & Hillenbrand, C. (2015). Corporate responsibility research: Past—present—future. *Group & Organization Management, 40*(3), 271–294. ISSN 1059-6011. doi:10.1177/1059601115590320.

Money, K., & Hillenbrand, C. (2006, Autumn). Using reputation measurement to create value: An analysis and integration of existing measures. *Journal of General Management, 32*(1), 1–12.

Money, K., Pain, S., & Hillenbrand, C. (2014, July 8–13). *Introducing the better balance model: A psychological solution to the problem of sustainability.* Paper presented at the 28th International Congress of Applied Psychology, Paris.

Money, K., Pain, S., & Hillenbrand, C. (2016). *Extending the better balance model: How psychology could help to solve the problem of sustainability.* Henley Discussion Paper Series. Paper number: JMC-2016-01.

"Stoner Sloth"

Lessons from Evaluation of Social Media and Virality

JIM MACNAMARA
University of Technology Sydney

GAIL KENNING
University of Technology Sydney

EDITOR'S NOTE

This case came to our attention as the winner of the 2016 International Association for Measurement and Evaluation (AMEC) award for the best use of an evaluation framework. Over the years, governments around the world have launched advertising campaigns to modify behaviors and educate the population but very few bothers to find out if the millions of dollars spent have had an impact. Many such campaigns capitalize on humor and on the shock value of the creative work to gain attention and indeed create controversy. This case took on the challenge of setting up an evaluation framework that offers an evidenced-based evaluation that is a model for others to follow and adapt. The lesson here is that effective measurement is not only desirable, it is essential to establish at the onset of a campaign or public relations initiative and it is possible to choose an effective and relevant framework to do so. Readers should follow the work done by AMEC to learn the best evaluation and measurement techniques. Another key finding discussed here is the pitfalls as well as benefits of virality and the need for curation of websites and digital campaigns as part of strategic planning and management.

INTRODUCTION

In November 2015, the New South Wales (NSW) Department of Premier and Cabinet launched a digital campaign using social media, websites, and paid online search to reduce the incidence of recreational use of Cannabis among 14–18 year olds—the age range identified as the period in which people are most likely to first try recreational drugs. Media metrics and social media tracking of the campaign found that it was perceived to be "fun" but "credible" and was widely shared within the target audience in its first month when messages were highly targeted through special youth sites and paid search. But in mid-December when the videos and GIFs featured in the campaign went "viral" attracting more than 3.5 million views in a few weeks, the campaign received widespread criticism in traditional media and more than 30,000 comments on social media, most of them negative. It was labeled "one of the worst campaigns of 2015" in newspaper headlines and the government terminated the campaign in mid-January 2016 and ordered a detailed independent evaluation.[1] Subsequent in-depth quantitative and qualitative evaluation showed that the "edgy" youth campaign did in fact achieve many of its objectives among 14–18 year olds, causing them to "think twice" about using Cannabis and reducing perceptions that using the drug was "cool". However, the campaign raised major questions about the common view that "going viral" is positive (Godin, 2001; ImagePro, 2016) and provides lessons for planning digital campaigns.

BACKGROUND

Research by the National Cannabis Prevention and Information Centre (NCPIC) in Australia found that 14–18 years of age is the period in which people are most likely to first try recreational drugs and that Cannabis is most often the first recreational drug tried (Copeland & McDonald, 2015). The research also identified that many young people believed that Cannabis is "harmless"; many perceived using Cannabis as "cool"; and young people in this age range also were often pressured by peers to try Cannabis.

In 2015 confusion about the effects of Cannabis was exacerbated as Australian state and national governments moved towards legalization of Cannabis use for medical purposes. Consequently, the NSW Government decided to conduct a public communication campaign to address the perceptions of young people in relation to Cannabis and reduce the risks associated with early recreational drug experimentation.

GOAL

The overall goal of the campaign developed was to discourage young people from trying Cannabis, commonly referred to as "weed", "dope", "pot", or "marijuana" (the name of the plant from which the drug is derived). Based on formative research, an early decision in developing the campaign strategy was to use the term "weed" as the most commonly used term within the target audience (DPC, 2015).

COMMUNICATION OBJECTIVES

The specific communication objectives of the campaign were to:

- Raise awareness of the risks and consequences of recreational use of Cannabis
- Challenge the belief that Cannabis is a safe and acceptable first drug
- Dispel the curiosity and excitement associated with trying Cannabis for the first time
- Empower teens to reject use of Cannabis for recreational purposes; and
- Empower young people to look after their mates and discourage use of Cannabis (DPC, 2015).

TARGET PUBLICS

The target publics of the campaign were as shown in Figure 9.1.

Primary audience	Secondary audience	Other influencers
Young people 14–18 years old in NSW, who are: • contemplating trying cannabis • have tried cannabis (but not frequent users) • more influenced or surrounded by peers/family who are avid users	Young people 14–18 years old in NSW, who are: • not contemplating trying cannabis (never users)	Peer groups of the primary target audience Key influences of the primary target audience including teachers and older peers

Fig. 9.1. Target publics of the Stoner Sloth campaign (DPC, 2015; Macnamara & Kenning, 2016, p. 4).

KEY MESSAGES

In line with the communication objectives and the strategy developed, the key messages of the campaign were:

- Using "weed" is harmful to one's health (e.g., potentially leading to problems such as brain impairment, schizophrenia and anxiety)
- Using "weed" can be harmful to others, such as passive smoking and driving while under the influence of "weed"
- Using "weed" makes you slow and dull, unable to think straight or perform effectively in day-to-day situations such as at school, socializing with friends, or with family (DPC, 2015; JWS, 2016).

The messages of the campaign were integrated into a central theme *"You're worse on weed"*.

COMMUNICATION STRATEGY AND ACTIVITIES

Given the target audience (teenagers), an "edgy" digital campaign was developed that communicated the key messages through a series of videos showing young people performing poorly in various everyday situations. The strategy and theme were brought to life using an animated character "Stoner Sloth" based on the reputedly slow and lazy animal named after one of the "seven deadly sins". The campaign included:

- Three videos featuring Stoner Sloth floundering while attempting an exam at school, being uncommunicative and a bore while socializing with friends, and being embarrassing at a family dinner, which were hosted on a special Tumblr page (www.stonersloth.com.au)
- Six GIFs (3-second animations) were also produced and posted on Tumblr and other social media
- Promotion of the videos and GIFs through online advertising on Tumblr, Facebook and Google paid search with links to the videos and GIFs
- A *Stoner Sloth Community* Facebook page where the three videos and one GIF were also hosted and could be viewed, liked, shared, or commented on
- Links from the social media sites to *Your Room*, a NSW Health and St Vincent's Alcohol and Drug Information Service initiative containing more detailed information and resources related to drugs.

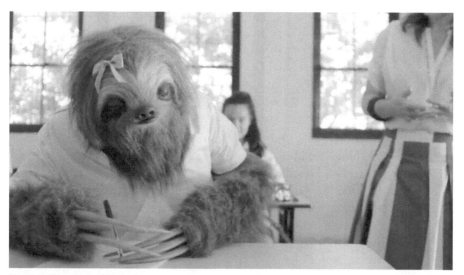

Fig. 9.2. The Stoner Sloth digital campaign featuring a human-size slow-moving sloth and the theme "You're worse on weed".

The NSW Department of Premier and Cabinet appointed Saatchi & Saatchi to create the campaign, supported by UM (Universal McCann), the NSW Government's media buying agency. In addition, DPC appointed a team of academics at the University of Technology Sydney (UTS) to provide independent evaluation of the results,[2] working in conjunction with a survey research company.

TIMETABLE

The campaign was launched on November 18, 2015 and was scheduled to run for up to three months. However, as subsequently reported, it was discontinued in mid-January 2016.

BUDGET

The campaign had a total budget of $500,000 (Australian), with $50,000 allocated for evaluation. This significant allocation for evaluation was not based on arbitrary principles such as suggestions that 10 percent of communication budgets should be devoted to evaluation. Evaluation planning included recognition that, in addition to digital and social media tracking, a pre- and post-campaign survey would be required to identify outcomes and impact and that teenagers are a difficult

audience to research, with minors (under 16) requiring parental consent (see "Ethics"). Also, given that drug use is a sensitive topic, gaining feedback from teenagers presented a significant challenge.

MEASUREMENT AND EVALUATION

The evaluation approach taken provided empirical as well as qualitative data at *output, outtake* and communication *outcome* levels, as recommended in academic and best practice evaluation literature (e.g., Bauman & Nutbeam, 2014; Macnamara, 2014, 2015, 2017; Watson & Noble, 2014)—although evidence of ultimate *impact* on behavior will not be known for some time. However, outtakes (what the target audience said about the information received and what they did with it online) and their stated attitudes and intentions as revealed in the post-campaign survey provide indications of likely impact.

Methodology

Three research methods were used in the evaluation and findings were triangulated[3] to report results, insights, and learning gained from the evaluation as follows:

- *Media metrics* on audience reach of the digital advertising campaign as well as views, likes, and shares, which were provided by Universal McCann (UM), the NSW Government's media buying agency
- *Content analysis* of social media user comment and media reporting to identify reactions to the campaign conducted by researchers at UTS. This analysis sought to identify reactions to the campaign, particularly within the target audience, as well as uses of the information provided (see details of the content analysis method below), and
- Responses to a post-campaign *pre- and post-exposure survey* of target audience youth independently conducted by JWS Research in consultation with academic researchers at UTS.

Content Analysis

Content analysis of media reporting and social media user comment was progressively conducted during the campaign to identify reactions using traditional quantitative methods (Neuendorf, 2002) as well as qualitative techniques as described by Newbold, Boyd-Barrett, and Van Den Bulck (2002), Shoemaker and Reese (1996), and others. Social media content analysis was a particular focus because of its direct relevance to the target audience and because it afforded near real time

access to reactions of the audience to the campaign, such as likes, shares, and comments. This provided early indications of audience reaction, response, and likely impact. Press and TV content were downloaded by the researchers to gain an understanding of general community reaction to the campaign, particularly when the campaign went "viral."[4]

Social media content and metadata (e.g., date of birth, photos, location, and occupation) were retrieved from Facebook, Tumblr, Instagram, and Twitter during the period November 9, 2015 (two weeks prior to launch of the campaign) to January 4, 2016. As well as establishing a baseline of discussion about Cannabis use, analysis of social media comments combined with profile data[5] allowed segmentation of discussion by age group, which proved to be very important as will be shown later. Social media content was retrieved using a proprietary script to open all comments and then import the text and metadata into Microsoft Excel where it was categorized by names, dates, and content format (e.g., like, share, comment, re-posted, and so on). Other calculations were also made from data that were not available in site metadata (e.g., number of replies to comments). Slightly more than 27,000 comments were retrieved and analysed from more than 30,000 comments identified online in relation to the Stoner Sloth campaign in the period. This figure gives a clue to the extent of public interest in the campaign and the scale of online debate that occurred.

The text of comments was then imported into Microsoft Word for removal of "stop words" (i.e., words that do not contain importance or significance such as "a", "an", "the") and "gobbledygook" that occurred through glitches in some downloads, and then taken into NVivo (an application for qualitative and mixed data analysis) for more detailed analysis. The content of social media discussion was categorized using inductive and deductive coding[6] An initial set of categories was deductively established such as "school"; "family dinner", "socializing with friends" (the themes of the three campaign videos), as well as "humour"; "criticism"; and "support". In addition, a number of other categories were inductively created based on the frequency of terms appearing in comments identified using word clouds. These included messages such as "this is you"; "don't be a Stoner Sloth"; "me"; "hilarious"; "stupid"; and "waste of money". Two researchers undertook the analysis to reduce the effects of individual subjectivity and verify interpretations, although formal inter-coder reliability assessment was not undertaken due to the short time frame for analysis.

Survey

The post-campaign survey of target audience youth was conducted to identify awareness, attitudes, perceptions, and intentions following exposure to the campaign. This included a facility for participants who had not seen the videos to

view them via a link in the survey questionnaire and then complete the survey to gain pre- and post-exposure data. The post-campaign survey involved an online questionnaire designed by the researchers and administered to a pre-qualified sample of 14–18 year olds obtained from a panel (n = 400). This afforded a maximum error rate of ±4.9 percent at the 95 percent confidence level. Participants were pre-qualified to identify their age as well as other factors to ensure they were within the target audience). Quotas applied to age, gender, and location in sample selection, and weightings applied in analysis to calculate percentages were based on census data from the Australian Bureau of Statistics. The survey was in the field from January 8–17, 2016.

The evaluation of the campaign including the conduct of the survey received ethics approval through the UTS Human Research Ethics Committee (HREC Ref No. 2015000688). Ethical procedures included de-identification of all individuals and a requirement for parental consent in the case of minors participating in the survey (i.e., 14–16 year olds).

Outputs

Media metrics showed quite extensive reach for a targeted digital media campaign. Between its launch on November 18, 2015 and early January 2016 the Stoner Sloth campaign achieved a total reach on Facebook of 2.19 million per Facebook Statistics, yielding a total of 8.31 million impressions.[7]

The three videos at the centre of the campaign each generated between 1.1 and 1.28 million impressions on Facebook and more than 230,000 views for the school exam video, more than 210,000 views for the family dinner video, and almost 195,000 views for the party video (see Figure 2). UM assessed that the campaign reached 78 percent of the target audience against a target of 72 percent at a cost of $0.05 per 3-second video view compared with a target cost of $0.10 per 3-second video view.

Video Name	Spend	Impressions	Views	CPV	Complete views	Average duration	Total engagements	Likes	Comments	Shares	Website clicks
Delilah – GIF	$3,067	356,787	-	-	-	-	3,894	1,849	367	98	885
Party	$11,500	1,102,232	194,644	$.0.06	42,531	14	199,789	2,263	1,254	179	353
Dinner	$11,500	1,200,418	211,055	$0.05	47,588	16	216,854	2,391	1,466	264	479
Exam	$11,500	1,278,565	232,655	$0.05	72,358	17	239,260	3,317	114	446	825

Fig. 9.3. Media metrics including impressions, views, cost per view, likes, comments, and shares (Universal McCann, 2016).

Outtakes

Content analysis of social media in the first few weeks of the campaign revealed that the videos were seen as "funny" "amusing" or "hilarious" (posted 512 times) and a substantial number of young people shared the Stoner Sloth videos with peers and colleagues in ways that supported the objectives of the campaigns. For example, comments included the following.

- "This is me", "was me", "is my family", "me" or similar statements were posted 381 times
- "This is you" messages or suggestions were sent to others 230 times
- The hashtag #stonersloth appeared 97 times, and
- "Loving" the content and/or Stoner Sloth was stated 51 times.

Comments posted online with names (but de-identified here as part of ethics requirements) included the following:

- Me tryna (sic) talk to you lol. [NAME], December 13, 10:12 pm (estimated to be 18–19, from Gorokan, NSW)
- Me/10. [NAME], November 22, 8:46 pm (estimated to be 18, from Sydney NSW)
- Me. [NAME], November 23, 10:08 pm (estimated to be 18–19, from NSW)
- Daniel you're worse when you're stoned buddy. [NAME], November 19. 3:30 pm (estimated to be 17–18, from NSW)
- 10/10 Matt [SURNAME] exactly you. [NAME], November 23, 6:39 pm (estimated to be 17–18, from NSW)
- Emily Maria stop smoking weed, sloth. [NAME], November 21, 9:22 am (age 17, from NSW)
- [NAME] don't be a stoner sloth m8. [NAME], November 21, 9:18 am (estimated to be 16–17, from NSW)
- Shane don't be a stoner sloth mate *note don't kill me. (NAME, estimated to be 18–19, from Tuggeranong, NSW, November 21, 6:35 pm).

In the first month of the campaign, during which access was largely restricted to the target audience by making the videos only available via paid links placed in the Facebook, Instagram, and Tumblr pages and searches of 14–18 year olds, only a small amount of criticism occurred. For example, suggestions that the content was "bad" or that the videos were "creepy" were made only 11 times.

However, from mid-December 2015, around one month after the campaign was launched, a large amount of negative publicity began to appear in newspapers, TV, and online media. The "tipping point" for this shift can be identified as

December 15, 2015 when a compilation video of the Stoner Sloth digital commercials was unexpectedly posted on YouTube—thereby being exposed to mass viewing. In just one month, the Stoner Sloth videos received more than 3.5 million views on YouTube and, while they received 9,382 likes, they also received 8,853 dislikes and 4,334 comments, most of which were critical.[8] As of December 2016, the Stoner Sloth video compilation on YouTube had over 4 million views

A Tsunami of Criticism Gathers Force

Specialist online media were among the first to weigh in with criticism of the campaign. For instance, *New Matilda* commented on December 18, 2015:

> While drug and alcohol policy experts *New Matilda* reached out to for comment were today unavailable, the campaign has certainly managed to grab attention with the videos already attracting hundreds of thousands of views. That's not to say those engaging with the material were completely sold, with many questioning whether the campaign was authentic or not. Others were perplexed by the involvement of the state government. (Chalmers, 2015, p. 10)

The Huffington Post published a report under the headline "Stoner Sloth campaign is peak anti-marijuana absurdity" (Hanson, 2015). *The Pedestrian Daily* reported that it was "confused" by the campaign and described it as "chillingly hilarious at best and a gross misuse of taxpayers" money at worst' (NSW anti-weed campaign, 2015, p. 3). Trade media also joined in the attack. For example, the leading US advertising and marketing journal *AdWeek* commented on December 20:

> There's a long and not-very-proud tradition of anti-drug advertising that gets ridiculed for missing the mark with young audiences. Australia's New South Wales government just added a classic new entry to that hall of shame with #StonerSloth, a campaign. (Nudd, 2015, p. 1)

A number of mainstream national and even international media picked up on the campaign in late December and most were critical. For instance, *CBC* News reported on the campaign on December 21 under the headline "Bizarre Stoner Sloth anti-marijuana campaign delights the internet". The report described the campaign as a "viral smash", adding that it was "widely successful online, though probably not for the reasons the NSW government had in mind" ("Bizarre 'Stoner Sloth' anti-marijuana campaign", 2015, p. 4). In one of several articles published on the topic, *The Sydney Morning Herald* alleged that:

> The National Cannabis Prevention and Information Centre will ask the NSW Premier's department to retract its claim that the centre's research lay behind its #stonersloth anti-marijuana social media campaign which is going viral for all the wrong reasons. The campaign, which depicts a stoned sloth failing in class and messing up at the dinner table,

is being mercilessly ridiculed by social media users. Many are predicting that, because sloths are cool among young people, the campaign character may be perceived as more loveable than pitiable and it will have the opposite effect of steering young people away from marijuana. (Armitage, 2015, pp. 1–2)

The Guardian similarly reported that the "the Stoner Sloth campaign has gone viral" but described it as "a pyrrhic victory for the NSW government", claiming the campaign's message had been lost (Wahlquist, 2015, p. 2). *The Daily Telegraph* waded in with similar critical comments, branding the campaign "cringe inducing" and claiming it was developed by "a group of middle-aged, buttoned-up bureaucrats desperate to prove they can 'get down' with the kids" (Marquand, 2015, pp. 3–4).

The New Daily listed the campaign among the worst ads of 2015 with reporter Anthony Colangelo claiming that "it was clear the campaign missed the mark", although he did not produce any evidence to support his claim (Colangelo, 2015, p. 10).

The Seven Network *Sunrise* program, Australia's top-rating TV morning program, joined the critical chorus on December 26 with a segment on "the biggest failures" in advertising that focussed mainly on the Stoner Sloth campaign. The segment in which *Weekend Sunrise* comperes Edwina Bartholomew and Andrew O'Keefe were joined by "advertising gurus" Jane Caro and Dan Gregory branded the campaign one of the "world's stupidest ads" and claimed that it had been "widely ridiculed", with a news ticker (scrolling text) stating "Stoner Sloth fail". Dan Gregory said that the campaign had "gained attention", but claimed that it "missed the mark" in terms of gaining behavioural engagement by youth (Bartholomew & O'Keefe, 2015)—although, again, no evidence was produced by the critics.

Along with the posting of the Stoner Sloth videos on YouTube and the subsequent widespread distribution, sharing, tagging, and commenting that occurred, another key development observed in social media content analysis was the entry of celebrity and "Pro-Am" *meme makers* into the debate. The term "Pro-Am" was coined by Leadbeater and Miller (2004) to denote amateur enthusiasts who become increasingly professionalized in skills and focus, but who often work for fame or personal satisfaction rather than money. Today, along with Pro-Am bloggers and video producers, this group includes meme makers—internet users who identify potential issues of wide interest and set about making those issues spread virally. In a classic example of meme making, self-professed "kinda celebrity" in the world of meme making, 25-year-old South Australian Michael Trembath, produced a high-quality *Sloth Wars* movie poster, sub-titled "The Grass A bakens", parodying the movie *Star Wars: The Force Awakens*. Trembath's creative work was no accident or simple spoof. It was timed to coincide with the long-awaited release of Episode VII of the *Star Wars* series, which premiered in Los Angeles on December 14, 2015. With a few Facebook posts (see below) and his poster online, Trembath linked Stoner Sloth to the massive worldwide audience of *Star Wars*

fans and created further fame for himself. The fact that the animated human-size sloth also looks somewhat like the Wookie of *Star Wars* fame only added to the digital virality that followed. A characteristic of meme makers is that, in addition to coming up with a creative idea or angle, they actively promote their creation, such as this Facebook post by Trembath:

> The two biggest hits of the summer combine into one blockbuster film—Sloth Wars: Episode [7]: The Grass A-bakens. Our heroes have been tasked with retrieving the saltshaker that once belonged to Luke Hightoker. Will you be able to complete the mission, or will you be tempted by the dark side? (Michael Trembath, December 21, 2015; 75 likes)

While meme makers effectively hijack online content for their own fame or personal satisfaction, another emerging internet practice that has different objectives but similar effects is *news jacking* by commercial or political interests. Several individuals, organizations, and interest groups used the campaign as an angle to promote their political views on Cannabis and drugs generally. For example, a pro-Cannabis Stoner Sloth website in the US (www.stonersloth. com), operated by a person named as "Daniel" in media reports, had just 93 participants on his WordPress online forum when the Australian Stoner Sloth campaign started. Daniel joined the gathering media storm to increase online traffic to his site. Furthermore, pro-Cannabis Web sites and publications such as *HighTimes* and *The Cannabist* "jumped on" to the issue as a pulpit to spread their messages.

As the campaign spread to this wider audience, social media content analysis revealed that the target audience (14–18-year-old youths) withdrew from online discussion and fell silent. Therefore, this stage of media analysis raised serious doubts about the effectiveness of the campaign. However, the post-campaign survey conducted in mid-January generated some interesting and more positive findings.

Outcomes

The post-campaign survey produced a detailed 48-page report with findings that demonstrated some significant outcomes despite the campaign's hijacking and the subsequent storm of controversy. For example, a significant number of 14–18-years-olds in NSW could recall key messages of the Stoner Sloth campaign, as shown in Figure 9.2. A quarter (25 percent) recalled that "using weed makes you slow and dull like a sloth"; 17 percent recalled that "you can't think or act straight on weed"; 12 percent recalled the campaign theme "you're worse on weed"; and 11 percent recalled the character "Stoner Sloth" and "using weed has risks and immediate negative consequences" (JWS, 2016, p. 20).

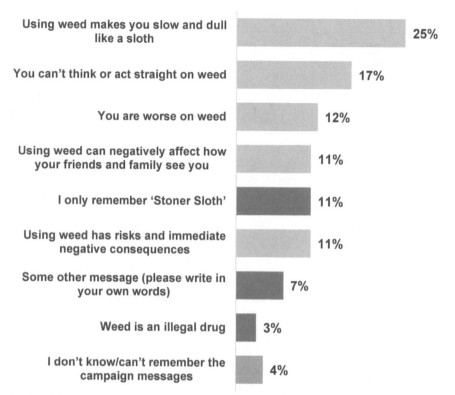

Fig. 9.4. Messages recalled by 14–18-year-olds in NSW following the Stoner Sloth campaign (JWS, 2016). Q4. What is the main message that you took away from the Stoner Sloth advertising? Please select only one message. Reduced Base: Recall seeing "Stoner Sloth" at Q2 (n = 211).

Even more significantly, post-exposure responses indicated that perceptions of a number of negative consequences of using Cannabis increased significantly compared to pre-exposure levels as shown in Figure 9.5—some by up to 10 percent.

A significant majority of 14–18-year-olds in NSW were found to perceive specific harmful effects of using Cannabis post-campaign. For example:

- 57 percent indicated that they believe "there is a possibility of long-term effects, such as brain impairment, schizophrenia and anxiety";
- 42 percent perceived Cannabis use as "a potentially risk to my health";
- Almost one-third (32 percent) perceived Cannabis use as "a risk to others (e.g., passive smoking, affects my driving skills, etc.)"; and
- 31 percent agreed that "there are short-term effects such as having reduced reaction time and acting slow".

Message	Pre	Post	% change
Performing poorly at school including in exams	69%	74%	+5%
Not able to follow conversations or interact with friends socially	54%	63%	+9%
Being an embarrassment to friends in social situations	50%	58%	+8%
Being isolated and alone at parties and other social events	46%	56%	+10%
Having awkward family dinners	45%	54%	+9%

Fig. 9.5. Key messages about the potential negative consequences of Cannabis use pre- and post-campaign (JWS, 2016, p. 8). Q9. To what extent are you concerned about the following potential consequences associated with using weed? Please rate your concern toward each consequence on a scale from 1 to 5, where 1 equals "very concerned" and 5 equals "not concerned at all". Q17. To what extent are you concerned about the following potential consequences associated with using weed? Please rate your concern toward each consequence on a scale from 1 to 5, where 1 equals "very concerned" and 5 equals "not concerned at all". Percentages based on top two ratings on 5-point Likert scale. Base: All respondents (n = 400).

Only 2 percent of 14–18-year-olds respondents saw Cannabis use as "cool", "fun and exciting", or something that they are "curious to try once or twice a week", and post-exposure only 5 percent of teenagers in the sample perceived Cannabis is safe to use. Conversely, 27 percent described using "weed" as "uncool".

Post-campaign perceptions of the physical harmfulness of using Cannabis did not increase compared to pre-campaign perceptions—in fact perceptions of harmfulness declined overall by 2 percent (JWS, 2016, p. 40). However, this finding needs to be read in the context that perceptions of the harmfulness of Cannabis were already high and remain high. For example, before exposure to the Stoner Sloth campaign, 80 percent of 14–18-year-olds in NSW perceived Cannabis use to be harmful compared to 78 percent post-exposure. This difference is not statistically significant and it may be that around 80 percent is the "saturation point" for perceptions of harmfulness (i.e., the maximum achievable in a diverse community). A further factor for consideration is that, even though perceptions of harmfulness did not increase, the campaign provided reinforcement of harm messages to a substantial number of 14–18-year-olds in NSW, and reinforcement is an important element of both interpersonal and mediated communication, including in digital and social media (Cairns, 2006).

But how to explain this paradox that the social marketing campaign was widely criticized and condemned as a failure—even an embarrassment to the NSW state government—yet empirical research shows that it substantially achieved its objectives—at least to a point? The final stage of this analysis returned to the segmented data (categorization by demographic) and synthesized the findings of the

three methods of research on a segmentation basis, informed by critical analysis of the emerging practices of meme making and news jacking.

Segmented Analysis and Synthesis for Insights

Detailed analysis of social media content by demographics as revealed by online profile data (date of birth, photographs, and occupation) confirmed that (a) the vast majority of those engaging with and commenting on the campaign in the first month (from the launch on November 18 to December 18) were in the age range 14–18 or only slightly older (i.e., mostly in the target audience), and (b) the majority of online reaction to and comment on the campaign and its messages during this period was positive and supportive. This indicated that the creative concept and the messaging were appropriate to the target audience.

As the campaign progressed in late December 2015 and into January 2016 media content analysis (traditional and social) showed widespread and growing criticism of the campaign such as branding it "a misuse of taxpayer's money" and describing it as "missing the mark" and "backfiring". Also, comments progressively moved away from the central messages of the campaign to discussing other drugs; alcohol; the communication strategy of the campaign (mainly by advertising industry competitors and vested interests); and even promoting Cannabis and other drugs. Reach of the campaign increased exponentially. But, analysis of articles and online posts revealed that the vast majority of comments in this period were written by people who were not in the target audience. Many were well outside the target demographic. Furthermore, this expansion phase of media discussion of Stoner Sloth and Cannabis was increasingly curated and manipulated by vested interests including semi-professional meme makers and subject to news jacking by a range of political interests.

Based on segmentation and synthesis of data, analysis concluded that the campaign passed through three stages which, without careful strategic planning, monitoring, and management, can be problematic and which raise fundamental questions about the benefits of virality. The Stoner Sloth campaign evolved as follows:

- *Target audience engagement* stage during which links to videos and information were accessible only to the target audience through strategic digital advertising (by demographic). Analysis of this stage showed the information was appropriate and effective
- *Themes and memes* stage during which a number of themes and memes began to emerge—initially related to the campaign, but gradually broadening to open public debate about other drugs, alcohol, the campaign itself (e.g., criticisms of the creative strategy), and so on, as discussion spread to

public social networks and mass media. In this stage the campaign was progressively commented on by non-target audience people and professional meme making and news jacking began to occur

- *Viral* phase in which the campaign became a full-on viral phenomenon. In this stage, which began with the videos being posted on YouTube and receiving more than 3.5 million views, the target audience retreated from conversations and the campaign was hijacked by various interests, with discussion departing almost entirely from its original topics, themes, and messages.

CONCLUSION

This case study raises important questions about the largely unquestioned phenomenon of virality that has become increasingly possible and frequent in the age of the internet and social media and networks. The capacity for viral communication to go off topic and even become contradictory and damaging to an individual, organization, or campaign needs further investigation. If the findings of this analysis in relation to the Stoner Sloth social marketing campaign are indicative, there is much to think about critically before succumbing to the populist mantra of "going viral" (Godin, 2001; ImagePro, 2016).

While this case study does show that the campaign was successful within its specific and quite narrow target audience, it demonstrates the importance of conducting an *environmental scan* in planning media engagement that takes into account the possible reactions of others outside the target audience, especially in an environment of convergence and loss of media "gatekeepers". The three stages of virality identified by Kaplan and Heinlein—"giving the right message to the right messengers in the right environment" (2011, p. 253)—go some way towards providing a framework to avoid the unintended and unfortunate experiences that this case study illustrates. Their admonition to give messages to "the right messengers" in "the right environment" suggests avoidance of non-target audience media users and risky environments. However, the open largely uncontrolled and uncontrollable environment of the internet makes this advice challenging if not impractical. In this case, the strategic success of the Stoner Sloth campaign was overshadowed by "collateral damage" caused by extensive criticism of the NSW Government for launching the campaign. As a result, the campaign ended after just two months and further use of the concept is doubtful.

This analysis also demonstrates the necessity for *curating* media sites and content. Content cannot be posted and simply left for people to view without risks such as unanswered questions that cause frustration, critical comments, parodies,

and mash-ups. Such risks can be managed and mitigated by regular moderation and curation to respond to user comments and steer online conversation back on topic. In the Stoner Sloth campaign, "Stoner Sloth" was an active voice online in the first few weeks to answer questions and respond to comments, but was withdrawn when severe criticism started. This was almost certainly another aggravating factor in the viral discordance that followed.

Fourth, this analysis demonstrates the importance of evaluation beyond simple media metrics that show the total audience reach of content. More is not always better. Also, simplistic qualitative indicators such as likes and even sentiment scores are limited in providing insights into engagement, reaction, and impact. Segmented audience analysis and synthesis of multiple qualitative as well as quantitative data sets are necessary to evaluate the effectiveness of media communication—whether it is advertising, editorial publicity, or social media.

This evaluation provides new insights not only into the Stoner Sloth campaign, but into the phenomenon of viral content. It shows that when concepts or content go viral—something that many commercial and social marketers seek and see as a positive—they in fact lose their strategic focus and can become ineffective. In short, virality results in volume of exposure, but not necessarily effective communication. In many cases, it may be more effective to avoid viral communication and, if virality is sought or likely, careful planning, moderation, curation, and evaluation are necessary.

NOTES

1. Evaluation of the "Stoner Sloth" campaign by the University of Technology Sydney on behalf of the New South Wales Department of Premier and Cabinet won the Gold Award in the "Best use of a measurement framework" category of the AMEC Global Communication Effectiveness Awards in 2016.
2. Professor Jim Macnamara, Professor of Public Communication at the University of Technology Sydney, led the evaluation team.
3. Triangulation involves comparing data from two or more sources to validate findings.
4. The term "viral" was reportedly first used in relation to marketing by Steve Jurvetson and Tim Draper from the venture capital firm Draper Fisher Jurvetson in 1996, according to Porter and Golan (2006, p. 31), although Kaplan and Heinlein (2011, p. 253) claim Jeffrey Rayport first introduced the term in the same year. Theoretically, the notion of viral communication is linked to the concept of *contagion* (Sampson, 2012) and "seed marketing" (Hinz, Skiera, Barrot, & Becker, 2011; Watts & Peretti, 2007).
5. For social media users who did not make public their date of birth, photos or "occupation" (e.g., student) allowed identification of those within the target audience and those not in the target audience.
6. Inductive analysis identifies words and concepts that are common or frequently appearing in the data; deductive analysis pre-determines categories and codes the data into those categories.

7. Impressions here denote the total number of users who accessed a page with an in-stream video. In-stream is a format where a video begins playing without a user clicking "play". Views are the number of times videos are viewed for at least 30 seconds by a viewer clicking the "play" button.
8. As at January 22, 2016 when the evaluation was conducted.

REFERENCES

Armitage, C. (2015, December 20). Stoner Sloth Anti-marijuana Campaign: Take our name off it, says expert body. *Sydney Morning Herald*. Retrieved from http://www.smh.com.au/nsw/stoner-sloth-antimarijuana-campaign-from-nsw-government-relentlessly-ridiculed-20151219-glrjzh.html

Bartholomew, E., & O'Keefe, A. (2015, December 26). Stoner sloth fail: NSW government anti-drug campaign has been widely ridiculed. *Sunrise*, Seven Network, Sydney.

Bauman, A., & Nutbeam, D. (2014). *Evaluation in a nutshell: A practical guide to the evaluation of health promotion programs* (2nd ed.). North Ryde, NSW: McGraw-Hill.

Bizarre "Stoner Sloth" anti-marijuana campaign delights the internet. (2015, December 21). *CBC News*. Retrieved from http://www.cbc.ca/news/trending/stoner-sloth-marijuana-ad-1.3374925

Cairns, L. (2006). Reinforcement. In O. Hargie (Ed.), *The handbook of communication skills* (3rd ed., pp. 147–164). East Sussex: Routledge.

Chalmers, M. (2015, December 18). The NSW government is trying to make a sloth go viral to stop kids smoking weed. *New Matilda*. Retrieved from https://newmatilda.com/2015/12/18/the-nsw-government-is-trying-to-make-a-sloth-go-viral-to-stop-kids-smoking-weed

Colangelo, A. (2015, December 21). Stoner Sloth and 2015's other advertising fails. *The New Daily*. Retrieved from http://thenewdaily.com.au/news/2015/12/21/stoner-sloth-worst-ad-2015

Copeland, J., & McDonald, A. (2015). *Public awareness campaigns about cannabis: Evidence check*. Sydney, NSW: National Cannabis Prevention and Information Centre and University of New South Wales.

DPC (Department of Premier and Cabinet). (2015). *Brief for evaluation of anti-Cannabis campaign*. Sydney, NSW: NSW Government.

Godin, S. 2001, *Unleashing the IdeaVirus*, Do You Zoom, Dobbs Ferry, NY.

Hanson, H. (2015, December 18). Stoner sloth campaign is peak anti-marijuana absurdity. *The Huffington Post*. Retrieved from http://www.huffingtonpost.com.au/entry/stoner-sloth-seems-like-a-joke_567424d6e4b06fa6887d0234

Hinz, O., Skiera, B., Barrot, C., & Becker, J. (2011). Seeding strategies for viral marketing: An empirical comparison. *Journal of Marketing, 75*(6), 55–71.

ImagePro. (2016). Viral communication [website]. Retrieved from http://imagepro.gr/strategicdigitalcommunication/viralcommunication

JWS Research. (2016). *Cannabis campaign evaluation: Prepared for NSW Department of Premier and Cabinet*. Melbourne, VIC: Author.

Kaplan, A., & Heinlein, M. (2011). Two hearts in three-quarter time: How to waltz the social media/viral marketing dance. *Business Horizons, 43*(3), 253–263.

Leadbeater, C., & Miller, P. (2004). *The pro-am revolution: How enthusiasts are changing our economy and society*. London: Demos.

Macnamara, J. (2014). Emerging international standards for measurement and evaluation of public relations: A critical analysis. *Public Relations Inquiry, 3*(1), 7–28.

Macnamara, J. (2015). Breaking the measurement and evaluation deadlock: A new approach and model. *Journal of Communication Management, 19*(4), 371–387.

Macnamara, J. (2017). *Evaluating public communication: Exploring new models, standards, and best practice.* Abingdon: Routledge.

Macnamara, J., & Kenning, G. (2016). *Independent evaluation of the NSW Government "Stoner Sloth" cannabis awareness campaign.* Sydney, NSW: Department of Premier and Cabinet.

Marquand, S. (2015, December 22). Stoner sloth campaign: What was the government thinking? *The Daily Telegraph.* Retrieved from http://www.dailytelegraph.com.au/rendezview/stoner-sloth-campaign-what-was-the-government-thinking/story-fnpug1jf-1227684723300?sv=6fcd5efa97491460159fb1f51403b8f8

Neuendorf, K. (2002). *The content analysis guidebook.* Thousand Oaks, CA: Sage.

Newbold, C. Boyd-Barret, O., &Van Den Bulck, H. (2002). *The media book.* London: Arnold.

NSW Anti-weed campaign "Stoner Sloth" is so bad it's basically pro-weed. (2015, December 18). *The Pedestrian Daily.* Retrieved from https://www.pedestrian.tv/news/arts-and-culture/nsw-anti-weed-campaign-stoner-sloth-is-so-bad-its-/8d9055d4-0f96-45e9-a922-307fde0ea9c1.htm

Nudd, R. (2015, December 20). Australia's Stoner Sloth anti-marijuana campaign is an instant and classic fail. *AdWeek.* Retrieved from http://www.adweek.com/adfreak/australias-stoner-sloth-anti-marijuana-campaign-instant-and-classic-fail-168702

Porter, I., & Golan, G. (2006). From subservient chickens to brawny men: A comparison of viral advertising to television advertising. *Journal of Interactive Advertising, 6*(2), 30–38.

Sampson, T. (2012). *Virality: Contagion theory in the age of networks.* Minneapolis, MN: Minnesota University Press.

Shoemaker, P., & Reese, S. (1996). *Mediating the message: Theories of influences on mass media content.* White Plains, NY: Longman.

Trembath, M. (2015, December 21). Facebook [website]. Retrieved from https://www.facebook.com/michael.james.trembath

UM (Universal McCann). (2016). *Insights report: Campaign to date.* Sydney, NSW: Author.

Wahlquist, C. (2015, December 20). Stoner sloth anti-drug campaign gets reality check as medical experts walk away. *The Guardian.* Retrieved from http://www.theguardian.com/society/2015/dec/20/stoner-sloth-anti-drug-campaign-gets-reality-check-as-medical-experts-walk-away

Watson, T., & Noble, P. (2014). *Evaluating public relations: A best practice guide to public relations planning, research and evaluation* (3rd ed.). London: Kogan Page.

Watts, D., Peretti, J. (2007, May). Viral marketing for the real world. *Harvard Business Review.* Retrieved from https://hbr.org/2007/05/viral-marketing-for-the-real-world

YouTube. (2015). Stoner Sloth commercial [website]. Retrieved from https://www.youtube.com/watch?v=1Sq9FfHWDiE

Cases IN Crisis Communications

#indeepsorrow

Lufthansa's Agile Crisis Communication Management During and After the Crash of Germanwings Flight 4U9525

SWARAN SANDHU
Stuttgart Media University

SIMONE HUCK-SANDHU
Pforzheim University

EDITOR'S NOTE

We chose this case because of its value as a best practice in crisis communication on a global scale. It demonstrates how a strong brand is always vulnerable, but also shows how a steady and caring hand in the management of communications is critical for restoring or maintaining trust and a good reputation. The narrative in this crisis was unique and tragic. Management's response was indeed agile, adept and empathetic. Faced with an almost impossible task, Lufthansa managed, through transparency and authenticity, to take appropriate and necessary steps to communicate with many stakeholders at a time when they faced uncertainty and a quickly shifting situation.

BACKGROUNDER

On Tuesday, March 24, 2015, 10:41 a.m. Germanwings flight 4U 9295 on its way from Barcelona, Spain to Dusseldorf, Germany crashed in the remote French Alps. The aircraft was instantly shattered, with the largest piece of wreckage, later

recovered, described as "the size of a car". On impact, all 144 passengers from 18 countries, two pilots and four cabin crewmembers perished. Among them, toddlers, newly-weds, celebrities and sixteen high-school students with two teachers returning from an exchange program in Barcelona. A timeline of the accident and subsequent events is appended. The news of the crash spread almost instantaneously via social networks and traditional media.

At 11:49 a.m., Germanwings confirmed on Facebook and Twitter that the flight had an accident. It was the first fatal crash in company history for Germany-based Lufthansa, owner of the low-cost carrier Germanwings. It struck at the very heart of the brand—known for its safety record. Lufthansa has one of the highest safety standards in the industry. In a press statement, CEO Carsten Spohr described the accident as the airline's "darkest hour". What started out to be the celebration year of the iconic airline's 60-year anniversary turned into a nightmare.

Within 48 hours of the accident, it became apparent that the co-pilot deliberately crashed the plane. He had locked the cockpit door while the pilot went to the bathroom and set the autopilot for a straight descent into the mountain range. Then, over a time span of 10 minutes, he sat back and waited for the crash to happen. He ignored all radio contacts initiated by air traffic control, which registered the plane's deviation from the flight plan. His even breathing captured on the recovered voice recorder, the pilot's desperate attempts to pry open the cockpit door with a fire ax and the front row passenger's cries of fear were a shocking testimonial of the unimaginable events that unfolded aboard.

A few days into the investigation, the identity of the co-pilot and his medical records were leaked to the press. Documents subsequently released by the prosecutor's office showed that he suffered several episodes of depression during his flight training in 2009 and paused for six months. However, after receiving medical treatment he completed his training and was cleared for a commercial pilots' license. In the weeks previous to the crash his symptoms had returned and his doctor had declared him to be medically unfit to fly. However, he destroyed the medical sickness certificate and appeared for duty (BEA, 2016).

SCOPE OF THE CASE

As is often the case with plane crashes, this case study on crisis communication has a truly international scope. The flights' departure was in Spain, its crash site in France, destination and ownership in Germany, with passengers and members of the crew from 18 nations aboard. The crash dominated news reporting and social media platforms all over Europe for several days. When it became known that the crash was intentional, media coverage went global. This news changed the frame and narrative of the tragedy entirely: Any accident caused by human or technical

failure can be accepted as a basic uncertainty of life. But becoming the helpless victims of a deliberate suicidal act stretches the boundaries of our imagination. Especially when we are leaving our lives into the hand of trained and certified professionals. Thus, the Germanwings crash led to an intense discussion of German medical confidentiality laws, international safety regulations, and gave rise to the issue of whether airlines should have a responsibility to monitor their pilots' psychological health more closely.

This case study is particularly instructive for public relations as it provides an illustration of what we would like to call *agile* crisis communications. It can be discussed in three dimensions:

First, the case demonstrates how the airline dealt with an unexpected change of situation in the ongoing frame of crisis communication. While fatal accidents are tragic, professional communicators are trained and prepared for it. However, the revelation of a deliberate crash by one of their own staff challenged and changed the organizations' response to multiple publics.

Second, the case once more illustrates how important the public face of the company can be. With CEO Carsten Spohr, who was trained as a commercial pilot himself, Lufthansa had a charismatic leader and sensible, empathic communicator.

Third, Lufthansa actively engaged publics in social media and offered a platform for collective mourning. The airline went public with an additional site www. indeepsorrow.com. The site became a public place of commemoration by compiling all posts that use the hashtag #indeepsorrow on social media platforms like Twitter, Facebook, and Instagram or that are posted directly on the site. The site remains online for an indefinite time and, thus, is also a public manifestation of how employees and people from all over the world could express their feelings online.

METHODOLOGY

This case was researched and written using a detailed study of Germanwings/ Lufthansa's crisis communication. Additionally, publicly available material like the company's corporate and communication strategy, media coverage, interviews with professional experts and background articles are included. For the established facts of the crash, the official investigation by the French Authorities was used (BEA, 2016). It was not possible to supplement this case study with in-depth interviews of Germanwings/Lufthansa communication managers as the company neither disclosed its crisis strategy nor commented on the case from a communication point of view. Only after the first anniversary of the crash the former Chief Communication Officer Barbara Schaedler and her successor Andreas Bartels granted German professional magazine PR REPORT one interview.

They stressed that "this will remain the sole interview on the topic" (Schaedler & Bartels, 2016, p. 16; this and all subsequent exact quotes translated from German by the authors).

SITUATION ANALYSIS

In a global environment flying is an important means of business and leisure. In 2015, more than 3.5 billion people flew on 37.6 million flights, per statistics of the International Air Transport Association (IATA, 2016). The rise of low-cost carriers made flying cheaper and more accessible for more people in the last decade. At the same time, the improvement of safety standards made flying safer as IATA's long-term data show. The risk of flying is calculated at 0.07 fatalities per billion passenger miles (Savage, 2013). To put this number into context: it is much more likely to die in the car on the way to or from the airport (1:5,000) than during a commercial flight (1:11,000,000). But it is human nature that the emotional and societal impact of a single plane crash with 149 innocent victims looms larger than e.g. 149 traffic fatalities that happen in separate accidents.

The security of the passengers and crew is paramount for all airlines. Highest safety standards and excellent training of all crew have always been a top priority for Lufthansa and its low-cost carrier Germanwings. Safety is deeply ingrained in the identity of the iconic German airline with a history dating back to the early days of commercial airline operations. Although Germanwings' branding distinguishes it visibly from Lufthansa, the airline relies on the parent company's resources e.g. in training pilots and crew or using the same maintenance crews. People working at Lufthansa and its subsidiaries feel like they belong to a family, not a commercial operation.

During the economic crisis of the 2000s the company lost money and had to initiate several restructuring programs, like a low-cost carrier strategy, centralizing hubs and cutting down staff expenses because of high pension benefits. In the highly competitive airline sector, the Lufthansa aviation group had to make difficult decisions. These decisions led to several union strikes by pilots, flight attendants and ground workers protesting against cost savings, longer working hours and wage reductions. Safety had been and still is the top priority for all involved. The last fatal incident of a Lufthansa flight was 1993 at Warsaw airport were one crewmember and one passenger were killed. During 18 years of operation, Germanwings had no fatal crash until flight 4U 9295. Despite the economic challenges and union strikes, Lufthansa was consistently ranked among the top 15 safest airlines worldwide since 1993 (JACDEC, 2016). Image and reputation rankings placed Lufthansa as the most trusted airline in Germany by outdistancing its competitors by a wide margin (e.g., Brandfinance, 2016; Spiegel, 2015).

CORE OPPORTUNITY AND CHALLENGE

Many crisis handbooks and experts claim that each crisis is also an opportunity. They usually refer to the Chinese language sign of crisis (*wēijī or wei-ji*), which allegedly is composed of "danger" and "opportunity". This is a misconception: The sign is composed out of two syllables, which are written in two different characters (*wei* and *ji*). "Wei" indeed means danger, however, "ji" has multiple meanings, none of which includes opportunity. Depending on the situation "ji" is something like "incipient moment" or "crucial point". Per sinologist Victor Mair (2009), the graph for "ji" also indicates "quick-witted (ness)", "resourcefulness" or "machine/device".

A fatal crash with 149 victims is a crucial turning point for any airline. It threatens to destroy the company's public image as a reliable airline operator and thereby jeopardizes its long-term economic survival. Thus, a quick and vigorous response to the situation is paramount. Lufthansa's communication and leadership rose to this challenge and excelled in crisis communication. Many PR experts interviewed during and after the incident called Lufthansa's response a "by the book approach" and "a classic example of crisis communication" with almost "no mistakes". They perceived Lufthansa as well prepared and its crisis communication—true to its brand attributes—as reliable, compassionate and diligent.

GOALS

In times of crises, the primary communication goal is to protect the company's reputation from any damage as best as possible. For Lufthansa and Germanwings, the key goal was to maintain the airlines' reputation as a highly reliable airline and one of the safest carriers in the world. Underlying this goal are two conflicting institutional logics (Thornton, Ocasio, & Lounsbury, 2012), which will reappear throughout the case: The rational-economic logic demands that the airline keeps its operations running, maintains or regains passenger confidence quickly and safeguards its intangible assets like reputation even in the face of tragedy. The symbolic/moral logic, however, requires the leadership of the organization to assume responsibility for the crash, steer its communication and deal sensitively with the emotions of the different parties and publics involved.

The goal to safeguard a company's reputation is comparably easy to achieve in the event of natural disasters or accidents where the company is perceived as a victim itself. But when stakeholders attribute responsibility to the company because they assume that the crisis could have been prevented, corporate communication has a much more challenging task (Coombs, 2007a; Coombs & Holladay, 2002).

OBJECTIVES

Objectives help to translate the main goal(s) into clear and measurable communication tasks. They are directly derived from the overall goals and illustrate the conflicting demands in crisis communication.

The goal to keep Lufthansa's and Germanwings' reputation intact as best as possible can be translated into several objectives. The first objective was to provide clear and reliable information promptly without speculating. Lufthansa Chief Communication Officer Schaedler stated in the interview on crisis response: "I believe that it is essential to do the important things right instead of doing the wrong thing quickly" (Schaedler & Bartels, 2016, p. 16). Lufthansa kept the lines of communication open with authorities, the media and publics.

The second objective was to put the victims' families and friends first. During the first half hour after receiving the news of the crash two important decisions were taken at Lufthansa Headquarters as Schaedler explained: "First, Lufthansa as the corporate owner of Germanwings will communicate in the person of Lufthansa CEO Carsten Spohr. We will not hide. Second, in all communication, we will consider the effects on the families and friends of the victims. The most important thing is to provide them support and to express our sorrow and deepest sympathy adequately" (Schaedler & Bartels, 2016, p. 17).

Although technically Germanwings had the operational responsibility for the flight, presenting Lufthansa CEO Spohr as the public face of the crisis was a strong statement. From a rational-economic point of view, it stressed the high importance that the crash had for the Lufthansa family. From a symbolic/moral perspective, Lufthansa assumed responsibility by sending the clear signal that it cared deeply. In hindsight, "transparency, empathy, speed and diligence" were named as the four primary objectives of Lufthansa's crisis communication (Schaedler & Bartels, 2016, p. 20).

KEY PUBLICS

During a plane crash communicators are faced with multiple constituents, including the victim's families, employees, partners and passengers, local communities, media and official authorities, which will be described in more detail below.

Victims' Families

In the case of a plane crash, victims' families have the highest priority. It is usually a non-public communication handled by psychologically trained specialists with a focus on grief management. The timeframe is crucial. Families of victims should

be informed personally by airline representatives before they hear the news from other sources or even worse: before they are in the public spotlight and questioned by reporters about their feelings. In the age of almost instantaneous worldwide communication via social networks, this goal is becoming increasingly difficult. Germanwings and Lufthansa staff tried to inform all relatives personally. The CEOs of Lufthansa and Germanwings flew to the crash site immediately. The day after the crash, they met with family members at the airports of Barcelona and Dusseldorf, conveyed their condolences and informed about the current status of the investigation.

Employees

The emotional toll of a crash also impacts the employees of an airline. In a small carrier like Germanwings, many employees knew the pilot, co-pilot or someone from the cabin crew of flight 4U 9295 personally. Germanwings let the crews decide for themselves if they were fit to fly. For those who mourned the loss of a colleague or friend off-duty pilots and cabin crewmembers stepped in voluntarily. Illustrating solidarity, and to keep flight operations on the next day, some 40 flights were handled by crews from other airlines, even crews from competitors pitched in. In the end, only one flight had to be canceled.

Passengers and Partners

Passengers and partners of the airline are directly affected by the crash, too. The better the previous relationships with the passengers and partners, the easier it is to keep the channels of communication open and build upon a basis of trust and reliability. A story widely shared on social media reports how the captain of a domestic Germanwings flight on the day after the crash greeted each passenger with a handshake. Standing in the aisle for all passengers to be seen, he gave a compassionate speech on how all crew was there voluntarily, each one of them would want to be back home with their family for dinner safely and would do their best to ensure a safe flight. The story was liked on Facebook by more than 300,000 and made it into general news (Clamann, 2015). It shows how a single symbolic gesture could help to restore trust.

Local Communities

Furthermore, the local communities at the departure and destination airports, at the crash site and the victim's places of residence are affected. The airports provide vital infrastructure like crisis intervention teams or areas for public grieving.

Barcelona and Dusseldorf—as well as other airports that are served by Germanwings and Lufthansa—offered books of condolence. A particular case is the little town of Le Vernet, the settlement with around 120 inhabitants some 3 km from the crash site. Shortly after the impact, it became the center of search-and-rescue operations, investigations and reporting. Journalists from all over the world wanted to report directly from the site. Later, the town became a place of commemoration for the relatives. Its small cemetery doubled in size with a large memorial site for all unrecovered bodies and several individual graves for the victims. Most official ceremonies were held in the vicinity of Le Vernet.

Media

Among the most important publics are also media outlets. In unsettling events, the general public turns to news media (TV, radio, and newspapers) as sources of reliable information. Mass media inform about the crisis and report on developments and, thus, frame the crisis. They capture the atmospheres at the airports, at the crash site or in local communities that have lost members. However, when a situation is complex, dynamic and lacking solid information, the media tend to speculate. In such a context, a factual, proactive communication by the airline is of utmost importance. Lufthansa and Germanwings stated in their press conferences very clearly that they would not take part in speculations but offer verified facts only.

Political Authorities and Trade Associations

Political authorities and airline industry trade associations are relevant stakeholders concerning the aftermath of the crash. On April 2, 2015, the German Federal Ministry of Transport invited airlines, airplane manufacturers, professional associations (for pilots and flight attendants), medical examiners and psychologists to discuss flight security. They agreed to set up a task force under the chairmanship of the German Aviation Association to discuss safety procedures on board and the procedures for determining and checking a pilot's medical fitness (BLM, 2015). With such a high-profile international case symbolic politics is also involved, especially when high-ranking heads of state or politicians are visiting the crash site or a state ceremony is held for the victims.

KEY MESSAGES

The key messages Lufthansa expressed in all official statements were deepest sympathy and a sense of responsibility. The following table shows how these messages were adapted for each public.

Publics	Key messages
Victims' families, relatives, and friends	• We are very sorry for your loss. • We support you the best we can.
Lufthansa Employees	• We are one family and in this together. We care for each other. • It is ok to show emotions and to grief.
Passengers/Clients/ Partners of the Lufthansa Group	• Our pilots and safety measures are excellent. • Flying with Lufthansa remains safe.
Legal/Criminal Investigation Teams	• We are fully cooperating with legal authorities.
Media Outlets	• We will give selected sources/leading media direct and unfiltered access to the CEO. • We do not speculate. We will inform you as we have solid information.
General Public	• We are as shocked as you are. • Flying is still safe.
International Regulators/IATA/ Associations	• We meet all legal requirements to make flying as safe as possible. • We are and will continue working with the industry to improve safety measures.

Fig. 10.1. Publics and key messages. Author's creation. Source: Author's summary.

From an analytical point of view, these messages address the two logics introduced earlier. Messages belonging to the rational-economic logic stress functionality and safety of Lufthansa whereas the messages concerning the emotional-symbolic logic emphasize sympathy.

STRATEGIES AND TACTICS

Strategies are overarching plans or routes to reach a particular goal or objective. True to its goal and objectives, Lufthansa's crisis communication was defined by two main strategies: a clear focus on CEO communication and using social media as a shared platform to show compassion and empathy.

During the highly charged atmosphere of a crisis, the CEO has a unique role. He represents the company and is ultimately the face to public inquiries. Spohr, born 1966, is a new breed of CEOs (Lufthansa, 2016) and looks back at a 20-year career at Lufthansa. He holds a diploma in industrial engineering from Karlsruhe University and earned a commercial pilot's license from Lufthansa Flight School. He was trained for the Airbus 320 family, the same aircraft model which was

involved in the crash. This combination of knowledge and experience made Spohr a very credible spokesperson.

On the day of the crash, the GERMANWINGS CEO in Dusseldorf and a Lufthansa board member in Barcelona handled the first press conferences. Spohr was already on his way to the crash site in France and onwards to Barcelona, Marseilles and one day later to Dusseldorf to talk to the victims' families. On March 25, the first day after the crash, Lufthansa (2015) posted a short video statement by the CEO in English and German addressing "customers and partners of Lufthansa". Besides expressing sorrow and deepest sympathy on behalf of the airline he stresses that: "Safety in aviation is not a given. It is something that we have to work hard for every day and every night. And this is why this terrible accident hits us at Lufthansa even more. Because in our sixty-year history we have always said: 'safety is our top priority'".

This first statement framed the incident as an accident. As described above, the key message to customers and partners was that Lufthansa with its 120,000 employees around the world is known for excellent safety measures and flying with Lufthansa remains safe. It is a routine statement that refers to the brand attribute of reliability and safety.

After returning to Dusseldorf on March 25 in the afternoon, Spohr gave a five-minute live TV statement (Phoenix, 2015a) where he stressed the emotional impact and compassion for the families but also said: "We will not speculate on the reasons for the crash. [...] I am sure this accident will be explained eventually. The best experts worldwide are working on it and they will do it."

The situation changed dramatically during the night. Around 1:00 a.m., her deputy in charge informed Chief Communication Officer Schaedler that the New York Times had just published an article claiming that the co-pilot "deliberately" crashed the plane (Bilfesky & Clark, 2015). The report contained so much detail that there had to be a leak at the French prosecutors' office (Schaedler & Bartels, 2016, p. 18). However, the information leak gave the communication team the opportunity to prepare their response in the ensuing hours of the same night.

At 12:30 p.m. on March 26, the French authorities held a press conference and disclosed the cockpit voice recordings. They showed that the co-pilot was alone in the cockpit during the crash. The public prosecutor in charge of the investigation stated in the press conference that the co-pilot deliberately intended "to destroy the aircraft" (Bilfesky & Clark, 2015). At 2.30 p.m., Lufthansa held a press conference led by Carsten Spohr. In his introductory statement, he refers to the results of the French investigation (Phoenix, 2015b):

> We have to acknowledge that the plane was intentionally crashed by its co-pilot. [...] All of us at Lufthansa, at Germanwings, are deeply shocked. I could not have imagined that something worse than the last two days could happen. Not even in our worst nightmares, we could have imagined that something like this could happen here, in our company. [...]

We are very rigorous in selecting our pilots, it is part of our DNA. [...] We are very proud to have one of the best qualification tests for pilots. What happened today was out of the scope of our imagination. [...] The co-pilot was 100 percent fit to fly without any restrictions. [...] We can only speculate about his motives. Right now, we have no idea what lead to his terrible decision. Let me stress after the most terrible accident in our sixty-year history: I, and all my colleagues, have complete trust in our pilots. They are [...] and will be the best of the world. This is what we at Lufthansa distilled into our DNA. They [the pilots] are a vital part of our brand and for me what happened here is a terrible, tragic singular case.

With this statement, Spohr acknowledged the shift of the crisis from the accidental to the intentional cluster. But it is noteworthy how his key messages stayed true to the communication objectives despite—or perhaps precisely because of—the new context frame. Later that day, Spohr had the opportunity to present Lufthansa's as well as his personal perspective on the case to an international audience. At 5:50 p.m., first parts of a CNN exclusive interview led by Frederik Pleitgen, Senior International Correspondent at the London Office of CNN, were aired in the main program (McLaughlin & Pleitgen, 2015). The full interview of about 8 minutes was made available on CNN's YouTube channel later the same evening (CNN, 2015). In a one-on-one situation, Spohr had the opportunity to answer questions that were discussed in general and social media. How do you explain that something like this could have happened on a pilot that was trained in your company and flew for your company? Pleitgen asked. Spohr answered genuinely:

To tell you the truth, we have no explanation at this point. We, Lufthansa, have been for decades so proud of selecting the best people to become pilots, train them in the best way, having them qualified in the best way. That something of this kind would ever happen to us is incomprehensible. And I think we just need to understand that this is a single case which every safety system in the world cannot completely rule out.

He also stated that there had been no indications that the co-pilot could have been mentally unstable as he had passed all tests and medical exams and stressed:

All the other safety nets we are so proud of had not worked in this case [...]. Even if this is just a single case, we will now go back and see what we can do to improve our system even further. Because for Lufthansa safety has always been number one and that's why we do our utmost to bring it even to a higher level after this terrible accident.

Throughout the interview, he explained how Lufthansa had a focus on the victim's families and friends, explained how the situation aboard went down to his knowledge and answered questions on how this case would impact flight regulations, passengers' trust in Lufthansa and the airline's image.

Spohr had several assets to handle this interview and the many others in the days of the crisis. He has an excellent command of English, has been with Lufthansa for 20 years and could draw on his prior pilot training. The strategic decision to

center all communication in the person of "a CEO who can be the public face of the crisis" (Schaedler & Bartels, 2016, p. 20) proved to be the right one. Being the public face required a lot of empathy, eloquence, and stamina to meet the relatives of the victims and handle press conferences and (at least) 15 public interviews within three days besides making strategic decisions in an extreme situation. The Frankfurter Allgemeine Zeitung (FAZ), one of Germany's leading national newspapers published an article about Spohr on March 28. The author (Hank, 2015) concludes that Spohr showed an almost "somnambulatory confidence" in handling the multiple demands and various stakeholders and that he could become a role model within the corporation. One might add that he could also be regarded as a role model for CEO communication during crises.

In addition to CEO communication and media relations, the Lufthansa communication team put special emphasis on social media relations. Given the ubiquitous usage of social media, organizations and media outlets alike need to switch into a real-time crisis mode. New technologies like smartphones or instantaneous communication are changing the landscape for crisis communication. Nowadays, coordinating one-voice messages is much harder than it was in the last century or even virtually impossible. The traditional crisis management guidebook recommends implementing a so-called "dark site". This is a pre-arranged website that will just give the emergency information relevant to the case without any photos and therefore load much faster. The idea is, to draw a line to the regular website which might depict happy travelers and, thus, separate crisis information requests from the actual routines of online ticket sales.

Germanwings and Lufthansa used Twitter and Facebook as their prime information outlets. Only a few minutes after the first media reports on a suspected Germanwings crash over the French Alps were published, Germanwings posted a short notice on Twitter and Facebook that they were working on confirmation of the speculations. However, the Germanwings site crashed almost immediately and remained inaccessible for approximately two hours. "We were too slow to host the dark site", Lufthansa Chief of Communication Officer Schaedler admitted. "But we launched it as soon as we realized that it was not yet online." The process of launching the dark site was not well defined in the crisis handbook.

Within 90 minutes after the crash Lufthansa and Airbus acknowledged via Twitter that the plane was down. At 1:48 p.m. on the day of the crash Lufthansa posted: "We must confirm to our deepest regret that Germanwings flight 4U 9525 from Barcelona to Dusseldorf has suffered an accident." On the next day, Lufthansa posted the first video statement and used the hashtag **#indeepsorrow** for the first time (Lufthansa, 2015a). Simultaneously, they replaced their colorful airline logos with black-and-white versions on all social media accounts. The hashtag #indeepsorrow and the monochrome logos of the Lufthansa group became the dominant

frame for all communication. Other airlines from all around the world followed this idea to express their sympathies (Figure 10.2).

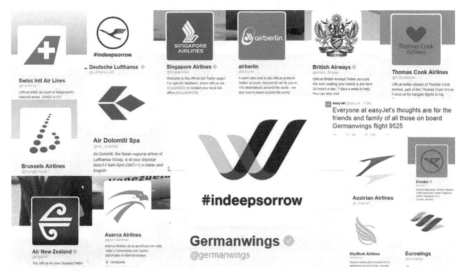

Fig. 10.2. Airlines replace logos with black-and-white versions after crisis. Public domain. Source: Facebook posting retrieved from https://www.facebook.com/Germanwings4u9525/

Another image coined in this crisis was a black ribbon with the flight number. Many Lufthansa employees and crewmembers also wore it during the mourning period. These actions were not orchestrated or planned but initiated by single employees. They were embedded in the network logic of social media and are a new way to communicate emotions and solidarity. However, this public form of mourning exerts a subtle communicative pressure to react to the event. On social media, many people (and organizations) with no affiliation to Germanwings or the victims used the web to express and share their feelings.

Lufthansa respectfully picked up this collective form of mourning and established the website www.indeepsorrow.com. Lufthansa launched the website for the following reasons:

The events of March 24, 2015 have plunged many people into a deep state of shock and grief. In reaction to this tragedy, individuals from all over the world have publicly expressed their thoughts and condolences. In response to this overwhelming amount of global outreach, we felt the need to provide an environment to share these acts of sympathy. This site has been created as a public space of commemoration for those who lost their lives on board Flight 4U 9525. We would like to preserve this display of compassion as a sign of humanity and solidarity, valuable to those in need.

Retrieved from http://www.indeepsorrow.com/#aboutoverlay-template

The multi-language site went public on April 1 with identical versions in German, French, Spanish, Catalan, and English. Technically the website aggregates statements tagged with #indeepsorrow on Facebook, Twitter, Instagram and Google+ and shares them on this site (Figure 10.3). The social media team checks if a post meets the guidelines and if it is respectful towards the victims. Dialogue options like comments were never used, which indicates that the site is not a forum for exchange but more of individual mourning and a form of self-expression. However, individual posters can read the statements by others and feel that they are not alone in their grief. Additionally, Lufthansa offers a telephone hotline with psychologically trained professionals. Posts are written in Spanish, French, Russian, English and mostly German.

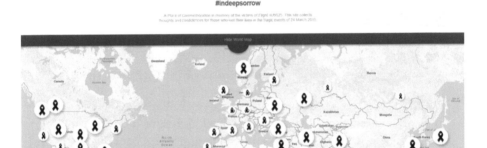

Fig. 10.3. Screenshot of indeepsorrow.com website, including geo-tagged statements. Public domain. Source: www.indeepsorrow.com

These comments offer a detailed glimpse into the psychology of mourning. Relatives and friends of the victims, cabin crewmembers, pilots, and other personnel in the aviation industry and also by persons who are not associated with Germanwings at all, posted comments. Entries were slowly declining in May 2015 but peaked again at ritual commemoration dates like the official funeral ceremony in Cologne in June 2015 or the one-year anniversary of the crash in March 2016.

BUDGET AND EVALUATION

Lufthansa communicated early on that the company would "generously" compensate the victims' families for pecuniary and personal damages well beyond

the legally required sum. Apart from legal requirements, a victim family's compensation for material damage reached the seven-figure euro range according to Schaedler (Schaedler & Bartels, 2016, p. 20). Although Lufthansa is the subject of lawsuits on that matter and felt that the controversial media reporting on compensation was incorrect, the airline decided not to discuss payment publicly out of respect for the value of life (ibid.).

The budget for crisis management and communication in general, however, was not disclosed and probably never will be. Regarding communication, personnel costs and consultancy fees usually are a major part of costs. Publicly available information (Williams, 2015) reveals that Lufthansa deployed crisis management firm Kenyon to handle international call center services, translation support, Family Assistance Center management, and Special Assistance Team personnel (http://www.kenyoninternational.com/history.html). For communications, Lufthansa had the German branch of international PR agency Burson-Marsteller on retainer (Bradly, 2015). The consultancy has a long-term relationship with the airline. In 2014 they renewed a three-year consultancy contract. Another spending were media costs. In the first week of the crisis, several video statements with the CEO were produced. At March 28, four days after the crash, Lufthansa launched several full-page condolence advertisements in main German newspapers.

Lufthansa emerged from the crisis almost unscathed. Four months after the crash a public opinion poll in Germany showed that 81 percent of the population still trusted the brand Germanwings (Spiegel, 2015). In October 2015, the Germanwings brand was incorporated into Lufthansa's Eurowings group, as had been strategically decided and published well before the crash. One year after the crash Lufthansa's image has not suffered any long-term effects either. Its customer base remains strong—a fact that can also be attributed to the excellent reputation and strong brand Lufthansa had built in 60 years. The crash also did not lead to a decrease in flying in general. In a survey by the German Airline Association after the crash 97 percent said they will continue to do so (Airliners, 2015).

LESSONS LEARNED—AGILE CRISIS COMMUNICATIONS

Crisis can be defined as "the perception of an unpredictable event that threatens important expectancies of stakeholders and can seriously impact an organization's performance and generate negative outcomes" (Coombs, 2007b, p. 2). A crisis is unexpected, complex and dynamic. It is characterized by changes that might occur over time, for example shifting the event from an accident to an incident that could have been prevented by an intentional act of sabotage or terrorism. Most crises are characterized by intense emotions, considerable public attention and a lack of reliable information during the first crises phase(s). Thus, crisis management

and communication has to cope with changing circumstances and shifting expectations—especially in trans-national or international crises contexts.

Per the situational crisis communication theory (SCCT; for an overview, see Coombs & Holladay, 2010), crisis communication should consider whether—and if so, how strongly—publics hold an organization responsible for the crisis. In the case of the Germanwings crash, there were two phases that can be distinguished. During the first phase of the crisis, everybody assumed the crash to be an accident, caused by a technical failure, human error or maybe even a terrorist attack. These speculations gave way to something much harder to understand: a co-pilot commits suicide and kills all passengers aboard the plane in the process.

Lufthansa was able to remain faithful to its two communication logics and key messages throughout both phases. From the start, the crash was labeled as an "accident" in the first phase. In the second phase, Spohr declared it to be "the most terrible accident in our sixty-year history" and thus continued the frame of reference. Everyone at Lufthansa and Germanwings was "deeply shocked", he stated in the CNN interview, and said that nobody could have imagined "that something like this could happen here, in our company". His statement was highly credible because safety standards were high, all regulations had been fulfilled and the fact that such a malicious act of a pilot was almost unprecedented.

Spohr neither presented the company as a mere victim nor did he use the co-pilot as a scapegoat. However, the shifting baseline of the crisis required Lufthansa to change its strategies and rely on the principles of agile crisis communication. As mentioned earlier the Chinese syllable "ji" indicates "quick-witted (ness)" and "resourcefulness" at a crucial turning point. In hindsight, the communication strategy of Lufthansa adapted fluidly to the changing realities of the crisis. First, the CEO exemplified the values of the organization and at the same time found the right words of compassion and sympathy. He acknowledged the uncertainties of the crisis but did not offer speculations. He only said, "we have no explanation at this point". Second, during a crisis all employees are communicators for their company. Earlier we introduced the story of the pilot who greeted each passenger with a personal handshake and gave a compassionate speech in the aisle. Such actions cannot be staged or prescribed. They speak louder than words. In an agile crisis communication, every employee intuitively acts as an ambassador or spokesperson on behalf of the company. The stronger the roots in organizational culture and identity, the more consistent are individual actions. Third, true to the deep dismay over the catastrophe Lufthansa let go of pre-fabricated condolence messages and established a public platform where mourners or emotionally affected persons could share their feelings. This move shows the resourcefulness of the communication team and the root of communicative behavior: the recognition of myself mirrored by the communication of my alter ego. To summarize, agile crisis communication is based upon these principles:

- Be prepared. But also, be prepared to be surprised.
- Act genuinely. Stay true to the company's corporate identity and your personal values.
- Communicate truthfully. Inform, do not speculate. Empathize, do not shirk responsibility.
- Trust your employee's sense of community. If identity is strong, every person in the organization might contribute to overcome the crises. Even publics that arise in times of crisis and sympathize.

Appendix: Timeline

Date, Time	Event
03/24/2015 (Tuesday) 10:00*	Germanwings Flight 4U9525 leaves Barcelona with destination Dusseldorf, Germany with 144 passengers, four crew and two pilots. *All times are CET (Central European Time)*
10:33	Pilot leaves the cockpit; co-pilot initiates descent from 38,000 feet to 100 feet via autopilot.
10:33	Air traffic control contacts airplane and requests information about the deviation from the flight plan. Two more attempts were made.
10:35	Crew requests access to the cockpit, returning pilot tries to open the armored door manually.
10:38	Air Traffic Control tried to contact the plane repeatedly. French Air Force launched a military reconnaissance flight but was too late make visual contact.
10:40:41	Acoustic and visual warning signals for the imminent crash were automatically triggered.
10:41:06	Fatal crash of Airbus A320-211 in Prads-Haute-Bléone, French Alpes.
11:10	French airborne surveillance reports pieces of wreckage at the remote mountain site.
11:30	First breaking news via news agency hit the wire and social media/Crisis coordination teams are installed at the airports and at Germanwings HQ.
11:34	The French newspaper Le Figaro and others post the news of the crash online. Social networks immediately distribute the news.
11:49	Germanwings acknowledges on Facebook and Twitter that media reports of a missing plane are circulating and will report as soon as valid information is secured. Relatives and friends at the destination airport are escorted to special care facilities. The official Germanwings website goes down and is replaced with a "dark site" three hours later.
12:15	French president François Hollande twitters his condolences: "Je veux exprimer aux familles des victimes de cet accident aérien toute ma solidarité. C'est un deuil, une tragédie."

Date, Time	Event
12:27	Lufthansa officially acknowledges the crash. CEO Carsten Spohr twitters in English: "We do not know exactly what happened with flight 4U 9525. My deep sympathies go to all relatives and friends of the passengers and crews of 4U 9525. If our fears come true this is a black day for Lufthansa. We hope to find survivors."
12:42	First official statement by Germanwings with a news release simultaneously on their website, Facebook und Twitter. Assistance for relatives of the passengers is offered by a free telephone hotline.
13:00	Lufthansa and Germanwings replace their colorful logos with black-and-white versions on websites and social media platforms.
13:00	At noon all major news outlets cover the story extensively. First speculations about the cause of the crash discussed by experts, this includes speculations of a terrorist attack.
14:00	Personal statement by Lufthansa CEO Spohr. He promises fast help for victims' families.
15:00	First official press conference in Cologne, run by the Germanwings CEO Thomas Winkelmann and the Head of Flight Operations Stefan-Kenan Scheib.
18:00	Press conference at Barcelona Airport with Lufthansa's Vice President Europe Heike Bierlenbach: "We will do our utmost to support the relatives and friends of these passengers on board. We are now looking into options and possibilities to bring them to the scene which is not yet confirmed."
18:45	Second press conference by Germanwings CEO Winkelmann concerning the crisis management in France, investigations and next steps.
19:00	Live pictures from the crash site flood social media sites. All major news outlets worldwide cover the crash as number one news. The media disclosed first personal information of the victims. Lufthansa CEO Spohr personally visits the crash site with members of the German authorities.
03/25/2015 (Wednesday)	Spohr posts on Twitter: "We will enable the relatives to grieve on site as soon as possible. [...] Two special flights for families and friends of the victims will fly to France tomorrow."
10:41	Minute of silence in Lufthansa HQ in Frankfurt, attended by CEO Spohr.

Date, Time	Event
12:30	Third press conference by Germanwings CEO Winkelmann, thanking the search teams at the crash site and all helpers. Care for the families of the victims has the highest priority.
13:20	Video message by Spohr for clients and partners of the Lufthansa family, stressing the shock but also strong safety record of Lufthansa.
16:45	Press conference in Seynes-les-Alpes with German chancellor Merkel, French president Hollande and Spanish prime minister Rajoy thanking the crews on the ground and commitment to a speedy investigation.
17:45	Press conference by the lead investigators, the French Air Traffic Security Office BEA. State that this morning, Germanwings was indicted of involuntary manslaughter in 150 cases. The voice-recorder was found, but the data was not yet secured and analyzed.
03/26/2015, (Thursday) 01:00	Leaked information of the French prosecutors office makes headlines at The New York Times article "Fatal descent of Germanwings plane was 'deliberate', French authorities say." The New York Times also releases the name of the co-pilot and subsequently more personal details during the day.
08:00	Media disclose co-pilot's name and place of residence. Many media outlets also publish his photo, taken from publicly accessible social media sites and profiles.
10:41	During a minute of silence people all over the world commemorate the victims.
12:30	Press conference of the French prosecutors office in Marseilles on the state of the investigation. They have proof that co-pilot locked himself in the cockpit. Analysis of the voice-recorder leads to the conclusion that the crash was intentional.
13:35	Germanwings posts on Twitter: "We are shaken by the upsetting statements of the French authorities" and announce the next press conference for 2:30 p.m.
14:30	Fourth press conference by Germanwings run for the first time by Lufthansa CEO Spohr. He covers the statement of the French authorities and explains the safety procedures. Spohr calls the pilot "100 percent fit to fly" and expresses trust in his pilots. The incident is described as "tragic, singular case".

Date, Time	Event
15:00	All German airlines agree to implement the two-person-rule, which means that two crewmembers need to be in the cockpit at all times. This rule was already in force in the United States and other countries.
17:00	Families of the victims reached Marseilles (by Lufthansa flights) and were shuttled to the crash site. German flight authorities claim that routine medical checks of the co-pilot fulfilled all criteria.
17:55	Parts of CNN exclusive interview with Lufthansa CEO were aired. The full one-on-one interview is available later that night in the regular program and on CNN's YouTube Channel.
03/27/2015 (Friday)	Lufthansa posts two media releases. One covers the situation at the crash site, the other the implementation of the two-person-rule. The media speculate on motives of the suicidal co-pilot. German investigators leak to the press that "substantial evidence" was found in his flat.
13:00	German prosecutors post a press release, which confirms that the co-pilot had a (torn) medical bill for the day of the crash, which means he was unfit to fly. German authorities inform their French colleagues. Germanwings replies with a press release explaining that the co-pilot did not call in sick for the week.
15:15	Lufthansa and Germanwings coin the hashtag #indeepsorrow in all official communication channels. The media continues to speculate about the motives of the co-pilot. Reports from the visit of the victims' families at the crash site add to the emotional turmoil.
03/28/2015 (Saturday)	Lufthansa publishes one-page in-memoriams in major German newspapers, signed by Spohr and CEO Winkelmann. Media, especially the yellow press, continue to dig into the personal life of the co-pilot.
03/29/2015 (Sunday)	Lufthansa publishes the in-memoriams on Facebook and Twitter together with the hashtag #indeepsorrow.
03/31/2015 (Tuesday)	Lufthansa announces the cancellation of its 60-year anniversary celebration scheduled for April.

Date, Time	Event
04/01/2015 (Wednesday)	A summative press release by Lufthansa thanks all rescuers and psychological staff in France, Spain, and Germany. Lufthansa opens the public condolence site www.indeepsorrow.com, which aggregates posts on Facebook, Twitter and Instagram.
04/02/2015 (Thursday)	The final press release of the German prosecutor confirms that the browser history of the co-pilots computer showed his research into suicide and into mechanics of the cockpit door.
04/06/2015	Germanwings logo goes back to color with a mourning band. It returns to normal on June 19.
04/16/2015	Cologne hosts a memorial service in the cathedral, Germany's largest church with a capacity of 1,200 seats. The public service was streamed on German national TV. German flags at public buildings were at half-staff.
06/15/2015	The mortal remains of the victims are flown back to Dusseldorf. The caskets are transported in a motorcade of white hearses.
07/01/2015	Germanwings publishes information about the financial compensation for the victims' relatives.
03/13/2016	French authorities release final report consisting of 124 pages, concluding the official investigation into the crash. Summary: The co-pilot was unfit to fly but did not report his condition to his employer. He intentionally initiated the crash. He was under the influence of antidepressants and barbiturates. The airline cannot be blamed for the actions. However, a more intense screening of the psychological conditions of pilots is recommended.

REFERENCES

Airliners. (2015). *Deutsche Passagiere fühlen sich an Bord sicher* [German passengers feel secure on board]. Retrieved from http://www.airliners.de/deutsche-passagiere-sicherheit-flugzeuge-bdl-verbraucherreport/36258

BEA. (2016). Final Report on Accident on March 24 2015 at Prads-Haute-Bléone (Alpes-de-Haute-Provence, France) by Airbus A320-211 registered D-AIPX operated by Germanwings. BEA Bureau d'Enquêtes et d'Analyses pour la sécurité de l'aviation civile [French Civil Air Safety Authority], published March 13 2016. Retrieved from https://www.bea.aero/uploads/tx_elydbrapports/BEA2015-0125.en-LR.pdf

Bilfesky, E., & Clark, N. (2015, March 26). Fatal descent of Germanwings plane was "deliberate", French authorities say. *The New York Times.* Retrieved from http://nyti.ms/1FK2Wrd

BLM. (2015). *Bundesverband der deutschen Luftverkehrswirtschaft BDL* [German Aviation Association] Task Force on Airline safety. Interim report. Published June 30th. Retrieved from https://www.bdl.aero/download/1881/task-force-interim-report.pdf

Bradly, D. (2015). *Burson helps Lufthansa with crisis comms after Germanwings crash.* Retrieved from http://www.prweek.com/article/1340186/burson-helps-lufthansa-crisis-comms-germanwings-crash

Brandfinance. (2016). *The world's most valuable airline brands.* Retrieved from http://brandfinance.com/press-releases/the-worlds-most-valuable-airline-brands

Clamann, A. (2015). *Der Bericht einer Passagierin rührt Hunderttausende* [Tale of a passenger touches hundreds of thousands]. Retrieved from http://www.rp-online.de/panorama/deutschland/germanwings-bericht-einer-passagierin-ruehrt-hunderttausende-aid-1.4975066

CNN. (2015, June 1). *Lufthansa's CEO discusses company's darkest hour … Published on March 26 2015 on the CNN's Youtube.com channel.* Retrieved from https://www.youtube.com/watch?v=Urin5fYLSI0

Coombs, T. W. (2007a). Protecting organization reputations during a crisis: The development and application of situational crisis communication theory. *Corporate Reputation Review, 10*(13), 163–176.

Coombs, T. W. (2007b): *Ongoing crisis communication: Planning, managing, and responding* (2nd ed.). Los Angeles, CA: Sage.

Coombs, T. W., & Holladay, S. J. (2002). Helping crisis managers protect reputational assets: Initial tests of the situational crisis communication theory. *Management Communication Quarterly, 16*(2), 165–186.

Coombs, T. W., & Holladay, S. J. (Eds.). (2010). *The handbook of crisis communication.* Chichester: Wiley-Blackwell.

Hank, R. (2015, March 28). Aufrecht im Mediengewitter [Walking tall in a media thunderstorm]. *FAZ.* Retrieved from http://www.faz.net/aktuell/wirtschaft/unternehmen/lufthansa-chef-carsten-spohr-aufrecht-im-mediengewitter-13511270

IATA. (2016). *International Air Traffic Transport Association Safety Report 2015.* 52nd edition. Retrieved from http://www.iata.org/publications/Documents/iata-safety-report-2015.pdf

JACDEC. (2016). JACDEC (Jet Airliner Crash Data Evaluation Center) Airline Safety Report 2016 (based upon 2015 values). Retrieved from http://www.jacdec.de/airline-safety-ranking-2016

Lufthansa (2015). *Lufthansa CEO Carsten Spohr about Germanwings Flight 4U 9525 on March 24th 2015.* Retrieved from https://www.youtube.com/watch?v=Plnhh1QELag

Lufthansa. (2016). *Short Biography Carsten Spohr.* Retrieved from http://investor-relations.lufthansagroup.com/fileadmin/downloads/en/corporate-governance/Biography-Carsten-Spohr-2016-04.pdf

Mair, V. (2009). *How a misunderstanding about Chinese characters has led many astray.* Retrieved from http://pinyin.info/chinese/crisis.html

McLaughlin, E. C., & Pleitgen, F. (2015). *Lufthansa CEO: Germanwings co-pilot passed all medical tests, exams.* Published on CNN March 26 at 17:50, updated 20:34 GMT. Retrieved from http://edition.cnn.com/2015/03/26/europe/lufthansa-ceo-germanwings-crash

Phoenix. (2015a). *Flugzeugabsturz: Statement von Carsten Spohr nach Gespräch mit Angehörigen am 25.03.2015.* [Airplane crash: Statement by Carsten Spohr after meeting relatives]. [Live recording of press conference, duration: 5 min]. Retrieved from https://www.youtube.com/watch?v=JA9aM6R4feQ

Phoenix. (2015b). *Flugzeugabsturz: PK Lufthansa/Germanwings zu den aktuellen Erkenntnissen am 26.03.2015.* [Airplane crash: Press conference by Lufthansa/Germanwings on recent developments] [Live recording of press conference, duration: 35 min]. Retrieved from https://www.youtube.com/watch?v=9Xc0iUKio2I

Savage, I. (2013). Comparing the fatality risks in United States transportation across modes and over time. *Research in Transportation Economics, 43*(1), 9–22.

Schaedler, B., & Bartels, A. (2016). *Da bleibt immer ein Stück Trauer* [There will always remain a piece of grief]. Sole interview with the former and present Chief Communication Officers of Lufthansa on the Germanwings Crash. *PR Report* 3/2016, 16–20.

Spiegel. (2015). *Deutsche vertrauen Germanwings* [Germans trust in Germanwings]. Retrieved June 1, 2016 from http://www.spiegel.de/wirtschaft/unternehmen/germanwings-deutsche-vertrauen-lufthansa-tochter-a-1043266.html

Thornton, P. H., Ocasio, W., & Lounsbury, M. (2012). *The institutional logics perspective.* Oxford: Oxford University Press.

Williams, S. (2015). *Inside the little-known Berkshire firm called when disaster strikes.* Retrieved from http://www.telegraph.co.uk/news/worldnews/11849255/Inside-the-little-known-Berkshire-firm-tasked-with-clearing-up-the-Germanwings-plane-crash.html

The African Union Commission's Multinational Ebola Campaign's Localization Strategies

TOLUWANI C. OLOKE
College of Journalism and Communications,
University of Florida

JUAN-CARLOS MOLLEDA, PH.D.
School of Journalism and Communication,
University of Oregon

EDITOR'S NOTE

This case was selected not only because of the global scare around the spread of Ebola but also because, as the authors explain, of the criticality of application of localization communication strategies within a global communications framework. The first author was assigned as communication officer and was on the ground to implement the communication strategy thereby providing readers with a first-hand account. As a native African, her insights and discussion of the effectiveness of these strategies are of great value to others who may face a crisis that requires not only a good grasp of the local cultural context but also how to apply insights to provide effective communication in times of human tragedy and crisis.

BACKGROUND

This case study describes the effect of the localization strategies and efforts of the African Union in fighting the spread of an infectious disease. Contrary to other

strategies of localization in public relations and communication management with actual products or global marketing of services, the application of localization techniques was chosen to offer humanitarian service and health communications. It describes the communications efforts deployed during a period of seven months between September 2014 and March 2015.

The Ebola Virus Disease (EVD) outbreak was first recorded in Guinea on March 20, 2014 and spread to Lofa county—one of the rural villages in Liberia that borders with Guinea ("*West Africa: Ebola Outbreak,*" 2014). Due to its highly contagious nature and slim chances of survival, the EVD outbreak scared the entire world and turned all attention on the affected countries in West Africa for immediate local, national and international medical and humanitarian intervention. EVD has the potential to put the world in total jeopardy, possibly extinction, if not nipped in the bud because the world is a global village, which makes it easy for the Ebola virus to be transmitted easily across borders and continents with lightning speed.

The African Union Commission (African Union or AU), then established a civil-military support mission: the African Union Support to Ebola Outbreak in West Africa (ASEOWA), as part of their efforts in helping to fight the Ebola virus spread in the continent.

Symptoms of the EVD are generally known to be the same as fevers at the initial stage and clinical presentations at the advanced stage include bleeding and body sores and eventual death. The EVD is a highly contagious disease with no known medical cure and a survival rate of about ten percent or less. Prevention and control of the spread becomes the only viable operational strategy. Effective public relations and communications strategies across cultures and sub-cultures, as we will explore in this case, is paramount. With increased awareness and knowledge through communication on the preventive measures and the need for immediate reporting of suspected cases of Ebola, the survival rate improved. Unfortunately, survival is largely dependent on a patient's immunity and supportive care ("Ebola Virus Disease," 2015). This notwithstanding, patients with low immunity may also survive if they report the slightest symptom of a fever.

An Ebola patient becomes symptomatic after about seven days of contracting the virus, which means an EVD carrier may unknowingly take the virus across national and international borders and possibly transmit it to others before detection. It should be noted as well, that the EVD has a window of 21 days maximum from when a patient unknowingly contracts the disease to when the patient dies if not detected and treated early enough. This explains why the EVD outbreak caused a global stir and scare and, therefore, the need for immediate global and coordinated response. At the onset of the Ebola outbreak, certain factors militated against the initial efforts of the affected countries, in their bids to curb the epidemic. The two most debilitating factors were the weak health systems of the

countries, and the high level of illiteracy. In other words, the health sectors of these countries already lacked basic amenities and personnel that could handle other relatively mild diseases that are common to the African region such as malaria, typhoid and fevers. Facilities for maternal health and deliveries were inadequate or practically non-existent. So it is expected that a health system that was too weak to provide adequate basic medical services, would literally crumble under the weight of an epidemic such as the EVD.

Eighteen volunteers from five African countries (i.e., Nigeria, Democratic Republic of Congo, Ethiopia, Uganda, and Rwanda), were initially deployed by the African Union Commission for the ASEOWA mission.

The multinational public relations campaign localization process adopted by the African Union in its campaign against Ebola virus disease will be analyzed and evaluated in this case study. The five steps of the localization model designed by Molleda, Kochhar, & Wilson (2015) included the need to localize, the ability to localize, the extent of localization, the localization tactics, and the evaluation metrics for the success of the localization efforts. The need to localize, as earlier explained, is culturally informed by the host environment's reaction to the standardized strategy.

We know from academic research that resistance to the globalized (westernized) public relations campaign strategy approach gives rise to the need for more adaptable strategies and tactics that can only be fully achieved through localization. The extent and tactics of localization are chosen carefully to support the focus on the primary goal of the public relations efforts. In other words, the localization extent and tactics need to be balanced to forestall being heavily infused with cultural influences at the expense of the primary goal of the efforts as a whole. Context is crucial in localization strategy.

SITUATION ANALYSIS

Even though Ebola could be avoided and brought under control if basic infection prevention and control protocols (IPC) were observed, the level of illiteracy coupled with poverty worsened the situation. The locals were not informed about IPC, neither were they receptive to information for a long time because there were always one or several counter opinions that were deeply rooted in traditional beliefs and methods of curing all diseases. It was difficult to convince the receptive few, because most of the IPC measures were strict measures that required many people to quit their means of livelihood for a while. This was the case with people who sold or hunted for "bush meat"—an African delicacy—for a living. Other people such as public transporters otherwise known as "okada riders" were also affected in their line of business. These are mostly young men who make a living

by giving rides to passengers on their motorcycles. There was no way to determine the health status of either the rider or the previous passengers who have been on the "okadas". This also affected public transit buses and cabs as well. Passengers became weary of taking taxicabs that already had passengers in the rear seats. The usual practice before the Ebola epidemic was to have four passengers in the rear seats of taxicabs, and two passengers if taking the "okada". With that kind of seating arrangement, it was almost impossible to avoid body contacts between the passenger and the rider, neither were there any measures put in place to sanitize the seats before the next passenger sits. Because Ebola campaign messages strongly persuaded people to avoid body contacts, it became a tough decision for commuters to choose public riders. This explains why the resistance was strong and sometimes even violent.

The response to the EVD outbreak in Liberia, Sierra Leone, and Guinea by international organizations and especially the African Union was faced with the challenges of convincing the people in the affected countries that the EVD outbreak was real and not politically master-minded by the western countries and governments of the affected countries. Another challenge was to convince the people to trust the western medical intervention teams or organizations. In parts of Africa, there is still a great deal of distrust in orthodox medicine, which was widely termed the "white man's medicine" during this crisis in Guinea, Liberia, and Sierra Leone. Rapport building and establishing trust with the host communities especially in the rural areas of the affected countries was also a fairly difficult challenge. Another challenge was the ability to effectively communicate with the people without offending their traditions, on sensitive issues tied to religious beliefs and practices, the tenets of which encouraged the spread of the EVD virus. Such religious practices like washing of dead bodies, initiation practices of local cults, unsafe burial practices, and belief in the curative powers of witch doctors and sorcerers were encountered.

Technically, other challenges were posed by issues such as inadequate funding, lack of transport access to some parts of the affected areas due to deplorable road conditions, weak health systems of the affected countries. Most importantly, the politicization of the EVD epidemic in the countries affected posed another great challenge.

CORE OPPORTUNITY

The African Union ASEOWA had an edge over other international players on the scene of the Ebola campaign because, African Union ASEOWA deployed personnel who were Africans to the affected regions. Trust became the most relevant issue in communicating with the population. Africans with stronger

cultural affiliations to the affected countries, garnered more trust in the messages communicated to them, in the spirit of African brotherhood and due to unfortunate incidents of miscommunication. This was not the attitude shown towards western interventions by the USAID and the European Union. Initially, there were no sentiments against other international responders but at one point, Médecins Sans Frontières (MSF) and the Red Cross initially had issues with the local communities in Liberia. The MSF primarily administered oral rehydration solutions to patients. Because survival mainly depended on the immunity of each patient, the MSF did not achieve a high survival rate. In contrast, other ETUs managed by the African Union in collaboration with teams from Cuba and some other African countries administered intravenous fluids to patients and, there was a relatively higher survival rate. As a result, the local citizens lost trust in MSF. In another development, there was an incidence of miscommunication and misinterpretation between the Red Cross and the community dwellers in Jene-Wonde district in Liberia. The Red Cross allegedly supplied some protective equipment to the people as part of prevention measures, with instructions to be informed of any incidence of death. Sadly, the people failed to immediately report new Ebola deaths. Rather, they used the protective equipment and wrapped the bodies themselves before informing the burial teams- thereby infecting themselves.

During the awareness campaign and training of trainers organized by the African Union, the local citizens shifted blame on the Red Cross. At this point, the African Union ASEOWA noted that it was not in the best interest of the campaign efforts to empower the people or to suggest that the people should engage in any form of first aid measures. The African Union ASEOWA discovered that the people most likely misinterpreted the messages and instructions of the Red Cross in the first place. Nonetheless, the damage was done. "Engaging the local communities was the smartest move that the AU made, which made the locals own the problem and this was very strategic in winning their hearts and minds," argued Pamella Adong (personal communication, May 2016). The local communities felt more involved in solving their own problems with the help of their own "brothers".

GOALS

The ultimate goals of the campaign included

- Strengthening public information: Provide overall direction in the production of key communication resources for Member States, public, and development partners'

- engagement and position the response with local, regional, and international media
- Strengthening media relations: promote positive media coverage of the African Union's response
- Media capacity development—responsive that play supportive role in media advocacy
- Advocacy communication—support on-going resource mobilization efforts.

OBJECTIVES

The main objective was to strengthen public information and awareness on the EVD and Infection Prevention and Control (IPC) protocols, and media relations to situate the efforts of the AU-ASEOWA on the global map, and promote positive and useful media coverage of AU-ASEOWA as a key component of the EVD response. The African Union ASEOWA set out to primarily complement the ongoing national efforts of each affected country. Nevertheless, there was the need for coordination of all efforts of both the local and international responders. There were operation centers that coordinated all the local or international with an obligation to report through the centers. This helped to avoid duplication of efforts. The public relations officers for each organization were able to stay abreast of what has been done and where, in terms of communication campaigns.

The aim of the communication campaign was also to strengthen advocacy for mobilization of improved efforts and volunteering. The African Union ASEOWA aimed at recruiting more volunteers from other African countries, to establish the African presence and voice in the efforts towards combating Ebola. Contingents from Ethiopia, Kenya and Nigeria were successfully recruited as volunteers to support the African teams that were already on ground.

The objectives of the campaign were to ensure:

- Clear, accurate messages on the Ebola outbreak and the AU response disseminated to all stakeholders
- Positive media coverage reduced stigmatization and informed public policies on the response
- Support extended to national efforts in communication activities among all actors operating in the Ebola response, including governmental and non-governmental stakeholders and partners
- Organization-wide donor communication coordination
- Regular updates and information on the EVD outbreak to stakeholders.

KEY PUBLICS

The target audiences for this communication plan primarily included the affected and the infected citizens of Liberia, Sierra Leone, and Guinea, through local and international media and all partners involved (International and local NGOs).

Other key publics included Member African States, African and international citizens, Media Institutions—local, regional, and international—, AU organizations and offices, regional organizations United Nations organizations, bilateral organizations, and African and International Civil Society Organization/ NGOs. Communicating with school-aged children and teenagers proved to be an effective way to broadcast messages.

STRATEGIES

Ability to Localize

The availability of required skills set and resources, access to information, and the attitude of the authorities directly impacted on the success of the localization process.

In Guinea, message translations were difficult. Translations to French did not suffice because it was later discovered that the mostly affected regions in the country spoke a different dialect. French was widely spoken in the cities by the educated elites who were the minority. The challenge then was to locate people who were educated and could still transcribe in the local dialects.

The Ebola epidemic was most prevalent in the rural settlements of Liberia and people in these regions spoke either the Liberian English or their native languages that varied from one area to the other. The native languages spoken in Liberia were not universal. Here as well, local interpreters who could converse in native languages and understand English was a necessity.

Sierra Leone was more liberal because standard English language was more widely spoken by a larger population countrywide. The youth volunteer translators were also used as middlemen to create rapport with the people especially in Liberia. Rapport building in Guinea was quite far reaching for a long time. This was due to the fact that Guinea was resistant to western ideas. Like Sierra Leone, the Guinean government strongly resisted the AU-ASEOWA because it was co-funded by the U.S. government, and the Ebola treatment units managed by the AU-ASEOWA were donated by the United States Agency for International Development (USAID). This perception had to be overcome in order to establish familiarity and trust of the people in the campaign messages.

Grassroots Mobilizations

As stated earlier, the need to localize the campaign strategies of the AU-ASE-OWA was informed by quite several factors, such as cultural differences, economic conditions, and language differences. The communications officer in Grand Cape Mount county in Liberia noted especially in an interview, that,

> ... this was the first time African Union was doing this kind of operation and it was a learning curve for us. We concentrated more on mobilization campaigns at the grassroots so we can be closer to the rural people who were the most affected. We needed to speak their language and establish some form of identification with them culturally too. At a point, we had to spend nights in the rural villages and eat their local food so they can identify with us and accept our Ebola campaign messages. (O. Olaoye, personal communication, October 10, 2015)

Selective Personnel Deployment and Message Translations

The communications officer in Guinea, Paschal Chem (Skype interview, October 16, 2015) explained that language differences compelled us to adapt the campaign messages in Guinea. This was because Guinea is a predominantly Francophone country with strong resistance for any Anglophone ideas and messages. The communications officer deployed to Guinea noted that the Guinean government requested that only French speaking officials be permitted to work in Guinea and all English-speaking staff had to be redeployed. The print news clippings provided by the communications officer were French translations from the original English versions. The French translations were done sensitively to clearly avoid messages against the washing of dead bodies because Guinea is a predominantly Islamic nation with strong religious tenets that encouraged washing dead bodies as part of the burial rites. In a statement provided by the communication/mobilization officer in Guinea, Ms. Mayah Ngala, explained that there was an existing national strategy that had to be complied with. She also stated that,

> Basically, upon arrival of the ASEOWA Team in Guinea Conakry, since there was a centralized national strategy, to flow with the tides, the Representative had to place the various ASEOWA personnel at the disposal of the corresponding sub-commission involved in specific response, these included Sub Commission on Case Management, surveillance and contact tracing, logistics and emergency relief, communication and psychosocial support, data management and burial. For a consistent response flow, the strategy used by ASEOWA Guinea was to flow with the ongoing response scheme by placing volunteers at the disposal of the different Sub Commissions. (M. Ngala, personal communication, May 16, 2016)

In Liberia, language barrier also made it compulsory to employ local people who could speak the type of English referred to as Liberian English that was preferred and widely accepted.

Sierra Leone was more welcoming to the standard English language. Message reinforcement in local dialects became key to the success of the campaign efforts of AU-ASEOWA.

The two-step flow of communication by disseminating information to the wider population through their opinion leaders, was an important strategy at this point because the people had more confidence in the local volunteers who doubled in their roles as interpreters for AU-ASEOWA and opinion leaders for the older uneducated community dwellers.

Re-orientation of Local Publics

Local political climates also dictated adaption of campaign messages. The outbreak happened at the height of political tensions in Liberia and Sierra Leone. Liberia was preparing for major national elections and Sierra Leone had recently elected a new democratic government. The outbreak of the epidemic saw opposition parties using the epidemic as electioneering propaganda against the incumbent leaders. Largely because of low levels of literacy, particularly in the rural areas, many fell for the brainwashing ideas that Ebola was politically masterminded by the incumbent parties as a way of campaigning for international financial support. Per these reports, the government was seeking a way of amassing wealth for themselves by diverting the disaster relief funds allocated to the countries to other personal uses.

AU-ASEOWA was vested with the task of ensuring a re-orientation of the people through messaging, to help them understand the Ebola outbreak as a health disaster that needed to be addressed through Infection, Prevention, and Control (IPC) protocols. In Guinea, for example, the communications officer reported that there were insinuations by the people that the Ebola was a man-made disease by the "white-man," and was injected into monkeys and bats that were released onto the shores of Africa. Per his reports, the people believed that the intervention of the U.S. government in terms of relief funds was a strategy by the United States to overthrow their government under the disguise of a crisis situation to eventually colonize them.

In Sierra Leone, the AU-ASEOWA was initially resisted because the commission's support program was funded by the U.S. Department of State and Sierra Leone was a former British colony. Only British-funded disaster relief efforts were initially welcomed. AU-ASEOWA was later accepted mainly because of personnel shortage. The limitations of technological infrastructure such as access to Internet and media such as TV and radio due to scarce electricity made it necessary and partly easy to adapt campaign strategies. There were widespread rumors in Liberia that the "white men" had intentions to colonize Liberia because it is the only West African nation that had no history of colonization. This explained why the government of Guinea and Liberia showed some tacit resistance to the efforts of foreign

governments at the early stages of the Ebola epidemic. It was believed that international response to the epidemic would portray the home governments as irresponsible, unresponsive, and insensitive to its obligations. The Liberian government resisted outsourcing of support and personnel initially until it became a global emergency that could no longer be locally handled by individual governments.

Humanitarian Donations of Relief Materials

Poverty levels in these regions also imposed a new responsibility on the campaign team to raise resources for relief materials donation. This was both a humanitarian gesture as well as a tactic to warm the hearts of the people and consequently, get them to be responsive to the messages of the campaign plan. The economic situations in the host countries were such that survivors and the affected Ebola victims needed material and financial support to start a new life after Ebola. They were not allowed to have access to anything they had before because all their properties including documents in their places of residence were burnt to stop the spread of the virus. The overwhelming nature of their economic needs, compelled people to readily accept any information given by organizations that rendered support towards their welfare.

In Sierra Leone, branded t-shirts, food items, and other relief materials were some of the packages given to survivors to start their new lives. In Liberia, survivors and volunteers were also given branded t-shirts and some volunteers were employed as counselors and campaign team members. The t-shirts were branded with messages such as, "Africa against Ebola", "Ebola is Real", "I am a Survivor," and "Let's Unite Against Ebola". Communications officers provided pictures of donations to the local residents of the communities and these gestures of relief materials donations enhanced the acceptance of the AU-ASEOWA in the affected rural communities.

Message Sensitivity to Strong Religious and Cultural Beliefs and Ties

There were boundaries set by culture, religion, and community laws, which limited the extent to which campaign strategies and tactics could be localized. Also, localization efforts had to be limited to avoid a total shift in the focus of the campaign efforts. Despite efforts at adapting the campaigns to suit the host environments, localization efforts of the AU-ASEOWA were limited by some factors.

In Guinea for instance, both the elites and the proletariats upheld strong religious ties to burial rites. Education about safe burial practices did not suffice to dissuade the people from washing dead bodies of Ebola victims. The Islamic tenet

of washing dead bodies before the final burial rites was regarded as an essential cleansing ritual that must be observed regardless of the circumstances of the death. The sensitivity of the issue of Islamic burial rites and the violent reactions from the people as reported by the communications officer, limited the extent to which the strategies could be employed in Guinea. Thermometers for checking temperatures were donated by the AU-ASEOWA in Guinea but were rejected for unexplained cultural reasons.

Although, it was necessary to redesign campaign plans to suit the host communities, anticipated outcomes of the plan needed to be achieved. Goals could not be compromised completely. Even though it was apparent that the use of electronic media did not prove effective, due to limited access or lack of electricity in most parts of the countries, the ASEOWA still needed to engage in media capacity building. Social media (Twitter and Facebook) were used to project the efforts of the campaign to the larger publics. Ongoing efforts were communicated through newspaper feature articles, and a website dedicated to ASEOWA. The efforts targeted stakeholders outside these three countries as part of the strategies in creating awareness and making a statement to the larger world on African solidarity. There was a need to inform the world that Africans do not necessarily sit back idle and rely on the western world for help in every crisis.

KEY MESSAGES

Message Scripting

The strong cultural affiliations of the people in the host countries to traditional medicines and beliefs in witchcraft and wizardry as solutions to every problem also gave rise to the need to adapt the campaign strategies. There was the need to carefully disengage the people from the thoughts that traditional medicines through consultations with the occults could cure Ebola. The messaging focus had to shift from simply explaining the IPC protocols, but also to include messages to dissuade the people from waiting too long on ineffective traditional procedures that claim to cure Ebola. Some of the messages included:

- Ebola is real, but now we know you can avoid getting Ebola, you can recover from Ebola; you can contribute to the fight against Ebola;
- It is simple as Avoid Body Contact (ABC);
- Protect yourself, protect your family, protect your community;
- Report to the nearest clinic if you feel sick; and
- Ebola is a VIRUS. (W. Musabayana, personal communication, October 15, 2014)

TACTICS

Localization of Tactics

A variety of tactics were employed- all subject to the localization approach. Word-of-mouth and "two-step flow" were effective in training sessions and one-on-one direct communications. Basic information tools in print and electronic forms were available. Secondary tactics such as media relations, and use of SMS as well as ring tone messaging supported these.

The two-step flow of communication was the primary tactic employed for adapting the campaign strategies in the three countries where AU-ASEOWA was present. This strategy required that the messages of the African Union communication team convince the opinion leaders. These leaders such as youth leaders, religious priests, community heads and local chiefs, disseminated the information given to them, to their wider audiences-hence the term "two-step flow". As evidenced by the pictures and documents retrieved from the AU-ASEOWA officers, the communications officers in each of the three countries conducted training workshops. The trainings were designed to involve the community, opinion, youth, women group, and religious leaders, as well as the traditionally respected elderly age groups and their leaders. These leaders were invited for training sessions during which they were educated on the IPC protocols for the Ebola virus. The trainings were weeklong programs with each day assigned to each county or communities within the selected counties. After the sessions with the opinion leaders, the representatives from each community were given tasks of communicating what they have been taught to the rest of the community, under the supervision of one of the AU-ASEOWA staff members. Electronic media campaigns did not prove useful for this strategy because the mostly affected people were in the remote areas where access to modernization was far-reaching. Instead, personal protective equipment, gloves, chlorine, thermometers, and water barrels were supplied to these communities to encourage them to observe the IPC protocols they were taught.

In the Jene-Wonde community in Liberia, the community leaders expressed commitment to the IPC protocols if they were provided with the items needed, such as chlorine and water barrels. Remarkably, during the monitoring and evaluation exercise conducted in these community regions, the community leaders had enforced a hand-washing routine at the borders of each village and clan. The borders were manned 24 hours a day by youth volunteers working in shifts. Hand-washing buckets and chlorine were also distributed to the households and the monitoring and evaluation exercise reports indicated that almost every house in each of the rural communities asked their guests to wash their hands and feet in the chlorinated water before gaining entrance into their houses.

Channel of communication was another tactic subject to localization. Word of mouth instead of televised messages and aired messages on radio proved more effective. People had more access to interpersonal information and education than media messages and campaigns. To reach the few elites in the cities, AU-ASE-OWA launched an SMS campaign in the three countries. Service providers such as Cellcom and Libtelco in Liberia agreed to partner and sent subscribers occasional text messages, using content from the IPC protocols in case of any suspected case of Ebola. In Sierra Leone, Communications company Airtel supported the Ebola campaign by rolling out pre-recorded Ebola messages as ring tones or caller tunes for all their subscribers. Partnering with local businesses proved to be quite effective re-enforcing the notion that if it comes from native sources, it is more credible.

A key tactic, adopted later, was to change the tone of the campaign messages. The communications officer in Liberia noted that, opinions sampled confirmed that the people responded much better to positive messages in their dialogue. He stated that:

> We discovered that Liberians are generally strong willed people; they hate to be instructed on what to do or what not to do ... They are more easily persuaded than instructed. (phone or otherwise, interview, event)

The messages of the campaign were changed from using the phrase, "DO NOT" and "AVOID", to more positive choices of words. The message tone also had to be changed from instruction to advice.

School-age kids and teenagers were also considered as key audience of the Ebola campaign especially in Liberia. The Liberian government considered reopening schools in March 2015 and the cartoon fliers were distributed at preschool reopening orientation program within the communities. A social mobilization event was also organized with support from the Liberian police force in WestPoint community in Monrovia, Liberia to encourage kids and parents to adhere more strictly to the IPC protocols when schools reopen. The increase in number of children getting infected with the Ebola virus, which resulted in the closure of all schools in the three affected countries, was a source of consideration. Messages targeted at children were carefully designed as illustrative cartoons in pamphlets and fliers and were distributed to kids especially in the metropolis of Liberia and Sierra Leone. An example as produced by Pabio Stone Foundation (2014) is pictured in Figure 11.1.

This was a coordinated effort of the communications officers deployed to the three affected countries. The version sent to Guinea was translated into French language by an independent humanitarian organization known as Pabio-Stone foundation.

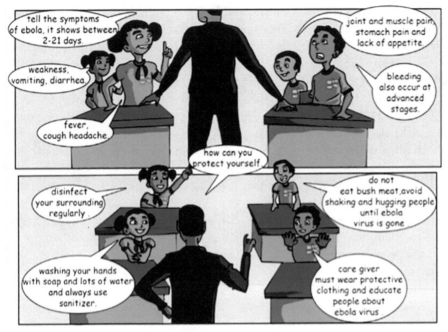

Fig. 11.1. Ebola awareness cartoon for children. Public domain, courtesy of PabioStone foundation.

METHODOLOGY

This case study is theoretically based and focused on the Ebola campaign's components of the AU-ASEOWA in Liberia, Guinea, and Sierra Leone, which are analyzed retroactively from September 2014 to March 2015. To provide supporting evidence, data were gathered from a total of 198 documents obtained from the AU-ASEOWA, such as the Concept of Operations for each of the three involved countries, one overreaching Communications Plan, 114 situation reports from field officers, 60 pictures from the Ebola treatment units and Ebola awareness and education programs, 17 video interviews of AU-ASEOWA healthcare workers and survivors, three print news coverage, three feature stories and one psychosocial work plan. Interviews were also conducted over the phone with seven AU-ASEOWA personnel. Five of them were communications officers; one person was the team lead for the contact tracing team of epidemiologists, while the last person was the psychosocial officer who worked closely with the communications officers.

The timeline of the generated documents from the LexisNexis database was from August 25, 2014 to September 23, 2015. For the purpose of this study, we narrowed down to February 27, 2015 when the first batch of AU-deployed Ebola volunteers returned home. This left us with 29 documents for review. Factiva

search over the past one year (i.e. 2014 to 2015) returned no search results for the AU-ASEOWA and returned only three documents for the search using the term "Ebola" only.

Appointment and Departure of Head of mission	PR, Interview Head of Mission Photo AU golf shirts and caps	4 Sept
Departure of ASEOWA mission	AU branded golf shirts PR, Media coverage Press conference Chairperson/ Commissioner/ key partner Live streaming Photography	10/11 Sept
Arrival of ASEOWA mission and commencement of duties	PR Photo	12/13 Sept
ASEOWA mission at work	Stories, pictures and updates from ASEOWA communications officers Podcasts from ASEOWA communications officers	15,22,29 Sept-
Social media updated by DIC and DSA	Twitter Facebook	6,13,20,27 Oct

Human interest stories from ASEOWA Communications officers		3,10,17,24 Nov
Update on ASEOWA mission	Feature article (Media to be selected later) Media interview Commissioner	1,8,15,22,29 Dec
Update on ASEOWA mission	Press conference	15,22,29 Sept-
Updated information on ASEOWA Mission	News wire produced by DIC and DSA	6,13,20,27 Oct
Updated information on ASEOWA Mission	Media monitoring report produced by DIC and DSA and sent to AU and partners	3,10,17,24 Nov

Updated information on ASEOWA Mission	Website	1,8,15,22,2 9 Dec
Liaison with ASEOWA communications Officers	Communications teleconference Report of meeting	30 Sept, 31 Oct, 28 Nov, 30 Dec

Share success stories	Press conference. Target international media as well	25Sept, 23, Oct, 20 Nov, 18 Dec
AU, together with partners, is a caring institution Media liaison	Field visit at which vital supplies will be handed over Media to accompany Respond to media enquiries Arrange media interviews	25 Sept, 9 Oct 25 Sept
Advocacy	Develop advocacy briefs, briefing notes, fact sheets, Information packs for Donor Briefing and Engagement	
Media monitoring	Produce Media Monitoring Reports	
Compile final report		

Fig. 11.2. Table of tactics. Author's creation.
Source: Personal Communication (Sept., 2014)

BUDGET

The proposed budget for communication and psychosocial activities and efforts mainly outlined the different objectives of the non-medical aspect of the mission. The psychosocial and communication activities were intertwined and geared towards community awareness and mobilization campaigns against Ebola. The first objective of the psychosocial budget was to liaise with humanitarian actors and facilitate assistance to the quarantined areas. The anticipated costs of each objective are indicated in the budget and the total costs for each team are indicated as well. The specifics of each objective include but are not limited to, costs for projector smart boards, banners, billboards, social mobilization personnel hiring, car hire, public address systems, cameras, IEC materials, media coverage and adverts, production of rapid response emergency number stickers, fueling, laptops,

flap jackets, accommodation during field visits and monitoring, donation of food and non-food items to local communities, etc.

Liaise with humanitarian actors and facilitate, as may be required and within capabilities, humanitarian assistance to isolated and quarantined centers	OBJECTIVE SUBTOTAL			221,591
To support daily/routine administrative psychosocial activities.	Activity Subtotal			30,117
To support Field distribution of food and non food items.	Activity Subtotal			2,602
To support social workers and volunteers in field operation activities in the community.	Activity Subtotal			10,358
To provide survivors and target communities with food and non-food items.	Activity Subtotal			127,450
To provide human resource for psychosocial support in Ebola Treatment Units and the community.	Activity Subtotal			47,985
To provide support for psychosocial activities of Community groups like women, survivors network and the youth.	Activity Subtotal			2,500
Community training of target groups of people e.g. opinion leaders	Activity Subtotal			580

COORDINATION SUPPORT	COORDINATION SUPPORT SUB TOTAL			270,682
To provide within capabilities and as appropriate, technical and other support (e.g. equipment) for the enhancement of the capacity of local health workers and national authorities to eradicate Ebola	OBJECTIVE SUBTOTAL			270,682
Facilitate the coordination of the ASEOWA liberian team		Activity Subtotal		59,163
Conduct Field supervisions in counties		Activity Subtotal		3,229
Support ASEOWA staff welfare and health		Activity Subtotal		196500
Organise Social Events for the ASEOWA team in Liberia		Activity Subtotal		11790

INFORMATION AND COMMUNICATION		INFORMATION AND COMMUNICATION SUB TOTAL				$239,652
To document all public information gathered during the mission		OBJECTIVE SUBTOTAL				11100
Support ASEOWA operation internal communication		Activity Subtotal				2300
To provide ASEOWA information storage and documentation		Activity Subtotal				8800
To support national media on the affected countries in their efforts to provide correct information		OBJECTIVE SUBTOTAL				203802.25
To conduct community Information Education and Communication activities		Activity Subtotal				191622.25
		Activity Subtotal				12180
Field visit for assessment on communication gaps	Field Visits					0
		OBJECTIVE SUBTOTAL				$24,750
To provide clear, accurate message on the Ebola outbreak and the AU response		Activity Subtotal				24750
Communicate all ASE-OWA activities to the public	Radio Programs	Episodes	9	$1,000	1	9000

Fig. 11.3. Budget table. Author's creation. Source: Pamella Oder and Toluwani Oloke, personal communication.

EVALUATION AND MEASUREMENT

The measurement metrics for the success of the campaign by the African Union ASEOWA included: increase in number of self-reported cases, number of districts reached, increase in the number of participants in the trainings and awareness campaigns, increase in number of survivors, zero infection rate among African Union ASEOWA healthcare workers and attitudinal changes among the locals.

The campaign strategy initially was outlined and informed by the "concept of Operations" document provided by the African Union Commission headquarters in Addis Ababa, Ethiopia. The terms of reference of the outline relied heavily of the use of social media, electronic media, and print media, for communication processes. Eventually, the realization that the initial concept of operations was not applicable and may not be effective eventually, informed the need to re-strategize. In view of this, the communication campaign team had to localize and decentralize their communication strategies and health campaign to suit the political, cultural, security, and socio-economic concerns of the local stakeholders in Ebola affected countries, such as Liberia, Guinea, and Sierra-Leone. "The overall ASE-OWA Strategy localization differed from Country to Country based on Country needs assessment and specificity," said M. Ngala (personal communication, May 16, 2016).

The evaluation process for the AU-ASEOWA efforts in localizing the campaign strategies in Liberia, Guinea, and Sierra Leone was straightforward. Part of the mission exit plan was to assess and evaluate the felt impacts of the African Union ASEOWA efforts in the affected countries. Mayah Ngala, a communication and mobilization officer in Guinea stated that:

> It has been more than widely proclaimed from all quarters at home and abroad that the AU ASEOWA efforts in general and its corresponding localization efforts in specific Countries was very effective and successful. The inputs from ASEOWA Volunteers, be it in Case management, Coordination, Logistics, Communication and psychosocial or Surveillance was evidence based, knowledge centered and technical, yielding amazing returns coupled with zero infection of the ASEOWA Personnel in all three countries. (M. Ngala, personal communication, May 16, 2016)

Overall, localization strategies were most pronounced and successful in Liberia, per the Head of Mission in charge of coordinating the overall efforts of both the medical and non-medical personnel. Aside from the initial weak resistance, the Liberian community were more easily persuaded compared to the population in Guinea. In Guinea, localization efforts were mostly frustrated by strong, longstanding cultural and religious tenets that abhorred all forms of westernized efforts (J. Oketta, personal communication, February 12, 2015). Sierra Leone was also fairly successful to a large extent judging from reports and responses of the communication officer.

The localization process saw the community dwellers seeing themselves as part of the messaging efforts. The report from Liberia indicated that communications teams otherwise referred to as social mobilizers "were able to reach 83 districts out of 88 districts in Liberia via door-to-door interpersonal communication" (O. Adong, personal communication, October 10, 2015). The people's suggestions and opinions were sought during the education and training sessions and

evidently; their suggestions were incorporated as much as possible especially with the scripting of the messages. The effects of the localization were evident in the attitude change of the people in less time than anticipated. Another report stated:

> The communication team in collaboration with the psychosocial team also embarked on a social mobilization and awareness campaign in Cape Mount county which has recently emerged as a hot spot for EVD outbreak. An assessment visit was made to the county capital (Robertsport) on 11/19/2014 to be able to understand the situation exactly as it is revealed there is considerable increase in the number of attendees at the campaign to about 62 participants. (T. Oloke, 2015)

The number of self-reported suspected Ebola cases to the Ebola treatment unit managed by the AU-ASEOWA health workers in Liberia and Sierra Leone increased as shown in the situation reports data representation. Bringing the messages and education on Ebola to the doorstep of the people especially in the rural areas of Liberia gave them a sense of belonging and resulted in attitudinal changes. In Liberia, for example, the people were made to own the messages by giving them a voice in the scripting of the messages.

Subsequent IPC trainings and Ebola education campaigns conducted also experienced a noticeable increase in the number of participants

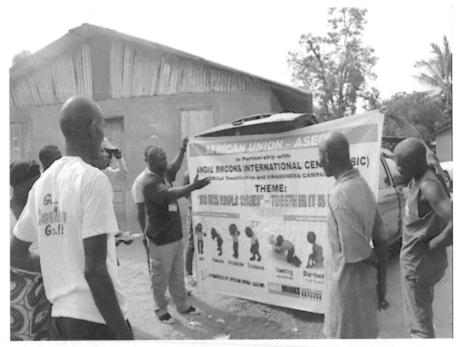

Fig. 11.4. Community residents listening to campaign messages from AU-ASEOWA staff in Grand Cape Mount community. Author's creation.

The increased level of education and awareness also helped the people to detect Ebola symptoms early and commence treatment at the Ebola treatment units early enough. At the rate at which more people self-reported themselves as suspected Ebola cases, the need for more ETUs became evident. As a temporary measure, community care centers otherwise referred to as holding centers were built in Port Loko, Kenema, Bombali and Koinadugu districts in Sierra Leone. At the holding centers, suspected cases were held in triage and tested for Ebola. Confirmed cases were transferred to the nearest ETUs while symptomatic, but negative Ebola patients were held for treatment for other diseases at the holding centers. The situation reports analyzed for this study reflected a decline in the number of Ebola related deaths in Liberia and Sierra Leone while the number of survivors increased commendably. The psychosocial officer interviewed also noted that the Ebola survivors were employed as trainers to educate the people on the benefits of IPC protocols and early reporting of suspected cases. In a reverse situation, the number of deaths and confirmed cases were relatively high and on the increase. The communications officer reported a case of violence unleashed on the ETU located in Coyah district in Guinea by the locals. Medical officers were reportedly injured and sent fleeing the center for a couple of hours. The reported resistance in Guinea was described as strong such that the ETU was not allowed within reasonable distance to the residential areas of the metropolis. The ETU was located in a far area with dilapidated road conditions, which made it distressing for probable Ebola cases to seek the required medical help. An effort of the AU-ASEOWA apparently was not successful in Guinea compared to Liberia and Sierra Leone, despite localization strategies because all efforts were strongly resisted by the people and their leaders.

REFERENCES

Ebola Virus Disease. (2015). *MedlinePlus Medical Encyclopedia website*. Retrieved from https://www.nlm.nih.gov/medlineplus/ency/article/001339.htm

Molleda, J. C., Kochhar, S., & Wilson, C. (2015). Tipping the balance: A decision-making model for localization in global public relations agencies. *Public Relations Review, 41*(3), 335–344.

West Africa: Ebola Outbreak. (2014, March). *Relief Web*. Retrieved from http://reliefweb.int/disaster/ep-2014-000041-gin

Cases Addressing National Opportunities

It's All IN THE Name

The Story of the Campaign for Marriage Equality in Ireland

DR. JOHN GALLAGHER, ED.D., FRII
The Dublin Institute of Technology

EDITOR'S NOTE

This case illustrates how a divisive issue can be a powerful tool in the skillful hands of communicators and policy makers working together. The role that communication and public relations strategies played in this case was significant and effective. Often politicians shy away from difficult and divisive issues because of the inherent political risks to themselves and their parties. Occasionally, a social justice issue is forced upon the political system, which must respond and choose a strategy. Public relations can be a powerful element of that strategy. The campaign used every traditional tactic that our textbooks must offer from media relations, to celebrity endorsement to event management, as well as three themes of communication that made this campaign so very unique and one of the best campaign in Ireland.

BACKGROUND

The story of this campaign hearkens back to 1993. This somewhat recent date was when homosexuality was decriminalized in Ireland. The legislation that put this into effect was the result of a campaign by Senator David Norris who brought

a case before the Irish Supreme Court in 1983 to overturn legislation enacted by the British Parliament (Offences Against the Person Act, 1861) (Criminal Law (Amendment) Act, 1885) in the previous century. Repealed in England and Wales (1967), Scotland (1980 and Northern Ireland (1982), the Irish Court decided in a ruling of 3 to 2 to dismiss the challenge arguing that criminalization continued to serve public health and the institution of marriage.

Norris then took his Campaign for Sexual Law Reform to the European Court of Human Rights. The Court ruled (Norris vs Ireland, 1988) that the law violated Article 8 of the European Convention on Human Rights violating the right to privacy in personal affairs. Five years later, the Irish Minister for Justice, Maire Geoghegan Quinn included decriminalisation in a bill to deal with various sexual offences, the Criminal Law (Sexual Offences) Bill (1993). The Bill was signed into Law by the President of Ireland, Mary Robinson who, coincidentally, as Senior Counsel, represented Senator Norris in his European Court Case. From this point, a number of laws were introduced in Ireland outlawing discrimination on the basis of sexual orientation including the Employment Equality Act (1998) and the Equal Status Act (2000).

In the same year that the Norris case was progressing through the European Court (1988), GLEN, the Gay and Lesbian Equality Network (www.glen.ie) was founded with the support of smaller lesbian and gay organizations The organisation asserts that it "has been instrumental in achieving a range of legislative and policy change in Ireland for members of the LGBT community."

In 2004, Katherine Zappone and Ann Louise Gilligan brought a case to the Irish High Court to have their Canadian marriage recognized in Ireland. The case became a catalyst for the movement of legal recognition of same sex marriages. It was significant on a number of levels:

a) It introduced Ms Zappone to the Irish public. Ms Zappone went on to become an Irish Senator, a T.D., and is currently the Irish Minister for Children and Youth Affairs.

b) It led to the formation of Marriage Equality which began as a support organization for Ms Zappone and Ms Gilligan, both through the Courts and "by making it visible to the public and politicians". (Booth, (Healy Interview), 2014, p. 31) The agenda of the organisation was legal recognition of same sex marriage in Ireland.

The "KAL" case (an amalgam of the litigators' names) was unsuccessful in the High Court. Ms Justice Dunne found that although the Irish Constitution was a "living document", it was always the intention of the authors that marriage was between a man and a woman. (Zappone & Anor v Revenue Commissioners & Ors, 2006).

With KAL supporters realising that the recognition of same sex marriage had to be pursued both through legal and political means, Marriage Equality was launched in February 2008 with the stated single goal to achieve equality for lesbian, gay, bisexual and transgender (LGBT) people in Ireland through the extension of civil marriage rights to same sex couples. GLEN and Marriage Equality would go on to become the two main advocacy groups to secure same sex marriage in Ireland.

SITUATION ANALYSIS

Though GLEN and Marriage Equality were organisations with similar goals they were not naturally drawn together. Indeed, under closer comparison, their goals seemed incompatible. GLEN had worked long and hard to develop strong insider links with members of the Oireachtas (Irish Parliament). Their experience had told them that change in a conservative society like Ireland could only be brought about through incremental change. Per Brian Sheehan, Executive Director of GLEN:

> Our strategy is primarily an engagement strategy which means consistent engagement with those in power to drive that change. ... GLEN literally had hundreds of meetings with T.D's (Teachta Dala) and Senators. Other organisations said they met about ten T.D.'s. I think we met 113 T.D.'s and Senators out of 260. We also met with government advisors, departments, ministers and all of the people involved. We met a lot with those very many times, so we had relationships built. It really was a large-scale operation. (Booth (Sheehan Interview), 2014, p. 26)

On the other hand, Marriage Equality, according to Booth (2014), "undertook a much broader advocacy strategy, which consisted mostly of indirect lobbying strategies." During his interview with Grainne Healy, the Chairman of Marriage Equality, Grainne asserted,

> One key area was mobilisation. We got people mobilised to engage with people and politicians. We got "how to" packs which provided people with a step to step guide on how to contact T.D's. We made it simple for them. We literally gave people all the answers to any misgivings politicians may have. You could argue that we were training advocates as part of our advocacy strategy. Grassroots lobbying played an essential part in this process. (Booth (Healy Interview), 2014, p. 28)

One of the more dramatic tactics was the "Out to Your TD campaign" in which people were encouraged to "come out" as gay to public representatives at their clinics as a means to mobilise the politicians on gay issues.

An important part of mobilisation involved internal communications within the gay community. The LGBT community themselves were not always supportive of marriage as advocated by their representative groups.

While gay people were looking for legal protections for themselves and their families, many of them regarded marriage as a patriarchal institution and wondered out loud why they should want anything to do with it. There was a wide feeling that they needed something different.

Zappone and Gilligan had seen this when they first tried to get their Canadian marriage recognised by the Irish state. They felt that they were forced to bring their case to court themselves because no one else was prepared to act either legally or politically. Though they would later find support from their colleagues in Marriage Equality, Zappone recalls that "the majority of same sex couples ... that we spoke to were very ambivalent to the idea of marriage." (Booth (Zappone Interview), 2014, p. 32)

In addition to this, there was discord among pro-marriage advocates. GLEN could point to all its major achievements since decriminalisation and interpreted them as the product of an incremental policy. Marriage Equality, on the other hand, always made it clear that they never supported an incremental approach.

According to Grainne Healy of Marriage Equality:

> The best way politically was to go for something like civil partnership which established a lot of the rights ... Marriage Equality and GLEN clashed over this, as we felt it added to our own sense of oppression as it did not provide full equality, whereas GLEN felt that "its so marriage like, there are hardly any differences". We said that is not true. (Booth (Healy Interview), 2014, p. 33)

Indeed Marriage Equality felt that its campaign was being stymied by GLEN. Brian Sheehan of GLEN recalled:

> There was a huge difference of opinion between ourselves and Marriage Equality and I think we did not agree to work together and they were coming out against civil partnership. ... Others turned the campaign into a campaign against civil partnership ... Other organisations presented an argument that there was a choice between either civil partnership or civil marriage which wasn't true. The choice was civil partnership based on marriage or nothing and that nothing could have remained nothing for twenty years. (Booth (Sheehan Interview), 2014, p. 33)

Behind these concerns was a very practical consideration, after the KAL case, it was clear that a constitutional referendum would be necessary in order to ensure that the constitution would allow same-sex marriages. This would require a ballot to be put through referendum to every citizen in Ireland; civil partnership, on the other hand, would simply require the successful passage of a law through the Irish Parliament.

In the meantime, GLEN was making political friends and perhaps the most important friend they made at this time was the Minister for Justice and Law Reform. Michael McDowell, SC. One of the first invitations he received was the

invitation to the 2005 Dublin Lesbian and Gay Film Festival. Out of the relationships forged between govenment and GLEN, this perhaps bore the most fruit, particularly when the Minister set up the Colley Working Group to investigate options for the relationships of same sex couples. McDowell's strategy was seen to be flawless (for the Government). In asking for options, not recommendations, he could still choose the most politically palatable option and still be regarded as a champion of equality. Otherwise, the unelected Working Group would take the political fallout if the reaction from the public was to prove less positive.

The Working Group was seen to be somewhat conservative, consisting largely of public servants, specialists in taxation, education, health and other relevant specialisations. Anne Colley, its Chair, however, saw the presence of another public servant as pivotal:

> What we did was give the pros and cons of all the options and we had a member of the Equality Authority on the group at the same time, who was legal advisor to the Equality Authority. She was very keen that we had a framework of reference which was reflective of the legislation on equality so that we could measure everything against the principles of equality that was in the equality legislation. The frame of reference was quite clear. (Booth (Colley Interview), 2014, p. 37)

In terms of equality, marriage was presented as the top option. The Working Group, however, recommended civil partnership. Anne Colley said, "We came up with that as a very viable option but pointed out that it would not satisfy the principle of equality. We worked our way through how to deal with the options and in what context they could be given. If we did not give the context, it would have been very difficult for the government to judge which one to go for" (Booth (Colley Interview), 2014, p. 37).

In December 2000, the government had requested the Law Reform Commission to examine the rights and duties of cohabitees. In April 2004, the Commission published a consultation paper, *Consultation Paper on the Rights and Duties of Cohabitees*, which included an analysis of issues for same sex couples and was launched in December 2006 by Minister McDowell, a month after the Colley Report was presented to Government. Anne Colley believes that this report in conjunction with the report from her working group "pushed the whole thing forward" (Booth (Colley interview), 2014, p. 38).

CORE OPPORTUNITY

In 2002, the manifestos of two political parties, the Labour Party and the Greens had referred to the rights of Gay Couples. By 2004, thanks to extensive direct lobbying by GLEN, all political parties supported policies providing some form of

recognition to same sex couples. Then the seismic event occurred with the Labour Party (in opposition at the time) introducing a private members bill about civil unions in December 2006.

Like most private member bills introduced by the opposition in Ireland, the bill was defeated. But this was due more to the fact that the opposition, than because of its content, introduced it. What the introduction of the bill did show, however, was that GLEN was the only LGBT advocacy group who supported civil partnership. Despite this, GLEN maintained a huge amount of political engagement with both Government and Opposition. This engagement included inviting an Taoiseach Bertie Ahern to launch the new GLEN Offices in 2006. GLEN officials worked on the content of the speech with officials from the Taoiseach's office. The speech put a lot of emphasis on the importance of diversity in a modern open and diverse country adding value to the economic advantages of investing in and operating out of Ireland. GLEN was speaking the language of the politicians, seeing the world from their viewpoint and reinforcing their support. Legal recognition for same sex couples was a platform in the manifestos of all the political parties leading to the election of 2007.

After the election when the Minister for Justice, the late Brian Lenihan, T. D. agreed to prepare legislation for civil marriage, GLEN maintained its contacts with all parties to maintain support and ensure that the bill would not become a hostage to fortune for any reason. In terms of Irish legislation, the *Civil Partnership and Certain Rights and Obligations of Cohabitants Bill*, went relatively quickly through the Oireachtas. First published in 2008, the bill became law on January 1, 2011, during a time when Irish politics was distracted by the collapse of the Irish economy.

The reactions to the new legislation were varied. The new Minister for Justice, Dermot Aherne, T.D. described the act as "one of the most important pieces of civil legislation to be enacted since independence," (www.justice.ie, 2010). Advocates of Gay Rights, other than GLEN were less enthused. Grainne Healy remarked:

> We were critical of civil partnership … Once it was in, we accepted it and viewed it as a stepping stone and looked forward to marriage. Our supporters got on board very quickly. LGBT noise ripped up the bill at pride one year, However, in advocacy, you can never depend on anyone to be grateful to you and you must do your best. (Booth (Healy Interview), 2014, p. 43)

Katherine Zappone, however, never lost sight of the core issue:

> I don't think civil partnership is equality. I think it is institutional discrimination. We kept quiet in relation to our own critique of that strategy. The way we responded was motivated by the importance of not allowing those who were in favour of discrimination to have any kind of ammunition. (Booth (Zappone Interview), 2014, p. 44)

A General Election was called a little over a month later. This gave the gay advocacy groups an opportunity to lobby the political parties again. Tax issues associated with the new Civil Partnership legislation had yet to be decided. Lobbying for this gave all LGBT groups opportunities, but with an additional new focus, that of full marriage.

GOALS

The goal both GLEN and Marriage Equality sought, regardless of their methods, was the securing of same-sex marriage. After the legalisation of civil partnership for same sex couples, the dilemma was how to initiate a dialogue about marriage with Government and indeed the wider Irish public so soon after most felt the issue resolved by the legislation for partnership.

With Ireland's economic collapse, a change in Government was eagerly anticipated. Fine Gael and the Labour Party formed that Government in the spring of 2011. Both parties had shown themselves to be responsive to the needs of the LGBT community, supported the previous Government's Civil Partnership Bill and had pledged to progress LGBT causes in their pre-election manifestos.

It was, however, a commitment made by the Government to review certain aspects of the Irish Constitution would prove to be most important for gay people. This commitment took shape in the creation of a public forum which would identify, debate and make recommendations about areas worthy of amendment in the Irish Constitution, Among these areas was same-sex marriage, presenting an opportunity to seriously engage the issue with the Irish public for the very first time.

Known best as the Constitutional Convention, this forum provided the best opportunity yet to secure same-sex marriage. Though the Government was not obliged to act on every recommendation made at convention, it was committed to replying to all recommendations, including same-sex marriage, thus galvanising the LGBT community and their advocates to secure that recommendation. The Convention began deliberations on December 1, 2012. According to Senator, Katherine Lynch, a member of the Convention and a supporter of the LGBT community, "Once they voted in favour of a referendum, it was very difficult to stop it, even if we wanted to" (Booth (Lynch Interview), 2014, p. 46). The Convention was due to discuss same-sex marriage in April, 2013.

Both GLEN and Marriage Equality realised as soon as same-sex marriage was included in the Convention's deliberations, that winning this debate at the Constitutional Convention would be the first objective on the road to marriage equality.

The Convention invited members from GLEN, Marrriage Equality and the Irish Council for Civil Liberties to make presentations. Each of the organisations

would be given thirty minutes to address the delegates. The Irish Catholic Bishops Conference, the Knights of Columbanus and the Evangelical Association of Ireland were invited to present the opposing case. In the meantime, the Convention Secretariat had received over one thousand submissions on marriage equality, the highest number received on any topic discussed by the Convention.

GLEN, Marriage Equality and the ICCL, sharing their time, worked together to outline the history of gay struggle for equal rights. Their emphasis was not on the homosexual aspect of the discussion, if indeed the term was even used. Instead, the emphasis was made on equality-a positive concept that could be embraced by most right-thinking citizens, that all sought equality, fairness and equal treatment under the law. Prohibition of any group from marriage was a violation of that equality. Equality had been the context for the struggles of the LGBT community before now in terms of employment, provisions of goods and services and other matters, but it was at this public forum that the struggle for same-sex marriage was reinforced as a struggle for equality.

What copper-fastened the argument for constitutional change in marriage were presentations made by two young people, Clare O'Connell and Conor Prendergast. They took those equality arguments and explained why their parents wanted to be able to marry. They spoke of their parents' regard for marriage, the love of their union and their own upbringing. In particular, Conor spoke of the irony how he himself was engaged to a young woman, after a relationship of six years and how their union was welcomed and supported but how his parents' union was not. He spoke too of his concern for his parents as they aged and whether he would be able to care for them in the manner he would wish if he were not legally recognised as next of kin. Their presentations were greeted with applause by the delegates.

On the next day, the delegates were to vote whether to advise the Government to hold a referendum to change the constitution to allow couples of the same sex to enter into civil marriages recognised and supported by the state. The result was definitive-79 out of the 100 delegates voted to change the constitution. What was even more extraordinary was that 81 out of 100 voted to ask the Government to change the laws around parenting, guardianship and the upbringing of children to equally include children in lesbian and gay headed families.

OBJECTIVES

By the autumn of 2013, there were suggestions from Government sources that it would accept the recommendations from the Constitutional Convention on same sex marriage. Sources were also saying that the family law reform legislation would precede the referendum and that the Minister for Justice, Alan Shatter, T. D. who

was an expert in family law was personally drafting the legislation. On November 5, 2013, the Cabinet made a formal decision that the referendum would be held in 2015 and that it had given approval for the Children and Family Relationships Bill, publishing an explanatory note of its contents. The Taoiseach, Enda Kenny, T.D, had declared his own strong support for the referendum and indicated that he would actively campaign for a "Yes" vote.

When the Joint Oireachtas Committee on Justice began pre-legislative hearings, GLEN, Marriage Equality and ICCL again coordinated their submissions and worked together at the hearings.

The decision to work together seemed in many ways to be a natural evolution. The issue of "what" had never been contentious. In the case of GLEN and Marriage Equality, both groups sought to protect the LGBT Community, seek equality for them and aspired to marriage rights as a goal. "How" had turned up differences, as one organisation, GLEN, sought to use insider tactics and achieve the ultimate prize through the only way they thought would prove practical- an incremental process. Marriage Equality had developed their expertise in the use of outsider or indirect tactics in which they would draw attention to the cause by keeping their publics involved and informed, and using events, natural and fabricated, to focus the attention of the general public on their issues.

After the achievement of Civil Partnership, there were no longer any issues to separate the two organisations. The only goal left on the incremental scale was "Marriage Equality". GLEN could observe during the convention the value of outsider tactics by the presentations of O'Connell and Prendergast. Marriage Equality, on the other hand, appreciated the use of insider tactics when they saw several public representatives defend the proposed referendum against misinformation by opponents to same sex marriage. A synergy was achieved by combining the expertise and experience of both organisations.

Shortly after the Constitutional Convention, Grainne Healy, the Chairwoman of Marriage Equality decided to invite Mark Kelly, Executive of the Irish Council for Civil Liberties and Brian Sheehan, the Executive Director of GLEN to meet to discuss the next steps. This began as a fortnightly planning session that intensified to become weekly meetings once the referendum date was announced.

The three organisations shared a number of objectives. The first was to convince the Constitutional Convention to recommend same-sex marriage to the Government. The second was to secure a formal government commitment to hold the referendum. This could not be to be taken for granted as the Government had indicated that they would be under no obligation to accept recommendations from the Convention. A more likely risk was the failure to select a date for a referendum, allowing drift to occur and with each month the increasing possibility that the Government may not last to fulfill its promises. The third objective was to get the Government to publicly identify a date for that referendum. The fourth objective

was to lobby for legislative reform agreeable to the LGBT community around children and family. And finally, the fifth objective was to win the referendum.

What emerged from the Constitutional Convention were three advocacy-type of organisations which realised they shared the same goals and objectives, but had different skills and competencies. This alliance would be the first of many alliances that would be informed to achieve Marriage Equality.

CALENDAR/TIMETABLE

On November 5, 2013, the Cabinet made a formal decision that the referendum for Marriage Equality, would be held in 2015.

In July 2014, Brian Sheehan of GLEN had drawn up a proposal for the Campaign to use the annual Voter Registration Window to remind voters that the referendum was expected the following year and to build on the work to raise awareness of marriage equality. Perhaps just as important was the opportunity to engage with the under-25 age group to motivate and involve this rather politically ambivalent group in the campaign. A National Youth Council study determined that 30 percent of this group were not registered to vote and of those that were just over half had voted in the last EU/Local Government elections.

The Voter Registration Campaign was supported by several well-resourced associations and most welcomed the Yes Equality campaign throwing their support behind the campaign. Voter registration allowed Marriage Equality to form more alliances. These would have included political parties, trade unions, the Union of Students in Ireland, College Societies and Youth and Community Groups. It would present an opportunity for the Yes Equality campaign to frame their campaign. It would help to introduce and build the new Yes Equality brand and most importantly to persuade younger people that registering to vote was not about continuing politics as usual but a means of becoming the agents of change they wanted to be. It became the first opportunity to connect with many supporters. The Yes Equality Register to Vote campaign was launched in Cork on November 3, 2014. Social media promotions on Facebook had a spectacular six million reach across the three weeks of the campaign.

On January 8, 2015, Yes Equality convened an all-day planning session. They were now working on the expectation that the referendum, would take place on May 8th and began to plan accordingly. Other dates were signposted such as April 7, the official start date of the campaign, thirty days before polling, and the first day that campaign posters could be mounted. It was likely, however, to run in the media from the beginning of the year. Concerns were expressed that such a long campaign would bore and alienate middle ground voters. Various roles were assigned to staff and activists from each of the three organisations and the

Campaign began looking for a new headquarters, which the leadership found at Clarendon House behind the Westbury Hotel in the centre of Dublin. Patterns of meetings were established. The campaign moved into Clarendon Street with 107 days before the Referendum, which the Taoiseach announced on February 20, would be held on May 22, giving the campaign an extra two weeks.

From the previous autumn, a mobilization campaign had seen the start of assisting Yes Equality Groups throughout the country. This involved identifying nuclei around which such groups could be built including LGBT activists, marriage equality groups or simply volunteers who wanted to become involved. A messaging bible was developed to provide the answer to every question the campaign could be asked. This would subsequently be supplemented by daily briefings about campaign developments, events and reaction from the national canvas.

Because advocates of the No side were already out in the media and gaining traction in early 2015, a consensus was building that the Yes Equality campaign launch should be brought forward. March 9, 2015 was set for the launch. It was held in the Rotunda Maternity Hospital. What was notable about the launch was the structural similarity to the presentation made by GLEN, Marriage Equality and ECCL at the Constitutional Convention. Ordinary people were introduced and began telling their stories, a father telling the story of the night his daughter "came out" to him and his fears for her and the life ahead for her, a young lesbian couple who wanted to marry, a young man who had been bullied at school because he was gay. These stories did not mask the hard politics that were involved. At the launch, Grainne Healy, laying claim to the territory that marriage equality opponents sought to take as their own, said:

> Attempts have been made to frame this conversation as if it was about people with family values against the rest of us. Nothing could be further from the truth. We want this referendum to say Yes because we want the freedom to marry because we value family. We are the family values campaign. (Healy, Sheehan, & Whelan, 2016, p. 36)

The launch attracted 300 people from across civic society and the political parties. It received extensive coverage both in the mainstream media and online. More importantly, the tone and imagery of a measured clarity of purpose for the campaign had been established and was being replicated by Yes Equality groups emerging throughout the country. There were sixty-one days to go before the referendum.

KEY PUBLICS

Published opinion polls during 2014 had all shown that there was an overwhelming majority in favor of marriage equality. Two polls had put the Yes vote as high

as 80 percent but the campaigners were agreed that much of this support was soft and could fall away as it had in other Irish referenda where a call for change in the constitution seemed unassailable months out, but had shortened to a few points or even a loss at voting day. The campaign was also well aware that it could not win the referendum by simply reaching out to the LGBT community. Their reach would have to extend to the population at large. The question was not only how to reach supporters and those who were uncommitted among the population, but who exactly were these electorate.

In late January 2015, following detailed *Red C* (a leading public opinion firm in Ireland) polling on voting intentions, the research company, Bricolage, had held a number of focus groups, which identified voting groups. One group, a mixed male/female aged between twenty-five and thirty-five were disengaged from the traditional news agenda and prevailing political debates. Intense users of social media, they followed opinion formers and shared views on-line. They were highly supportive of marriage equality to the point where they did not understand what the fuss was about. However, they did perceive it as a real issue, an issue that mattered. Aware but inactive, this group had to be motivated and enthused about the campaign to ensure the amendment carried.

Another group, females between the age of forty and sixty, were found to exhibit information-seeking behavior. They wanted to know more about the perspective of gay and lesbian people and were prepared to accept a more diverse view of family than other groups. Unimpressed by church teaching on this matter or other social issues, their thinking was influenced by their children on this topic.

Men between forty and sixty were influenced by what they perceived as the prevailing opinion on the question of marriage equality and wanted to be seen to be politically correct. They were considered a very soft vote that could easily be wooed to the "No" camp. They harbored deep-seated concerns about social change and seemed largely unhappy about it. At best, they manifested a "Live and Let Live." attitude to the question of Marriage Equality. They were seen to be susceptible to the suggestion that civil partnership should be enough. They needed to be more informed why the issue mattered to the LGBT community.

Males over sixty seemed to be overwhelmingly against marriage equality and unwilling to even contemplate changing their opinions. The research done in Ireland tended to reflect the polls conducted elsewhere, particularly in the United States.

The *Red C* poll also showed that the concerns about children were a source of weakness for the campaign particularly where the middle aged and particularly male voters were concerned.

All groups were most responsive to the "full citizenship" argument for gay people, that marriage was a secure foundation for relationships and a social good to which gay people were as entitled as anyone else. The most powerful positive response came from the argument that all children and grandchildren should be

able to marry the person they love and they should be allowed to celebrate their marriage in the same way as their "straight" brothers and sisters.

Somewhat contrary to the thinking of most of the strategists, celebrity endorsement by gay and lesbian personalities received a negative response. This was seen by the public as an issue of importance to ordinary people and people wanted to hear the views of ordinary mothers and fathers seeking equality for their own gay and lesbian children, rather than the self-serving testimony of the famous. The exception to this was advocacy from someone who was seen to have considered the issue seriously.

KEY MESSAGES

The tone of the LGBT presentation at the Constitutional Convention and its reception provided confirmation that the message of equality was most likely to strike a chord with Irish publics where same-sex marriage was discussed. The current law, even including civil partnership, institutionalized discrimination as Senator Zappone put it. It deprived certain people of rights of recognition that were enjoyed by and supported the majority of Irish people. Some of those deprived were brothers, sisters, parents, sons, daughters, and, of course, friends of most Irish people. Considering the strength and regard with which the family is held in Irish society, the current situation in Irish law took on a particularly repellent characteristic that demanded corrective action.

STRATEGIES

If the Working Group of the three organisations had any doubt about whether their choice of message was correct a distraction from that message put that doubt to rest on the night of January 11, 2014 when a drag artist and gay rights activist named Rory O'Neill aka Miss Panti Bliss, appeared on a talk show, The Saturday Night Show. With so much happening in the political environment on the gay issue of same sex marriage, it was only natural that this would become a topic on talk shows. The problem began when during the discussion, Mr. O'Neill spoke of a positive change in attitude toward gay people in Ireland but there remained some in the public eye who were "really horrible and mean about gays". Prompted as to who those people were, Mr. O'Neill mentioned several columnists who wrote in national newspapers and the right-wing Iona Institute which had supported the traditionalist speakers at the Convention.

The resultant uproar lasted for weeks with the Irish national television network, RTÉ (Ireland's national broadcaster), making a public apology two weeks

later and eventually paying settlements of €75,000 for libel and defamation. On a political level, commentators pointed to this as an example of the hectoring and harassment that the gay community subjected those who did not agree with them. The traditionalists were painted as victims, not the LGBT community who were portrayed trying to impose their lifestyles on everybody else. Concerned, independent commentators issued warnings that intolerance shown by liberal activists would undermine the prospects of achieving constitutional reform.

The leaders of the three organisations and their executive staffs were meeting weekly forming the organisational foundation for the referendum campaign. Among the most time-consuming debates were what the new campaigning entity should be called. At this point to mollify concerns whether religious marriage would be affected by constitutional change, they called themselves "The Campaign for Civil Marriage Equality." Five design companies were invited to present their ideas for an identity, which according to the brief would be "iconic, create talk ability, be dynamic, dignified but eye-catching, inspiring and simple ... it would have to energize ... the public imagination and engage people across all ages." In early August 2014, the pitch from the agency, Language, emerged as the winner with the title for the new campaign organization—*Yes Equality*. The identity that was created was not just about the gay community, but included everyone and the values that they were happy to support and vote for. Also in August, liaisons between the three organisations were formalized by the creation of a steering group who met regularly to oversee structural, financial and governing matters for the campaign. Per Healy Sheehan and Whelan:

> Marriage Equality had developed a "Road Way to a Referendum Win" as part of a funding drive to donors in late October 2014. This had set out many of the key elements that would appear in the campaign including canvasser mobilization, media activity, a bus tour and engagement with strategic partners such as children's organisations. The task now was to blend with GLEN's and the ICCL's plans for the referendum and to identify the staffing, funding and coordination necessary for a winning campaign. (Healy et al., 2016, p. 31)

On March 24, the campaign leadership, GLEN's Brian Sheehan and Marriage Equality's Grainne Healy (who became known to campaign workers as "Brainne" because of the synergistic way they worked together), held a meeting to introduce Noel Whelan to the operation and to the staffers. Noel was a barrister and a pundit writing weekly on politics in *The Irish Times*. He had also worked as a political operative for the Fianna Fail and ran for public office. At this daylong meeting, Tiernan Brady who had worked extensively on lobbying for the campaign shared a story he had read about coverage for the Scottish referendum on independence he had read some months earlier. He told of a picture of a woman he had spotted standing in a square in Inverness with a hand-made placard, which bore the message, "I'm Voting Yes. Ask Me Why."

This proved to be a Eureka moment for the campaign leadership. Those simple words seemed to capture everything the campaign should be. It was not merely a slogan but a strategy, indeed, the strategy. The campaign and the campaigners would tell stories rather than lecture, ask rather than demand, discuss rather than make a political pitch. It would replicate that which had worked so well for them in the past such as the stories told of their families by Clare O'Connell and Conor Prendergast at the Constitutional Convention and would work for them going forward into the future, such as the stories told at the launch of the Yes Equality in the Rotunda Hospital. It would encourage people at all levels to tell their stories such as the Minister for Health, Dr. Leo Varadkar who announced he was gay in a radio interview on January 18, 2015 or Pat Careyformer Minister of Community, Equality and Gaeltacht Affairs in the previous Fianna Fail/Green administration who had come out on February 13, 2014 or broadcast journalist Ursula Halligan of the TV3 network who revealed her sexuality in *The Irish Times* on May 16, 2015. As expressed in the book, *Ireland says YES, The Inside Story on How the Vote for Marriage Equality Was Won*, written by the leaders of the campaign and their advisor, Noel Whelan, who said:

> Personal stories [have] a powerful capacity to change minds. The key was to create, in a credible and uncontrived way, a calm environment in which such stories could emerge and be heard. At the same time, the campaign had to invite unsure voters to share what was on their minds. It could not just claim to be sensitive to the concerns of voters about marriage equality; it had to genuinely engage with their doubts. It would have to reassure them and, above all else, it would have to give voters real stories as a motivation to reach past their apprehensions. (Healy et al., 2016, p. 40)

By March 2015 after Yes Equality was launched, the Campaign Leaders realised that the formal campaign was still very much ahead of them and they took time to re-consider their strategy. They decided to set their strategic decisions down in a one-page campaign plan:

- They would lead support and co-ordinate all the Yes vote activity
- They would orientate the campaign as much as possible towards the middle ground older audience
- They would reassure, persuade and motivate that target audience to engage with the campaign issue and vote Yes
- They would intensely mobilise core supporters to campaign actively
- They would defend the Yes position, counteract misleading messages and robustly challenge misinformation and fear mongering

The page went on to include a chronology. The campaign would be divided into three parts:

- From the beginning of April to the first week of May, the theme of the strategy was "Starting Conversations". During these weeks, they would encourage people to engage with others in conversations on the issue of marriage equality. Under the banner of "I'm Voting Yes. Ask Me Why", there would be neighborhood invitation events, larger public gatherings and on-street opportunities for members of the public to speak about why they were voting yes
- The second stage was called "Full Engagement" and would run from May 5. It would include a highly visible nationwide canvassing operation; participation in national and local media debates, putting a newsletter through every letterbox in the state and a twenty-six-county bus tour
- The third and final phase of the campaign was known as "Closing Argument". How this would be executed and what the message would be, was not yet decided. They knew it would involve a massive Get Out the Vote operation but the rest would depend on what arguments worked best or what No argument most needed final rebuttal.

The plan ended with the remark, "From now on, all our messaging, activity and spending will go to delivering on these objectives and anything else is not our work" (Healy et al., 2016, p. 48).

TACTICS

Even with date of the referendum set and a declaration of support from all the political parties, lobbying contacts continued. Direct lobbying activities not only continued throughout the campaign but also dealt mostly with campaign coordination, as best illustrated by meetings with Government Ministers. Close relationships were forged with Minister Simon Coveney and Minister Alex White who had been appointed Fine Gael's and the Labour Party's Campaign Directors respectively. The campaign leadership met with the Minister for Agriculture, Simon Coveney before the campaign formally began. He had been named Fine Gael's Campaign Director for this referendum. He was supportive and focused on the campaign but when he heard that Yes Equality had no plans to use posters because they had not the funds for them and were planning a bus tour instead, Coveney told them, "You have no credibility as a campaign unless you do posters, even if it means no bus" (Healy et al., 2016, p. 51).

Once the decision was taken to use posters, answers were required as to what to put on them. YES Equality immediately returned to their first designers of choice, Language, to produce a design. They also decided to invite other Design Houses to pitch in the hope that competition would sharpen the creative process

of those involved. This paid off well in the end because it was a firm called Havas, which produced the winning design based on inspiration from the *I'm Voting Yes Ask Me Why* theme. It was a simple idea using two speech bubbles. The first was a large bubble, which said VOTE YES and the second smaller one gave the reason why featuring explanations like "because marriage matters", "for a fairer Ireland" and "for a more equal Ireland." the striking primary colours were in evidence again suggesting but not duplicating, the LGBT rainbow colours.

Indirect lobbying activities also accelerated as the campaign matured. No media opportunity was lost and much of the proactive material that was issued was in conformity with the I'm *Voting Yes, Ask Me Why* theme. Two issues continued to dog the campaign. The first was a hangover from the Children and Family Relationships Bill. The surrogacy issue had nothing to do with marriage equality but opponents continued to raise unnatural spectres around it. The second was why marriage was necessary when legislation had only recently been passed allowing civil partnerships for same sex couples. Answers to these questions was quite straightforward, but no matter how well and how often they were articulated, they arose again and again in an attempt to move elements of the soft vote to the NO side.

Forming alliances had proven effective even before a campaign formally began and they continued to do so as the Yes Equality campaign formed alliances with political parties, trade unions, business sources, children's organisations and others. Alliances were never more important than when they allowed Yes Equality to continue to address the concerns of the middle-aged vote which the campaign had earlier identified as soft. This work was possible only because organisations like the Union of Students in Ireland and the BelonG To organisation had taken over responsibility to ensure the young vote would remain strong and staunch. They worked regularly with the Yes Equality campaigners, attending meetings in their headquarters, publicizing the cause when they could, and getting the vote out. Other tactical choices included:

The Campaign Bus

The Campaign Bus appeared to be a favorite of the campaign leadership. Decked out in wild vibrant colours, the bus set out after a festive launch from Dublin City Hall to traverse the 26 counties of the republic for the full month before polling day. The logistics for the tour had been carefully planned and executed from Yes Equality headquarters. The objective behind the bus was to fill regional papers and broadcasts with positive stories of the Yes campaign. The bus was invariably photographed in front of famous local landmarks such as Blarney Castle in Cork and St Lawrence Gate in Drogheda. Local activists would gather as the bus appeared and a carnival atmosphere prevailed as campaign paraphernalia was distributed and locals greeted VIPs who travelled on the bus. Amongst those VIPs

were Senator David Norris who through his work to decriminalize homosexuality twenty years earlier was recognized as a gay icon and an Taoiseach Enda Kenny who campaigned, as he had promised, travelling on the bus in his native Mayo and in the Northwest of the country.

The Daily Briefing Book

Central to the campaign was the Briefing Book, an eight-page document that was updated daily during the campaign and emailed before 9.00 am to 800 email addresses, all activists involved with the campaign. The book identified key items in the day's newspapers that the Campaign had placed and other pieces where the case for the Campaign was well made. It also drew attention to "must see" coverage from the No campaign, describing their arguments and giving briefs on how to answer them. It provided ideas or wording and links to messages to tweet or post on Facebook and flagged events and media outings for the day ahead, including the itinerary of the campaign bus.

Media Outside Dublin

Some of the most discriminating and enthusiastic coverage of the campaign could be found in local newspapers and transmitted by regional broadcasters. Planting opinion pieces in regional media was organized from Campaign Headquarters in Dublin. This coverage included opinion pieces from local celebrities or well-known people from rural life endorsing the campaign.

Monitoring Broadcasts and Responding

For the last six weeks of the campaign, the organizers had a volunteer media expert monitoring and analyzing all broadcast debates and items about the referendum on national and regional radio. Through Tweetdeck, the campaign monitored chatter about the campaign both national and international. Most of this work was done to fulfill an early objective in the campaign, namely to come down on all misinformation projected by the No side. This was deemed necessary as Yes Equality felt there was ample evidence that the No side did seek to spread misinformation, as well as fear, in their contribution to the debate.

Controlling the Campaign

A great deal of effort went into ensuring that a respectful tone was adopted in presenting the "Yes" case. *I am Voting Yes, Ask Me Why* was an effort to initiate

dialogue, to listen to the stories of others and not to lecture, or harass or exert undue pressure in any way. Though the campaign would carefully control what it issued itself, it could not control the communication of others and no more was this truer than with social media. On a normal day, digital response to articles in *The Irish Times* could be absolutely scary. During something as polarizing as the Yes Equality campaign, this was multiplied many times. Part of the effort to monitor media at Campaign Headquarters was to regulate the behavior of pro-Marriage Equality tweeters and other on line contributors intervening when on line arguments rose beyond a certain temperature. The campaign pointed out that overemotional debates and postings which were personally insulting or abusive to Opponents was counterproductive. Yes Equality wanted its supporters to engage only in positive messaging.

National Publication

In early May, an eight-page full color newsletter, *Marriage and Family Matters*, was delivered to every home in Ireland. The content was not unlike the similar materials used in campaigns in the United States and elsewhere concentrating its attention on how the parents and families of gay and lesbian people explained how much marriage and family meant to them and how they wanted the same for their children. It proved particularly well received, even more so when readers were guided to several on-line short films expanding and illustrating more of the stories told in the newsletter. Produced by Anna Nolan for Coco productions, these films were arranged in staggered release to coincide with the distribution of the newsletter and creating a true multi- media experience. Many other films would emerge during the weeks before the campaign from a wide variety of organisations and individuals. Yes Equality was fortunate in the range of talented people upon which they could call to produce editorial and film to enhance digital communication.

New Voter Registration Campaign

So successful had the Voter Registration Campaign been in November that the Government decided to re-open the register for an additional 15 days after the referendum date of May 22 had been announced. Requiring a slightly more rigid process of registration, this campaign was a great success. Yes Equality, USI, BelonG To and other youth organisations put in a massive effort to get students to sign onto the Supplementary Registered. When canvassing those who had already registered, canvassers were coached to ask them to spread the word and ensure that their friends who were enthusiastic for marriage equality were in fact registered. In the days before the closing date, queues formed at many local council offices

as people tried to get on the supplementary register. Pictures of the queues that featured on social media reminded others to do the same. In all, 65,911 had been added to the register, suggesting a record turnout for the referendum.

The Vote Hardens

From mid-April, Dublin Canvas team leaders met in the Campaign Headquarters every Sunday evening to get a feeling of the issues that were coming up on the doorsteps and what responses the canvassers had found most useful. Detailed summaries were prepared and canvas returns discussed. The importance of these sessions was recognized on several levels. They allowed the campaign to maintain control, they prompted organizers about possible problems which could arise subsequently at a national level, and they provided a coaching and briefing opportunity for the canvassers and maintained the morale of the canvassers by showing to them how important their work was to the overall effort. They could mark when in early May; a hardening of the vote began. Behavior on the doors had shifted from politely taking literature to unsolicited declarations of how the canvassed party would vote.

Canvassing Network

Regional canvassing leaders were texted every night and a summary or reactions from the doorstep and an estimate of support levels sought. The following day they were asked to put more detailed figures and commentary into a shared Google document. Sometimes, people from headquarters would follow up with a telephone call. Training and briefing sessions for activists had been held in the Morrison Hotel by campaign headquarters and an event management company. The canvassing network was well supported by a range of rallies which could be described as *I'm Voting Yes, Ask Me Why* events which were held at venues as small as someone's living room or as big as a university hall. They gave people an opportunity to tell their stories, reinforced identification with the campaign and gave a great boost to canvassing efforts.

The Opposition

Reacting to the opposition always required significant control and poise. Part of this was what Yes Equality perceived as attempts to confuse issues, to misrepresent the Yes campaign's position, and to bait them so that they could adopt a victim's mantle. Another significant aspect to the Opposition was the backing of one of the most powerful institutions of Irish life-the Roman Catholic Church. The Church had lost a great deal of its clout due to scandals, exposure of cruelty and abuse

within Catholics institutions, Nevertheless, the Church was still a formidable institution. It had scheduled the final three weeks before the vote for letters by the bishops to be read from church altars. This was a powerful, if very old weapon. It caused considerable concern at Yes Equality Headquarters though it did not seem to have much perceivable impact in the polls that followed. On the other hand, some well-known members of the clergy who were publicly identified with social issues did make statements supporting Marriage Equality. This helped Marriage Equality to demonstrate that the campaign was not simply opposing the Catholic Church, and that it was not simply a Church issue. Otherwise, the Catholic hierarchy rarely involved themselves in debate, preferring to leave confrontation and debate to the likes of the Iona Institute. Their campaign, apart from a poster campaign which did their cause more harm than good, seemed very reactive, always willing to respond to media invitations or produce articles as required, but otherwise not proactive in any way.

Celebrities

This was where the work on building alliances paid off. Whenever a broadcaster approached a human rights organisation, a political party, government, a children's organisation or any other body with a tangential interest in the campaign, these people contacted Yes Equality to inform them firstly of the approach and secondly to meet for a comprehensive briefing on what they were likely to be asked. Even if no one directly associated with Yes Equality was included in a broadcast, those being interviewed had been briefed and coached by Yes Equality before they reached the camera. This extended to discussion both before and after the media event itself.

Yes Equality could not always control the as closely as it wished. An example of this came in the final week of the campaign when a journalist who was an opponent of Yes Equality, Brenda O'Brien, challenged Rory O'Neill aka Panti Bliss to a televised debate. O'Neill consulted the campaign. The challenge created considerable disturbance at campaign headquarters recalling as they did a previous television appearance by the drag artist. Things were going quite well and there was no appetite to engage controversy at this point or to go off message. On the other hand, Rory O'Neill had been publicly challenged and did not want to back down. O'Neill was advised firstly to accept the challenge, but only as his O'Neill identity. Soon after he did this, O'Brien withdrew her challenge citing illness.

The Final Push

The final week brought an uneasy confidence to the Yes Quality Campaigns. Although all the polls predicted a Yes victory, there was quite a disparity about the

margin of victory. Red C gave the Yes Quality campaign a 69 percent lead; Behaviors Attitudes had it at 63 percent. The *Sunday Independent*/Millard Browne poll saw a margin of 54 percent. What made the Yes Quality people very jumpy was a headline in that paper which read, "Yes Vote in Free Fall" which did not reflect the story underneath.

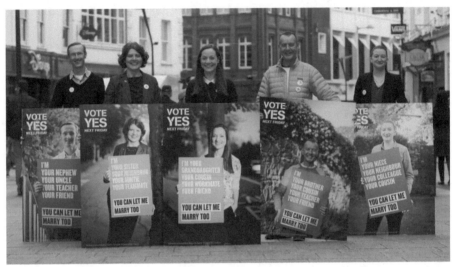

Fig. 12.1. Yes Equality Campaigners, posing in Grafton Street, Dublin, with "their" posters, which were released by the campaign the week before voting day. Credit: Sharpix, Yes Equality, Dublin 2015.

As with most campaigns, the final week was a mass of activity that included but small poster campaign and numerous appearances on the many talk shows on radio and television. Their position was strengthened as Government Ministers and senior jurors made contributions settling the more volatile issues, which had arisen over the campaign. The Minister for Health, Leo Varadkar, T. D. gave an interview distancing the surrogacy issue from the referendum by explaining that it was primarily heterosexual couples that had made use of the technology. This was only a gay issue in the most peripheral sense. The Chairman of the Referendum Commission and the Chairman of the Adoption Board had earlier confirmed the Minister's statement.

On the polling day, there was a massive get out the vote effort that was answered by people who not only traversed the country to vote, but who also had come over by ferry or plane from the United Kingdom, the Continent and even the United States. This odyssey was recorded over Facebook and over Twitter under the hashtag, #hometovote. There were thousands of retweets.

Maintaining the same attention to detail the campaign always had, campaigners produced stickers with the legend, *I've Voted. Have You?* recalling the

main theme of the campaign. There were other clever aids for perhaps the largest GOTV campaign ever launched, with all Yes Equality allies and confederates participating. Yes Equality itself launched an app that could be set to remind you to vote. Oscar nominated actress, Saorise Ronan, herself a first-time voter, arranged a photo opportunity in O'Connell Street, Dublin's main thoroughfare in which she urged her contemporaries to vote and Vote Yes, saying, "This is something that will change our futures and define our generation. If we don't vote, it's on us."

Yet perhaps the best was saved for last or the last week in any event. It had always been the intention of the campaign that former President of Ireland Mary McAleese would make a well-timed intervention. The President's son was gay and an activist in the campaign. She herself was a supporter of gay rights. A constitutional lawyer and a canon lawyer, she was well able to deconstruct all of the Church's arguments against the referendum. She was also able to put to bed any argument about civil marriage being enough,

> We, who are parents, brothers and sisters, colleagues and friends of Ireland's gay citizens, know how they have suffered because of second-class citizenship. This referendum is about them and them alone. The only children affected by this referendum will be Ireland's gay children. It is their future that is at stake, It is in our hands. We, the majority, have to make it happen for them and for all the unborn gay children who are relying on us to end the branding, end the isolation, end the inequality, literally once and for all. (Healy et al., 2016, p. 153)

This was not the final contribution. The Taoiseach appeared on television the following evening calling for a Yes Vote, just as the Archbishop of Dublin called for a No vote. However, the former President's contribution was, in many ways, the final word.

On Friday, May 22, the polling booths throughout Ireland opened at 7.00 am to determine whether the Irish Constitution would be amended.

BUDGET

In all about €800,000 was spent by Yes Equality on their campaign all of it funded by individual donations including on line crowd funding efforts. The legislative regulations governing campaign expenditure on referendums in Ireland are very strict. All donations have to be from Irish citizens and no individual could donate more that €2,500. The average individual donation to the Yes Equality campaign was about €75.

In January 2015, a campaign budget had been drafted setting the figure required to run the campaign at € 300,000. Executives of all three organisations met to identify potential funding sources including directly from the LGBT

Community and crowd funding campaigns. Yes Equality also recognized retail benefits from sales of campaign paraphernalia using the iconic logo on t-shirts, high-visibility vests, posters and buttons (in Irish and in English) and candy. Most felt that the majority of funds would come in during the last two or three weeks of the campaign, but the organizers had to commit to spending immediately.

At the end of March, there was only €3,000 left in the bank. Per the campaign leadership, this was because on one hand, there had been no general fundraising appeal made to the people of Ireland. On the other hand, the rules around campaign finance in Ireland were extraordinarily strict. Campaign organisations were required to register with the Standards in Public Office Commission and donations were confined to coming from Irish citizens and legally capped at €2.500 per person. When Yes Equality registered, and became operational as the lead organisation for the Yes campaign, the organisation could then ask for donations and go online with crowd funding initiatives, According to Healy et al. (2016, p. 52) both these forms of fundraising proved surprisingly successful.

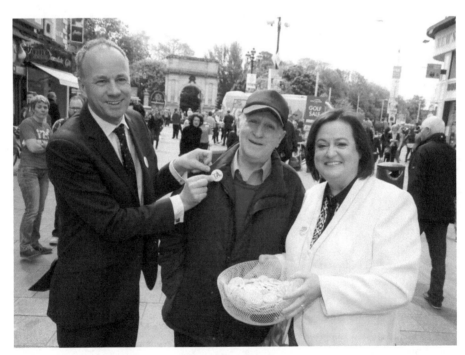

Fig. 12.2. On Dublin's Grafton Street, receiving the 500,000th Yes Equality badge from Brian Sheehan, Chief Executive of GLEN and Grainne Healy, Chairperson of Marriage Equality, was 85-year-old Mr. Vivian Sheehan of Castletownbere, Co Cork (no relation). Credit: Sharpix, Yes Equality, Dublin 2015.

The level of success from campaign merchandising could not have been anticipated. A pop-up shop in St Stephen's Green and a on-line store were set up and began to sell campaign buttons saying Yes or Ta at €2 each,

> In all, the YES Equality merchandising Department sold 6,500 t-shirts, 2,300 tote bags and 800 high visibility jackets. By mid May 2015 Yes Equality had also shifted about 450,000 TA or YES badges. (Healy et al., 2016, p. 139)

EVALUATION AND MEASUREMENT

The people of Ireland approved the thirty-fourth amendment to their constitution. As if to show how discerning their decision was, on the same day, they rejected the thirty-fifth amendment which called for a reduction of the age a candidate could be to run for the Irish Presidency.

At 9 am throughout the country seals on ballot boxes were broken and counts began. By 10 am, tallymen could predict the vote in Dublin would be at least 70/30 in favor of the referendum. By noon, the No Side had conceded.

The final result was 1,201,607 Yes votes to 734,300 for No. All constituencies except for Roscommon had Yes majorities and there, the majority was only by 1,029 votes. It seemed as if anyone who had been involved in the campaign and many who had not appeared to hear the result in Dublin Castle. The Irish do celebrations well and this was no different. Even the weather seemed to be on their side.

By way of evaluation, perhaps it is best to go to the organizers themselves, Grainne Healy, Brian Sheehan and Noel Whelan who wrote of themselves:

> The most important things they had learned during the previous two months [before the referendum] were that the positive style of campaigning worked, and that it was personal appeals and personal stories which had the greatest impact on voters on how gay men and lesbian women seeking equality were part of every voter's community.

REFERENCES

Binderkrantz, A. S. (2005). Interest group strategies: Navigating between privileged access and strategies of pressure. *Political Studies, 53*(4), 694–715.

Booth, C. (2014). *The Road to Marriage: An Analysis of Lobbying Strategies Adopted by Advocacy Groups To Secure the Decision by the [Irish] Government to put the Question of Civil Marriage for Same Sex Couples to the Irish People ny Referendum*, Unpublished Dissertation. (Bacik Interview, Colley Interview, Healy Interview; Lynch Interview, Sheehan Interview, Zappone Interview)

Building Sustainable Change (2006). (www.glen.ie)

Children and Family Relationships Bill (2013)

Civil Partnership and Certain Rights and Obligations of Cohabitants Bill, (2009)

Criminal Law (Amendment) Act, 1885 (United Kingdom)

Criminal Law (Sexual Offences) Bill (1993)

Department of Justice and Equality-Press Statements- *www.justice.ie*

Employment Equality Act (1998)

Equal Status Act (2000).

Healy, G., Sheehan, B., & Whelan, N. (2016). *Ireland says yes: The inside story of how the vote for marriage equality was won*. Dublin: Merrion Press.

Norris vs Ireland, 1988 (European Court of Human Rights)

Offences Against the Person Act, 1861 (United Kingdom) (www.glen.ie)

Zappone & Anor v Revenue Commissioners & Ors, 2006

GLOSSARY OF TERMS

The Abbey Theatre—Ireland's national theatre founded by the poet, W. B. Yeats

Atlantic Philanthropies—A Trust originated by Duty Free Mogul, Chuck Feeney which funded a number of Irish and international liberal causes.

BelonG To—a gay youth organisation

Bricolage, an Irish Design Company,

Dail—The lower house of parliament, representing all citizens, holding greater power than its upper house, the Senate

Fianna Fail—Ireland's most successful political party, being in power for more years than any other political party in the state. Found by Eamonn DeValera-its current leader is Micheal Martin, T. D.

Fine Gael—the senior party in the current Irish Government. It can trace its existence back to the beginning of the state in the 1920's. Its current leader is A Taoiseach Enda Kenny, T. D.

The Green Party—a minority party that can trace its origins back to ecological and environmental activists of the 1980s

The Iona Institute—a conservative, Catholic activist group that characteristically defends traditionalist and conservative causes in Ireland

The Labour Party—the political wing of the trade union movement in Ireland. Founded by James Connolly who died during the Irish Insurrection in 1916, its current leader is Brendan Howlin, T. D.

The Law Reform Commission—a body of senior jurors who advise Ireland on revising and modernising Irish law.

The Irish Times—Ireland's national daily broadsheet newspaper

LGBT—refers to the Lesbian, Gay, Bisexual and Transsexual Community

Oireachtas—Parliament, composed of two assemblies, the Senate and the Dail

Red C—an Irish polling company

Revenue Commissioners—The Irish Tax Collection Service

Rotunda Maternity Hospital—a famous building in the centre of Dublin housing the country's largest maternity hospital

RTE—The Irish National Television Service

Standards in Public Office Commission—The state body which regulates the performance of elections.

St Stephen's Green—a beautifully maintained park in the centre of Dublin and its surrounding streetscape.

Taoiseach—Prime Minister (literally Translates as Chief), currently Enda Kenny, T.D.

TV3—A privately held television service licensed to broadcast in the Republic of Ireland.

T.D. or Teachta Dala—a member of the lower house of the Irish Parliament (Dail Eireann)

USI—The Union of Students in Ireland- a body representing students in third level education

Communicating Food Safety IN THE Highly Multicultural Country OF Kuwait

MARIAM F. ALKAZEMI, FAHED AL-SUMAIT, AND
CRISTINA NAVARRO
Gulf University for Science and Technology

EDITOR'S NOTE

Communicating with diverse publics is always a challenge, requiring cultural sensitivity. When a food distribution company in Kuwait recognized an increase in media coverage of foodborne illnesses despite a decline in actual cases reported to health authorities, the company and its public relations agency began a campaign to educate consumers and regulators on food safety techniques. The communication campaign, Safe Food, Safe Families, was designed to be culturally appropriate given that Kuwait is a Muslim-majority nation with collectivist values but also the home to a large population of expatriates, many of whom do the food shopping and preparation for Kuwaiti families.

BACKGROUND

Kuwait is a small Arab country located at the northern end of the Arabian (Persian) Gulf. It is flanked by Saudi Arabia to the South and Southwest, Iraq to the North and Northwest and Iran across the Gulf to the East. It is a country most recognized internationally for its oil wealth and its status in the 1990–1991 Gulf War as the country occupied by Saddam Hussain's forces and then liberated by a

US-led coalition. However, a brief exploration of some of Kuwait's contemporary indicators demonstrate why it is also a notable country for examining the emergence of modern public relations practices tailored for Middle Eastern markets.

Kuwait ended its status as a British Protectorate in 1961 and quickly established the Gulf Region's first constitution in 1962, granting it standing as one of the most politically free countries in the Arabian Gulf and the broader Middle East (Al-Roomi, 2007; Herb, 1999; Tétreault, 2000). This degree of relative freedom has helped to create an environment with a traditionally active press and one of the highest rates of mass media saturation among any Arab country (Al-Sumait, 2013; Mellor, 2005). The situation with digital media has quickly followed suit. By 2014, Internet penetration had reached nearly 80 percent of the population (not accounting for Internet access through smartphones), in comparison to the average for all Arab countries of 35 percent (The World Bank, 2016). In terms of social media penetration, of the 22 Arab League countries Kuwait is among the top for both Facebook (sixth) and LinkedIn (third), as well as the leading Arab country for Twitter users per capita (Arab Social Media Report, 2014). Although accurate data is hard to locate, indications are that newer platforms like Instagram and Snapchat are also gaining rapid popularity since their inception. Like many media-rich environments, Kuwait hosts a wide range of powerful media options for savvy public relations practitioners to use in reaching their targeted audiences.

To be effective, however, strategic communication must also consider the unique socio-economic conditions of a given environment. Kuwait is a Muslim-majority country steeped in traditional values and customs, combined with a high level of affluence. Its oil wealth has resulted in a GDP per capita (PPP) of over $72,000 USD, ranking it within the top 10 countries worldwide (Central Intelligence Agency, 2016). This wealth has also attracted a large percentage of foreigners. Out of its population of approximately 3.5 million residents, nearly 70 percent are expatriates (United Nations Statistics Division, 2016), a portion of whom serve as domestic workers within many family households. From a cultural perspective, two notable considerations for understanding the current case study are that Kuwaitis, like most of their Arab counterparts, can be classified as primarily collectivist (placing a high value on group membership and harmony), and has a hierarchal power orientation (expected social discrepancies in status difference) (Feghali, 1997; Hall, 1997; Hammoud, 2011). In the case study that follows, a keen understanding of these various dynamics was instrumental to developing a nationwide PR campaign that addressed the seemingly obscure but important issue of food safety.

METHODOLOGY

The authors of this study collected information using primary qualitative research techniques as well as obtaining relevant data from secondary sources.

Semi-structured in-depth interviews were conducted with multiple representatives from the client organization (Al Yasra Foods), as well as employees of its public relations firm (Bensirri Public Relations) including the firm's managing director, the campaign manager and the primary nutritionist involved in the campaign's preparation. Newspaper articles, government statistics, public records, relevant academic literature and other types of information were consulted. The three authors also thoroughly reviewed all available campaign materials and archives, including web-based information, campaign fliers, promotional videos, social media accounts, media clippings, evaluation documents and transcriptions of all interview sessions. Information was categorized and analyzed using AtlasTi qualitative software.

SITUATION ANALYSIS

In 2013, Al Yasra Foods, a large-scale wholesale food supplier in Kuwait, embarked on a countrywide initiative to introduce and encourage the practice of food safety among the general public. Inspired in part by sensationalized media coverage over poor food handling practices and food poisoning cases in the country, the company commissioned the assistance of its primary public relations company, Bensirri Public Relations, to engage in a public service campaign. Although Al Yasra itself had a strong record of safe food practices and did not intend to use the campaign primary as a marketing initiative given its behind-the-scene status as a wholesale distributor, it still decided to dedicate resources to this project based on a commitment to the community. As outlined in this chapter, there were a number of significant goals planned that could benefit the company, including the education of regulators and journalists, brand building among key stakeholders ranging from government agencies to retail distributors, and improved public awareness about food safety, which carried the potential to reduce unsafe practices that can contribute to avoidable but serious health risks.

According to government statistics, food poisoning cases reached a peak of nearly 1,000 incidents in 2007, but had declined to roughly a third of that in the years between 2009-2012, with the numbers as low as 230 cases in the year directly preceding the campaign's launch (Kuwait Central Statistical Bureau, 2014). However, it was the perception of Al Yasra that media coverage had in fact risen disproportionately in relation to the steady decline of actual cases. This may be due in part to the laws governing the food industry that give regulatory authority to numerous, largely uncoordinated, government agencies (such as the Ministry of Commerce and Industry, the Ministry of Health, Ministry of Interior, Ministry of Electricity and Water, local municipalities, etc.). One consequence of this plethora of regulators is that individuals working within these various agencies are unintentionally incentivized to "compete" and find unsafe practices in order to

demonstrate the value of their authority in comparison to other regulatory bodies. Thus, it is not uncommon to hear stories of inspectors engaging in dubious activities, such as leaving food samples in their cars for extended periods before submitting them for lab tests, or incorrectly fingering food already marked for disposal as if it was prepared for sale to the public. For obvious reasons, journalists are quick to cover such instances and sometimes even used as sources for their reporting the very inspectors who generated the trumped-up accusations.

To address these conditions, Al Yasra and Bensirri pooled their resources and created a Safe Food, Safe Families Steering Committee which worked to conduct preliminary research, develop campaign goals and strategies, and train company spokespeople in order to roll out its nation-wide educational initiative. The SWOT analysis that follows demonstrates many of the key strategic considerations feeding into the campaign's development.

Strengths

- Food safety is an issue of concern to all people in society regardless of social, national, ethnic or other status, thereby granting it the potential for broad appeal
- The campaign idea was driven by the company's CEO out of personal commitment to public service, rather than primarily as a branding exercise. This can foster a high degree of credibility
- The local nature of the selected PR agency (as opposed to being a branch office of a multinational agency) ensured a strong understanding of the local cultural and social environment, as well as the consumer marketplaces
- Some localized research was consulted in advance to get a better understanding of awareness about food safety from a selected group of participants. Research on international food safety campaigns provided additional ideas and guidance
- Basic messages about food safety could be consolidated into a few primary points, as well as a number of secondary messages which could target very specific groups in a clear and direct way across multiple language
- The terminology chosen for the campaign, "Safe Food, Safe Family" has several positive elements, including its parsimony and clarity, alliterative phrasing, and its focus on families (which has a strong cultural relevance from the collectivist worldview common in Kuwait)
- The campaign was designed with a high degree of face-to-face interactions to improve credibility and the educational impact of the messages
- The campaign was supported by experts with high public credibility, such as nutritionists, well-known chefs, social media figures and then later by select members from government agencies

- Food safety laws in Kuwait are among the most stringent in the region, leading to a high degree of professionalism by private enterprises at all levels of the food supply and distribution chain. This can increase their receptiveness to a public service campaign of this nature, since there is also mutual self-interest.

Weaknesses

- Food safety is a novel issue in which many people might not have a pre-existing interest, nor an awareness about, thus requiring more effort to gain attention, build awareness and motivate action.
- High costs were associated with the planned publicity events and campaign materials, with no expectation to derive financial return or greater market control
- Most consumers would not associate the company sponsoring the campaign with the brands it distributes. Bottom-line returns on investment (ROIs) are thus likely to be indirect and un-measurable at best, or virtually nonexistent at worse
- All previous similar campaigns reviewed were conducted in different countries with significantly different social-economic and linguistic compositions, making the direct adoption of best practices somewhat difficult
- The broad and diffuse publics of such a multicultural environment as Kuwait make nation-wide targeting efforts potentially difficult and expensive to execute
- Many of the people preparing the food or in charge of meal planning may not be the ones doing the shopping at supermarkets that were the targeted location of many of the campaign's efforts. For example, it is not uncommon that a household matriarch plans the meals, a maid or male member of the household does the shopping, and a chef prepares the food. Although living in the same household, they may each have different first languages, varying educational levels and different attitudes toward hygiene
- Journalists (and possibly regulators) are not likely to be as attracted to the educational dimension of topics related to food safety as they are to the sensationalized instances of food mismanagement
- Since Kuwait is a tax-free country, tax break incentives (a common motivator for participating in public service campaigns elsewhere in the world) are not available in Kuwait to encourage organizations to help fund the campaign
- While goals, target audiences, strategies and tactics were pre-planned to a large degree, SMART (Specific, Measurable, Achievable, Realistic, Timebound) objectives were not clearly designated in advance of the campaign's execution

- Evaluation of the root causes for previous food poisoning cases and the true ability of the campaign to affect widespread change are both difficult to evaluate. Government statistics also vary and provide only a rough baseline of data against which the campaign's success could be measured

Opportunities

- The ability to be a pioneer of food safety as a public service message offers the possibility for Al Yasra to become the first brand publicly associated with the concept in Kuwait. This can help strengthen the company's standing among specific stakeholders (such as supermarkets, regulators, commercial brands that they represent, journalists, etc.)
- The chance to influence and educate regulators and journalists, with a possibility of also garnering support from government officials
- Recent sensationalized media coverage of unsafe food handling raised the profile of food safety as a public concern, possibly priming audience receptivity to some degree
- High levels of media use among various communities in Kuwait offers an opportunity to reach significant numbers of people at a relatively low cost through earned coverage in the mass media and through target messaging using social media usage
- The hierarchal arrangements in many households with regard to food preparation do offer some prospects for household decision makers to exert a high degree of control over the process, despite the numerous people often involved. Therefore, successfully delivering the key messages to one key individual in a household could have associated impacts on everyone living within it
- Large gatherings associated with major meals are common in society among many different cultural groupings. These include winter camping in the desert, beach barbecues, frequent male gathering sessions (called diwaniyyas), the tradition of Friday family lunches, larger holiday feasts, and many other occasions. Each type of gathering point offers opportunities to target significant publics and help spread the campaign's messages through interpersonal discussions
- The potential to help reduce the occurrence of food poisoning cases in the country.

Threats

- Given the cultural and linguistic diversity of society as a whole, certain populations may be excluded or uninterested in the campaign's messages

- Given the common reliance on domestic servants, difficulties exist in terms of access, language and interest when directly targeting the food preparers in typical households
- Multiple laws and overlapping governmental authorities related to food safety make the operating environment somewhat unclear and the potential somewhat high for different organizations to interfere in the campaign
- Regulators and journalists were not seen as highly trained nor well informed about the issue of food safety. As previously discussed, they also operate under a system (and to some degree a broader culture) that encourages a "hero syndrome" for those who can ostensibly be seen as protecting the public's interests. Should any member of these groups (accurately or inaccurately) accuse Al Yasra of improper food safety practices, the campaign's credibility could be undermined
- Many journalists and social media influencers in Kuwait expect to be paid in order to provide positive coverage for PR and marketing campaigns, as such practices are widely used in the country. A failure to pay and include these influential media could lead to difficulties in gaining coverage by more ethical means
- The extreme hot climate in summer months always makes food handling, storage and preparation particularly vulnerable to contamination. As such, cases of food poisoning or improper food handling could arise or even increase despite the campaign's efforts, due to factors beyond the control of Al Yasra or its public relations firm.

CORE OPPORTUNITY

Foodborne illnesses can be minimized by raising awareness about food contamination in the home and during the cooking process (Kadariya, Smith, & Thapaliya, 2014). Studies conducted in Europe have confirmed that simple improper food handling can lead to illnesses (Da Silva Felício et al., 2015), and public health interventions focused on improving food handling practices through education have been implemented in the United States with notable success (Kadariya et al., 2014). Yet, the challenges in developing countries include lower levels of knowledge and inappropriate food handling techniques (Tessema, Gelaye, & Chercos, 2014), as well as varying degrees of regulatory maturity and oversight.

Although existing data were sparse, initial indications noted by the campaign planners were that proper food handling techniques were not widely known by general publics in Kuwait. For example, Kuwaiti students had demonstrated low

levels of knowledge about food handling as a source of foodborne illnesses according to Nedaa Al-Khamees (2007), a scholar whose published work was reviewed by the Safe Food, Safe Family campaign's Steering Committee. Al-Khamees revealed that these university students could explain why food safety is important, but did not possess knowledge about how to handle food safely. One such reason for this finding, Al-Khamees noted, is that Kuwaiti schools do not teach food safety even when home economics is taught, and therefore a proposed solution involved the use of hands-on, practical, visual means to transmit the knowledge. In addition, many Kuwaitis do not participate directly in food preparations, as this is often the province of domestic helpers within the typical household.

GOALS

Overall, the goal of the Safe Food, Safe Family campaign was to raise awareness about food safety in an attempt to prevent cases of food poisoning that may result from improper food handling by consumers.

The goals of the campaign can be summarized in three main points, ranked in order of importance as described by the interview respondents:

- To educate people on food safety and potentially reduce the number of food poisoning cases in the country
- To promote the corporate social responsibility of the Al Yasra brand among its most important stakeholders
- To influence and educate regulators to show "concern and diligence," as both protectors of the public interest and as supporters of such a public service campaign.

OBJECTIVES

The objectives of this campaign can be expressed in relation to three groups of key stakeholders. The first objective was to increase *consumer* awareness about food safety by engaging with individuals. The second objective was to add credibility to *food retailers* by providing reassurance to the consumers. Finally, the tertiary objective was to educate *regulators* to identify effective food handling practices within the industry and to create a list of best practices that can improve their professionalism. However, the primary focus of this campaign was on the consumer. Due to the demographics of the Kuwaiti population, tactics were delivered in five languages. More specific, measurable objectives were not set as a part of the campaign planning.

KEY PUBLICS

The main target audience of the corporate social responsibility campaign was a typical household in Kuwait. To reach an individual household, the Safe Food, Safe Family campaign planners, identified several key publics:

- Household matriarchs:

Due to the traditional gender roles, prevalent in Kuwaiti society, women are likely to be more knowledgeable of domestic activities. Al-Khamees (2007) noted that females were more likely to know more about food safety than their male counterparts. This can largely be attributed to traditional gender roles, which emphasize the role of women in the domestic sphere in Kuwait, such as meal planning and preparation. Given the hierarchical power structure within the typical household, this population was also seen as exerting primary influence over the domestic helpers most commonly tasked with food preparation and thus in the best position to promote safe food handling practices. This targeted public included women over the age of 18 who communicate in English and Arabic languages.

- Domestic helpers:

As stated previously, live-in maids and housekeepers are common in Kuwait. These roles are primarily filled by females from low-income countries in South Asia, as well as Indonesia and the Philippines. On the other hand, hired chefs (also living in many households) can be either male or female, frequently from India and the Philippines, and therefore the Hindi, Tagalog and Malayalam languages were used in addition to Arabic to communicate with these domestic workers. Both groups, maids and chefs, were expected to participate in food preparation and be over 18 years of age.

- Bachelors:

Bachelors refers to unmarried men or women over the age of 18 living outside of the family. Kuwait has a high number of (mainly male) bachelors who migrate there for employment opportunities. This group was expected to do most of their own food preparation. Bachelors were expected to mainly speak in Hindi, Tagalog, Malayalam, Arabic or English.

- Students:

Students were children up to the age of 30 years old. Young children were included in order to remind parents of the importance of food safety practices inside the

home. Older students, including high school students, were included because many would be learning to prepare food independently. They include both males and females, who spoke either Arabic or English. They were included to raise awareness among future generations and spark discussions among family members.

- Kitchen entrepreneurs:

This public refers to small businesses that sell food prepared in the residences of the entrepreneurs. Such businesses are increasingly common in Kuwait with the advent of digital means for ordering food deliveries and are a popular enterprise in the country. Given the possible risks associated with food preparation among this community, they were also considered important targets for the campaign. These entrepreneurs typically range between the ages of 18–50 years old. They can be male or female, and communicate in the English or Arabic languages.

- Al Yasra Customers:

Al Yasra Foods is a food distribution company, and its customers are often retailers—supermarkets, restaurants and other businesses that consumers of food would generally visit to purchase items. Staffs in these retail organizations play a function in wholesale purchasing decisions and retail promotional activities. Their perception of Al Yasra's professionalism can have a direct impact on the retailers' operations. These customers are predominantly male and above the age of 18. They were targeted in the Hindi, Tagalog, Malayalam, English and Arabic languages.

KEY MESSAGES

The campaign planning team reviewed international food safety standards to examine various messages previously communicated to consumers in other countries. In the United States, the website of the food distribution organization ConAgra Foods was reviewed, along with linked material from FoodSafety.gov—an initiative put together by three federal agencies: Centers for Disease Control and Prevention, Food and Drug Administration, and Food Safety and Inspection Services. In Australia, information directed at consumers by the Food Safety Information Council was consulted. Further, information to inform consumers by a British-Irish initiative, Safe Food, was examined. Regionally, the Abu Dhabi Food Control Authority website has a list of awareness tips that relate to food safety as well. The conclusion of this research process was that there are some techniques to improve food handling to prevent food contamination that could be translated into the local cultural context.

"We analyzed it and then we came out with the right structure that would work for Kuwait specifically," said Ashlina Davidson (personal interview, April 21, 2016), a member of the public relations team working on the campaign. Among the customizations deemed necessary for adaptation to Kuwait were adapting food safety standards so that they are applicable to local customs. For example, how food safety during weekly family meals common to Kuwaiti homes, often referred to as family gatherings, was included. Davidson added that the campaign assumed the general population did not understand the basics of food safety since "this was the very first time something like this was done in Kuwait." Further, the phrase "Safe Food, Safe Family" (SFSF) was used as the branding associated with the key messages. "We made sure that we did not put Al Yasra in the face of everything," said dietician Dana Ghareeb (personal interview, April 26, 2016). Instead, the focus of the campaign was on the public service component with an explicit emphasis on the relationship between food and family safety. The campaign strategy document prepared before launching the campaign articulates this relationship well:

> Everyone has the potential to contract foodborne illness. Certain people, however, can be at far greater risk of developing serious illness, due to underdeveloped or impaired immune systems. Especially children, pregnant women, and the elderly [sic]. As more and more of what we eat is grown by others, prepared by others, and served by others, we have to be aware of how to protect our families from the risks of mishandled food in our homes. (Bensirri Public Relations, 2013, p. 9)

After completing the initial research and planning, the team decided to focus on four main messages for the campaign: clean, separate, chill and cook. Although these four themes were often repeated as the primary messages communicated in this campaign, other messages were also included to make the campaign less monotonous, according to Davidson. "To make it a bit more interesting, we did customize it," she added, by including "different and other elements" that pertain to food safety. This also increased the potential utility of the information, adding to the campaign's appeal. These messages include information about food safety while traveling, during family gatherings, at barbeques and at work. However, these secondary messages were emphasized less frequently than the four primary messages.

STRATEGIES

The Safe Food, Safe Family campaign applied a diversified communication strategy focusing on (1) building in-person relationships, driving change by engaging with the key publics and households; (2) using third-party endorsers or influencers, such as news reporters, bloggers, nutritionists and the Ministry of Health in Kuwait; (3) producing educational material in five different languages, and (4) engaging in online

conversations about food safety with members of the general public who had not been properly introduced to basic food-safety practices. Each are elaborated below.

- In-person relationships. The campaign sponsors capitalized on their existing ties with co-operatives (state-owned supermarkets) in Kuwait as an important part of the campaign. Face-to-face interactions with consumers shopping at the co-ops used competitions and information stands to increase the efficacy of the key messages for the target audiences. These organized activities tried to match the communication to the audience's expectations and levels of understanding, keeping them engaged through interactions and avoiding a more formal educational or academic approach.
- Third-party endorsers. The initiative was fronted by a registered dietician employed by the client, Al Yasra, as a nutrition and health officer, Dana Ghareeb, who oversaw each nutritional fact presented through the campaign and was present at all major campaign events. She was also the main spokesperson for press engagements. Two other part-time nutritionists in the Al Yasra team, Hyatt Al Sayegh and Zahraa Alkabazz, were part of the initiative, as were four key influencers in the local food arena—Sami Bader, "Diet Ninja," Chef Adlah and Ahmad Bader—who became ambassadors to the campaign. These chefs are youthful Kuwaiti nutritionists and chefs who appeared at public events and on social media. In addition, the Ministry of Health in Kuwait endorsed the initiative, recognizing the importance of food safety in households and the credibility of being associated with the campaign.
- Multilingual materials. Flyers and the main educational video were produced in five different languages (Arabic, English, Hindi, Tagalog and Malayalam) to cater to the needs of both the local and expatriate populations. With the guidance of a team of the previously identified nutritionists employed by Al Yasra and dedicated to the cause, the messages were built to intrigue and educate various target audiences. The content was designed to be simultaneously engaging, consumer-friendly and educational.
- Social Media Engagement. Given the high proportion of social media users in the country, specific Twitter, Facebook, Instagram and YouTube accounts were created. In addition, social media posts were developed for high-profile partner accounts including known retailers and social media influencers, such as nutritionists and general figures.

TACTICS

Based on these strategies, multiple tactics were implemented, including the SFSF website, educational materials, publicity events, videos, social media profiles and media relations.

- *Website* http://safefoodsafefamily.org/en/

The website played a role as the epicenter of food safety knowledge in both Arabic and English. The interface was simple, yet creative and current. Its main mission was to ensure the audience could easily find the right answers to whatever they were looking for. Food safety materials were available for download from the website in multiple languages and all videos were also linked through the site.

- *Educational materials*

Educational brochures were developed in five languages and approved by the nutritionist team. The design was friendly and contemporary and the information was included in four different flyers: "What's on your chopping board?" "What's in your fridge?," "What's underneath those gorgeous nails?" and "What's in your food?" These materials were distributed at the events organized during the campaign and were also available for download on the website.

- *Outreach events*

The program included a total of 34 events held across Kuwait at supermarkets, public beaches, schools, banks, oils companies, expos, ministries and other venues. As part of the event program, 19 co-ops and hypermarkets held a "Food Safety Week," spreading awareness on the importance of food safety by targeting the first stage of the consumer food preparation experience, which happens at the supermarket. Booths were set up to pass out information, demonstrate how to pack grocery carts and answer consumer questions. The week culminated with a grocery-cart competition that tested how well consumers understood the basics of food safety. Three winners who could shop and pack their grocery carts in the safest manner walked away with a grocery cart full of food items worth 500 Kuwaiti Dinar ($1,660 USD). The competitions generated buzz, excitement and good visual materials for press circulation, as well as general campaign promotions.

Safe Food, Safe Family campaigners also visited several government-funded and private schools in Kuwait to teach to students about food safety. In addition, they hosted a half-day seminar at the Kuwait National Petroleum Company (KNPC) headquarters and educated over 1,000 employees on the basics of food safety in the workplace. This event also featured an outdoor barbecue session to explain how to avoid both food contamination and food poisoning while barbecuing, plus ways employees could make their own safe cleaning detergent at home. Another two barbecues, organized at Messila Beach and Green Island, resulted in heavy promotion, and posters and booklets were massively distributed.

A food safety booth was also installed in a popular outdoor farmer's market with the aim of reaching younger, alternative shoppers. The booth consisted of two

parts, an educational component that aimed to introduce food safety in a fun and engaging way, as well as an interactive demonstration showing people how to create their own safe detergent. The program was completed with additional activities at several local malls and beaches.

Figure 13.2 includes a list of the events, their locations and the time in which they took place.

- *Educational videos*

The Safe Food, Safe Family YouTube channel offered 18 educational videos in total. Among them, there were videos related to barbecuing safely as well as others with comic stop-motion animation to attract attention and provide a soft approach to pushing the information. The primary challenge with this tactic was getting the audience to watch the educational videos, which had the potential to be long and dry. So instead, the campaign organizers focused heavily on producing short Instagram videos. In addition, the PR company produced videos about food safety for the event partners and various social influencers.

- *Social media*

Given the high degree of their use in Kuwait, social media platforms enhanced the campaign's ability to raise awareness and engage with the audiences. As stated, the campaign used four popular social media platforms available at the time: Instagram, Twitter, Facebook and YouTube. Instagram (@safefoodsafefamily) played a pivotal role in the education of the public through engaging and informative posts with strong visuals, as well as event posts. In addition, social media posts were also developed for partner accounts as well as for influencers who were both nutritionists and general figures. By the close of the campaign, the Instagram account had more than 4,300 followers. Interactive video-posts, tips and event snapshots were posted three times a week. All posts with tips provided an explanation on why the food safety tip should be followed as well as a call to action to learn more through the website.

The public was also able to ask questions about food safety and learn more about the campaign as a whole.

Figure 13.1 outlines some of the key elements of the various social media platforms used in order to demonstrate both their similarities and where they were perceived as offering different opportunities.

- *Media relations*

Press engagement through both print media and television also played a key role in disseminating information about the initiative and highlighting Al Yasra Foods'

	Instagram	Facebook	Twitter	YouTube
Audience	Women, Men, Locals, Expats (High-income)			
Language	Arabic, English (80%, 20%)			
Tonality	Ad-campaign style with humour injected when possible	Friendly, Elongated messages + Image	DYK-based, Friendly, Fun, Brief Links to Instagram	Factual, Straight to the point with keywords
Frequency	Every 2 days for the first 3 months			Monthly
Comment Monitoring Frequency	Every 3 hours			Every alternate day
Hashtags	#kuwait #foodsafety #safefoodsafefamily			

Fig. 13.1. Social media strategy. Author's creation.

role in reducing the potential number of food poisoning cases in the country. Press feature stories were specifically drafted and pitched to dailies, with exclusivity, for a more in-depth approach to press coverage. The initiative also gained regional attention when the Middle East Food Magazine, a leading B2B food distribution magazine and the BBC's Good Food Middle East all featured articles on the Safe Food, Safe Family campaign and the role the initiative has in reducing the number of food poisoning cases in households in Kuwait. In addition, a DVD package with information about the campaign was sent to key influencers such as bloggers and journalists.

CALENDAR/TIMETABLE

The Safe Food, Safe Family campaign was launched on November 5, 2013 with an event held at a large, popular mall and inaugurated by the assistant undersecretary of the ministry of health for medical services, Dr. Mohammad Al-Khashti. The event was also attended by a large audience from Kuwait's health and safety industry, including officials from governmental and corporate bodies, nutritionists, influential guests within the health industry and the national press. Figure 13.2 reflects the calendar of events and the estimated number of families reached, based on the assessment provided by the managing PR company.

	Event	Activity	Day	Families reached
1	Launch Event	Launch	November 5	160
2	Zahra Cooperative	Food Safety Week & Grocery Cart Competition	October 20-24	300
3	Lu&Lu Hypermarket	Food Safety Week & Grocery Cart Competition	November 11-16	240
4	BBQ event at Messila Beach	Learn to BBQ Safely	November 29	226
5	Saad Abdullah Cooperative	Food Safety Week	November 30-December 3	N/A
6	BBQ event at Green Island	Learn to BBQ Safely	December 6	274
7	Khaldiya Cooperative	Food Safety Week & Grocery Cart Competition	December 8-11	260
8	Rawda/Hawally Cooperative	Food Safety Week & Grocery Cart Competition	December 15-19	380
9	Shamiya/ Shuwaikh Cooperative	Food Safety Week & Grocery Cart Competition	December 21-24	280
10	Adailiya Coop	Food Safety Week & Grocery Cart Competition	January 19-22	330
11	Jabriya Coop	Food Safety Week	January 26-29	N/A
12	Marina Mall	Learn Food Safety Basics	January 31	521
13	Qout Market	DIY: Safe & Organic Detergent	February 1	487
14	Bayan Bilingual School	Food Safety at Universities	February 16	65
15	Hateen Coop	Food Safety Week & Grocery Cart Competition	February 16-19	122
16	Cambridge English School	Food Safety for Kids	March 4	511
17	Al Salam Coop	Food Safety Week & Grocery Cart Competition	March 2-5	270
18	Ministry of Health Expo	Learn Food Safety Basics	March 10-12	670
19	Prime & Toast	Food Safety Month	March 5- April 5	3000
20	Bubbles Montessori	Talk+DIY Detergent+Demo	March 12	25

	Event	Activity	Day	Families reached
21	Bayan High School	Seminar	March 26	60
22	Adaliya High School	Seminar	March 16	55
23	City Center Jahra	Food Safety Week & Grocery Cart Competition	March 16-19	200
24	City Centre Salmiya	Food Safety Week & Grocery Cart Competition	April 6-9	880
25	Yamouk Coop	Food Safety Week & Grocery Cart Competition	March 30- April 3	410
26	The Sultan Centre-Shaab	Food Safety Week & Grocery Cart Competition	April 10-14	351
27	The Sultan Centre-Shaab	DIY: Safe & Organic Detergent	April 10	56
28	The Sultan Centre-Shaab	Food Safety Week & Grocery Cart Competition	April 18-21	270
29	The Sultan Centre-Shaab	DIY: Safe & Organic Detergent	April 18	45
30	The Sultan Centre-Jabriya, Al Kout Salmiya Shuwaikh	Learn Food Safety Basics	April 10-22	N/A
31	KNPC	Seminar, BBQ, DIY Detergent	April 15	1,000
32	Ministry of Islamic Affairs	Seminar	May 12	80
33	National Bank of Kuwait	Consultation, Pack Your Cart	May 21-22	210
34	Kuwait Oil Company	Consultation, Pack Your Cart	June 3-4	400

Fig. 13.2. Table of activities. Author's creation.

BUDGET

The expenditures on the campaign were less than half a million U.S. dollars. The Safe Food, Safe Family campaign "was fully funded by Al-Yasra," said Dana Ghareeb, the primary nutritionist associated with the campaign. According to

the PR company's managing partner, Fawaz Al Sirri, this is especially significant considering that charities and corporate social responsibility (CSR) initiatives in Kuwait are not eligible for tax breaks, as in many Western countries. "These guys are so genuine," he explained.

This budget was utilized to develop multilingual content, purchase printed materials (roughly 20 percent of the budget) and to cover agency fees (roughly 80 percent), such as labor, content development and production.

The translation of the content into multiple languages was also covered as part of the agency fees. This distinguishes the communication market in Kuwait, other Gulf States, and similar multicultural environments. According to Al Sirri, "language is a major issue," pointing to the fact that public relations firms in the United States and Europe operate predominantly in a single language. "But here everything is in [at least] two languages. If it's Arabic, it's subtitled in English. And if it's English, it's subtitled in Arabic." Al Sirri's opinion is consistent with that of a communication scholar from the United Arab Emirates who explained that public relations practitioners in the region "must consider a range of language and cultural disparities" (Al-Jenaibi, 2014, p. 20).

While the developed content was included in media coverage, this was primarily through earned media. Despite the fact that Onyebadi and Alajmi (2016) showed that there is an expectation that even well-paid Kuwaiti journalists often expect to receive gifts for writing reports, the Safe Food, Safe Family's public relations team refused and voiced objections to unethical practices involving paying journalists. In the words of the company's managing partner Fawaz Al Sirri, "When a newspaper covers us, it is because they like what we are doing. We earn the coverage, we don't pay for it. We think paying journalists is unethical." To bolster this earned coverage, several direct advertisements were also purchased in the local media.

Although research was conducted, the budget for research and evaluation was kept to a minimum. According to members of the PR team, due to the small size of the Kuwaiti market (consisting of only a single city) justifying the cost of primary research was difficult and unnecessary for the SFSF campaign. Since the project was not commercially oriented, secondary indicators were utilized to gauge public knowledge and attitudes through monitoring and coverage reports as outlined in the next section. "Kuwait is a market where you can get a feel," said Al Sirri, as he explained a process of engaging in conversations with various people to gain anecdotal assessments of success. He further explained that he expected this informal process to change in the future as "the market gets bigger and more sophisticated," thereby requiring more objective and systematic tools for suitable evaluations.

EVALUATION AND MEASUREMENT

The lack of formative research, measuring pre-campaign levels of awareness, attitudes and perceptions about food safety, and developing SMART objectives prevented accurate evaluative research. But even if it is not possible to know the extent to which the target audience understood, retained and acted on information, notable campaign outputs still appeared significant. Some of the primary evaluative metrics are listed below.

Results:

- Mass media coverage: 54 articles in national dailies, 9 in magazines, 24 in online publications, and 8,412 minutes of TV airtime
- 7,500 families directly engaged through face-to-face interactions
- Over 90,000 video views
- 4,200 Instagram followers, 258 likes on Facebook and 26 Twitter followers.
- 6,500 website visits over the seven months of the campaign's activity
- An estimated 700,000 potential people reached through media exposure, events and social media combined (approximately 1 out or every 5 residents in the country)

One of the factors affecting the results of the SFSF campaign was the shortening of the time originally planned. Actually, the initiative was supposed to last three years, with phase 1 slated for one year. However, the campaign only ran for seven months due to a change in Al Yasra's leadership, thereby making it difficult to reach the broad spectrum of publics conceived during the planning phase. Per the PR company's managing partner, Al Sirri, outreach initiatives like SFSF need time to grow and the lack of time was a significant barrier to achieve all the expected outcomes. "The initiative concluded at its peak, at the pick-up of a J-curve. We now know that more time is needed to get maximum reach", affirmed Al Sirri.

Interactive and in-person events had high reach in terms of direct engagement. The campaign activities that facilitated these events were the main success of the campaign, with more than 7,500 families reached. Dana Ghareeb, nutritionist and spokesperson, explained that younger housewives, newlyweds and students were more receptive to their messages than older women who felt they had sufficient experience handling food. In her experience, interactive activities were more successful and effective than visual messages and videos, because the audience had the opportunity to ask for clarification. Cooperative events in low-density areas were not highly successful as it was not able to reach large numbers of the target audience. Moreover, certain cooperatives were not as enthusiastic as others in hosting the campaign, thus not capitalizing on the pre-event hype that

could have been attained. Also, due to the delayed timeframe in approaching the cooperatives, some of the events were finalized in just one day, which resulted in the cooperatives/hypermarkets not fully understanding Food Safety Week's function in education.

The constant availability of a spokesperson was considered integral to the success of all communication activities as well as to the influencers' endorsements. Regarding the digital communication tactics, the website did not attract constant flow of visitors—although it served its purpose as a reference point/library for information. Social networks, especially Instagram, reached a high number of citizens and were seen as an important part of the campaign success, even though the PR agency acknowledged that they should have place more emphasis on the social media strategy. Within their various social media platforms, Twitter and Facebook accounts were less successful and reached less followers during the campaign than desired.

Finally, this campaign demonstrated the importance of perceptions of food safety when data indicating the rise of foodborne illnesses are unavailable according to reports made to Kuwait's Central Statistical Bureau.

REFERENCES

Al-Jenaibi, B. (2014). Disparities between UAE and other Public Relations Professionals: Challenges, Opportunities, and Cultural Obstacles. *Review of Journalism and Mass Communication, 2*(2), 19–40. doi:10.15640/rjmc.v2n2a2.

Al-Khamees, N. A. (2007). Food safety knowledge and reported behaviour of university students in Kuwait. *International Journal of Health Promotion and Education, 45*(3), 93–99. doi:10.1080/146 35240.2007.10708110.

Al-Roomi, S. (2007). Women, blogs, and political power in Kuwait. In P. M. Seib (Ed.), *New media and the new Middle East* (pp. 139–155). New York, NY: Palgrave Macmillan.

Al-Sumait, F. Y. (2013). Communicating politics in Kuwait. In P. N. Howard & M. M. Hussain (Eds.), *State power 2.0: Authoritarian entrenchment and political engagement worldwide* (pp. 99–112). Farnham, Surrey; Burlington, Vermont: Ashgate.

Arab Social Media Report. (2014). Twitter penetration. *Twitter in the Arab Region.* Retrieved from http://www.arabsocialmediareport.com/Twitter/LineChart.aspx?&PriMenuID=18&CatID= 25&mnu=Cat

Bensirri Public Relations. (2013). *Safe food, safe family: Strategy, direction and operational plan.* Retrieved from document authors.

Central Intelligence Agency. (2016). Kuwait. *The world factbook.* Retrieved from https://www.cia.gov/ library/publications/the-world-factbook/geos/ku.html

Da Silva Felício, M. T., Hald, T., Liebana, E., Allende, A., Hugas, M., Nguyen-The, C., … McLauchlin, J. (2015). Risk ranking of pathogens in ready-to-eat unprocessed foods of non-animal origin (FoNAO) in the EU: Initial evaluation using outbreak data (2007–2011). *International Journal of Food Microbiology, 195*, 9–19. doi:10.1016/j.ijfoodmicro.2014.11.005.

Feghali, E. (1997). Arab cultural communication patterns. *International Journal of Intercultural Relations, 21*(3), 345–378. doi:http://dx.doi.org/10.1016/S0147-1767(97)00005-9.

Hall, E. T. (1997). Context and meaning. In L. A. Samovar & R. E. Porter (Eds.), *Intercultural communication: a reader* (8th ed., pp. 45–54). Belmont, CA: Wadsworth.

Hammoud, J. (2011). Consultative authority decision making: On the development and characterization of arab corporate culture. *International Journal of Business and Social Science, 2*(9) 146–147.

Herb, M. (1999). *All in the family: Absolutism, revolution, and democracy in the Middle Eastern monarchies.* Albany, NY: State University of New York Press.

Kadariya, J., Smith, T. C., & Thapaliya, D. (2014). Staphylococcus aureus and Staphylococcal foodborne disease: An ongoing challenge in public health. *BioMed Research International*, 1–9. doi:10.1155/2014/827965.

Kuwait Central Statistical Bureau. (2014). *Annual Bulletin of Health Statistics 2013.* Kuwait Government. Retrieved from http://www.csb.gov.kw/Socan_Statistic_EN.aspx?ID=59

Mellor, N. (2005). *The making of Arab news.* Lanham, MD: Rowman & Littlefield Publishers.

Onyebadi, U., & Alajmi, F. (2016). Gift solicitation and acceptance in journalism practice: An assessment of Kuwaiti journalists' perspective. *Journalism, 17*(3), 348–365. doi:10.1177/1464884914557924.

Tessema, A. G., Gelaye, K. A., & Chercos, D. H. (2014). Factors affecting food handling Practices among food handlers of Dangila town food and drink establishments, North West Ethiopia. *BMC Public Health, 14*(1), 571. doi:http://dx.doi.org/10.1186/1471-2458-14-571.

Tétreault, M. A. (2000). *Stories of democracy: Politics and society in contemporary Kuwait.* New York, NY: Columbia University Press.

The World Bank. (2016). World Development Indicators. *Internet Users Per Capita.* Retrieved from http://databank.worldbank.org/data/home.aspx

United Nations Statistics Division. (2016). *Kuwait Country Profile.* Retrieved from http://data.un.org/CountryProfile.aspx?crName=KUWAIT

Mead Johnson

Infant Formula to Make a Difference in China

CHUN-JU FLORA HUNG-BAESECKE
Massey University

XIAOHONG CHEN
Huazhong University of Science and Technology

XIAODONG YIN
17PR organization

EDITOR'S NOTE

Targeting messages to appropriate publics is critical to the success of any public relations campaign, and is even more important when the publics are from a country and culture far different than a company's home base. This case illustrates how Mead Johnson, whose vision is to be the world's leading nutrition company for babies and children, tapped into a country's concern over pediatric nutrition and provided medical support and special infant formula to children with a condition called Phenylketonuria (PKU) in rural areas in China. In addition, Mead Johnson also engaged closely with relevant stakeholders for providing substantial support to the PKU families, and raised awareness of PKU and its treatment. The project won a Golden Flag award in China in 2015

INTRODUCTION

Mead Johnson Nutrition Company, founded in 1905 and now headquartered in Glenview, Illinois, USA, is a global corporation in pediatric nutrition. Its corporate

vision is "to be the world's leading nutrition company for babies and children" (Mead Johnson, n.d.). One of these products, Enfamil, was the top-selling infant formula brand in the US and in Canada in recent years (Key, 2016). More than 100 years after the company started, Mead Johnson had its IPO in 2009, and as of January, 2016, it serves more than 50 markets in North America, Latin America, Asia and Europe (Mead Johnson, n.d.).

Mead Johnson entered the market in China in 1993. Since then, the company has been committed to become the most trusted nutrition company for babies and children in China (走进美赞臣, 2014). With its advanced technology, accumulated knowledge and more than 100 years of expertise in pediatric nutrition, Mead Johnson also is providing support and assistance to mothers with newborn babies, babies and children in rural areas in China (走进美赞臣, 2014). For example, since 2005, Mead Johnson has been greatly involved in various corporate social responsibility (CSR) programs such as providing subsidized nutrition to babies and children of poor families in rural areas, offering professional training for frontline pediatric medical staff, collaborating with the government and national NGOs for raising public awareness on some medical conditions affecting children and donating to disaster relief in the rural provinces (企业关爱, 2014). Among all these CSR endeavors, Mead Johnson's campaign (2009 – 2014) in support of the Phenylketonuria (PKU) treatment by providing Mead Johnson's products and technology and getting more government and public attention on this illness is a major achievement which has received recognition from the Chinese government and society.

BACKGROUND

Phenylketonuria is a hereditary metabolic disorder. The body of the patient with PKU fails to process and convert phenylalanine, an essential amino acid that the human body needs for good health, and development of the brain and nervous system can be severely affected. Phenylalanine can only be obtained from food.

Medical studies have shown that most infants with PKU who receive special food treatment containing no/low phenylalanine can avoid being intellectually damaged. Research also has demonstrated that treatment is most effective when such an illness is diagnosed in the first three months after birth. Thus, babies with PKU diagnosed by neonatal screening (also known as "new screening") should immediately be given continuous treatment. However, the expensive special dietary requirements make it impossible for many children of poor families afflicted with PKU to receive a timely, sustained and effective treatment diet. Meanwhile, there is no nationwide system in China for the management of PKU or for the sharing of related medical technology and experience. Moreover, public and community awareness for PKU disease, and neonatal screening is seriously inadequate.

In June 2009, China began to put into force the "Administrative Measures for neonatal screening" issued by the Ministry of Health (now known as National Health and Family Planning Commission, NHFPC) and incorporated PKU as one of the new diseases for which newborns would be screened. In this context, led by the Maternal and Child Health Services Division of NHFPC, co-sponsored by the National Maternal and Child Health Surveillance Office and Mead Johnson Nutritionals (China) Co., Ltd, the "PKU children with special milk subsidy project" was officially launched in December 2009. Over a period of five years, Mead Johnson offered free Mead Johnson ® benzene alanine formula milk powder to impoverished children with PKU in midwestern China for three years per child. This initiative covered 21 provinces and regions.

This is China's first project that concerns children with PKU which also explores treatment and management of PKU. It also has established a national standard PKU treatment follow-up and management system. Meanwhile, the project continues to spread of the knowledge regarding PKU and brings the disease, the community and the notion of neonatal screening into the public view.

PROJECT RESEARCH

To ensure a successful implementation in providing support to PKU babies and children, during the preparatory phase of the project, Mead Johnson had to identify various stakeholders in the project and available resources. It also conducted a feasibility analysis that generated important data:

- Project operational resources provided the NHFPC (the supportive institute), the National Maternal and Child Health Surveillance Office (organizer) and Mead Johnson Nutritionals (China) Co., Ltd. (co-organizer), namely:

The identification of the partnership with the relevant government agencies was a crucial step for the success of this initiative because it meant this project was also supported by the government, thus enabling Mead Johnson to obtain the authorization from the most important stakeholder in China for project implementation and supportive resources.

The "Administrative Measures for Neonatal Screening" carried out by NHFPC promoted the wide adaptation of neonatal screening. The diagnosis and effective treatment for PKU disease is closely related to the neonatal screening. The implementation of "Measures" was the basic step that allowed the project to identify children with disease and to carry on with diagnosis and treatment as soon as possible.

The global scientific and nutritional resources that Mead Johnson has developed over a century allowed the company to quickly identify treatments for PKU

patients. Thus, these world-leading scientific technology and treatment experiences were introduced into China.

- Insights provided by PKU patients and families for the communication project:

In order to increase public awareness for PKU disease and families that made up the PKU community, understanding and exploring the patients' experiences were needed in preparation for the communication campaign. Therefore, in the beginning phase, the project team visited and interviewed a total of 16 children with PKU throughout the country and evaluated the typicality of the samples and the feasibility of the project.

The interview results showed that the PKU patients were relatively reserved in talking about their experiences. However, the government and the medical system in China had lacked the awareness of the seriousness of PKU before 2009, and there was no comprehensive treatment or newborn screening for PKU. Therefore, families with children afflicted with PKU were lured to trust the unofficial and unauthorized treatments introduced by unethical pharmaceutical companies or local hospitals, which resulted in extensive unsuccessful PKU treatments. These experiences caused their low trust or distrust of society and the Chinese government.

For these reasons, communication with the PKU community (the families of PKU patients) was frequent as the PKU families formed their own support groups and shared information. The relationships inside the PKU community also were tight-knit.

- Communication channels between the publics and the PKU community provided by the media. In the initial communication stage, research was carried out by Mead Johnson and its public relations firm, Blue Focus, on how to ensure there would be continuous interactions with the target audience in the communication process, and to collect information and insights for future communication.

Through this research, information on the target audience (identified in the "Project Planning" section), special communication issues and concerns (such as blaming the government for neglecting the seriousness of the disease, exaggerating the negative disease effects that produced the negative perception on the disease and other factors detrimental to the interviewed families), consensus was built with all the relevant parties. These issues and concerns provided insightful information in developing the communication plan.

GOALS AND OBJECTIVES

Objectives were:

- To provide impoverished infants with PKU with nutritional support from birth to 3 years old and with continuous follow-up treatment

- To motivate the Chinese government, medical institutions and social welfare organizations to help people with rare birth defects and to comprehensively support the operation of the project
- To establish a national standard for PKU follow-up treatment and management
- To enhance public awareness of PKU, the PKU community and the new screening; to advocate concern about PKU in the general population and to support the PKU community
- To promote the project achievements, highlighting the social value of the project
- To demonstrate the social mission of Mead Johnson as the project partner, its commitment to public services and its professional brand image in the field of infant nutrition.

KEY PUBLICS

This campaign aimed at raising more awareness of PKU among:

- The medical and health staff in China
- The relevant government departments
- The Chinese public.

In addition, this campaign also aimed at enhancing the relationship between the families of PKU patients and the relevant government departments and the medical and health sectors in China.

KEY MESSAGES

- To widely enhance public and government awareness of PKU, local and national mass media and social media were utilized in this campaign
- Urban mass media for widely spreading the knowledge on new screening, PKU and the PKU community
- State or provincial media, such as *People's Daily* and China Central Television, for highlighting the government's attention to and leadership role in enhancing awareness of PKU and PKU treatment
- Major social media in China, such as WeChat and Weibo, for communicating and interacting with the publics online

STRATEGIES

To achieve the objectives of providing medical and nutritional support to PKU patients and establishing a nationwide PKU medical system, Mead Johnson developed the following strategies:

- Identifying PKU infants and children from China's poverty areas for treatments and providing infant formula subsidies
- Providing the supervision, training and education for new screening diagnosis and treatment technology
- Developing close and collaborative relationships with major nationwide medical systems in China for the support and resources of the project operation
- Motivating the commitment of the relevant government agencies, medical institutions and social welfare organizations for helping PKU patients and families

In addition, Mead Johnson also developed the following media and communication strategies:

- Using the associating points between the new neonatal screening and the public, exploring the common universal value between PKU community and the public that can cause resonance between them
- Using a communication warm-up video to circulate on the internet
- Using special occasions and events for more communication promotion opportunities
- Emotionally motivating the target audience by real stories from PKU patients and families.

TACTICS

Supporting PKU Patients and Their Families

Under the leadership of the Planning Services Division of Maternal and Child Health of NHFPC, co-sponsored by the National Maternal and Child Health Surveillance Office and Mead Johnson Nutritionals (China) Co., Ltd., the "Special Milk Powder Subsidy Project for Children with Phenylketonuria" was launched. Within five years, each of the families with PKU patients were provided free Mead Johnson ® benzene alanine formula powder for 3 years. In all, more than 500 impoverished families with children diagnosed with PKU were subsidized.

The first special milk powder subsidy project that focused on children with PKU not only improved the PKU treatment success rate but also identified a successful model for PKU treatment and management. These achievements helped promote the positive outcomes of new screening procedures, provided a scientific foundation for Mead Johnson's nationwide promotion on the disease treatment, and most of all, drew more attention from the government and the general public on awareness of the disease. In recent years, a number of provinces and cities have adopted policies on aiding PKU patients and have gradually included PKU treatment costs in the new rural cooperative medical system.

Technical Training and Health Education

During the implementation period, the project held a variety of technical training courses, distributed 232 million copies of health educational materials and visited 162 households with PKU children. More than 120 provincial and municipal new screening centers and thousands of medical staff participated in these activities. This helped enhance domestic PKU treatment technology and management, and had a positive effect on the implementation of the national treatment subsidy policy for children with PKU.

Mead Johnson used the advantage of its global reputation on infant nutrition to provide nutritional supports in the infant medical sector. The company also invited prominent international PKU specialists to offer training on PKU treatment and dietary management to the Chinese medical personnel in specializing in treating PKU. As a result, the world's leading scientific research technology and experiences were introduced into China.

High-level Government Meetings on PKU

Within the five years during which the project was implemented, there were four periodic meetings held by the government. Each participant as well as involved medical staffs and media shared the progress and results the project had achieved at different stages. In the project wrap-up meeting in 2014, some new activities also were included:

- Medical staffs and new screening experts shared their unforgettable memories
- Five PKU children receiving aid represented all the PKU children who received the "Bloom of Hope Baby" prize. Moreover, three of them gave live singing and dancing performances, showing their healthy and cheerful images.
- Children aided by the project participated in the creation of more than 30 pieces of palm print paintings that demonstrated sunshine and vitality. The paintings were displayed at the wrap-up meeting and were given to project

representatives from different regions in China to show the appreciation from the PKU children

- Representatives of the aided children presented flower-patterned jigsaw puzzles to representatives of each project participants. The souvenir carried the meaning that through the five-year care and support from this project, the lives of the 509 aided PKU children were able to blossom and the children were given hope for their lives. The jigsaw puzzle showed the great gratitude from these children and their families to the project, the medical staffs and Mead Johnson
- In the future, the government, relevant medical organizations and more social welfare organizations will continue working together, by providing nutrition assistance, professional training and other public service activities, a broader platform for newborn PKU care in China.

EVALUATION AND MEASUREMENT

During the implementation of the project, the project team visited Hebei, Jilin, Anhui, Gansu, Hunan and other places in China, engaging in detailed exchanges with local health authorities on the management and the implementation of the project and the technical specifications of new screening and PKU case management. The team also paid visits to some of the children with PKU in rural areas.

Based on statistics accumulated by Mead Johnson and the Chinese government, among all levels of new PKU screening organizations, 90 percent expressed satisfaction with the recruitment and management of the PKU children treatment, the distribution and management of special milk powders and the new screening technical training and health education within the project. Moreover, parents of PKU children showed 90 percent satisfaction with the PKU treatment, the distribution and management of special milk powder and PKU education provided to parents whose children were diagnosed with PKU.

Effectiveness of Communication Actions

Using special occasions, such as China's Birth Defects Prevention Day, the team widely used the national and local media in promoting the awareness of PKU and encouraged pregnant women to consider having neonatal screening for their newborns.

Furthermore, with the popularity of neonatal screening as the breakthrough point, the team also carried out an online survey on Sina Weibo about knowledge of new screening. The survey results were adopted for preparing the communication materials for raising public awareness on screening and PKU.

The warm-up video uploaded on the Internet prior to the launch of the program was developed around the central idea of "belief", which highlights the perseverance of PKU community, their families and medical personnel facing the disease. This also corresponds with the universal social value.

Adopting the successful story of the Ice Bucket Challenge, the team also took the opportunity to issue news releases to raise public awareness and knowledge that PKU is also a rare disease severely affecting newborns and children in China.

To emotionally motivate the public and the target audience in supporting PKU treatments, the team did the following:

Collaborating with the mainstream urban media for several in-depth interviews with PKU patients and their families for developing news feature stories and publishing reports on PKU.

Producing documentaries on children with PKU, in which their happiness and hopefulness from receiving help and the dilemma in their daily lives, the experiences they narrate themselves are documented in the initial, middle, and the concluding stages of using the product. These were short documentaries genuinely and authentically recording the lives of the PKU communities and the changes after receiving aid from the project.

Immediate Effects

Four government meetings shared the progress, results and shortcomings in different stages of the project, in order to guide the project to the next step.

During the meetings, the living conditions of PKU children was demonstrated using exhibition boards and short videos. On the one hand, participants (mostly leaders of NHFPC and National Maternal and Child Health Surveillance Office, medical staffs of all levels of new screening centers, media) were deeply gratified with the healthy and happy life those children lived after receiving the help. On the other hand, they further felt the mission and the responsibility that had fallen on their shoulders.

At the five-year concluding meeting in 2014, through sharing of working experience by frontline medical staff, the display and distribution of the paintings that PKU children participated in creating, the ceremony to honor the PKU children, and the live singing and dancing performances, participants were able to witness the "best beginning" that the aided children can have. Members at the meeting also felt and appreciated the sacrifice that every medical worker had made for the project.

Media Reports

In the five years of the continuous online and offline communication and promotion campaign, the achievements and experiences of treating PKU provided

valuable information that was shared within the medical system. In addition, the PKU community became recognized by the general public. Positive reports on this project were covered by the national mainstream media, including *People's Daily*, and CCTV. Thus, communication of the project had received satisfactory social effects.

Nationwide, there were about 400 print, television and online media reports by central and mainstream regional media. There were about 3,500 reports or reposts online.

From 2013 to 2014, there were more than 300 reports and republishing of articles on central and mainstream regional media, including *People's Daily*. Among them, journalists of Chongqing Morning News, Beijing News, Shenzhen Evening News and *Oriental Morning Post* were invited to visit and interview several PKU families, demonstrating the undesirable living conditions of PKU children with detailed and in-depth stories. Those stories were published extensively, a half-page or a full-page in many newspapers, bringing the social concern and attention to PKU disease and children.

As for social media, there were in more than 5 million site visits to read posts on Weibo and Wechat

Testimony by Project Participants

Since its inception in 2009 till 2014, the project has benefitted 509 PKU children in impoverished families in the midwestern area in China. Those children are now growing up happily like other normal kids. It is because of the support from a socially responsible company, like Mead Johnson, and those devoted doctors that made all this happen.

There are still difficulties in the implementation of the project, such as the remoteness of certain families that affects the distribution of the special milk powder, and the need for supervision and guidance for the neonatal screening centers in certain provinces. This has provided guidance to Mead Johnson regarding availability of milk powder subsidies and distribution for some families in the remote areas, more supervision and guidance required from provincial neonatal screening centers to the front-line staff, and so on. So, there is still a long way to go.

In short, the efforts in these five years have achieved good results, and the results are especially significant from the perspective of child healthcare in China. At the same time, this project also has advanced the inclusion of PKU treatments into China's new rural medical cooperative reimbursement system. Some cities also have begun to include this disease into those medical situations covered by medical insurance.

SUMMARY

The social and practical significance of this project can be summarized as "one focus, two establishments, three enhancements and four actualizations." They are explained as follows:

- One focus: the focus was always on providing efficient support to impoverished PKU families. Within five years, the project provided a total of 147,210 cans of free Mead Johnson ® benzene alanine formula milk powder to 500 impoverished PKU children.
- Two establishments: Firstly, the on-going establishment of archives of the health, treatment and growth of PKU children. Secondly, the establishment of a media communication and broadcasting system to disseminate the positive energy of corporate social responsibility and brand image.
- Three enhancements: The first enhancement was the upgrade of the PKU treatment technology and management levels. Secondly was the enhancement of treating PKU children treatment into the rural medical reimbursement system. The third enhancement was focusing attention from the Chinese government and Chinese publics on the community of PKU babies and their parents and of other rare diseases. It was only recently that quite a few provinces and municipalities introduced their PKU support policies
- Four actualizations: this included actual implementation of supporting families, responsibilities of doctors and medical institutes, distribution and management channels, and positive support and treatment results.

CSR Activities Aligned with the Corporate Values and Vision

Mazutis and Slawinski (2015) contended that, for corporations' corporate social responsibility (CSR) initiatives to be perceived authentic, these CSR activities should be aligned with corporate values and vision. For Mead Johnson, the corporate vision has been to become "the world's leading nutrition company for babies and children" (Mead Johnson, n.d.). Consequently, the company's citizenship initiatives were developed with that direction in mind. Nurturing communities by helping individuals and families grow and prosper drove the company to engage with its stakeholders and their communities and to identify social issues to which the company's expertise can be put to use.

In the case of supporting PKU treatment, Mead Johnson utilized its advanced scientific and technological knowledge in pediatric nutrition in a five-year initiative. The company not only provided special infant formula to newborns with PKU in the midwestern provinces in China, but also helped establish a PKU

treatment management system and networks for helping more families worldwide with PKU patients.

Social Connectedness of CSR

For an organization's, CSR to be perceived as authentic, Mazutis and Slawinski (2015) considered the necessity of social connectedness of CSR initiatives, which means an organization should deeply engage with stakeholders and be responsive to stakeholders' issues and concerns. Mead Johnson's success in this PKU treatment project lay in the fact that the company went beyond monetary donations. Mead Johnson reached out to poor PKU families in rural areas, came to understand the problems those families encountered, provided training to medical staff and collaborated with the China Foundation for Poverty Alleviation in setting up "Bloom of Hope Fund" for continuously providing support to families with PKU infants and children.

Building Trust via CSR Efforts

Numerous studies have demonstrated the effects of CSR on establishing public trust (e.g. Hung-Baesecke, Chen, & Boyd, 2016). Mead Johnson's long-term effort in supporting PKU treatment and raising public and the government's awareness of PKU illness has reinforced Mead Johnson's corporate vision of being the leader in providing nutrition for infants and children. Most importantly, the behavior of caring for the Chinese society gained public confidence on corporate products and trust that the company is taking its stakeholders' interests into account in developing an authentic CSR program.

Furthermore, before implementing the project, through in-depth interviews with PKU patients and families, the project team was able to identify the inadequacies of the government health system and to focus on repairing the government's relationships with the PKU patients and their families. During the project implementation period, by showing more concern and listening to the PKU families via frequent visits and treatment follow-ups, trust in the government and the medical system could be re-built.

Partnering with Strategic Stakeholders

To maximize the effect of CSR initiatives, literature has demonstrated the positive outcomes of social partnership. Eid and Sabella (2014) speculated that a corporation's partnership with an NGO has implications of social, political and ethical effects. Neelankavil (2013/2014) suggested, for achieving a successful

collaboration, corporations and their partners should "initiate a dialogue, work toward establishing common goals, get involved in every stage of planning, cooperate on activities, bring complementary skills to the alliance, and keep the interest of the public and community at the forefront" (p. 61). Moreover, in ensuring a successful implementation of various projects and initiatives, governments have been identified as the most important stakeholders in China (Chen, 2007; Halff & Gregory, 2014).

First, before launching the PKU project, Mead Johnson integrated the internal and external resources required for this project by consulting with the relevant government agencies, such as NHFPC, the National Maternal and Child Health Surveillance Office, health administrative departments in the midwestern regions in China and all neonatal screening centers, to better understand how Mead Johnson could contribute to the support of PKU treatments.

Mead Johnson, in aiming at getting the public's awareness on PKU and assisting families with PKU infants and children, partnered with the Ministry of Health for the five-year PKU Special Milk Powder Subsidy Program. In ensuring continuing such effort beyond the five-year introductory period, a sustainable platform, the Bloom of Hope Fund, was established by the collaboration with the China Foundation for Poverty Alleviation.

The Next Step

On May, 29, 2016, NHFPC and National Maternal and Child Health Surveillance Office worked together again with Mead Johnson to launch in Beijing the second phase of the "Special Milk Powder Subsidy Project for Children with Phenylketonuria." In this phase, 200 PKU newborns from Chinese provinces that have high rates of PKU (for example, Tsinghai, Inner Mongolia and Jilin) will receive the free special milk powder subsidy for three more years (*Life Times*, 2016, June 7, p. 12). In order to ensure this project is sustainable, the team will set up a platform for donations from the public during this phase, and more social media activities will be incorporated to further enhance the awareness of and attention to PKU and PKU patients.

REFERENCES

Chen, Y. R. (2007). The strategic management of government affairs in China: How multinational corporations in China interact with the Chinese government. *Journal of Public Relations Research, 19*, 283–306.

Eid, N. L., & Sabella, A. R. (2014). A fresh approach to corporate social responsibility (CSR): Partnerships between businesses and non-profit sectors. *Corporate Governance, 13*(3), 352–362.

Halff, G., & Gregory, A. (2014). Toward a historically informed Asian model of public relations. *Public Relations Review, 40*, 397–407.

Hung-Baesecke, C. J. F., Chen, Y. R., & Boyd, B. (2016). Corporate social responsibility, trust, media source preference, and public engagement: The informed public's perspective. *Public Relations Review.* doi:10.1016/j.pubrev.2016.03.015.

Key, D. (2016, January 15). *Mead Johnson is no newcomer in baby food: Key investor breakdown.* Retrieved September 24, 2016 from http://marketrealist.com/2016/01/infant-nutrition-may-fastest-growing-packaged-food-market/

Mazutis, D. D., & Slawinski, N. (2015). Reconnecting business and society: Perceptions of authenticity in corporate social responsibility. *Journal of Business Ethics, 131*, 137–150.

Mead Johnson Nutrition: Company | Mead Johnson Nutrition. (n.d.). Retrieved September 23, 2016 from http://www.meadjohnson.com/company

Neelankavil, J. P. (2013–2014). Corporate social responsibility and the importance of forming collaborative partnerships with country governments. *International Journal of Global Management Studies Professional, 5*(1), *61–72.*

走进美赞臣 [Entering Mead Johnson]. (2014). Retrieved September 23, 2016 from http://www.meadjohnson.com.cn/about

企业关爱 [Care from the Corporation]. (2014). Retrieved September 24, 2016 from http://www.meadjohnson.com.cn/about/csr.html

The GST Campaign

Convincing Malaysians to Accept a New Taxation System

KIRANJIT KAUR
Universiti Teknologi MARA Selangor

EDITOR'S NOTE

It's not uncommon for countries to utilize public relations and communications strategies and tactics to introduce or change public policies. Malaysia, in cooperation with partners in other government agencies and businesses, launched a "Blue Ocean Communication on GST" campaign to create awareness and educate the public about the benefits and necessity for the new Goods and Services Tax despite strong initial resistance. The campaign achieved its targets.

BACKGROUND

According to the 2016 Asian Development Bank and 2016 Malaysian Institute of Economic Research Reports, there was a broad economic slowdown in Malaysia in 2015. Despite Malaysia's positive strides in socio-economic development over the past four decades, transforming itself from an underdeveloped country reliant on natural resources into a middle-income country with a vibrant manufacturing sector, the Malaysian economy slowed down in 2015 due to low commodity prices and a generally weak global financial environment. Malaysia's real GDP growth for 2016 is maintained at previous years' levels of 4.2 percent with a heavier

reliance on domestic demand. In 2015, the Malaysian government introduced measures such as the goods and services tax to address these economic challenges and strengthen the country's fiscal position.

The viability of introducing the Goods and Services Tax (GST) in Malaysia was initially brought up in the country's 2005 Annual Budget Report, after which the government began to study the socio-economic implications of the implementation of GST on the Malaysian *rakyat*[1] (people). As with other countries that have introduced similar taxes, introduction of taxes on goods and services was a contentious issue in Malaysia. After almost 10 years of dialogue and negotiations, the Malaysian prime minister announced the introduction of GST in the 2014 Annual Budget Report and it was duly implemented on April 1, 2015, amid negative public sentiments towards its implementation due mostly to a lack of understanding of the benefits of GST to the national economy. The 6 percent GST replaced the sales and service taxes of 10 and 6 percent, respectively. The GST implementation is part of the government's tax reform program to enhance the capability, effectiveness and transparency of tax administration and management in the country (*Staronline*, 10 March 2016).

The International Monetary Fund (IMF) had recommended the introduction of GST to raise the efficiency of the Malaysian tax system and ultimately increase tax collections. Theoretically, a GST with a uniform rate is neutral with respect to all forms of productive inputs. However, political, economic, and social considerations have demanded modified systems with multiple rates and exemptions that vary from country to country that have adopted a GST. Most nations currently using a GST apply a reduced or zero rate to necessities such as food, shelter and medical care; that was not the case in Malaysia The country has been saddled with fiscal deficits for more than a decade. The government's fiscal policy includes restructuring or removing various subsidy schemes in the country and reducing financial deficits and the rising debt burden. GST, the new tax system, is believed to have the potential to allow improved federal assistance and to contribute to stable economic conditions and limit inflation (Mohd & Mohd, 2011).

In 2014, the Malaysian Prime Minister announced that effective April 1, 2015, Malaysia would implement the Good & Services Tax (GST), like the GST or Value Added Tax (VAT) system already implemented in many other countries. The GST replaces the existing Sales Tax and Service Tax system. The GST introduction makes Malaysia the eighth country in the Association of Southeast Asian Nations (ASEAN) to implement the value-added tax structure with only Myanmar and Brunei abstaining from doing so thus far. Indonesia was the first ASEAN nation to introduce GST, back in 1984, and its initial 10 percent rate has been retained until today. Thailand followed suit in 1992, with a starting rate of 10 percent, which has since been reduced to 7 percent. Singapore began its GST scheme a year later, with an initial rate of 3 percent (now 7 percent).

The Philippines currently has the highest GST rate of all ASEAN members, at 12 percent. In all, 160 countries around the globe have implemented a GST (known as VAT, in some of those countries).

The GST is a multi-stage broad-based consumption tax imposed on all goods and services produced in a country, including imports. It is based on a tax-on-value-added concept that avoids duplication of taxes. This is in contrast to the Sales and Service Tax in Malaysia, which was just added at one stage. The GST also avoids the cascade effect of sales by taxing only the value added at each stage of production. Most goods and services supplied to and produced in Malaysia will be taxed at 6 percent, unless an exemption is granted under the relevant GST legislation (Official GST website). A person or business is required to register for and pay GST if he/it makes taxable supplies where in a 12-month period the taxable turnover exceeds 500,000 Ringgit Malaysia (RM) (General Guide, 2015; Laws of Malaysia, 2014). Failure to register for the GST, upon conviction, would result in a fine of up to 50,000 Ringgit Malaysia and/or imprisonment for a term of three years (*Staronline*, October 2, 2015).

Because the Malaysian government began considering a GST in 2005, the country could introduce preparatory legislation prior to the implementation of the new tax. The Price Control and Anti-Profiteering Act 2011 was passed to provide consumer protection during the GST implementation period and prevent unreasonable increases in the prices of goods and services (ASEAN Briefing, 3 March 2015). An Anti-Profiteering Mobility Center was established to receive consumer complaints regarding this matter. In addition, government authority also received support from its partners to ensure effective implementation of the GST. For example, accounting software provider Sage Software Sdn Bhd conducted a nationwide road show to assist businesses in dealing with the reporting required by the new GST tax regime.

SITUATION ANALYSIS

Predictably, the announcement of the introduction of the Goods and Services Tax (GST) in Malaysia saw strong initial resistance from businesses (especially small and medium enterprises) and the public (taxpayers), which was attributed to fears on how GST would become a financial burden that would affect cost of living especially of the middle and low-income population. Relevant government authorities were also concerned about the social and economic impact on the middle and low-income wage earners and their ability to survive in a competitive environment.

Hence, the government conducted studies on consumer and business readiness, perceptions and acceptance of a GST. In preparation for the launching of the

GST on 1st April 2015, the Ministry of Finance and the Royal Malaysian Customs Department, with the support of other partners conducted a GST Campaign starting in 2010 to reduce fears about the GST as well as increase its acceptance through better understanding and preparedness so that the public did not perceive the GST a financial burden to them. There was an acceleration of the Royal Customs Department capacity to enhance readiness and effectively manage the GST implementation through training of more officers, partnership with relevant government authorities and other stakeholders, such as those offering the GST accounting software. The authorities also ran a nationwide "GST Customer Program" to promote informed compliance after launching the GST (*Staronline*, June 16, 2016).

In an early exploratory study on the readiness, perceptions and acceptance of the GST by Malaysians, Mohd and Mohd (2011) found that a majority of respondents were not satisfied with the information provided by the government pertaining to the introduction and implementation of GST and thus, were not in favour of GST. There was fear that the implementation of the GST would lead to an increase in the prices of goods and services as well as living costs.

On the first day of the implementation of the GST on April 1, 2015, 800 complaints were received through the official GST hotline and help desks nationwide. After 26 days, the number of complaints had risen to 5,205 in total. In addition, complaints received on the official Facebook (4,272 complaints) and Twitter (3,076) sites came to a total of 7,348 social media complaints within the same period of time. An app (EZ ADU or "easy complaint") was also launched on April 16, 2015 to simplify the complaint process, and within four days it had been downloaded 2,310 times (Ministry of Finance GST Media Conference report, April 27, 2015).

The highest number of complaints from consumers was about the increase in price of goods but other complaints focused on increased costs of newspapers and mobile phone prepaid cards, issuance of invoices not meeting the established GST criteria and hence consumers not being able to check how they were being charged GST by the trader; insufficient information on classification of goods and imports chargeable for GST; and inadequate response to queries by the GST help desks. There also were complaints about a lack of transparency on GST charges by errant traders, and wrongly charged GST on products that should not have been taxed. Faulty software or the inability of the trader to use it correctly was a common complaint by the traders (Ministry of Finance GST Media Conference report, April 27, 2015).

Other hitches in the GST introduction included a delay in the registration of retailers for the GST Refund Scheme, which resulted in numerous complaints by tourists who were unable to claim their refunds at airport customs when leaving Malaysia. Authorities also were initially slow in returning input taxes to retailers although that was rectified not long after the GST launch.

There were also calls from a few civic groups to exempt certain groups from being charged GST, including children, the disabled, old folks, and the poor (*Staronline*, August 19, 2015). Moreover, certain Muslim religious authorities (affiliated with the opposition Islamic political party) suggested that the Goods and Services Tax (GST) is *haram* (forbidden) as it does not fulfill the tax conditions outlined by the party's Ulama Council and had led to hardship on the people due to increases in the prices of goods (*Staronline*, June 2, 2016).

A year after implementation of the GST, there still was some confusion among businesses, per the Customs Department deputy director-general. Many companies were still not GST-ready. In addition, it was believed that there were thousands of companies which record an annual turnover exceeding the threshold 500,000 Ringgit Malaysia, but were not registered for GST with the Customs Department (*Staronline*, March 10, 2016).

A SWOT analysis, through identification of the strengths, weaknesses (internal factors), opportunities, and threats (external factors), clarified the situation. Broadly, there were a number of *strengths* including an available strategic alliance with mainstream media, especially the government news agency, Bernama, and Radio-Television Malaysia or RTM, which had nation-wide penetration; multi-government agency partnership providing a broader reach; a relatively low GST rate; support of vendors providing technical support, and availability of explanatory publications.

Some of the main *weaknesses* included insufficient staff to manage talks, town hall sessions, road shows and other communication channels for effective stakeholder engagement; a lack of capacity for effective monitoring of GST compliance and enforcement, and a number of GST officers still not knowledgeable when answering queries on the GST. The public and businesses also lacked understanding of what GST entailed, and businesses were reluctant to support full adoption.

Opportunities included the existence of legal controls on price of goods and fair taxation regulations in the Price Control and Anti-Profiteering Act 2011 that could be used to prevent fraudulent activities; a well-established media system and availability of high speed internet connections to ensure ease of communication and a wide reach of messages; and ability to partner with several government agencies to disseminate information about the GST.

Threats included fears by the public that the GST would reduce their quality of living and purchasing power as goods become more expensive. Businesses feared higher expenses in implementing the GST as it was more time consuming and they would also have to train their staff in the correct use of the application. Other threats included abuses of GST implementation, including non-issuance of receipts according to GST criteria but with the tax still charged to the customer, charging GST on zero rated products, not charging GST so as to offer a lower price to the customer and thus providing a handwritten receipt and invoice, and

the unexpectedly large number of complaints leading to inadequate GST hotline management of complaints.

CORE OPPORTUNITY

Malaysia needs a tax system that is similar to what is used in most countries in the region and globally. Previous examples show that the Goods and Services Tax may initially cause inflation but would level out within a short period. However, the small and medium enterprises and the public need to be made aware of the long-term benefits of GST to the national economy and to become better informed taxpayers. With the need to educate these businesses and the public (taxpayers) on the taxation system, there was an opportunity for the government to rethink communications by integrating a holistic messaging strategy.

The Ministry of Finance, besides being concerned about the technical aspects of formulating a new taxation system on the taxpayers, was also given an opportunity to strategically establish interactive communication with them. In the process of educating the taxpayers, it could also gain their cooperation in monitoring ethical implementation of the new taxation system by businesses through the implementation of easy reporting systems. Despite the relatively strong negative public sentiments towards the new GST taxation system, the Ministry of Finance, through collaboration with strategic partners in other government agencies and other corporate financial and public institutions, has successfully led a "Blue Ocean Communication" strategy to effectively implement GST and achieve its initial targets.

GOAL

The primary goal of this campaign was to create public awareness, educate the public and increase public acceptance of the GST through a better understanding to ensure its effective implementation with the registration of all eligible businesses.

OBJECTIVES

The GST campaign was tagged as "Fair, Transparent, Efficient and Business Friendly" and driven by the Ministry of Finance. Initially, it spelled out three key objectives to be achieved over four phases from 2010 until the implementation of GST in 2015. These objectives included:

- Achieve consistency in messaging and topics across all media (print, electronic, outdoor, below-the-line, online)
- Demonstrate a common purpose and objectives during every phase of the campaign period
- Consistent use of logos and other mandatory information (GST Campaign Guideline, Ministry of Finance, 2010)

Nearer to the date of the GST implementation, the Blue Ocean Communication of GST used a more rigorous GST Communication Strategy with the following three objectives to:

- Raise understanding and acceptance of GST;
- Manage misconception and address negative perceptions toward GST; and
- Assist in implementation of GST (Blue Ocean Communication of GST, Ministry of Finance, 2014).

KEY PUBLICS

The key internal publics included the Ministry of Finance (MOF); Ministry of Domestic Trade, Cooperatives, and Consumerism (KPDNKK); Ministry of Communications and Multimedia Malaysia (KKMM); Special Affairs Department in the Prime Minister's Office (PMO); Royal Malaysian Custom's Department (JKDM); and the Malaysian Public Services Department (JPA). Strategic coordination was established through representation of each entity on committees to ensure a smoother implementation process.

The media also were a key public and were viewed more than a public but as a partner of the government program. The Malaysian media system is authoritarian in nature (either government owned and controlled or affiliated to government political parties) and most of the traditional mainstream media-both government and independent, are perceived by many to be natural allies of the government in disseminating information on the latter's numerous programs for national development.

The external stakeholders were the four key publics for the GST campaign. These were the general public, the business community, informed groups (experts, including providers of required accounting software and taxation experts), and the public sector (federal, state and local government agencies).

KEY MESSAGES

The primary emphasis of messages was on introducing a new taxation system called the Goods and Services Tax or GST and what it means to the consumer, businesses

and the national economy. Messages were developed with some variation in consideration of the needs of the specific identified key publics at the different phases of the GST campaign (GST Campaign Guideline, Ministry of Finance, 2010).

Phase 1: During this phase to create awareness, the committee disseminated basic and general information about the GST to both the consumer (general public) and the business community. This was to fulfill the informational objective.

Consumers: Message content focused on what is GST, when it would be implemented, at what rate, why GST, whether it would burden the people (*rakyat*), how it would affect the consumer, how it differed from the then existing Sales and Services Tax, what were the taxable types of supply and list of items taxed at which rate (standard rated (6 percent), zero-rated, exempt or relief), how taxation and GST was viewed in Islam (this is important in Malaysia, a Muslim majority country where such matters are deemed necessary from a religious perspective), and finally whether the GST message was fair, transparent, efficient and business friendly.

Business community: Message content included the same basic information on GST that was provided to the consumer group but with additional information on technical aspects regarding input/output tax, accounting software for point of sale (POS), how GST affects business, the deadline for registering a business, incentives provided like the e-voucher and free seminars and "handholding" programs for smooth and effective implementation, and penalties for not registering within the given period.

Phase 2: In the second educational phase, information provided was more subject-matter specific and in-depth as it addressed probable common concerns regarding "the what-ifs" upon implementation. This can be likened to information provided was designed to fulfill the motivational objective.

Consumers: Message content at this stage emphasized information about the GST mechanism or procedures; key areas of concern for consumers, such as housing, education, healthcare, transport, weddings and vacations; awareness of what constituted profiteering attempts by business; international comparative studies on taxation; spending habits to differentiate between wants and needs, and exercising prudent spending.

Business community: Message content for businesses focused on educating them about registering for GST before December 31, 2015 and incentives provided as well as penalties imposed for not registering before the cut-off date, and how the GST impacts the various industries: technology, electrical & electronics, oil and gas, chemicals, agro-industries, manufacturing, hospitality, trading/retailing, property development, insurance, financial services, automotive, food and beverages, and the like.

Phase 3: The third phase concentrated on message content to promote GST acceptance, positive sentiments towards GST with a focus on benefits to the people and business, and to soften the ground for Phase 4. This addressed the objective of achieving behavioral intent for eventual adoption.

Consumer: Message content was mainly about the benefits of GST to the people, how GST collection would be used, how consumers could prepare for it, experiences of other countries, and paying tax as a national duty and responsibility.

Business community: For this group the messages were about preparing for GST, especially the point-of-sale system, GST compliant accounting, price labelling, claiming for refunds, rules for GST enforcement, and penalties for offenses.

Phase 4: Messages in the fourth and final phase were to encourage positive acceptance of GST and addressed unforeseen problems and solutions to these problems, as well as post-implementation "to do" items.

Consumers: The message content emphasized drawing positive testimonials from the people (*rakya*), feedback from consumers on GST implementation, consumer responsibility and GST, and direct benefits from its implementation.

Business community: Similarly, message content for this group was directed more towards positive testimonials from business owners, feedback from business owners on GST implementation, information on the GST Appeal and Customs Appeal Tribunal, GST auditing, and direct benefits from its implementation.

Tourists: Information on a GST refund was also provided to tourists to ease their refund applications.

STRATEGIES

The Malaysian government had the problem of launching a GST to uninformed taxpayers and a reluctant business community. The main strategy adopted by the GST coordinating committee was continuous public engagement with various stakeholders through exhaustive two-way communication tactics were emphasized with several channels provided for public feedback.

There was an initial GST Campaign Plan where four communication phases were identified to deliver specific communication objectives throughout the length of the campaign beginning with when it was discussed in the 2010 Annual Budget. These phases included:

Phase 1: Awareness (Year 2010–August 2014)—To create awareness on GST.

Phase 2: Educate (September 2014–February 2015)—To educate the public on GST.

Phase 3: Accept (February 2015–March 2015)—To create acceptance of GST and assist with preparedness and implementation, and

Phase 4: Launch & Follow Up (April 2015 onwards)—To create positive "feel-good" sentiment; reinforce acceptance of GST; and address unforeseen problems or glitches with the GST system.

The GST Coordinating Committee subsequently drew up the *Blue Ocean Communication of GST plan* to achieve established objectives. A GST coordination team was set up comprising four Committees to manage and monitor specific aspects of GST. These included the GST Steering Committee, GST Monitoring Committee, GST Strategic Communication Committee and the GST Advocacy Committee.

The Ministry of Finance enlisted the strategic cooperation of several divisions and agencies under the Ministry of Communications and Multimedia Malaysia to assist in the communicating about GST to the public: the Strategic Communication Division, Department of Information, the government run Radio-Television Malaysia (RTM), the national news agency BERNAMA, and the National Film Corporation or FINAS. These communication agencies were involved in implementing a multi-pronged communication penetration plan to reach consumers and businesses in urban, semi-urban and rural regions throughout the country. They lent support to the Ministry of Finance, Royal Malaysian Customs Department and the Ministry of Domestic Trade, Cooperatives and Consumerism through concerted information and education efforts regarding the GST.

Communication strategies were drawn up corresponding to the four key stakeholder groups: to inform and educate them, motivate them and get their buy-in (positive acceptance of implementation of the GST). Specific activities were identified to effectively reach each of these groups. Strategic government partners, meaning the most relevant agency for a stakeholder group, were brought in as the chief collaborators to communicate and leverage support from identified stakeholders for smooth adoption of GST. They were:

- Communication of GST for the Public: Managed by the Ministry of Communications and Multimedia Malaysia, in particular by the Department of Information and the Department of Special Affairs (KKMM: JAPEN & JASA)
- Communication of GST for the Traders and Consumers: Managed by the Ministry of Domestic Trade, Cooperatives and Consumerism (KPDNKK)
- Communication of GST for the State Governments and Industries: Managed by the Ministry of Finance and Royal Malaysian Custom's Department (MOF & JKDM)
- Communication of GST for the Public Sector: Managed by the Public Services Department (JPA).

There was also collaboration with non-governmental organizations to widen efforts to reach the grassroots community (including the National Council of Women's Organizations Malaysia).

TACTICS

It was important to develop the understanding and buy-in of both consumers and the business communities as well as the internal public—government employees or civil servants (a relatively large group of taxpayers and generally natural supporters of government programs and the ruling government), and to reduce any fears regarding adopting GST.

Thus, several communication tactics were used to achieve the set objectives.

• Roadshows

GST awareness talks for both consumers and business communities were organized through a series of roadshows targeted to specific groups. The roadshows comprised talks, town hall meetings, forums, dialogues, exhibitions and the like to provide platforms for face-to-face and more interactive communication with the traders and the public, nationwide. Both information and customs officers from respective relevant agencies and departments nationwide were trained to deliver these talks about the GST to the community. Talks were held throughout the country to raise awareness on the GST and to educate consumers and businesses on its key aspects as well as to get their feedback and concerns.

• Public roadshows (Communication of GST for the public)

Awareness programs and informal engagement were conducted for the public on the GST by the Ministry of Communications and Multimedia officers from the Department of Information and Strategic Communication Department. Billboards carrying the relevant information were also put up throughout the country.

• GST Public Advocacy program (Communication of GST for public sector employees)

The public service department organized a series of talks to various government sectors nationwide to educate them about the GST. Approximately 1.3 million civil servants were targeted through the GST Public Advocacy program. These civil servants were seen to be natural allies who could become influencers.

• Communication of GST for the state governments and industries

The Ministry of Finance and the Royal Customs Department of Malaysia conducted talks at the state level to give GST updates to state executive committees and leaders for more effective implementation support. The Customs handholding and enforcement program was also intensified in the states.

- Communication of GST for traders and consumers

The Ministry of Domestic Trade, Cooperative and Consumerism provided various materials to better educate traders and consumers about GST. Training to understand the procedures necessary for registration and compliance was conducted for businesses. The business community was also given "hand-holding" sessions on how to register for the GST and to better prepare for its adoption.

- Seminars

National public seminars were organized by the GST coordinating committee to create awareness and discuss relevant issues on the matter with experts and academics, such as the National GST Conference 2016 (May 30, 2016).

- GST guidebooks as informational references (print and digital versions)

A series of educational materials was made available to help consumers, businesses and organizations prepare for GST implementation in Malaysia. The Ministry of Finance General Guide on Goods and Services Tax (GST) (2015) was offered as a good reference providing thorough information to business/traders/public. It contains information on who needed to pay for GST, who was exempt, how to calculate GST, when to pay, how to register for it, compliance procedures and who to contact for more information. Besides that, industry guides also were made available to provide guidance to businesses and organizations operating in specific industries, such as the MOF Handbook for Goods and Services Tax (GST) for businesses. The GST Shopper's Guide was issued in February 2015; the Price Control pledge program was launched, and a ministry Price Item Guide booklet was also made available by the Ministry of Domestic Trade, Cooperatives, and Consumerism. Thus, a number of booklets and guides on GST have been published and distributed to consumers and businesses to ease understanding of the GST and necessary procedures for ease of compliance.

- *"Jom Minta Resit GST"* (Ask for the GST Receipt) contest

Contests also were introduced as a way to educate consumers on their right to demand a GST receipt from businesses. Bi-monthly lucky draws were held from receipts submitted with the GST reference numbers in a contest from April to November 2016. The public could join the contest by downloading the form from the website (www.myresitgst.com.my) or downloading the mobile application *MyResitGST* (*Staronline*, May 20, 2016). The contest aimed to increase business compliance by issuing receipts with a GST reference number in accordance with

Sections 33, 34 and 36 of the Goods and Services Tax Act 2014 (*Staronline*, May 20, 2016; June 27, 2016).

- EZ ADU
 An application, EZ ADU or "easy complaint," was launched on April 16, 2015 to simplify the complaint process.
- Media engagement

This included engaging with established media to ensure promotion about GST through television and radio interviews and talk shows, advertisements, crawlers, and coverage in the print media. Government media, like Bernama (news agency) and RTM (radio and television), were instructed to create media opportunities for the key spokespersons to share information regarding the GST. In this regard, special reporters were assigned to manage media support. The independent media also reported about the GST under the business section to educate the public.

Media conferences to disseminate information to the public were also held periodically in the lead up to the launch of the GST, and weekly media conferences were organized immediately after GST was launched, with the secretary-general of the Ministry of Finance and the deputy director-general of the Royal Customs Department as spokespersons to provide latest updates on adoption of the GST and to address consumer and business concerns regarding it.

- Official GST website

An official website on Malaysia Goods and Services Tax was set up by the Royal Malaysian Customs Department, at the url: *http://gst.customs.gov.my* to provide as much GST-related information as possible to the public and businesses. Links to additional GST-related information as well as GST registration schedules and forms were also made readily available on this site for easy access. A detailed FAQ section was provided for ease of understanding various aspects of GST.

- Social media—Facebook, Twitter @gstmalaysiainfo, YouTube, Blogs

Social media channels were provided to inform and educate as well as to get public feedback on enforcement of the GST. These digital media were diligently monitored by a specially assigned cyber war-room team. Legitimate GST related complaints[2] received on Facebook and Twitter were forwarded to the e-complaint section for action.

- GST Hotline and GST Call Centers
 Direct communication channels including a Hotline and Call Centers were also established to provide immediate response. The hotline and call center

could closely monitor and manage queries and receive GST-related complaints to assist with enforcement.

- A Ministry of Finance or MOF anti-GST rally rebuttal program was also launched when groups held or threatened to hold anti-GST rallies, (This involved sending business and political allies and supporters of GST to an organized rally).
- Informed groups
 Cooperation also was sought from taxation experts and other informed groups and experts (including economists, accounting firms, financial experts, and trained information officers) to support the efforts of the GST coordinating committee in explaining its value to the nation.
- Promotional and publicity materials
 These included billboards, brochures, bunting and posters, among others.

Fig. 15.1. Screen shot images. Public domain.

TIMELINE

The overall timeline of the GST communication campaign was over four phases from 2010 to the actual implementation of GST in 2015 plus the follow-up to the compulsory registration date.

Year 2010–August 2014: To create awareness among publics about the GST

September 2014–February 2015: To educate publics on the applications of the GST

February 2015–March 2015: To ensure acceptance by publics and pre-paredness for implementation

April 2015 onwards: Launch & follow-up to get positive sentiment and maximum compliance

EVALUATION AND MEASUREMENT

The GST communication and education programs were deemed to be effective primarily because there was a higher than expected acceptance by businesses that led them to comply with the new taxation system. On April 1, 2015, the day of the GST implementation, there were 364,862 businesses already registered. Three weeks after implementation, on April 24, there were 373,954 GST registered businesses (Media Conference report, Ministry of Finance, 24 April 2015). In fact, according to the Customs deputy director-general, since the introduction of the GST, there were 390,000 companies registered with the GST (by October 2015) compared to only 63,000 companies registered under the previous Sales and Services Tax system, (*Staronline*, October 3, 2015).

The public and businesses were continuously informed about the government's investigation of complaints, monitoring and enforcement efforts in attempts to encourage adoption and adherence to the GST regime. In a GST Implementation Report Card press conference in March 2016, Subromaniam, the deputy director-general of the Royal Customs Department, announced that after nearly a year since the launch of the GST, there were 406,000 companies registered. He attributed the continuing success in part to the numerous initiatives to better aid businesses in the ongoing GST filing process (*Staronline*, March 11, 2016).

The roadshows and educational seminars and workshops offered by the partnering accounting software provider, Sage Software, reached 3,000 business owners over 16 sessions to increase businesses' knowledge on submission accuracy. They also assisted in troubleshooting through email and a dedicated hotline. From April to July 2015, they handled over 53,000 calls (300–500 calls a day) and

40,000 email queries (*Staronline*, August 1, 2015). This was in addition to support from the hotlines and call centers managed by the government authorities.

Generally, the GST campaign can be viewed to have been successful. In a basic objectives-driven evaluation, the three objectives of the GST Blue Ocean Communication Strategy were met: the informational (where comprehensive information about the GST and procedures for compliance were provided to raise awareness, understanding and acceptance); the motivational (where communication was emphasized to get identified stakeholders to support GST through the management of misconception and addressing of perceptions); and the behavioral (its adoption by the identified four target groups).

Evaluation of Dissemination of Identified Key Messages

Generally, the identified messages for each of the four phases of communication outlined in the GST Communication Guide were delivered accordingly as planned. The multi-pronged communication activities and tactics by the joint GST coordinating committee resulted in widespread information dissemination. Mainstream media monitoring by the committee revealed that between August 2014 and February 2015, most of the media coverage was either neutral (information based) or positive, with only a very small percentage that was negative. There were 767 awareness programs held by the MOF and Customs department for government officers and public between January and December 2014, which reached 162,292 participants. GST registration between June 2014 to March 7, 2015 rose from 2,368 registered businesses to 348,943 by March 2015 (Blue Ocean Communication of GST, 2014) and then to 406,000 by March 2016.

In addition, approximately, 1.3 million public sector employees were activated? through the GST Public Advocacy program. Up to early 2015, 41,951 participants were reached through 292 programs under the Communication of GST for traders and consumers program.

The *MyResitGST* contest also saw enthusiastic response. The first two months of the contest, April–May 2016, saw submissions of 146,968 GST receipts from 13,069 customers (mostly from the state of Sarawak, where the publicity was very high on the contest). The other states saw an increase in submissions in subsequent months (*Staronline*, June 27, 2016). There was increased awareness that customers could and should request a GST bill, an indication of behavior change.

Evaluation of Publications

A number of relevant publications to explain GST also were issued for the public and business audiences. These included the GST Shopper's Guide that was issued in February 2015; the Price Item Guide by the Ministry of Domestic Trade,

Cooperatives, and Consumerism; the General Guide on Goods and Services Tax (2015), and a Handbook for Goods and Services Tax (GST) for businesses by the Ministry of Finance (2015).

Media Engagement, Publicity and Promotional Collaterals

Media engagement was effectively applied in raising awareness and acceptance of GST. Information about GST was deemed to have been successfully disseminated to the public through various communication, publicity and promotional collaterals. These included brochures, billboards, taxi, bus and train ads; corporate and music videos, exhibition booths,; buntings, surveys, roadshows; newspaper articles and ads; magazine articles; blog articles; TV interviews and ads; and radio interviews, ads and jingles. Media monitoring showed that all press conferences and media releases were covered by a significant number and variety of electronic and print media. As many as 80 media were represented at all the key press conferences.

The goods and services tax (GST) collection exceeded the RM27 billion-mark target set by the government for 2015 within a period of nine months. Per the Royal Malaysian Customs Department deputy director-general, for the year 2016, the Customs department has been given the task of raising RM39 billion from the GST, and he said that the department was confident of achieving the target based on the achievement in 2015 (Media Conference report, Ministry of Finance, April 24, 2015).

Author's Note

This case on the launch of the GST in Malaysia was awarded the Gold prize in its category (Media Relations—Government) at the 2015 ASEAN PR Awards held in Kuala Lumpur by the Institute of Public Relations Malaysia and BIEM.

This chapter could not have been written without valuable input from the communication personnel involved in the campaign and detailed information provided in the form of slides and reports. In particular, the author would like to thank Dato' Ibrahim Abdul Rahman, Director-General of Information Department, and Madam Amidah Hamim and her staff from the Corporate Communication unit in the Ministry of Finance, for their support in providing information relevant to this research.

NOTES

1. *Rakyat* refers to the (Malaysian) people and the word has an emotional context to it. It is often used by politicians and activists to garner support emphasizing unity.

2. Legitimate complaints refer to complaints related to GST issues and procedures. Complaints that were not directly related to GST matters and were more of criticisms of government or policies were addressed separately, where relevant.

REFERENCES

ASEAN Briefing. (2015, March 3). *Malaysia GST implementation on April 1, 2015.* Retrieved from http://www.aseanbriefing.com/news/2015/03/03/malaysia-gst-implementation-draws-near.html

Blue Ocean Communication of GST. (2014). Ministry of Finance, Putrajaya, Malaysia.

Cuepacs: Exempt kids, disabled, old folk and the poor from GST. (2015, August 19). *Staronline.* Retrieved from http://www.thestar.com.my/news/nation/2015/08/19/cuepacs-exempt-kids-disabled-old-folk-and-the-poor-from-gst/

Don't be late for GST submission. (2015, October 2). *Staronline.* Retrieved from http://www.thestar.com.my/news/nation/2015/10/02/dont-be-late-for-gst-submission-dg-autoassessment-for-defaulters/

Handbook for Goods and Services Tax (GST) for businesses. (2015). Ministry of Finance, Putrajaya, Malaysia.

General Guide: Goods and Services Tax. (2015, December 23). Royal Malaysian Customs Department. Putrajaya, Malaysia.

Getting to grips with GST. (2015, August 1). *Staronline.* Retrieved from http://www.thestar.com.my/metro/smebiz/news/2015/08/01/getting-to-grip-with-gst/

GST Campaign Guideline. (2010). Ministry of Finance, Putrajaya.

GST collection exceeds 2015 target. (2016, March 10). *Staronline.* Retrieved from http://www.thestar.com.my/business/business-news/2016/03/10/gst-collection-exceeds-2015-target/

GST haram as it causes hardship, says PAS ulama chief. (2016, June 2). *Staronline.* Retrieved from http://www.thestar.com.my/news/nation/2016/06/02/gst-haram-as-it-causes-hardship-says-pas-ulama-chief/

GST refunds within two weeks. (2015, October 3). *Staronline.* Retrieved from http://www.thestar.com.my/news/nation/2015/10/03/gst-refunds-within-two-weeks/

Laws of Malaysia, Act 762: Goods and Services Tax Act 2014.

Ministry can gauge total GST collection by Aug. (2015,). *Staronline.* Retrieved from http://www.thestar.com.my/business/business-news/2015/06/16 June 16/ministry-can-gauge-total-gst-collection-by-aug-says-chua

Mohd, R. P., & Mohd, A. I. (2011). The impacts of goods and services tax (GST) on middle income earners in Malaysia, *World Review of Business Research, 1*(3), 192–206.

Official GST website, Malaysia Goods and Services Tax, Royal Malaysian Customs Department. Retrieved from http://gst.customs.gov.my

RM39bil collection target from GST this year. (2016, March 11). *Staronline.* Retrieved from http://www.thestar.com.my/business/business-news/2016/03/11/rm39bil-collection-target-from-gst-this-year/

Royal Malaysian Customs Department extends GST contest till November. (2016, May 20). *Staronline.* Retrieved from http://www.thestar.com.my/news/nation/2016/05/20/dept-extends-gst-contest-till-november/

Sarawak records the highest entries in GST contest. (2016, June 27). *Staronline.* Retrieved from http://www.thestar.com.my/news/nation/2016/06/27/sarawak-records-the-highest-entries-in-gst-contest/

Restoring Confidence IN A Global Company AND Healthcare Brand IN Brazil

The Bayer Jovens Youth Education Campaign

PAULO NASSAR
University of São Paulo (USP)

TERENCE (TERRY) FLYNN
McMaster University

EDITOR'S NOTE

Customizing a public relations campaign to audiences in a specific country is essential for companies doing business on multiple continents and in multiple countries. On the verge of celebrating its 120th anniversary in Brazil in 2013, the global pharmaceutical company Bayer identified the need to strengthen its relationship with younger audiences and improve public discourse and discussions based on science, technology and high quality information. Through an innovative project that inspired the company globally, Bayer's Brazilian communications office used digital and social media to develop original content for engaging young people in discussions about sustainability, science, technology, sexuality, culture and citizenship, called "Bayer Jovens" [Bayer Youth]. The case won an ABERJE (Brazilian Association for Business Communication) Award in 2015, recognized as the best digital media project of the year.

BACKGROUND

Established in the city of Leverkusen, Germany in 1863, Bayer is a global company with operations in the fields of Pharmaceuticals, Consumer Health and Crop Science. Over 150 years old, and boasting core competencies in the fields of health and agriculture, Bayer uses innovation to create new solutions, improving the health of people, animals and plants. All its research and development activities are based on understanding the biochemical processes that occur in living organisms, according to Bayer's website (Bayer, 2016).

The company's operations are based on four key values: leadership, integrity, flexibility and efficiency, which together form the word LIFE, and become the foundation for the communication of these values to many stakeholders including employees, the media, the community, suppliers, customers, trade unions and authorities. In its communications, Bayer seeks to illustrate its four key values with examples. These statements from Bayer's (2016) global website shows how these values are transmitted:

- Leadership

Be committed to the employees and care about their performance; show personal drive, inspire and motivate others; take responsibility for actions and results, as well as for successes and failures; treat others fairly and with respect; give clear, honest and timely feedback; manage conflicts constructively; create value for all our stakeholders.

- Integrity

Be a role model; comply with laws, regulations and good business practices; trust others and build relationships based on trust; be honest and trustworthy; listen carefully and communicate properly; ensure sustainability, balancing short-term results and long-term requirements; care about people, safety and the environment.

- Flexibility

Proactively promote changes; be ready to adapt to future needs and trends; challenge the status quo; think and act focusing on customers; seek opportunities and take calculated risks; stay clear of prejudice; be willing to be always learning.

- Efficiency

Manage resources wisely; focus on activities that create value; do things simply and efficiently; deliver work and results with quality, speed and appropriate costs;

take responsibility for consistent execution; speed up decision-making processes; cooperate to find the best solutions.

It is clear that the actions of the management and communications of Bayer are guided by what is useful and in line with the goals of the countries, communities and publics where the company has its operating units. This harmony is important for creating a favorable social environment for running the businesses well and for the company's relationships with its key stakeholders.

Managing the balance between the company, its products, society and markets where Bayer is present is done by the communication and public relations department in collaboration with the departments of human resources, marketing, finance and compliance, and with the company's board of directors.

One of the best examples, listed on Bayer's publication Reclames da Bayer—1911–1942 (1986, p. 1), of the company's successful communication history is represented by the creation of the slogan "If it is Bayer, it is good" by the poet Bastos Tigre, in Brazil, in 1922. This is one of the best-known slogans of Brazilian and Latin American communication. Another example of this history, also on this publication, is the Aspirin® ad, which is strongly present in the visual memory of the Brazilians. Back in 1911, Bayer publicized the product's therapeutic strength through advertisements in major Brazilian newspapers and magazines. The product was first placed on the market worldwide in 1899. Bayer, which is originally from Germany, has become "Brazilianized" through its communication, states Zélio Alves Pinto, who coordinated extensive research on Bayer's communications, which culminated in the publication of a book in 1986, Reclames da Bayer—1911–1942:

> When Bayer was opening its way in the domestic market, with all its German experience, accidentally or deliberately, it also forged a path into the Brazilian culture. This face could be rosy and fat, as fat and rosy as is the face of a smiling Bavarian, having a beer with a snowy mountain in the background. This face could convey the idea of the German efficiency and rationalization, so appreciated by the Latins. On the other hand, it could be strange. A nice foreign figure, not fully identified and with a strong way of being. The other face Bayer could have would be the native face: it was being born in Brazil and wanted to be like the Brazilians. And this was the chosen face. It was Brazilian since its first words. It spoke without an accent. It sought for dialogue on local culture, community and geography. And it was through the Brazilian language that Bayer started its dialogue with our society, choosing popular types, celebrations, events, landscapes and habits of the people as its interlocutor, or even spokesman. (Bayer, 1986, p. 7)

In this context, Bayer Group has the constant challenge of reconciling the image of a company with a solid global history of over 150 years and, at the same time, one that offers innovative solutions and cutting-edge technology to the market.

Per Bayer's website (2016), Bayer has subsidiaries in almost every country in the world, and it is organized into four major regions that cover all five continents:

Asia-Pacific, Europe, North America and Latin America, Africa and Middle East. The communication and public relations of Bayer in Brazil follow the global guidelines of the company's headquarters—leadership, integrity, flexibility and efficiency—without inhibiting local communication initiatives, innovations and related actions.

Since January 2016, the operations of Bayer are managed in three divisions: Pharmaceuticals, Consumer Health and Crop Science. Animal Health is a separate business unit.

The Pharmaceuticals Division focuses on medicines sold by prescription, especially for cardiology and women' healthcare and in the areas of oncology, hematology and ophthalmology. This division also includes the radiology business unit that markets image and diagnosis equipment and contrast agents, substances that differentiate tissues and structures of the body that have different compositions.

The Consumer Health Division markets mainly non-prescription medicine and products in the allergy, analgesic, cold and flu, dermatology, foot care, gastrointestinal, dietary and sun protection categories. These products include world-famous brands such as Aspirin™, Azelan™, Bepanthol Baby™, Bepanthol Derma™, Bepanthol Mamy™, Canesten™, Claritin™, Coppertone™, Dr. Scholl's™, Flanax™, Gyno-Canesten™, Redoxon™, Redoxitos™ and Supradyn™.

The Crop Science Division has business in seeds, crop protection and non-agricultural pest control. It is organized into two operating units: Crop Protection and Seeds and Environmental Science. Crop Protection and Seeds markets a broad portfolio of high-quality seeds, along with innovative agriculture chemicals and biological pest control solutions, providing at the same time extensive customer service for modern and sustainable agriculture. The Environmental Science unit focuses on non-agricultural applications through a broad portfolio of pest control products and services to areas ranging from the household to forestry sectors.

Products for farm and pet animals are under the management of the Animal Health operating unit, which reports to the Board member responsible for the Crop Science Division.

Bayer in Brazil

In Brazil, Bayer was established in 1896, just 33 years after its creation in Germany, and is one of the top five companies in Brazil in the chemical and petrochemical industry, according to the "Melhores e Maiores" ranking of Exame magazine (2015, p. 544) (The Best and the Biggest—Exame Magazine), the most important Brazilian business magazine With 4,500 employees throughout the country, the company is the fourth largest Bayer Group operation in the world, and the first in Latin America. It has two major facilities, one in São Paulo, State of São Paulo,

where the Brazilian head office is located, and the other in Belford Roxo, in the State of Rio de Janeiro.

In recent years, the Brazilian subsidiary has increasingly gained prominence among Bayer's worldwide operations, making it one of the countries in which Bayer recorded its highest volume of sales. Together, the three business divisions of the Group in Brazil—Crop Science, Pharmaceuticals and Consumer Health—sold approximately $2.9 billion in 2013, a 24 percent growth over the previous year. In the following year, 2014, the growth was even greater, and the company recorded $3.1 billion in sales, according to Bayer's website (2016).

The Brazilian unit does not draw attention only because of its growth and good results. Communication and relationship initiatives developed in the country have also caught the head office's attention, turning the Bayer Brazil into a role model for the entire corporation, other organizations and the community of professional public relations communicators.

One of Bayer Brazil's most significant communication and relationship is the digital platform "Bayer Jovens", an innovative initiative created to bring Bayer closer to the public between the ages of 18 and 24. That initiative won the ABERJE Media of the Year Award in 2015 (ABERJE, 2015).

ABERJE was founded in the 1960s primarily to combat an existing prejudice at the time: business communication was considered a stronghold of journalists who could not find a job in newsrooms. It was necessary to dignify the role of the editors of newspapers and magazines, and of this type of media.

The recognition of the role of ABERJE as the protagonist of the foundation and development of professional and theoretical field of Organizational Communication in Brazil is found in Kunsch (1997, pp. 57–61), which, based on documentary sources and statements, proves that ABERJE are the embryo of Brazilian Organizational Communication. Torquato (1984, 2002) also highlights the pioneering role of ABERJE, especially that aimed to professionalize the business publications.

On October 8, 1967, a group of business newspaper and magazine editors founded the Associação Brasileira de Editores de Revistas e Jornais de Empresas (Brazilian Association for Business Communication, known as ABERJE). The "Prêmio ABERJE" (ABERJE Award), which came soon after the creation of the association, sought over the years to raise the level of management strategies that include business and organizational communication policies, and to recognize outstanding communication activities.

SITUATION ANALYSIS

Bayer has for several years conducted a global survey of its institutional image in more than 30 countries. The survey has identified that although Bayer has been in

Brazil for more than 120 years, many young people know little about the company profile, its areas of activity and its products. For some, the Bayer brand is associated only with the health segment. The company's presence in industries such as agribusiness, chemicals and innovative materials is lesser known.

In 2016, for the third consecutive year, Bayer Brazil appears on the select list of companies most desired by young professionals to start their careers, according to a study released by "Você S/A" magazine, in the June issue. The study was focused on people from 18 to 26 years of age and mapped out what companies offer to support young people at such an important stage of their lives. The magazine highlighted, among others issues, the practical learning provided by Bayer's internship programs, the autonomy granted by Bayer management for this public and the importance that Bayer gives to the quality of life of each collaborator. These statements should be good news for Bayer, but the participants who contributed to the study represent just a small part of the young Brazilian people and do not represent the majority that are not connected to Bayer's values or even know about the company and the issues that are involved. "Guia Você S/A—As Melhores Empresas para Começar a Carreira" (2015, p. 202) Você S/A Guide—Best Companies to Start a Career—is a pioneer research program carried out by "Você S/A" magazine in association with the company Cia de Talentos and with Fundação Instituto de Administração (FIA). It's aimed to understand the expectations of those who are entering the job market.

Another trend detected by the company was the decline of interest of young Brazilians on issues linked to math and science, especially chemistry and physics, all of them important subjects to the future of a company like Bayer, whose activity on all fronts is strongly based on research and development in scientific and technological innovation.

Bayer Brazil felt it was necessary to understand life conditions and the worldviews of young Brazilians who face those issues and to change this unfamiliarity with Bayer. Data for this purpose were found in many secondary research reports that studied this segment (young Brazilians) of the Brazilian population. One of these studies was the Brazilian Census of 2010, released in 2010, carried out by Instituto Brasileiro de Geografia e Estatística—IBGE (Brazilian Institute of Geography and Statistics), the main provider of population data in the country. It showed that young people represented a quarter of the Brazilian population. In other words, almost 52 million Brazilians were between 15 and 29 years old at the time of the survey. Of these, 85 percent lived in cities and 15 percent in the rural areas of the country (IBGE, 2010). The IBGE (2010) survey also stated that 54 percent of the young people were working, 36 percent of them were students and 22.8 percent were studying and working simultaneously.

Another source of information for the communication and public relations department of Bayer Brazil was a survey conducted in 2014 by Secretaria Nacional

da Juventude (SNJ) (National Youth Secretariat), an institution connected to the Office of the President of Brazil, responsible for gathering data related to schooling of young Brazilians. The SNJ survey showed that 65 percent of youth in the range from 15 to 17 years were exclusively dedicated to their studies. Meanwhile, only 12 percent of those between 25–29 years were still studying. This showed that there was a large public need for information related to the challenges inherent to the youth job market and also to other challenges of young adult life in Brazil. Documents from the Ministério da Educação do Brasil (Ministry of Education) produced in the 2007 (BRASIL, 2007) showed that young Brazilians from families with higher incomes were more prone to find a position in the job market and to continue their studies, executing activities both at school and at work. In this environment, social inequalities that still affect the lives of poorer young Brazilians were strongly highlighted. Governmental surveys emphasized that there were large populations of poorer and black young people outside both the job market and the education system. Some highlights of the Census 2010 (IBGE) and SNJ surveys (2007) showed other realities of this share of the population:

- Access to education

Only 16 percent of young people among all Brazilians have access to undergraduate studies. Only 46 percent completed high school. Almost 36 percent have their education limited to just achieving basic literacy.

- Gender, ethnicity and religion

Half (50.4 percent) of young Brazilians are women and 49.6 percent are men. The self-reported race in Census 2010 is divided as follows: 60 percent are black or brown; 34 percent are white. The majority of young Brazilians are Catholic (56 percent). Another 27 percent are Evangelical (Protestants), 16 percent do not identify with any religion and one percent are atheists.

- Social networks used by young Brazilians

According to data from the Brazilian Media Research 2015, from the Secretaria de Comunicação Social da Presidência da República (Social Communication Secretariat of the Presidency), 65 percent of Brazilians under 25 years of age have daily access to the internet (2014, p. 49). Of these, 67 percent also stated that their access is mostly related to entertainment activities and news search functions. The same research listed the most used social networks and instant messaging apps among this share of the population. They were: Facebook (83 percent), WhatsApp (58 percent), YouTube (17 percent), Instagram (12 percent) and Google + (8 percent). Twitter, a social network popular among the Brazilian political elite and

opinion leaders, was mentioned by only 5 percent of the young Brazilians interviewed (2014, p. 50).

An article published by "Exame" magazine in July 2015 stated that 90 percent of young Brazilians from 9 to 17 years old had at least one profile on a social network (Mesquita, 2015), according to TIC Kids Online Brazil, a research study conducted by the Centro Regional de Estudos para o Desenvolvimento da Sociedade da Informação (Cetic.br) (Regional Centre of Studies for the Development of the Information Society). The research (2015) showed that children as young as six had their own profiles on the web. The main medium that young people used to access their social networks was their smartphones, a device that showed a growth of 29 percent in usage compared to 2014.

The research (2015) also analyzed the online behavior of youth in Brazil in 2014 and researchers interviewed 2105 young people from all Brazilian regions. The study showed that 81 percent of teenagers surf the internet daily and 73 percent of them claimed that they used it to access social networks. Sixty-eight percent of them said that they carried out online searches for school purposes on a monthly basis. Among those who used social networks, 75 percent said that their main goal was to exchange instant messages, and 28 percent stated that their main activity was updating information and content from the Internet.

- Concerns of the young

The SNJ document identified the main concerns of young Brazilians: 43 percent said that violence and security of the country were their most important concerns. According to the SNJ, 51 percent of young Brazilians had already lost family members or someone close to them due to violence. The losses, in most cases, were of friends (18 percent) and cousins (12 percent) who were from the same generation.

The second issue that most concerns the youth who responded to the survey is job or career aspirations (34 percent): issues of health concerns was 26 percent and education was 23 percent.

Among issues that young people put as their top priority to be addressed in order to promote changes in society were social inequality and poverty (40 percent), drugs and violence (38 percent), politics (33 percent), citizenship and human rights (32 percent), education and career future (25 percent), racism (25 percent), and environment and sustainable development (24 percent).

- Habits of consumption, behavior and memory of the young

Per SNJ, being young "is a social condition with specific qualities that manifest in different ways, according to historical and social characteristics. When it comes to age, even if it incurs inaccuracies—because on some level every categorization

is necessarily inaccurate and unfair—a young person in Brazil is a citizen aged between 15 and 29 years. This is an international standard that tends to be used in Brazil. In this case, young people are teenagers or adolescents aged between 15 and 17 years, young people aged between 18 and 24 years and young adults are those between 25 and 29 years". Wanessa Valeze Ferrari Bighetti, a researcher of Universidade Estadual Paulista (UNESP) who worked in scientific research about young Brazilians for the brand Havaianas, a world-known Brazilian shoemaker, said "subdivisions represent the distance of childhood and adolescence and the proximity of adulthood, which marks youth as a period of transition and shaping of positions and world vision". According to Bighetti (2016, p. 65), the age condition is:

> … a brief shared experience between a young audience and a particular brand, product or organization, [which] constitutes a major barrier to the work of organizational memory that has young people as target audience. That's because, generally, the relationship between the individual at this stage of life and a particular company is not long enough to elicit stable feelings, such as affection and trust, which are part of the image and organizational reputation. (p. 65)

These findings lead Bighetti (2016, p. 66) to claim that "young people are, to contemporary organizations, a potential strategic public, with their consumption preferences focused in education and their lives going through a period of full expansion of purchasing power".

The planning of the project began in 2012. Research included monitoring social media, in order to analyze the perception of the company's image among young people.

The study aimed to identify communication opportunities with the young audience, and also to map the main influential people in the press, social media, universities and institutions connected with social responsibility and environmental preservation.

An in-depth study of the graphic concept showed that the predominance of vibrant colors, which convey a sense of energy, enthusiasm and vitality was helpful. The visual elements were combined in order to make the environment striking and attractive.

From a technical point of view, the research was carried out in partnership with Bayer's technology team from Germany, to ensure the compatibility of the project with the global platform of the company.

CORE OPPORTUNITY

Bayer wanted to create and produce a public relations and communications campaign focused on the creation and production of a public relations and communications

campaign targeted at young people. The campaign must include themes and aesthetics, many of them present in social networks, in entertainment and training activities for the youth, such as cultural events, television shows and official documents. These included themes highlighted in Política Nacional da Juventude (PNJ) (Youth National Policy):

> The youth living experience in contemporary times showed itself more complex, combining training and experimentation processes and the construction of trajectories which include insertion in the world of work, the definition of identities, the experience of sexuality, of sociability, of leisure, of enjoyment and of cultural creation and also social participation. (2006, p. 5)

Various ethnographic approaches to juvenile experiences in large global cities, among them São Paulo and Rio de Janeiro, were highlighted in studies conducted by Future Concept Lab. They reveal that young people:

> … who live their own identity as "exposure" (a concept that includes the exhibition, but also exposure to technologies, the use of codes of some tribes and the sensitivity to language, of which music plays a special role) create their own aesthetic reference using such references. In the world of this generational core, fashion meets art, graphic arts and design. (2009, p. 12)

Based on these findings, Bayer Brazil concluded that it was essential to develop a specific communication project targeted just at young people to renew its image and strengthen its relationship bonds with this audience.

The company bet it could develop a project that sought to combine the primary focus of Bayer's activity—innovation in search of solutions to the major problems of humankind—with the themes that appear in the daily life of young people who will have the responsibility to sustain the country in the coming years.

OBJECTIVES

Bayer's main challenges and goals regarding the creation of the Bayer Jovens [Bayer Youth] platform were: rejuvenating the brand, coming closer to young people between 18–24 years of age; promoting the engagement of this market by encouraging their interest in subjects related to science, innovation and sustainability; reinforcing the brand's attributes among youth, such as sustainability, innovation and commitment to Brazil, and lastly, emphasizing Bayer's identity as an innovative company that is good to work for in order to attract professional talent.

KEY PUBLICS

The strategy adopted by Bayer Jovem for reaching its stated goals was to reposition Bayer's image in the digital environment with the launch of a communication platform focused especially on 18–24 year olds (college students).

KEY MESSAGES

Bayer Jovem used digital language and environments that are familiar to the target market – concepts from science, technology, the environment and health in a relaxed fashion, thus facilitating communication and interactivity with youth.

STRATEGIES

The development and implementation of the Bayer Jovens project involved eight professionals in total—among collaborators of Bayer's Communication area and a team from Jeffrey Group, the marketing agency working with the company. The project also involved members of Bayer's IT team from Germany, who were responsible for ensuring the technological alignment of Bayer Jovens with the global platform used by the company.

Currently, a team of six professionals of creation and production of content is responsible for defining the agendas, surveys and interviews, preparing texts and posts, selecting and treating images, managing texts written by columnists and interacting with followers on social media. Furthermore, two people guarantee the technical support and part of the programming of the website. The project was created under the coordination of the director of Corporate Communications of Bayer Brazil, Paulo Pereira Junior.

TACTICS

In a connected society, like that of today, communications actions, no matter how simple they may be, are reflected in many people's lives. And what Bayer does is invest in science, research, technology and innovation ethically and responsibly to find solutions and products that satisfy global needs.

Be it with drugs for diseases that affect the daily lives of millions or the seed prepared to tolerate the harshest climate conditions and create stronger fruit, Bayer's products and services are designed to benefit the population as a whole and to improve living standards.

On the other hand, Bayer aims at creating value through innovation that is in harmony with sustainable development and ethical and social responsibilities of today's corporations.

In its 152 years, 120 of which have been spent as part of Brazil's history, Bayer is taking steps to make science really be used for a better life. It is in this spirit that over 118,900 employees tirelessly work around the world to make science the greatest ally for quality of life.

In view of its goal of communicating with youth through social media and digital content available on the internet, Bayer created Bayer Jovens, in 2013, a digital platform for marketing content aimed at educational coverage of topics related to the company's business areas of particular interest to 18–24 year olds like sustainability, science, quality of life and innovation. Developed by Bayer Brazil with the support of the Jeffrey Group, the company's United States communication agency with a strong presence in Latin America, the Bayer Jovens project was created as a permanent digital platform for communicating and building relationships with youth. The platform intends to spark discussions so that this young college generation knows what it needs to do to make our planet a better place to live. The audience can participate by sending suggestions, criticism and comments. In mid-2015, the website was given a new, modern design and a more dynamic information architecture to follow content consumption trends in the youth market.

The Bayer Jovens platform is made up of an exclusive website (www.bayerjovens.com.br) and exclusive channels on Facebook (www.facebook.com/bayerjovensBR) and Twitter (twitter.com/BayerJovens).

Fig. 16.1. QUEM SOMOS—Bayer Jovens, screen shot image from website. Used with permission from Bayer.

Quality Original Content

The Bayer Jovens website leads internet surfers to information about science, sustainability, behavior, health, culture, innovation and careers, which is written in a straight-forward, young and interactive style, which encourages readers to collaborate with the development of the website. Currently, an average of 40 new pieces of content appear on the site each month. The subjects are divided among the following editorial topics: career (job market/education), science and behavior (articles about behavior, variety and general curiosity), culture and leisure (calendar of cultural attractions, reading tips, films, etc.), innovation (news in various fields of knowledge and technology tips), health and wellbeing, and sustainability.

Career

This section presents useful information for young people who are at the start of or planning their careers. It features interesting topics and tips from professionals about the job market. Professional life is not the only topic to be addressed: there are also academic topics. This editorial section also provides information about universities, entrance exams, scholarships and general information that can help young people become more competitive in the job market. There is also content explaining the dynamics of a variety of careers, thus helping young students when it comes time to making professional choices.

Science

This section features information related to the field of science and focuses on interesting topics, tips and useful information on the subject for youth. Bayer approaches these otherwise complex subjects in a light and relaxed way that relates to the daily lives of young people. This section, which is Bayer's great specialty, presents content that touches on several different sectors, like physics, chemistry and biology, to fully address the information connected to each of these pillars of science.

Behavior

This section introduces information related to the daily lives of youth and addresses everyday situations through more informational articles; other articles have a more thought-provoking quality. A variety of behavioral questions are raised, so that the reader can think about the topic. The informational part of this section mainly offers novelties in the youthful world, tips that keep them informed about the latest subjects that surround them.

Culture and Leisure

Aimed at encouraging youth to consume cultural products as well as publishing information about events related to culture and leisure, this section is basically made up of calendars and cultural information of a variety of types and targeted to a variety of cultural tastes. The site offers tips and suggestions for cultural plans that could be enjoyable for and interesting to youth. Additionally, there are a variety of articles about culture as well as lists of films, music, books and games of rather different styles to accommodate the greatest number of readers.

Innovation

This space addresses topics related to innovation and the role of science in creating solutions for the great challenges facing humanity around the globe. The section features the most diverse of subjects that ate taking place all over the world. Topics are mostly focused on technology, and so articles in this section are meant to feature content about tools and innovative discoveries of interest to youth in addition to thoughts about the elements that surround this news. The language is easy to read and the subjects are useful for expanding the knowledge that this youth audience has and which is extremely connected to topics like this one about innovations and new discoveries.

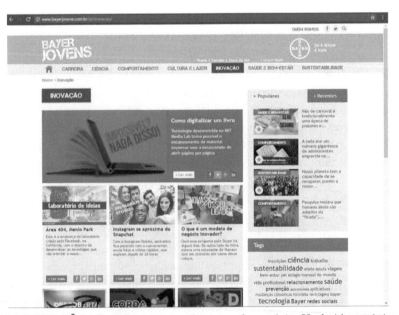

Fig. 16.2. INOVAÇÃO—Bayer Jovens, screen shot image from website. Used with permission from Bayer.

Health and Well Being

This section's main focus is health, with subjects focused on wellbeing and quality of life in articles presented by professionals and researchers in the field. The section, which is also one of Bayer's primary interests, deals with topics that involve health and wellbeing in general, focusing on what could be of interest to a young audience and encourage them to lead a healthy life.

Sustainability

This section highlights Bayer initiatives that can contribute towards the preservation of the planet as well as success stories and tips for a sustainable life. In addition to this, the space is dedicated to speeches that focus on the obstacle of involving citizens in sustainability because otherwise, their actions could put the lives of all human beings living on earth in danger.

In addition to the articles developed by the team of copywriters, the website has weekly columns written by professionals on a variety of areas such as sexuality, tourism, innovation, sustainability and science. They are:

Paulo Jubilut—Science

He is a professor, whose scope of action is connected to the teaching and dissemination of biology information through social media and the internet. In Bayer Jovens he focuses on talking about science subjects and especially about the area of biology focused on human health.

Rafael Bento—Sustainability

He is a biologist, holds a doctorate in the molecular biology of cancer and a post-doctorate in neurosciences by the University of São Paulo. Passionate about education and scientific dissemination, he was the coordinator of the mobile pedagogical content; is a science blogger since 2006, and is currently a partner of NuminLabs, a company of generation of content in education and scientific dissemination, and director of content of Scienceblogs Brazil, the largest network of science blogs in Portuguese. One of his main goals is a more sustainable world and that is what he writes about in Bayer Jovens.

Nathalie Ziemkiewicz—Sexuality

She is a journalist, postgraduate in sex education, a social communicator and author of the blog Pimentaria. In the past two years, she gave lectures to thousands of people about sexuality, the main subject of her articles in Bayer Jovens. She also writes her column three times a week on Yahoo.

Gisela Blanco—Innovation

She is a journalist and holds a master's degree in business innovation by University of London. For 10 years, she has been writing about science, technology and innovation, the focus of her publications in Bayer Jovens. She has contributed as a reporter and editor to some of the main magazines in Brazil such as "Superinteressante", one of the main Brazilian magazines of cultural and scientific curiosities; "Veja", the most widely distributed magazine in the country; "Exame" magazine, and "Claudia", the most highly-esteemed women's magazine in Brazil.

Gaía Passarelli—Travel

She is currently a freelance writer in São Paulo. As a reporter, she ran the website rraurl.com and contributed to "Rolling Stone" magazine and "Folha de S. Paulo", one of Brazil's main daily newspapers, among others. As a presenter, she worked at former MTV Brazil and at the TuboBR network on YouTube. Today she dedicates herself to the world of travel and writes mainly on her own blog How to Travel Light. In Bayer Jovens she writes about travel, especially giving tips on destinations and on how to prepare to hit the road.

Social Media: Facebook and Twitter

The content of the Bayer Jovens website is disseminated through Facebook (facebook.com/bayerjovensBR) and on Twitter (twitter.com/BayerJovens). The texts published daily on the website are converted into illustrated posts on Facebook and in posts on Twitter.

Facebook and Twitter replicate the content of the website and encourage the interaction of the brand with the youth public. Exclusive content also is produced for the Facebook fan page, such as videos and galleries of images.

CALENDAR/TIMETABLE

The initial project's planning began eight months before its release, in January 2013. The research work included the monitoring of social media in order to analyze the perception of the company's image among young people. In the first half of 2016, the team responsible for the website realized new requirements from the interests of the people who interact with Bayer Jovens channels, which led them to an update process of the website. It was important to the team that the project was linked to trends and to listen to the public, to remain current and relevant.

BUDGET

The budget for creation and development of the project, in 2013, was approximately $180,000.00 US. From 2013 to 2016, the budget for production and content updates is approximately $20,000 per month.

EVALUATION AND MEASUREMENT (2013–2016)

As of August 2016, 500 articles were produced for the Bayer Jovens website, and more than 1,600 posts were produced for Facebook and Twitter. When it comes to specialized content, there were 70 columns written by the expert specialists.

Graphics, photos and infographics were equally important: there were in total 13 galleries of images, 5000 images and five animated infographics were published. In addition, 10 polls for the website and 32 videos were produced, specially designed for the Bayer Jovens channels.

• Bayer Jovens Website

Between January 2013 and July 2014, the number of unique visitors was about 225,000 users, with about 25,000 visitors a month.

• Website contents produced since January 2013

Between its creation, in 2013, and August 2016, contents produced for the website included 530 articles, 70 columns of specialists, 5 animated infographics, 13 galleries/albums of images assembled from more than 5,000 images, 10 polls, and 32 videos produced especially for the website.

• Facebook and Twitter

Twitter has already reached 2,700 followers, whereas Facebook has one and a half million fans. The impacts are about four million per month, whereas the engagement rate (interactions/total of fans) is 1.5 percent of followers.

The Bayer Jovens website alone had, from January 2013 to July 2014, more than 400,000 visitors, a monthly average of over 20,000.

The strategy designed to strengthen Bayer's image on social media was also successful in promoting greater participation of users, especially on Facebook. In August 2016, the Bayer Jovens fan page surpassed the mark of 1.5 million fans. On Twitter the number of followers also increased, reaching more than 2,700 followers.

Another significant result of the project is the profile of the audience reached, corresponding exactly to the target set by the company. On Facebook, 55 percent of the followers are between 18 and 24 years old; another 20 percent are between 25 and 34 years old.

The project earned Bayer Brazil (Bayer, 2014), a tribute in the digital media category as the best project of the Prêmio ABERJE 2015 (ABERJE, 2015). The award is considered the most important in the sector for corporate communications directors and executives in Brazil according to the Map of Brazilian Communications (FSB, 2013, p. 80), the most comprehensive study on corporate communications in private companies and in government institutions in Brazil.

REFERENCES

ABERJE. (2006). *Comunicação empresarial* (Vol. 2). São Paulo: ABERJE.

ABERJE. (2015). *Prêmio ABERJE 2014.* Vencedor regional Espiríto Santo e Rio de Janeiro. Retrieved September 1, 2016 from http://www.aberje.com.br/premio/2014/es_rj.php

Bayer. (1986). *Reclames da Bayer. 1911-1942.* São Paulo: Carrenho.

Bayer. (2014). *Projeto Bayer Jovens.* Vencedor regional do Prêmio ABERJE 2014, categoria Mídia digital. Rio de Janeiro: Bayer.

Bayer. (2016). *About Bayer.* Retrieved September 1, 2016 from http://www.bayer.com/en/Bayer-Group.aspx

Bighetti, W. V. F. (2016) *Memória organizacional como estratégia de comunicação: um estado sob o viés da recepção do público jovem.* Dissertação de mestrado, Faculdade de Arquitetura, Artes e Comunicação da Universidade Estadual Paulista "Júlio de Mesquita Filho", Bauru, São Paulo, Brasil.

Brasil. Ministério Da Educação. (2007). *Juventude e Trabalho.* Coleção de Cadernos EJA. Brasília: Ministério da Educação.

Brasil. (2014). Presidência Da República. Secretaria De Comunicação Social. *Pesquisa Brasileira De Mídia 2015: hábitos de consumo de mídia pela população brasileira.* Brasília: Secom. Retrieved September 1, 2016 from http://www.secom.gov.br/atuacao/pesquisa/lista-de-pesquisas-quantitativas-e-qualitativas-de-contratos-atuais/pesquisa-brasileira-de-midia-pbm-2015.pdf

FSB. (2013). *Mapa da comunicação brasileira 2013.* Brasília, DF: FSB. Comunicações.

IBGE. (2010). *Censo demográfico 2010.* Retrieved September 1, 2016 from http://www.censo2010.ibge.gov.br

Kunsch, M. M. K. (1997). *Relações públicas e modernidade: novos paradigmas na comunicação organizacional.* São Paulo: Summus.

Kunsch, M. M. K., & Nassar, P. (2009). The relationship between the academy and professional organizations in the development of organizational communication. *Management Communication Quarterly, 22,* 655–662.

Melhores e Maiores: as 1000 maiores empresas do Brasil. (2015). Exame, Abril.

Mesquita, B. (2015, July 29). 90% dos jovens brasileiros possuem pelo menos um perfil nas redes sociais. *Exame.com.* Tecnologia. Retrieved September 1, 2016 from http://exame.abril.com.br/tecnologia/noticias/90-dos-jovens-brasileiros-possuem-pelo-menos-um-perfil-proprio-em-rede-social

Morace, F. (2009). *Consumo autoral: as gerações como empresas criativas.* São Paulo: Estação das Letras e Cores Editora.

Nassar, P. (2009). A ABERJE E A Comunicação Organizacional No Brasil. In M. M. K. Kunsch (org.). *Comunicação organizacional: histórico, fundamentos e processos* (Vol. 1, pp. 29–44). São Paulo: Saraiva.

Pesquisa sobre o uso da internet por crianças e adolescentes no Brasil: ICT Kids online Brasil 2014. (2015). São Paulo: Comitê Gestor da Internet no Brasil. Retrieved September 1, 2016 from http://cetic.br/publicacao/pesquisa-sobre-o-uso-da-internet-por-criancas-e-adolescentes-no-brasil-tic-kids-online-brasil-2014/

Política Nacional de Juventude: diretrizes e perspectivas. (2006). São Paulo: Conselho Nacional de Juventude; Fundação Friedrich Ebert.

Torquato, G. (1984). *Jornalismo empresarial.* São Paulo: Summus.

Torquato, G. (2002). *Tratado de comunicação organizacional e política.* São Paulo: Thomson.

Você S/A. (2015). *Guia Exame-Você S/A: As melhores empresas para você trabalhar.* São Paulo, Editora Abril.

Reaching FOR THE Stars

The Launch of the UAE Space Agency

INKA STEVER
College of Communication and Media Sciences,
Zayed University

DR. GAELLE PICHERIT DUTHLER
College of Communication and Media Sciences,
Zayed University

EDITOR'S NOTE

This case caught our attention for its attention to careful planning and spot-on strategy and execution. It won an award from the Middle East public Relations Association and as you will see, the event lead-up was equally important to the success of the launch itself. It allowed a relatively minor participant in the space research area to shine and be recognized for its contribution-thereby contributing to the prestige of a nation.

BACKGROUND

Running extensive public relations campaigns leading up to the launch of a product, a company or a service are very popular and quite often an opportunity for creativity. Companies such as Apple are renowned for using exceptional public relations strategies before they launch a product. When launching a service or product, it should not be a one off activity, but should be part of an overarching strategy. Events provide the organization with opportunities to build relationships and manage their reputations.

On May 25, 2015, the United Arab Emirates Government officially launched the UAE Space Agency to international stakeholders. However, the work started

almost a year earlier in July 2014, when UAE President His Highness Sheikh Khalifa bin Zayed Al Nahyan announced the founding of the UAE Space Agency. The space agency was tasked with developing the UAE space industry's strategic and operational framework and to supervise all space exploration activities in the country, develop technology and spearhead knowledge development and transfer. It was also set up to establish international partnerships and enhance the role of the UAE and its position in the space sector.

The launch of the UAE Space agency came at a time when high profile agencies such as NASA and Roscosmos-the Russian Federal Space Agency-had been struggling with budget cuts: The U.S. government cut NASA's budget by $300USD million for 2017, while Roscosmos had to take a 30 percent budget cut due to falling oil prices and Western sanctions imposed on Russia (Lewin, 2016; Stubbs, 2016).

At the same time, renewed interest in space explorations, especially in missions to Mars, has seen a number of countries establishing new space agencies in the last 10 years: Spain (2010), United Kingdom (2010), Portugal (2009), South Africa (2010), Mexico (2010) and Belarus (2010) to name a few. None of the existing agencies though were located in the Arabic world. The UAE Space Agency is the first of its kind in the Arab World.

Reasons for the decision to establish the Space Agency were twofold: historically, Arabic astronomers were renowned for many of the scientific discoveries. In the 9th–16th century astronomers like Al-Battani, Al-Faraghani and Abdul Rahman Al-Sofi were amongst the first to map the exact positions of stars, and have moon craters named after them. Today, there is a strong urge amongst the Arabic science community "to reclaim its lost tradition of astronomical learning," as Nidhal Guessoum, a professor of physics and astronomy at the American University of Sharjah in the United Arab Emirates stated (Wall, 2013). The country's Prime Minister His Highness Sheikh Mohamed Bin Rashid al Maktoum liked this approach and saw the Space Agency spearheading the efforts to reignite the UAE's strive for leadership in innovation and scientific discoveries.

Additionally, the announcement of an ambitious and inspiring project stood out against the negative news of ongoing political turmoil that has been dominating the news from the Arab region, allowing the UAE to position itself as a positive force in the region. "Despite all the tensions and the conflicts across the Middle East, we have proved today how positive a contribution the Arab people can make to humanity through great achievements, given the right circumstances and ingredients. Our region is a region of civilization. Our destiny is, once again, to explore, to create, to build and to civilize," said Sheikh Mohamed Bin Rashid Al Maktoum, Prime Minister of the UAE and Ruler of Dubai during the launch of the UAE Space Agency (UAE wants space and probe to Mars by 2021, 2014).

The launch of the agency was not only the inception of a new regulatory body but also of a more organized industry as well. While the UAE did not have a fully developed space program, the country had already been active in space with communications satellites and Earth observation satellites, with companies such as Thuraya and Yahsat.[1] Additionally, the Mohamed Bin Rashid Space Center (MBRSC), originally established in 2006 had been tasked with accumulating knowledge, recruiting Emirati scientists and engineers, and launching advanced scientific projects (Discover the MBRSC Story, 2016).

The UAE Space agency had to come up with a strategy on how to position itself on three different fronts: the already existing companies in the industry; alongside renowned international space agencies such as NASA, Roscosmos the European Space Agency and others; and last winning the support and acceptance of the UAE population. The launch of this strategy in May 2015 is the subject of this case study. The launch was the highest profile public sector event undertaken by the UAE Space Agency since its inception as a federal agency in July 2014. The Agency wanted an international footprint despite the fact that it is a policy making body that does not build any sort of space hardware, and it is an organization that still is in the start-up phase with no history or achievements.

SITUATION ANALYSIS

Strengths

Sheikh Mohammed bin Rashid Al Maktoum, UAE Vice President, Prime Minister and the Ruler of Dubai officially announced the founding of the UAE Space Agency on his Twitter account on May 25, 2015. Stating: "Today we announce two epic projects in our history: establishing UAE Space Agency and sending the first Arab spaceship to Mars by 2021", over 6 million people were informed that the UAE had launched the space agency. In the past, the UAE government has exerted great vision in spearheading innovative and creative projects, such as building the Arab world's first Smart City or building the world's first carbon neutral city. With the UAE Space Agency, the organizers could count on the leadership support for this endeavor.

The international partners involved with the space agency are many and they are influential. Institutions like NASA, the European Space Agency, UK Space Agency, French National Space Agency and Italian space Agency and others welcomed the new player as their program complemented existing and recent missions and projects. In fact, the UAE Space Agency had already signed agreements with NASA, Lockheed Martin, the French National Space Agency (CNES), Airbus, and many others. These partnerships will help the UAE overcome some of its weaknesses, especially in STEM[2] education and expertise in space industry. On

the other hand, the agency will bring a financial powerhouse to the table as they are backed by the government of one of the richest country in the world.

At the time the UAE Space Agency was launched, the UAE's investments in space technologies was already exceeding AED 20 billion (USD 5.4 billion), including UAE-based companies who are among major international players (UAE Space Agency, 2016).

Although it is pale in comparison to NASA's $18 billion budget, the UAE Space Agency brings additional funding for future missions to Mars, which has been put on the back burner by the US Agency and others.

Weaknesses

The UAE Space Agency faced a number of challenges to successfully position itself: a lack of experience and history in space exploration; no track record of strong Science, Technology, Engineering and Maths (STEM) education and the reputation of the UAE as an "ATM" machine.

Although many Arab scientists have led to major discoveries in the field of science in the past, nowadays there is a lack of innovation in science coming from the Middle East. In fact, there are only a few Arabs involved in space exploration, including Abdulmohsen Hamad Al Bassam, Sultan bin Salman Al Saud the first Arab astronaut and Mohammed Faris as the second. In addition to Farouk El-Baz an Egyptian-American space scientist who helped NASA plan and identify the Moon landing location for Apollo 11 historic moon landing in 1969 (Verger, Sourves-Verger, Ghirardi, Lyle, & Reilly, 2003).

Interest in science among students and the general public the UAE remains low, which is problematic at a time when the region's young people need to compete in a world increasingly centered on STEM. Although the UAE government has launched a few national initiatives, it needs to step up its efforts to attract their young people to STEM education and careers.

Without a trained and prepared workforce, the UAE Space Agency faced the issue of being seen as "buying" the expertise. As Chief Corporate Officer and Director of Innovation, UAE Space Agency, Al Masakri (personal communication, June 6, 2016) reported that some background reputation research showed that the image of the UAE is often seen as that of an "ATM machine." There was a possibility that the UAE Space Agency was going to be perceived as one to purchase and compete rather than collaborate and add value.

Opportunities

With political unrest and wars dominating news from the Arab region, a positive message would fall on very fruitful ground and open ears. During a time where the

Middle East is facing some serious political issues, international cooperation on STEM issues can strengthen relationships between the Middle East and Western nations (Hajjar, June 27, 2016). With the UAE Space Agency, the UAE can build partnerships with European, American and other international education institutes involved in STEM education, as well as the aerospace industry, which would bring good will and positive collaborations between nations and science diplomacy. These international partnerships would elevate the push for space exploration as well as establish a stronger foundation for STEM education.

Threats

There are many space agencies, some are government agencies, some have launching facilities, and some have been in the planning stage for a long time. The launch of the UAE Space Agency (UAESA) in 2015 reflects a desire to join the club of the space industry. However, the UAE is the last to join in the crowded field. Lead by the Agency, the UAE needs to be seen as an active participant in order to receive any type of recognition.

The UAE is expected to contribute to the space industry despite the lack of Emirati scientists within the field of Space and a high dependence on foreign knowledge. They face the possibility of not being taken seriously by their international partners and competitors. The UAESA needs to establish its credibility through communication and investing heavily in their workforce. The UAE Government has already invested heavily in diverse industries to minimize its GDP (gross domestic product) on oil revenues currently pegged at 30 percent. The government aims for this to fall to 20 percent by 2021 and to zero percent in the next 50 years (Mayenkar, 2016).

CORE OPPORTUNITY

When the UAE Space Agency was first announced, it was received with a great amount of skepticism in the international press. The UAE did not have a reputation as a research driven, technologically innovative society, but was rather seen as the oil rich country that purchases expertise and technology. Therefore, international stakeholders were curious to see what expertise the UAE actually had to offer (Al Maskari, personal communication, June 6, 2016). Not too much added value for international space exploration was expected from the newly founded agency.

Therefore, the main challenge was to gain industry acceptance internationally as well as nationally. The UAE Space Agency is a new player in a 50-year-old industry. They needed to issue a policy framework without competing with already established policies such as the General Civil Aviation Authority and the

Telecommunication Regulatory Authority. This new agency had to find its place to establish itself among key stakeholders and other international agencies. It had to develop its own identity and content. Overall, their main objective was to gain acceptance and positive feedback as a key player in the international space industry.

GOALS

The oil rich country of the United Arab Emirates needed to convince its national and international audience that the new Space Agency was a valuable addition to the international space industry that can truly contribute to the common goal of space exploration. On the national level the main objective was to gain the buy-in and support of the key decision makers as well as the general public. In times where dropping oil prices forced the government to cut its federal budget, it needed to be well communicated to the public why it was advantageous for the nation to have a fully funded space agency.

The UAE Space Agency shares common objectives with many of its approximately 70 counterparts worldwide:

- To organize, regulate and support the space sector in the country and to enhance its position in this area;
- To encourage the development and use of space science and technology in the country and advance within the industry;
- To establish international partnerships in the space sector and to enhance the role of the state and its position in the space sector;
- To contribute to the diversification of the national economy through the space sector;
- To raise awareness of the importance of the space technologies, enhance national capabilities and encourage peaceful application of space research (UAE Space Agency, 2015).

But the agency's vision statement points to a grander plan: "To proudly craft the future of the United Arab Emirates as a leader in space exploration and inspire the next generations for the benefit of the nation and mankind." In exploration, the UAE intends to make an early mark—by launching a mission to Mars in July 2020 to arrive in early 2021, to mark the 50th anniversary of the UAE's founding.

KEY PUBLICS

The launch of the agency addressed two major target audiences: the international space community and the UAE population. At the international level, the goal

was to convince the major international space agencies that the newly founded UAE agency was not competing with the key players on the international scale but was interested in cooperating towards the common goal of space exploration. When the founding of the UAE Space Agency was first announced, international reactions were rather sobering. Media reports showed that the new space agency was considered as a financial contributor rather than a partner who can valuably assist in technological advancements of space exploration (Al Maskari, personal communication, June 6, 2016).

On the national level, the project needed the-buy in of the general population. Emiratis in general take great pride in the achievements of their country and are willing to fully support federal projects. They have a strong "can-do" attitude, especially when it comes to new projects that seem to break the superlative, such as building the highest building in the world, the Burj Khalifa, or creating the world's largest artificial island, The Palm. But as 2015 saw a drop in oil prices, severe cuts in the government budget made the Emirati population slowly begin to feel the slow down. The government needs to justify the additional spending on space exploration sensibly to gain the population's support.

OBJECTIVES

The objectives were threefold:

1. To strengthen the connections of the UAE Space Agency and the space industry
2. To engage key stakeholders within the international space industry
3. To position the UAE as a leader within the regional space industry

KEY MESSAGES

The launch campaign focused on a set of key messages to firstly, showcase the sincerity and expertise of the newly founded agency to the international space community and secondly, instill a sense of pride in the UAE population:

1. About the UAE Space Agency itself
 a. A Federal Decree No 1 established the UAE Space Agency in 2014 issued by President His Highness Shaikh Khalifa Bin Zayed Al Nahyan. The Agency's mandate is to develop the UAE space sector, create the space policy and regulation and direct national space programs that will benefit the UAE's economy.

 b. UAE sees the space industry as an important part of the future

 c. The UAE will be at the forefront of global space development and exploration, using the world's most advanced technology and resources.

2. About the space industry in the UAE

 a. The UAE Space Agency and its partners Yahsat and Thuray who come with more than 20 years of experience in space technology

 b. The UAE will be at the forefront of global space development and exploration, using the world's most advanced technology and resources.

3. The significance of Space Exploration for the UAE as a country

 a. The UAE Space Agency's initiatives and programs will be a source of national pride, contributing to the benefit of the nation and humankind.

 b. Emiratis will lead the space industry in the GCC region

 c. will be a source of pride for the UAE

 d. The mission is a source of national pride and will be a key milestone in history

STRATEGIES

The preparation involved careful planning to take into account large amounts of content that needed to be developed, and multi-pronged, multi-lateral media strategy to secure international coverage, as well as a number of facets that had to be managed on the day of the launch.

The main strategy pursued by the Space Agency was to run a pre-event PR campaign to generate pride and inform the larger space community leading up to the launch event itself. A widespread awareness campaign about the purpose and expertise of the Space Agency informed national and international partners and created a sense of pride and anticipation in the general Emirati public. To reach the different target audiences, the Space Agency followed these two-pronged strategy with different tactics: one to build on rational argumentation and fact driven information to address the space industry and another emotionally driven campaign that was to instill pride about UAE driven space exploration in the general public.

To ensure industry acceptance it was crucial to find the right international platform. The "Global Space and Satellite Forum" was due to take place in Abu Dhabi May 26–27, 2015 and offered the perfect opportunity to launch the Space Agency's strategy. The forum gathered international experts from all major space agencies and companies. The conference gave the UAE the opportunity to address their international stakeholders face-to-face and convince them of the expertise the new agency could add to international space discovery. By tying the launch event to the conference, it was guaranteed to receive international coverage in industry related media.

At the same time, the event allowed for all national industry stakeholders to play a part in the launch, mainly Yahsat, Thuraya and the Mohamed Bin Rashid Space Center. The three main partners were given the opportunity to display their own brand and expertise, contributing to a stronger buy-in into the newly founded agency. Winning them as active partners for the Space Agency added significantly to the success of the strategy for the launch. A task force responsible for the delivery of the event and developing all documents and materials was established. The group included the UAE's leading management and communications teams, Thuraya, Yahsat and the Mohamed Bin Rashid Space Center (MBRSC), Four Communications Group, the public relations and communications agency and Streamline Marketing Group (SMG), the event organizer. A detailed communications plan for combining elements was developed and shared with all stakeholders for execution.

To make up for the absence of existing information and content, the agency directed people's attention to the UAE's historic relations with the space industry. Industry news was also researched to create new content. This meant working with industry and government partners to collect relevant content, including:

- National Archives Department
- Abu Dhabi Media
- Thurayat
- Yahsat
- Malaysian Space Agency
- Farouk El-Baz
- Buzz Aldrin
- Al Ain Museum
- International Space Agencies and museums

The campaign was based on four phases the first of which was material preparation, followed by the approach phase (about 2 months before the event), the day before the event and the actual event day itself.

TACTICS

The pre-coverage campaign began two months before the launch event. Press releases were sent out to announce the event, invitations were sent out through international platforms, the Prime Minister's Office as well as the UAE embassies and the UAE UN representative. Media invitations went out 20 days prior to the event with reminder emails with further events following every two weeks.

Building the excitement

Fig. 17.1. The Independent integrated agency, flow chart for project. Credit: UAE Space Agency.

The communications plan included several types of PR activities and materials.

- Print communications

During the event, the journalists were given a press pack written in English and Arabic. The Press pack included the chairman's biography, the Director General's biography, the UAE Space Agency backgrounder, and copies of all the speeches. Participants were given the first edition of the UAE Space Agency newsletter "Madarat", a copy of the corporate brochure, and a copy of the chairman's white paper about the UAE Space Agency.

- Media relations

Six press releases were developed ahead and during the launch event:

April 25: Investing in Space Education Supports Industry Growth and National Security

May 18: UAE Space Agency and Airbus Group Partner to Foster Talent Development Among UAE Youth Through STEM Education Initiative

May 23: Official Launch of the UAE Space Agency to Take Place on Monday in Abu Dhabi

May 25: Mohammed Bin Rashid Witnesses the Launch of Strategic Plans of UAE
 Space Agency

May 26: Commercialization of Space a Growing Trend Within Space Industry

May 27: Mars Missions Help Nations Build Scientific Capabilities and Develop
 Technology

- Interviews

Several group interviews were conducted with local, regional, and international media. There were also three pre-event interviews with Dr. Mohmmed Al Ahbabi, Director General, with three UAE Arabic and English newspapers.

- Speakership opportunities

Several speaking opportunities were built in during several industry events including the Working Group on Emergency Telecommunications (WGET) Forum held for the first time in the Middle East. This Forum is well attended including the United Nations and other space programs.

- Digital and Social media

A website was developed to create a digital presence for the UAE Space Agency. In addition, an app was created to teach people about the development of the space sector and how the agency came about. Social media also played an important role. The content of social media focused on engaging and educating the public around themed plans. For example, the theme "UAE Space Industry" contained posts such as "How do you think the space industry will contribute to the #UAE? #UAESA" and "Islamic Civilization is deeply involved in astronomy and presented great achievements to society? #UAESA"

- The launch event

It was decided that the event itself would highlight "*The journey of the UAE into the Space Industry*" starting from the days of Sheikh Zayed and his meeting with the Apollo teams in the 1970s.

The creative treatment included the venue, which was developed to provide visitors with the feeling of space—this covered every detail including catering and set up. The exhibition informed about the UAE journey in space and its current assets. Special space catering was provided with a UAE flavor.

For the duration of the Global Space and Satellite Forum, the Space Agency partnered with Airbus to offer the *Little Engineering Space Workshop* for around

100 students from UAE schools to gain the interest of the future generation of space explorers. Additionally, the agency gained the *Arabic Sesame Street's* cooperation, which agreed to introduce space and science as the main theme for season one, giving the agency opportunity to awaken curiosity and interest in the sciences amongst children.

Third party endorsement was a key element of the announcements. The announcement press release included quotes from a number of stakeholders including the UAE Prime Minister, and representatives of Thuraya, Yahsat, NASA, Airbus Space and others. A number of interviews were also organized with local, regional and international stakeholders during the event to secure third party endorsement.

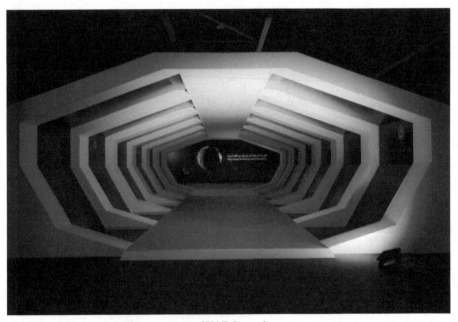

Fig. 17.2. Space entrance. Photo courtesy of UAE Space Agency.

CALENDAR/TIMETABLE

The government formally established the UAE Space Agency in July 2014. In November 2014, the public relations and communications agency Four Communications Group was appointed as the retained public relations agency for the UAE Space Agency. Four Communications Group worked on developing and implementation of the communications strategy and program for the official launch campaign of the agency's strategy. The date of the launch was set for 25 May 2015.

BUDGET

The budget allocated for the launch event itself was set at AED 6 million (USD 1.64 million). This covered the expenses for the event and logistic. The communications element of the launch event was executed within the agreed monthly retainer AED 50k–100k (USD 14k–28k) range.

EVALUATION AND MEASUREMENT

The campaign was covered mainly regionally (in English and Arabic). The international coverage amounted to a quarter of the media outputs (Four Communications Group, May 28 2015). More specifically, media outlets from 26 countries covered the launch of the UAE Space Agency. Many international media outlets also covered it, including CNN, BBC, AFP, AP, Bloomberg, Reuters, etc.

As of August 27, 2015-three months after the launch event-, the UAE Space agency reached 706 Facebook fans, 2,431 Twitter followers, 663 Instagram followers, 51 Google plus followers and had 13 YouTube subscribers.

In addition, the leaders of the industry recognized the UAE Space Agency. They won the "Innovator of the Year" category in the Gulf Business Industry Awards. The agency won recognition by key stakeholders by having their Director General listed as one of the world's five most influential space leaders by Space News Magazine. The event was named Gold Winner in the Best Launch Live Event/Stunt category of the Middle East Public Relations Association (MEPRA) awards in 2015(Four Communications. (2015 October 15).

REFERENCES

Discover MBRSC Story. (2016, June 18). Retrieved from http://mbrsc.ae/en/page/who-we-are

Four Communications. (2015, May 28). *Coverage report*. Abu Dhabi: Space Agency.

Four Communications. (2015, October 15). We have lift-off! Launching the UAE Space Agency strategy. *MEPRA Best Practice Awards*.

Hajjar, D. P. (2016, June 27). Want to ease tensions in the Middle East? Science diplomacy can help. *Markaz* [BLOG]. Brookings Institution Press.

Lewin, S. (2016, February 10). *NASA's 2017 budget request: Reactions from space industry experts, lawmakers*. Retrieved from http://www.space.com/31886-nasa-2017-budget-request-reactions.html

Mayenkar, S. S. (2016, April 11). UAE targets zero contribution from oil to GDP, Minister says. *Gulf News*.

Stubbs, J. (2016, March 17). Russia slashes space funding by 30 percent as crisis weighs. *Reuters*. Retrieved from http://www.reuters.com/article/us-russia-space-idUSKCN0WJ1YJ

UAE Space Agency. (2015). *Strategic objectives*. Retrieved from http://www.space.gov.ae/strategic-objectives

UAE Space Agency. (2016). *UAE space industry*. Retrieved from http://space.gov.ae/uae-space-industry

UAE Wants Space Agency and Probe to Mars by 2021. (2014, July 16). Retrieved from https://www.rt.com/news/173200-uae-space-agency-establishing/

Verger, F., Sourves-Verger, I. Ghirardi, R., Lyle, S., & Reilly, P. (2003). *The Cambridge encyclopedia of space: Missions, applications, and exploration*. Cambridge: Cambridge University Press.

Wall, M. (2013, June 12). *Time is right for Arab astronomy renaissance, scientist says*. Retrieved from http://www.space.com/21532-arab-nations-astronomy-renaissance.html

A Taste OF Harmony

Awareness and Celebration of Cultural Diversity in Australian Workplaces

INGRID LARKIN AND ROBINA XAVIER
QUT Business School, Queensland University
of Technology

EDITOR'S NOTE

Cultural diversity is a given in the audiences and publics of many public relations campaigns. In Australia, "A Taste of Harmony" was a public relations and communication campaign whose goal was to garner greater cultural awareness and acceptance by celebrating diversity in Australian workplaces—and in their cuisines. The campaign centered around food, with each company participant bringing to work a dish that reflected their cultural heritage, and sharing food and stories with their colleagues. Almost half of Australia's population was either born overseas or has a parent from another country, and research indicated there was limited recognition of cultural diversity in workplaces. The campaign used an integrated suite of tactics, some designed to equip workplaces with communication and other tools to successfully host A Taste of Harmony event. Other tactics focused on achieving broader awareness and participation through media relations, social media content, activations and ambassadors as influencers. The campaign was featured in the 2015 Public Relations Institute of Australia Golden Target Awards as the winner for New South Wales state awards.

BACKGROUND

A Taste of Harmony is an annual event held in March celebrating cultural diversity in workplaces across Australia. Launched in 2009, the free event encourages workplaces to recognize and celebrate the diverse cultural backgrounds of Australians. Organizations are invited to register an event for A Taste of Harmony, and workers bring a dish representing their cultural heritage, sharing food and stories with colleagues over a meal.

A Taste of Harmony was created by the public relations consultancy Haystac, part of the Dentsu Aegis Network, for the Scanlon Foundation. The Scanlon Foundation is a philanthropic foundation established in 2001 by one of Australia's wealthiest businesspeople, Peter Scanlon. Scanlon and his family are regularly listed on the Australian BRW Rich 200 List, an annual list of Australia's 200 wealthiest individuals and families (Stensholt, 2016). On the 2016 List, Peter Scanlon and family were ranked at 75, listed with wealth of $A766 million (Palmer, 2016). Scanlon established much of his wealth through the successful logistics and stevedoring business Patrick Corporation, which he sold to Toll Holdings in 2006. More recently, the wealth of Scanlon and his family has been built through stevedoring, logistics and ports, along with property and investment (Stensholt, 2015).

Alongside his strong business success, Scanlon is a significant philanthropist. In 2015, Scanlon was appointed as an Officer of the Order of Australia, one of Australia's highest honors for distinguished service, in recognition of his contribution to promoting multiculturalism and promoting social cohesion (Herald Sun, 2015).

The entry to the website for the Scanlon Foundation (www.scanlonfoundation.org.au) features a quote from Scanlon, which reflects his commitment and contribution to diversity and social cohesion:

> The peaceful settlement of millions of people ranks among our greatest achievements as a nation. New Australians strive to find belonging and acceptance, to forge new bonds of kinship, friendship, community and home. It is in our interest both economically and socially to provide support along the way.

Reflecting Scanlon's views, the Scanlon Foundation "aspires to see Australia advance as a welcoming, prosperous and cohesive nation particularly related to the transition of migrants into Australian society ... It was formed on a view that Australia, with the exception of Australia's First Peoples, is and always will be a migrant nation" (see www.scanlonfoundation.org.au/who-we-are/purpose-history).

Each year, the Scanlon Foundation supports research, grants and projects focused on supporting cultural diversity and social cohesion. In partnership with Monash University and the Australian Multicultural Foundation, the Mapping Social Cohesion report "tracks public attitudes on issues including immigration, multiculturalism, discrimination, and belonging, and maps [Australia's] national

mood via the Scanlon-Monash Index of Social Cohesion" (Scanlon Foundation, Monash University & Australian Multicultural Foundation, 2015). Other research includes a Multiculturalism Discussion Paper released in early 2016, which explores Australian attitudes towards multiculturalism (Scanlon Foundation, 2016b). The Scanlon Foundation grants program provides funding of up to $A25,000 for projects supporting the transition of migrants into local communities. The most recent annual community grant round supported 28 projects in 14 local government areas across Australia (Scanlon Foundation, 2016a).

A Taste of Harmony is also linked to Harmony Day, an initiative of the Australian government. Harmony Day is held on March 21 every year, aligned with the United Nations International Day for the Elimination of Racial Discrimination. Harmony Day is "a day of cultural respect for everyone who calls Australia home" (Australian Government Department of Social Services, n.d.) and promotes the message "everyone belongs".

This case study has been developed based on research into the Scanlon Foundation and searching of media databases, and an award entry prepared by Haystac and submitted to the Public Relations Institute of Australia Golden Target Awards in 2009 and 2015 also informed this case study.

SITUATION ANALYSIS

There are significant facts and statistics about diversity in Australia that underpin A Taste of Harmony. The Australian Bureau of Statistics 2011 Census data and the Mapping Social Cohesion National Report 2015 from the Scanlon Foundation (cited in Markus, 2015) include the following data:

- Around 45 percent of Australians were born overseas or have at least one parent who was born overseas
- Since 1945, around 7.2 million people have migrated to Australia
- Australians identify with around 300 ancestries
- 86 percent of Australians agree multiculturalism has been good for Australia
- Apart from English, the most common languages spoken in Australia are Mandarin, Italian, Arabic, Cantonese, Greek, Vietnamese, Tagalog/Filipino, Spanish, and Hindi
- More than 60 Indigenous languages are spoken in Australia
- 92 percent of Australians feel a great sense of belonging to their country.

The Diversity Council of Australia refers to "culture" as "a common set of norms and values shared by a group" and "cultural diversity" as "the variation between people in terms of ancestry, ethnicity, language, national origin, race,

and/or religion" (from Workplace Cultural Diversity Tool at www.cultural-diversity.humanrights.gov.au/faqs) When A Taste of Harmony was developed in 2009, it was informed by research from the Australian Center for International Business. The survey of 227 Australian CEOs showed "recognition of cultural diversity and its potential benefits to workplaces was largely untapped and unacknowledged" and "business leaders have been reluctant to acknowledge and embrace the benefits cultural diversity can bring to a workplace" (see Haystac PRIA Golden Target Award 2009 entry). This is evidenced through the attitudes of the CEOs surveyed in the Australian Center for International Business research that reported:

- Only 16 percent saw the recognition and management of diversity of high importance to the bottom line
- Only 14 percent ranked diversity of high importance in recruitment
- Only 32 percent ranked diversity as important to workplace productivity
- While 22 percent ranked diversity of high importance to their firms' social responsibility, another 15 percent ranked it of no or low importance.

The Scanlon Foundation had focused on annual grants program in local communities, but had recognized that issues of cultural diversity and social cohesion were not a focus of broader business, social, political and media conversations.

The value and contribution of cultural diversity and inclusion in the workplace has been established and reinforced through research. The fact sheet "Cultural Diversity: the benefits for business" from A Taste of Harmony website provides a summary of research that indicates cultural diversity provides access to new domestic and international markets, delivers productivity and innovation, allows business to recruit and retain the best talent and improves the bottom line for business.

The past decade has seen growth in peer-to-peer fundraising programs, and in awareness campaigns strongly supported by online tools and content for social media conversations and sharing led by individuals and organizations. A Taste of Harmony leveraged these trends.

CORE OPPORTUNITY

When Haystac developed A Taste of Harmony for the Scanlon Foundation, the initiative was carefully designed to start conversations in workplaces around the value of social cohesion and acceptance of diversity. The opportunity was leveraged from a strong understanding of the Australian cultural landscape, along with a range of policy initiatives from government and in organizations seeking

to support diversity. A Taste of Harmony provided the opportunity to start conversations and share stories of culture, building on the common global tradition of food being central to celebration and sharing. A Taste of Harmony is designed as a far reaching and impactful way to recognize and celebrate cultural diversity in the workplace.

GOALS

Broadly, the goal of A Taste of Harmony is to promote social cohesion and break down diversity barriers to create inclusive workplaces through sharing food and stories from the rich and diverse cultural backgrounds of workers in Australian organizations that are reflective of broader Australian society. The goal is to drive attitudinal and behavioral change, or reinforce existing attitudes and behaviors that embrace cultural diversity and social cohesion.

OBJECTIVES

Since its launch in 2009, A Taste of Harmony has centered on clear and specific objectives to monitor and measure the effectiveness of the communication activities. As a public relations consultancy, Haystac submitted A Taste of Harmony as an entry in the Public Relations Institute of Australia (PRIA) Golden Target Awards in 2009 and 2015. The award entries specifically outline the objectives set to measure success for A Taste of Harmony.

For the inaugural event in 2009, the award entry outlined the objectives set for A Taste of Harmony as:

- Recruit more than 1,000 workplaces
- Raise awareness of the benefits of social cohesion in the workplace measured through participant feedback survey
- Obtain support from participants for A Taste of Harmony as an annual campaign measured through participant feedback survey
- Secure partnership with Australian Government Department of Immigration linking A Taste of Harmony to national Harmony Day
- Secure mainstream suburban, regional, local, and trade media coverage
- Secure six business sponsors and supporters; and
- Secure five celebrity ambassadors.

Some objectives for A Taste of Harmony campaign in 2009 did not include specific quantifiable measures. As this was the inaugural year for A Taste of

Harmony, the first campaign may have been used to set quantifiable benchmarks for campaigns in subsequent years. For example, media coverage achieved during the first year of the campaign may have been compared against other campaigns with similar lead time and budget, and the 2009 results were used to set benchmark for objectives in the following years.

As A Taste of Harmony grew in its success, and was refined in its execution, similarly the objectives were refined. In 2015, the objectives for A Taste of Harmony were outlined as:

- Engaging new participants to reach 5,000 participating workplaces in 2015
- Re-engage at least 50 percent of 2014 participants in 2015, and
- Maintain the power and impact of A Taste of Harmony by ensuring workplace events are meaningful and impactful, as measured by participant survey and through digital and social media conversations, and editorial coverage.

KEY PUBLICS

Broadly, A Taste of Harmony was intended to engage employees in all Australian workplaces.

More specifically, the campaign was designed each year to reach primary key publics as decision makers and champions for A Taste of Harmony. The primary target publics included diversity managers, human resources officers and office managers in large businesses, along with owners of small businesses and small-to-medium enterprises (SMEs). These primary key publics were identified as having the capacity and authority to initiate and lead A Taste of Harmony events in the workplace.

Another group of primary key publics was ambassadors and sponsors.

The secondary key publics for A Taste of Harmony included business sector stakeholders and supporters such as industry and professional bodies (e.g. Australian Football League Multicultural programs, SBS, Diversity Council of Australia, Australian Industry Group). These publics endorsed A Taste of Harmony, and could influence primary key publics. Further secondary key publics were department managers, work-group coordinators, and similar mid-level employees who would lead and coordinate the implementation of initiatives in organizations registered to participate in A Taste of Harmony.

Media were a key intermediary public to connect with and influence primary and secondary publics. Media were segmented across print, broadcast, digital and social; and targeted as news, business, hospitality, food and cooking, trade and ethnic media.

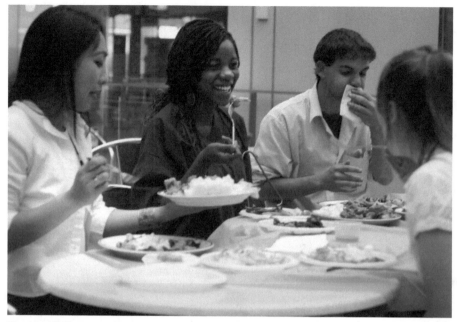

Fig. 18.1. Colleagues enjoying a meal together. Credit: A Taste of Harmony.

KEY MESSAGES

A Taste of Harmony seeks to encourage Australian workers to embrace and celebrate cultural diversity in the workplace, and to educate Australians on the benefits and value of cultural diversity.

The following key messages were identified for A Taste of Harmony:

- Cultural diversity is good for business. It provides access to new markets, delivers productivity and innovation, allows business to capture its best talent and improve their bottom line.
- A Taste of Harmony is a fun way to celebrate cultural diversity in the workplace, by sharing food and stories with colleagues.
- It is easy to register an event for A Taste of Harmony. There is no cost to register, and there is no fundraising for the event.

In 2016, the visual branding for A Taste of Harmony was refreshed, and the key message in the theme 'Every Taste Tells a Story' was prominent in all materials.

STRATEGIES

A Taste of Harmony is guided by an integrated communication strategy, leveraging from existing initiatives highlighting cultural diversity including national Harmony Day in Australia. The strategy draws on an aspect of human life that is common to all cultures—sharing food and stories with friends and family, and food as a feature of celebration.

The campaign looks to engage with influencers and decision makers in organizations, and then use word-of-mouth and storytelling by equipping Australian workplaces and workers with the tools to share stories and continue conversations about cultural diversity.

Ambassadors, sponsors and supporters are vital in the strategy as opinion leaders, to endorse and reinforce the goals of A Taste of Harmony.

TACTICS

A range of tactics have been developed, implemented and refined over the years that the campaign has been delivered. Built around a strong and engaging brand, the tactics are designed to equip participants with a range of tools to successfully run A Taste of Harmony event, combined with a variety of public relations and communications tactics across face-to-face, mediated, and online and digital channels.

A Taste of Harmony Brand

When A Taste of Harmony was first launched in 2009, an engaging brand and strong creative visual elements including logo were important to establishing the campaign. The original brand logo and other visual elements incorporated the orange tone which links to the national Harmony Day, and featured eating utensils, with the tagline "Share a World of Food and Culture at Work". In 2016, the brand and visual elements were refreshed maintaining the orange tone and eating utensils, with the new tagline "Every Taste Tells a Story." The brand and visual elements are used across all elements of the campaign.

A Taste of Harmony Website and Online Tools

The website for A Taste of Harmony (www.tasteofharmony.org.au) is the hub for most of the campaign's communication. The website provides all the information about the campaign for all stakeholders and publics, from initial interest in the campaign through to extensive resources and tools for participating organizations.

All sections of the website include logos and links to major sponsors and supporters of A Taste of Harmony, and links to contact details and social media channels for A Taste of Harmony. There is a News section on the website that includes newsletters, updates and some media releases.

The About section of the website provides a short background on A Taste of Harmony and the Scanlon Foundation, along with details on how the event works, and three easy steps for organizations to register. The section discusses diversity in the workplace, with resources for organizations to support cultural diversity in the workplace. These resources, created by the Australian Multicultural Foundation, include a training workbook and resource manual, and a PowerPoint presentation with presentation notes. All the resources can be downloaded, and this section of the website includes a link to an online portal for cultural competence customized for different industry sectors, and endorsed by the Australian Multicultural Foundation. The About section also includes a full listing of registered workplaces, and a Frequently Asked Questions (FAQs) section is valuable.

In the registration section of the website, an online registration form is provided for participants to register as a participating workplace. The registration form captures contact details, along with information on industry sector and size of the participating workplace, and how the participant heard about A Taste of Harmony.

The website also includes a searchable and rateable database of recipes by chef ambassadors and participants. Participants can upload and share their own recipes in this section.

The sponsors section of the website contains information and links to the major sponsors and key supporters of A Taste of Harmony. Alongside the Scanlon Foundation and the Australian Multicultural Foundation, five major Australian corporations partnered as sponsors for the 2016 event. These five sponsors were ANZ (Australia and New Zealand Banking Corporation), Australia Post, Commonwealth Bank, retailer Target, and environmental solutions company Veolia. These organizations all strongly value and support diversity, and as large employers facilitate many A Taste of Harmony events across each of the organizations. Supporters for the 2016 event were listed as local government group Municipal Association of Victoria, the AFL (Australian Football League) Multicultural Program, Netball Australia, SBS (Special Broadcasting Service), Ai Group (Australian Industry Group), and Cricket Australia. The sporting associations provided A Taste of Harmony with access to professional sportspeople as advocates for the event and for diversity more broadly. Other supporters provided access to networks in local government and industry, or supported through media coverage. All supporters held events for A Taste of Harmony. Sponsors and supporters set internal targets for the number of registered teams participating appropriate to the size of each organisation.

The website also maintains an event hub and a section on ambassadors. These are both major communication and engagement initiatives for A Taste of Harmony, and are discussed in following sections.

Online Event Hub

The online event hub is only accessible by registered participants, and holds a suite of resources and tools, allowing participants to promote and effectively host events for A Taste of Harmony. The promotional tools include an information sheet, flyer, and guide. All these tools are downloadable, so can be easily shared through a hosting organization's own communication channels. The tools focus on the benefits of cultural diversity in the workplace, and practical steps for hosting and promoting an event. There is content that can be tailored for newsletters and similar communication tools in organizations. A World Map branded with A Taste of Harmony can be downloaded for participants at events to plot or pin their cultural heritage or origin of the dish they contribute to the event. The hub also holds posters in different sizes, which can be downloaded and customized to promote events in workplaces.

Further support is provided to registered participating organizations with resources for the event. Editable certificates can be printed to recognize support of participants. Dish cards identify the recipe, its origin, and the name of the person who shared the dish with workmates. There are also placemats in different sizes, and a trivia quiz. An editable recipe book template, allows participants to contribute recipes, which can be compiled and shared in the participating organisation.

A flag generator allows participants to search for national flags, and drop into templates in a range of sizes suited to posters, table settings, and food flags for dishes. Participants can also check in on an online participation board, tracking number of participants and countries represented.

The hub also holds a collection of event ideas, curated from shared participant generated content. The event ideas include inviting participants at an event to dress in national costume, play games linked to a cultural background (for example, mah-jong from China or bocce from Italy), offer challenges and competitions modelled on popular television cooking shows and share music and anthems from countries. Other shared ideas suggest selecting a dream destination or place most often visited to bring food from that region, staggering events across a full week rather than just a day to encourage broader participation and considering takeout or dining in at local international restaurant with workmates. There are also suggestions on how to facilitate the sharing of stories at the event.

Ambassadors

In 2016, A Taste of Harmony partnered with more than 30 ambassadors—Hero Ambassadors, Chef Ambassadors and Business Ambassadors. All ambassadors are profiled on the website for A Taste of Harmony, with each reflecting on his or her own cultural heritage and the importance of multiculturalism and the value of diversity being celebrated in Australia. Their stories are also shared through social media channels for A Taste of Harmony, and through media relations activities. The ambassadors also used their own social media channels to promote A Taste of Harmony.

Hero ambassadors are selected to share stories about their own cultural backgrounds, and how they celebrate *A Taste of Harmony*. Videos of hero ambassadors preparing traditional meals from their cultures, and discussing diversity in their workplaces, are shared on the website and YouTube channel for *A Taste of Harmony*. Recent Hero Ambassadors were:

- Guy Grossi—Grossi Restaurants in Melbourne;
- Huss Mustafa—Commonwealth Bank of Australia;
- Jane Kennedy—actor and author of four cookbooks; and
- Maeve O'Meara—food and cooking author, global food tour guide, and media presenter.

FIg. 18.2. Chef Guy Grossi enjoying a meal with event attendees. Credit: A Taste of Harmony.

Similarly, chef ambassadors are selected each year based on their strong profiles as chefs and cooks in Australia, and to celebrate their own cultural stories and diversity in their workplaces. The chef ambassadors share profiles and videos through the website and YouTube channel for A Taste of Harmony. The chef ambassadors also contribute recipes to the e-cookbook that can be downloaded from the Event Hub for A Taste of Harmony. Chef ambassadors are from some of Australia's best known and respected restaurants, and most popular television cooking and food shows. Recent chef ambassadors included:

- Carly Day, food producer and founder of The Ja Joint, celebrating her cultural background from the United Kingdom, Jamaica, China, Ireland and Australia
- Ed "Fast Ed" Halmagyi, chef on television, radio, online, and magazines, celebrating cuisine from around the world
- Miguel Maestre, television chef, celebrating his Spanish cultural background
- Amina Elshafi, Masterchef contestant, celebrating her South Korean and Egyptian cultural background
- Chung Jae Lee, 2013 Australian Good Food Guide Hatted Chef, celebrating his cultural background from South Korea
- Samira El Kafir, executive chef at Middle Eastern Café at Islamic Museum of Australia, celebrating her cultural background from Lebanon and Syria
- Ryan Squires, 2014 Citi Chef of the Year and executive chef at Esquire, celebrating his Italian and Australian cultural background
- Jimmy Shu, chef at Hanuman, celebrating his cultural background from China and Sri Lanka
- Mark Olive, chef at The Black Olive and Outback Academy, celebrating his Australian Aboriginal cultural background from his Bundjalung family, and growing up in Tharawal country
- Alice Zaslavsky, Masterchef contestant and host of children's TV cooking show, celebrating her cultural background from Georgia
- Totem Douangmala, Masterchef contestant, celebrating his cultural background from Laos and the influences of Vietnam, China and Thailand on his cooking
- Christina Batista, Masterchef contestant, focusing on celebrating the diversity of Western European flavours
- Jason Wilkes, commercial cookery and bakery lecturer, celebrating his fifth generation Australian heritage, and the "world kitchen" of his workplace
- Alejandro Cancino, executive chef at Urbane and The Euro, celebrating his cultural background from Argentina, Italy, and Spain
- Harry Liliai, chef at Town Hall Hotel, celebrating his Albanian and Calabrese Italian cultural background

- Judith Sweet, food journalist and Slow Food Tasmania president, celebrating her love of Italian culture and cuisine
- Liliana Battle, Masterchef contestant, celebrating her Italian cultural background
- Herb Faust, founder of Herb Faust Food, celebrating his German and Thai cultural background
- Dominique Rizzo, television presenter and cooking school owner, celebrating her Sicilian and Irish/Australia cultural background.

Business ambassadors are selected from organizations that are key partners, sponsors and supporters of A Taste of Harmony. Recent business ambassadors from one of Australia's largest banking corporations ANZ included Susan Babani, Chief Human Resources Officer, and Mark Hand, Managing Director of Corporate and Commercial Banking. Business Ambassadors focus on the business benefits of embracing and celebrating diversity, and their own personal experiences of diversity in the workplace.

Food Truck Activations

In most recent years, A Taste of Harmony has drawn on the growing trend of food trucks in Australia. In February, to launch A Taste of Harmony for the year and encourage participants during March, A Taste of Harmony coordinated food truck festivals in five Australian capital cities—Adelaide, Brisbane, Canberra, Sydney and Perth. For one midweek day in each city, some of the best and most culturally diverse food trucks from the city gathered in central city squares or malls. Inner-city workers could visit the food trucks to sample food during the lunchtime rush, and learn more about A Taste of Harmony. A Chef Ambassador joined the food truck activations in each location, adding a celebrity element, and sharing stories and food ideas. The food truck activations achieved strong media coverage in food and lifestyle media, particularly online publications.

Connecting with Influencers and Decision Makers

A series of meetings and speaking events were arranged with influencers and decision makers in organizations to promote A Taste of Harmony and to build participation rates. In 2015, A Taste of Harmony keynote addresses were delivered at four events hosted by the Australian Human Resources Institute (AHRI) diversity network, in locations across Australia. There also was direct engagement with human resources professionals in their workplaces, through meetings with key decision makers in 12 major organizations for the 2015 campaign.

Digital and Social Media Channels

There has been an increased focus on digital and social media channels in recent years, reflecting the growth in their importance and influence. A Taste of Harmony has communities across Facebook, Twitter and YouTube where content is created, shared and managed. User generated content on social media channels, particularly Instagram, was tagged with #tasteofharmony. The social media channels of ambassadors, sponsors and supporters with their followers were important in creating conversations and sharing stories in social media spaces. A paid advertising strategy on Facebook and YouTube, along with search engine marketing, initiated visits to the website with encouragement to register.

Media Relations

Media relations played an important role in generating publicity to support the broad strategies and specific tactics for A Taste of Harmony. In the 2009 launch year, more than 380 media releases were developed and distributed. In the launch year and across subsequent years, Haystac has secured significant national, local and regional media coverage across print, radio and online for A Taste of Harmony as a client. The media relations tactics have targeted metropolitan and multicultural media with a focus on editorial content and photographs, industry and business media with focus on diversity management, trade media to reach restaurant owners and staff, and suburban and regional media for local case studies and competitions.

A significant piece of coverage in 2015 was an opinion piece by Peter Scanlon as Chairman of the Scanlon Foundation, which was published in the weekend edition of Australia's leading finance and business publication, Financial Review on the Australia Day long weekend (Scanlon, 2015). The Financial Review is a "must read" for business leaders and decision makers, and has consistently published feature articles on A Taste of Harmony since the launch year. The opinion piece reflected on both the achievements and challenges of diversity and inclusion in Australia.

Other Tactics

Through a sponsorship arrangement with the Dentsu Aegis advertising network, community service announcements were placed free of charge across television, radio and print media. An electronic direct mail campaign, supported by a tele-campaign, was implemented to re-engage past participants. Email newsletters were sent to registered participants for A Taste of Harmony with event ideas, recipes and suggestions for promotion to maximize success of registered events.

In 2015, A Taste of Harmony extended to schools with the launch of Recipes for Harmony, an e-book produced by the Scanlon Foundation with the

Department of Social Services. The e-book was supported by resources for teachers such as lesson plans, audio files and activities. In February 2016, the Scanlon Foundation extended the Mapping Social Cohesion research series, and delivered a Multiculturalism discussion paper to encourage "thoughtful debate about the concept of multiculturalism, and to better understand the nuances of our attitudes" (Scanlon Foundation, 2016c) in Australia.

CALENDAR/TIMETABLE

A Taste of Harmony is held in March each year, to align with Harmony Day in Australia and United Nations International Day for the Elimination of Racial Discrimination on March 21. The timing of activities is planned around the events being held in workplaces across Australia in the week around March 21. Most activities are focused from August to April.

In 2015, the online tools were reviewed and improved between August and November. Sponsor and supporter engagement and meetings with human resources professionals commenced in August and continued through to March, and there was follow-up after the event dates. Many activities were focused from January to March, including digital and social media, electronic direct mail, media relations, activations to launch campaign, keynote speaking events and community service announcements.

BUDGET

The budget for public relations and communication activities is not available to be shared publicly. However, in the 2015 entry submitted by Haystac for the Public Relations Institute of Australia (PRIA) Golden Target Awards, A Taste of Harmony was entered in the Big Budget category which is for campaigns or programs with a budget of more than $A100,000. A Taste of Harmony also was entered in the same category at the PRIA Golden Target Awards in 2009.

It is important to reinforce that A Taste of Harmony is funded by the Scanlon Foundation, as a private philanthropic foundation. Organizations can participate in A Taste of Harmony at no cost, and there is no fundraising, with the focus clearly on awareness and celebration of diversity in Australian workplaces.

EVALUATION AND MEASUREMENT

Each year the campaign for A Taste of Harmony is closely evaluated and measured against objectives set. For the inaugural campaign in 2009, the PRIA Golden

Target Award entry from Haystac outlined that the campaign was assessed against the following objectives, with the associated results:

- Recruit more than 1,000 workplaces—1,298 organisations registered to participate, with more than 60,000 individual participants
- Raise awareness of benefits of social cohesion in the workplace—survey indicated 77 percent of participating organisations indicated they gained a greater understanding of the cultural backgrounds of work colleagues
- Obtain support from participants for an ongoing campaign—99 percent of participating workplaces and 100 percent of participating restaurants indicated they will or might register again
- A partnership was secured with the Federal Department of Immigration aligning A Taste of Harmony to Harmony Day
- Media coverage—secured 333 media clippings, including two major television segments, and sponsorship agreement for more than $A350,000 in community service announcements placed
- Six business sponsors and a number of supporters were secured, and
- Secure five celebrity ambassadors—four business ambassadors and seven chef ambassadors were secured.

The results from the first delivery of the campaign set benchmarks for subsequent years, and A Taste of Harmony has grown each year since its launch. In 2015, Haystac reported in the PRIA Golden Target Award entry that participant registration data, digital and social analytics, and a survey and discussions with sponsors, supporters and stakeholders were used to evaluate and measure.

In 2015, there were 5,379 registered workplaces, a growth of 29 percent from 2014. The campaign re-engaged 59 percent of 2014 workplaces. Most importantly, participating organizations indicated the celebration of cultural diversity in Australian workplaces was making significant inroads with 95 percent of participants indicating a greater understanding and appreciation of the diversity in their workplace, 96 percent feeling the event brought their team closer, and 98 percent considering A Taste of Harmony to be an important part of their workplace's efforts to foster and cherish cultural diversity.

A Taste of Harmony, through the work of Haystac, has been recognized by the following industry awards:

- 2009 Public Relations Institute of Australia Golden Target Awards—shortlisted in Big Budget category for New South Wales state awards
- 2009 National Multicultural Marketing Awards winner
- 2015 Public Relations Institute of Australia Golden Target Awards—winner for New South Wales state awards, commended for national awards in Big Budget category.

REFERENCES

Australian Government Department of Social Services. (n.d.). *Harmony day about us*. Retrieved June 1, 2016 from http://www.harmony.gov.au/about/

Haystac. (2009). A taste of harmony public relations institute of Australia golden target award entry. Retrieved June 1, 2016 from http://www.lib.uts.edu.au/gta/14444/taste-harmony

Haystac. (2015). A taste of harmony public relations institute of Australia golden target award entry. Retrieved June 1, 2016 from www.pria.com.au

Herald Sun. (2015, June 8). Peter Scanlon. *A taste for philanthropy*. Retrieved June 1, 2016 from http://www.heraldsun.com.au/business/peter-scanlon-a-taste-for-philanthropy/news-story/4f198bc2568b5b98c40509f1180bdfdf

Markus, A. (2015). *Mapping social cohesion: The Scanlon Foundation surveys 2015*. Retrieved June 1, 2016 from http://scanlonfoundation.org.au/wp-content/uploads/2015/10/2015-Mapping-Social-Cohesion-Report.pdf

Palmer, D. (2016, May 27). Rich Listers keep it in the family. *The Australian*. Retrieved June 1, 2016 from http://www.theaustralian.com.au/business/news/rich-listers-keep-it-in-the-family/news-story/598ea44a0fef06c5d73a232b7be4eb9e

Scanlon, P. (2015, January 23). Australia Day: Food for harmony and celebrating diversity. *Financial Review (Australia)*. Retrieved June 1, 2016 from http://www.afr.com/opinion/columnists/australia-day-food-for-harmony-and-celebrating-diversity-20150123-12wmq3

Scanlon Foundation. (2016a, January 20). *Scanlon foundation announces grant recipients for 2016*. Media release retrieved on June 1, 2016 from http://scanlonfoundation.org.au/20-january-2016/

Scanlon Foundation. (2016b, February 26). *Multiculturalism a success, but a multilayered concept in Australia*. Media release retrieved on June 1, 2016 from http://scanlonfoundation.org.au/26-february-2016-multiculturalism-a-success-but-a-multilayered-concept-in-australia/

Scanlon Foundation. (2016c, February). *Multiculturalism discussion paper*. Retrieved June 1, 2016 from http://scanlonfoundation.org.au/wp-content/uploads/2016/02/DiscussionPaperMulticultural-ismFINAL.pdf

Scanlon Foundation, Monash University & Australian Multicultural Foundation. (2015, October 29). *National cohesion report reflects complex change*. Media release retrieved on June 1, 2016 from http://scanlonfoundation.org.au/wp-content/uploads/2015/10/Media-Release-Mapping-Social-Cohesion-Report-2015_final.pdf

Stensholt, J. (2015, June 3). Peter Scanlon wants to help manage your wealth. *Financial Review (Australia)*. Retrieved June 1, 2016 from http://www.afr.com/personal-finance/specialist-investments/peter-scanlon-wants-to-help-manage-your-wealth-20150519-gh4qz2

Stensholt, J. (Ed.). (2016, May 27). 2016 BRW Rich 200. *Financial Review (Australia)*. Retrieved June 1, 2016 from http://www.afr.com/leadership/brw-lists/brw-rich-200-list-2016-20160526-gp4ejn

Contributors

Jean Valin, APR, Fellow CPRS, Hon CIPR Fellow founded Valin Strategic Communications after a 30-year career as a senior communication executive. He has advised senior officials and ministers of the Government of Canada on communication matters throughout his career. Valin was co-editor of the first edition of *Public Relations Case Studies from around the World.*

He worked on several high-profile national issues such as a gun control program, anti-terrorism and organized crime legislation, same-sex marriage legislation, the launch of Service Canada (Canada's one-stop destination for all government services), as well as transportation policy for air, road, and marine safety and for security issues.

Valin is active in the professional association the Canadian Public Relations Society (CPRS). He was awarded his accreditation (APR) in 1987 and was called to the College of Fellows in 2001, becoming the youngest member to achieve that highest level of recognition. He served as national president of CPRS in 1996–1997 and has received several national public relations awards throughout his career. He is a co-author of the official definition of public relations adopted by CPRS in 2008. In 2014 he received the CPRS's highest award for lifetime achievement-the Phillip J. Novikoff memorial award.

In 2000, he was a founding member of the Global Alliance for Public Relations and Communication Management, a confederation of more than 70 major public relations associations around the world representing more than 170,000 members. He was chair of the Global Alliance for 2004 and 2005 and is an inaugural member of the Global Alliance Advisory Council.

In 2008 he received the President's Medal from the Chartered Institute of Public Relations (CIPR) in the United Kingdom, and he received the Award of Attainment from the Canadian Public Relations Society in both 2010 and 2013—the latter for his leadership in developing the Melbourne Mandate advocacy platform for public relations. He is the 2013 recipient of the David Ferguson Award presented by the Public Relations Society of America (PRSA) to a practitioner who has made an especially significant contribution to the advancement of public relations education. The CIPR conferred him the title of Honorary Fellow in 2016 for his leadership in creating a Global Body of Knowledge.

He can be reached at jvalinpr@gmail.com

Judy VanSlyke Turk, Ph.D., APR, Fellow PRSA, is professor emerita in the Richard T. Robertson School of Media and Culture (formerly the School of Mass Communications) at Virginia Commonwealth University (VCU). She was a Visiting Professor for the 2014–2015 school year at the School of Journalism and Mass Communication at Florida International University, and teaches part time in the communications management master's program at the S. I. Newhouse School of Public Communications at Syracuse University.

From March 2002 through June 2010, Turk was the VCU School's director. Prior to joining VCU in March 2002, she was founding dean of the College of Communication and Media Sciences at Zayed University in the United Arab Emirates, a position she held for 2.5 years. Previously, she was dean or director of several journalism and mass communications programs in the United States.

Turk is past president of the Association of Schools of Journalism and Mass Communication (ASJMC) and of the Association for Education in Journalism and Mass Communication (AEJMC), the largest associations of journalism faculty and administrators in the United States. She is a past president of the Arab-U.S. Association of Communication Educators.

Turk is a past chair of the College of Fellows of the Public Relations Society of America (PRSA). Turk was named Outstanding Public Relations Educator in 1992 by PRSA. In 2005, she received the Pathfinder Award from the Institute for Public Relations for her lifetime contributions of research,

and in 2006, AEJMC recognized her as its "Outstanding Woman in Journalism Education.

Turk is co-author of *This Is PR: The Realities of Public Relations* (Cengage/Wadsworth Publishing), now in its 11th edition, and author of dozens of articles in scholarly and professional journals.

She has consulted and lectured on public relations and journalism/mass communications teaching and curriculum issues in Eastern Europe, the Newly Independent States, the Baltics, Russia, the Middle East, China, and Asia.

She is a former member of the board of directors and former co-chair of the Research and Education Committee of the Global Alliance for Public Relations and Communication Management.

She can be reached at jvturk@vcu.edu

CASE STUDY AUTHORS (LISTED ALPHABETICALLY)

Mariam F. Alkazemi, Ph.D. is an assistant professor of mass communication at the Gulf University for Science and Technology in Kuwait, where she teaches public speaking, cases in public relations and fundamentals of advertising. She has received numerous awards for her research and teaching from the Association for Education in Journalism and Mass Communication, the Arab-U.S. Association for Communication Educators and the University of Florida. At the University of Florida, she taught media and politics, world communication systems, mass media and you, applied fact-finding and journalism studies. Her publications appear in *Journal of Media and Religion, Journalism: Theory, Practice and Criticism, Journal of Religion, Media and Digital Culture, Health Environments Research* and *Design Journal* among others. She holds a B.A. in Journalism from George Washington University, an M.A. in Public Relations and Advertising from Michigan State University and a Ph.D. in Mass Communication from the University of Florida.

She can be reached at AlKazemi.M@gust.edu.kw

Fahed Al-Sumait is an assistant professor of communication and department chair of the Mass Communication and Media Department at the Gulf University for Science and Technology in Kuwait, where he has also served as interim dean of student affairs and advisor to the vice president of academic services. He was previously a Fulbright-Hays Dissertation fellow for his research into contested discourses on Arab democratization, as well as a post-doctoral research fellow at the Middle East Institute in the National University of Singapore. He is co-editor of the books, *The Arab Uprisings:*

Catalysts, Dynamics and Trajectories (2014, Rowman & Littlefield), and *Covering bin Laden: Global Media and the World's Most Wanted Man* (2015, University of Illinois Press). He holds a B.A. in Journalism from the University of Washington, an M.A. in Intercultural Communication from the University of New Mexico and a Ph.D. in International Political Communication from the University of Washington

He can be reached at AlSumait.F@gust.edu.kw

Shannon A. Bowen, Ph.D is Professor at the University of South Carolina's School of Journalism and Mass Communications. Bowen is a member of the Board of Trustees of the Arthur W. Page Society, and the Board of Directors of the International Public Relations Research Conference (IPRRC). She is co-editor of *Ethical Space: The International Journal of Communication Ethics* and serves on several editorial boards, including the *Encyclopedia of Public Relations* (Sage). Bowen, a former chair of the Media Ethics Division of the Association for Education in Journalism and Mass Communications (AEJMC), researches public relations ethics and organization theory and has won the Jackson, Jackson and Wagner Behavioral Science Research Prize and the Robert Heath Outstanding Dissertation Award. She is a Page Legacy Scholar, heads the public relations major at USC, and has won several teaching awards.

She can be reached at sbowen@sc.edu

Xiaohong Chen, Ph.D., has a Bachelor's degree in History from Renmin University, and a Master's degree in Journalism and a Ph.D. degree in Management from Huazhong University. She is now the deputy dean of School of Journalism and Information Communication, a professor, a Ph.D. advisor, director of the Public Communication Research Center and founder of Red Woods Strategic and Innovation Center at Huazhong University of Science and Technology. She also is the academic leader of the first group of universities approved to offer a doctorate degree in public relations. Chen is the founding president of the Public Relations Society of China, affiliated with the Association for Chinese Journalism History; a member of the Think Tank of Research Center for Nation's Image at Tsinghua University; adjunct professor and Ph.D. advisor at Macau University of Science and Technology, and a member of the Think Tank for the Information and Communication Department of Hubei Provincial People's Government. She was the visiting scholar at Chinese University of Hong Kong (2003 & 2014), Queensland University of Australia (2004), City University of Hong Kong (2005 & 2012) and Macau University (2015). Chen's research interests include public relations, strategic

communication, new media and brand communication. She is the principal investigator in two nationwide research projects in China on government new media and public relations strategies and communication strategies for Chinese storytelling and for provincial research projects. She has published extensively in international and Chinese journals such as *Public Relations Review, Journal of Chinese Communication, Chinese Journal of Journalism & Communication, Modern Media, and Journalism and Communication.* She is the author of 16 books, including *Public Relations: An Ecology Perspective, Public Relations Research from the Perspective of Relationship Paradigm, Modern Public Relations Research, Public Relations Theory, Public Relations Planning, Crisis Communication Case Studies in China,* and *Creativity in Advertising Planning.*

She can be reached at 402928044@qq.com

Zifei Fay Chen is a doctoral candidate and instructor of record at the University of Miami. With a focus on public relations and corporate communication, her research interests mainly lie in crisis communication, corporate social responsibility (CSR) and new media. Chen has led and co-authored several chapters published in books including *Social Media and Crisis Communication, Casing Risk and Crisis Communication* and *New Media and Public Relations.* Her scholarly work has been presented nationally and internationally at conferences and was recognized with the Top Student Paper Award by the Public Relations Division at the 2015 annual conference of Association for Education in Journalism & Mass Communication (AEJMC). Chen is the recipient of the prestigious Don Bartholomew Award for Excellence in Public Relations Research (previously known as the Ketchum Excellence in Public Relations Research Award) in 2015 through which she worked as an analyst at Ketchum Global Research & Analytics in New York City; she also edited the book *MetricsMan: It Doesn't Count Unless You Can Count It* authored by the late Don Bartholomew. She currently serves as the conference coordinator for the International Public Relations Research Conference (IPRRC). Prior to joining the doctoral program at the University of Miami, Chen worked in a marketing analysis and communications capacity at Fiserv in Atlanta, Georgia, where her work helped lead to Fiserv's winning of the Direct Marketing Association Innovation Award for Global Sustainability in 2014. She also previously worked as s a television news reporter and translator at Xinhua News Agency in Hangzhou, China. Chen received her M.A. in Journalism and Mass Communication from the University of Georgia and her B.A. in English with a minor in Business Administration from Zhejiang University in China.

Gaelle Picherit Duthler, Ph.D., University of Kentucky, serves currently as the associate dean of the College of Communication and Media Sciences at Zayed University in Abu Dhabi. Prior to this, she served as the Graduate Program Director for the M.A. degree in Communications (specializations in Tourism and Cultural Communication, and Strategic Public Relations) at Zayed University. She teaches graduate and undergraduate courses within her interests such as public relations, internal communication, research methods and corporate social responsibility (CSR). She has published several articles and book chapters on issues of sustainability and corporate social responsibility, public relations, global virtual teams and organizational culture. She serves on the board of the GlobCom Institute and is an active member of the Middle East Public Relations Association.

She can be reached at gaelle.duthler@zu.ac.ae

Terence (Terry) Flynn, Ph.D., APR, FCPRS Over the last decade, Flynn developed and directed McMaster University's first professional communications graduate program (Master of Communications Management) in 2004, delivered in a blended-learning environment. He has also received numerous teaching award nominations and in 2010 was named an MBA Teacher of the Year at McMaster University. Prior to obtaining his Ph.D. in Mass Communications in 2004 from Syracuse University, Flynn had a 20-year career as a communications professional specializing in crisis communications, public relations and risk management. Flynn has also been an active member of the Canadian Public Relations Society (CPRS), serving on its Board of Directors for five years, and was elected the national president of CPRS in 2009. He is an accredited member of CPRS and was named a Fellow of the Society in 2008. In 2015, Flynn was awarded the Philip J. Novikoff Award, the highest distinction by the CPRS for contributions to the profession in Canada. His research interests rest at the intersection of public relations, crisis communications, reputation management and behavioral communications. Aside from numerous technical reports and industry white papers, he has published his research in the *Canadian Journal of Communication, Public Relations Journal, Journal of Public Relations Research* and *Journal of Professional Communications.*

He can be reached at tflynn@mcmaster.ca

Dr. John Gallagher is the course director of postgraduate public relations programs at the Dublin Institute of Technology in Ireland where he lectures in the theory and practice of public relations, public relations strategy and tactics and the theory and practice of public affairs and political communications. He acquired a B.A., M.A. and an H.Dip Ed. from the National University

of Ireland and an Ed.D.from the University of Sheffield in the United Kingdom. He has also completed a Diploma in Marketing with the Marketing Institute of Ireland, a Higher Diploma in Public Relations at the University of Stirling in Scotland and a Diploma in Operations Management. Gallagher's career began as a journalist between 1975–1979. He then was recruited to the press office at Dublin Airport by the Irish Airport Authority where he worked in various capacities from 1979 to 2002. In 2002, he left the Irish Airport Authority upon his appointment as lecturer at the Dublin Institute of Technology. Gallagher has been a Member of the Public Relations Institute of Ireland (PRII) since 1982 and a director of the Institute for two periods: 1995–2004 and 2005–2010. He was elected a Fellow of the Institute in 2005 and a Life Fellow in 2011. He served as the chairman of the Institute's Education Council 1995–1997 and 2007–2010, and represented PRII during the founding of the Global Alliance for Public Relations and Communication Management. Other memberships include: the Chartered Institute of Public Relations (UK), the Public Relations Society of America and EUPRERA, the European Public Relations Education & Research Association.

He can be reached at drjohngallagher@gmail.com

Dr. Simone Huck-Sandhu is professor of public relations at Pforzheim University, Germany. From 2011 to 2015 she led the certificate program in public relations. Since 2016 she has been responsible for a new master's program in corporate communication management. Huck-Sandhu earned a Ph.D. in public relations and a Habilitation in communication science (Venia Legendi; postdoctoral lecture qualification) from the University of Hohenheim, Germany. Along with her academic career, she has worked as a PR consultant and advises large and medium-sized companies in strategic communication and change management. Huck-Sandhu has taught at BA, MSc., and Master Executive leaves in Germany, Switzerland, Estonia and Finland. In 2015, she was awarded the Outstanding Teaching Award of the Pforzheim University Business School.

In her research, Huck-Sandhu is interested in strategic aspects of public relations and corporate communication. She focuses on international public relations, internal communication and innovation communication. She is co-author of 5 books and author or co-author of 38 articles and book chapters published in *International Journal of Strategic Communication, Innovation Journalism, the German Handbook of PR* (Froehlich/Szyszka/Bentele, 3rd ed.) and *Handbook of Corporate Communication* (Piwinger/Zerfass, 2nd ed.). Her most recent publication is an edited book on internal communication and change. Huck-Sandhu is chair of the PR division of the German Association for Communication Science (DGPuK). From 2004 to 2014, she served as a

member of the board of directors of the German Public Relations Association. She is a Board Member of the Scientific Committee of Bundesverband deutscher Pressesprecher, the German trade association for PR professionals; a member of the Advisory Board of SCM—Studies in Communication and Media, an affiliate journal of the International Communication Association; jury chairwomen of DGPuK's Dissertation Award, and the advisory board of her university.

She can be reached at simone.huck-sandhu@hs-pforzheim.de

Chun-ju Flora Hung-Baesecke, Ph.D., teaches in the School of Communication, Journalism and Marketing at Massey University in Albany (Auckland), New Zealand. She is also a member of the Academic Committee of the China International Public Relations Association (CIPRA) and a member of the Special Overseas Board of the Public Relations Society of China. She was voted one of the Top 100 People in Public Relations in China in 2009. In 2014, she was recognized by the Plank Center for Leadership in Public Relations as an Educator Fellow, for which she was sponsored for a two-week visit to Edelman Public Relations in the US. She also won the Faculty Best Paper award in the Public Relations Division of the 2014 Annual Conference of the International Communication Association. She is the 2014–2016 Page Legacy Scholar awarded by the Arthur W. Page Center at Pennsylvania State University. Her research interests are stakeholder engagement, relationship management, strategic management, corporate social responsibility, reputation management, crisis communication, social media and employee communication. Hung-Baesecke has published her research in international academic refereed journals such as *Journal of Public Relations Research, Journalism & Mass Communication Quarterly, Corporate Communication: An International Journal, Journal of Communication Management, Public Relations Review, International Journal of Strategic Communication, Communication Research Reports,* and *Asian Journal of Communication.* She is on the editorial boards of *Journal of Public Relations Research, International Journal of Strategic Communication,* and *Communication Research Reports.* In 2009, the Summit Conference on the Future of Public Relations in China that Hung-Baesecke organized for Hong Kong Baptist University was the winner in the category of Leadership and Development of the Gold Standard Awards from *Public Affairs Asia.*

She can be reached at flora.hung@gmail.com

Yi Grace Ji has spent more than five years working in new media, marketing and consumer research. Her research agenda centers on social-mediated communication; she seeks to understand in the new age of social media how behavioral

and communication patterns of stakeholder's benefit and challenge today's organizational message and relationship strategies. Her second main research interest is "big data," especially its power of examining real-time interactions between stakeholders and organizations and making powerful predictions. Her experience encompasses conducting primary quantitative and qualitative studies, collecting longitudinal data using experimental design, survey and data mining methods, and analyzing large-scale data utilizing advanced statistical methods. Her work has been recognized by the academic community and has been published and presented nationally and internationally, and won the top student paper award from the Association for Education in Journalism and Mass Communication. Ji is a third-year Ph.D. candidate at the University of Miami and a lecturer teaching statistics and research methods for strategic communication. She serves as editorial assistant for the editor of Communication *Research Reports* and as a conference coordinator for the International Public Relations Research Conference (IPRRC). Prior to starting her doctoral studies at Miami, Ji worked as a public relations specialist at Ronald McDonald House Charities South Florida where she assisted with fundraising events development and volunteer program management; a research analyst for Jennifer Jones & Partners and JARWIRE Group; and a Diplomatic News reporter at Hong Kong *Wenweipo* Newspaper.

She can be reached at jiyigrace@gmail.com

Kiranjit Kaur, PhD, is a professor of public relations at the Faculty of Communication & Media Studies, Universiti Teknologi MARA, Shah Alam, Selangor, Malaysia. She has published a number of journal articles and book chapters in her research interest areas of public relations management, media ethics and women and media. Kaur is a Fellow and an Accredited Public Relations member of the Institute of Public Relations Malaysia (IPRM) with more than 30 years of experience in public relations education. She serves on the IPRM council and chairs the IPRM Education Chapter. She also sits on the council of the industry-based Communication and Multimedia Content Forum (CMCF), and of the Networked Media Research Collaboration Programme steering committee of the Malaysian Communication and Multimedia Commission. She chairs the Media Committee of the National Council of Women's Organizations (NCWO), Malaysia. Kiranjit graduated with a PhD in Mass Communication from the University of Maryland, USA.

She can be reached at kkludher@gmail.com

Gail Kenning, PhD, is a research associate at the University of Technology Sydney (UTS) specializing in evaluation of media and various forms of art, media

arts and crafts in promoting individual and community quality of life and wellbeing. She is an member of a £500,000 UK AHRC funded study of the impact of art and design on people with dementia and was a Design United visiting fellow at the University of Technology Eindhoven (TU/e) in 2015 and a visiting fellow at the Powerhouse Museum, Sydney in 2016.

She can be reached at: gail@gailkenning.com

Ingrid Larkin is an educator and researcher in public relations at QUT Business School at Queensland University of Technology in Brisbane, Australia. She has focused her teaching and research on case based teaching, case writing, work integrated learning and campaign-based communication. Larkin has been recognized as a Fellow and National President's Award recipient of the Public Relations Institute of Australia. Ingrid also has received individual and team recognition through QUT Vice-Chancellor's Awards for Excellence and Performance. Prior to joining the QUT Business School in 2004, Larkin was a senior public relations and communication professional in both corporate and consulting roles for clients across Australia and internationally. She maintains strong connections across industry and education which is reflected in her research and her leadership of internships and projects for QUT advertising, marketing and public relations students.

She can be reached at ik.larkin@qut.edu.au

Alessandro Lovari, Ph.D. (Sapienza University of Rome), is a researcher of cultural and communicative processes at the University of Sassari, Department of Political Sciences, Science of Communication and Information Engineering (Italy), where he teaches corporate communication, public sector communication (undergraduate level), social media for public sector organizations and strategies of public communication (graduate seminar). He has been a visiting scholar at Purdue University (Brian Lamb School of Communication), University of Cincinnati (Department of Communication) and University of South Carolina (School of Journalism and Mass Communications) in the United States. His main research interests are public sector communication, public relations (PR), health communication and the relationships between institutions, media and citizens. He also studies the characteristics of Web 2.0 and social media and their impact on companies' and citizens' behaviors. His is a member of the scientific committee of the Italian Association of Public and Institutional Communication, and member of the board of the Master's degree program in Corporate Communication at the University of Siena, Italy. Before entering the academy, he worked for a decade as a PR professional for many private and public sector organizations. He is associated with

ICA (International Communication Association), ESA (European Sociological Association), and AIS (Associazione Italiana Sociologia). His works have been published in several books and in national and international journals such as *Public Relations Review, PRism, Health Communication* and *International Journal of Strategic Communication.*

He can be reached at alovari@uniss.it

Sandra Macleod is CEO of Mindful Reputation and Director of Reputation Dividend, advising senior corporate leaders and boards. From an early career in management consultancy, she set up the first international franchises for a media analysis company before launching her own firm, Echo Research, as a full-service global research group with offices in Asia, Europe and the United States, which secured more than 89 industry awards for innovation and excellence. Macleod founded the International Association of Measurement & Evaluation Companies (AMEC) 15 years ago, She is a Companion of the Chartered Institute of Management and a member of the McKinsey Women as Leaders' Forum, and sits on the boards of the Arthur W. Page Society and the University of Oxford's Public Affairs Advisory Group. Cited by PR Week as "among the 100 most influential people in PR", Sandra has been visiting professor on reputation at New York University's Public Relations and Corporate Communication Master's Program in New York.

She can be reached at sandram@mindfulreputation.com

Jim Macnamara, PhD, is professor of public communication at the University of Technology Sydney (UTS), a post he took up in 2007 following a 30-year career in professional communication practice spanning journalism, public relations and media research. He is the author of 16 books including *Organisational Listening: The Missing Essential in Public Communicatioon* (Peter Lang, New York, 2016) and *Evaluating Public Communication: Exploring New Methods, Standards, and Best Practice* (Routledge, UK, 2017), and numerous academic and professional journal articles.

He can be reached at jim.macnamara@uts.edu.au

Valentina Martino, Ph.D. in communication sciences, is an assistant professor in cultural and communicative processes at the Department of Communication and Social Research, Sapienza University of Rome, where she teaches corporate communication and coordinates a seminar on scientific writing and career guidance. At the same department, she participates in didactic and Ph.D. teaching boards in Communication, Research, and Innovation. Since 2001 she has taught and conducted research in the areas of corporate and cultural communication, university communication and innovation,

analysis of cultural consumptions and media studies. In particular, her scientific interests presently concern the role of culture and heritage in the communication strategies of both public and private organizations, with special reference to historical universities and Italian family businesses. She has been a lecturer in graduate and post graduate courses at Italian universities and other public and private organizations. She has been principal investigator and/or a member of research projects in collaboration with several universities, associations, companies, and public organizations such as the European Union, Italian Ministry of Education, Italian Ministry of Culture, Italian National Institute of Statistics (ISTAT), Conference of Italian University Rectors (CRUI) and the Italian Association of University Communicators (AICUN). Her work has been published in national and international books and journals such as *Public Relations Review, International Journal of Strategic Communication* and *Tafter Journal*. Her most recent book is *Dalle storie alla storia d'impresa. Memoria, comunicazione, heritage* (Bonanno, Roma-Acireale 2013).

She can be reached at valentina.martino@uniroma1.it

John A. McLaren was formerly corporate director of communications at Akzo-Nobel, the world's largest coatings company and a leader in specialty chemicals. He has been responsible for successfully communicating the massive transformation at AkzoNobel which included €27 billion worth of divestments and acquisitions (notably the purchase of Imperial Chemical Industries (ICI), as well as the complete rebranding of the company and the introduction of a new global identity. McLaren currently is chairman of Gulland Padfield, a public relations agency, and chief counsel at JMA, a global reputation advisory group. Before joining AkzoNobel, McLaren was vice president of corporate communications at Royal DSM, where he oversaw the communications around the purchase of Roche Vitamins and a global positioning campaign. Prior to that he was director of corporate communications for News Network, the digital arm of News International; vice president of World Space Satellite Radio in Washington D.C. (Sirius Radio), and on the corporate communications public affairs staff at IDV (now Diageo). He is widely recognized as an authority on promoting international brand image, having worked in London, Brussels, Washington D.C. and most recently Amsterdam, and is renowned in particular for developing effective global communications strategies. Based in Amsterdam, he has an honors degree in law from the London School of Economics.

He can be reached at johnnymclaren@talk21.com

Juan-Carlos Molleda is a professor and the Edwin L. Artzt Dean of the School of Journalism and Communication at the University of Oregon. He has accumulated 21 years of experience teaching and researching public relations and communication management at the University of Florida (2000–2016), the University of South Carolina (1997–2000), and Radford University (1995–1997). Molleda received his bachelor of science degree in social communication (1990) from Universidad del Zulia in Venezuela, a master of science in corporate and professional communications (1997) from Radford University in Virginia and a doctor of philosophy degree in journalism and mass communications (2000) from the University of South Carolina (USC). In 2010, he received the USC School of Journalism and Mass Communications Outstanding Young Alumni Award. Molleda is a member of the Board of Trustees of the Institute for Public Relations, the Latin American liaison for the Public Relations Society of America's Certification in Education for Public Relations program, and a member of The LAGRANT Foundation Board of Directors. Between 2007 and 2013, he also held leadership positions (secretary, vice chair and chair) with the Public Relations Division of the International Communication Association. Between 1987 and 1993, he was manager of public relations, corporate communication and advertising and promotions for a Venezuelan financial consortium. In 1998, 2003 and 2004, he worked "professional summers" at Blue Cross and Blue Shield of South Carolina's Corporate Communications Division, Burson-Marsteller Latin America and Perceptive Market Research. He consulted on strategic planning in international public relations for Mayo Clinic and training on behalf of Weber Shandwick in 2011. He can be reached at jmolleda@uoregon.edu

Kevin Money, PhD, is an associate at Mindful Reputation and the director of The John Madejski Centre for Reputation teaching in the MBA program and Henley Business School's flagship Advanced Management Programme in areas of reputation, responsibility, teams and leadership. He also supervises DBA and PhD research associates. Money also is director of The Positive Psychology Forum, an organization that applies advances in psychology to help individuals and organizations improve their performance through a process of reflection on success and failure. He is a Chartered Psychologist, a member of the International Association of Business and Society and an Academic Board Member of The European Association of Business in Society. He also is a former editor of the *Journal of General Management* and *Manager Update* and has acted as a consultant to major companies and voluntary organizations in the UK, USA and South Africa. He can be reached at kevin_guy_money@yahoo.com

Paulo Nassar has a PhD degree in Communication Sciences from the University of São Paulo (USP), where he is a senior professor. He holds a postdoctoral degree from IULM-Libera Universitá di Lingue e Comunicazione (Milan, Italy) and coordinates the University of Sao Paulo's Study Group of New Narratives (GENN—ECA/USP). He also is CEO of Aberje—Brazilian Association for Business Communication and won, in 2012, the distinction *Atlas Award for Lifetime Achievement International Public Relations* granted by *Public Relations Society of America (PRSA),* award that recognizes individuals who have made extraordinary contributions to the practice and profession of public relations on a global scale.

He can be reached at paulonassar@usp.br.

Cristina Navarro is an assistant professor of communication at the Gulf University for Science and Technology in Kuwait, a member of the Group of Advanced Studies in Communication and author of several publications in various international journals. Her research interests include online public relations, social media channels, leadership and public relations competencies, knowledge and skills. As a researcher Navarro, has been involved in projects such as the European Communication Professionals Skills and Innovation Program, the Cross-Cultural Study of Leadership in Public Relations and the European Communication Monitor. Currently she is participating in the Latin American Communication Monitor, an international research project that monitors trends in communication management and analyzes impacts of global dynamics and media occurrences on Latin American communication departments and agencies. Previously, she worked for almost 15 years in different print and online media as a journalist, and has been consultant to public relations agencies. She holds a Ph.D. in communication from the Rey Juan Carlos University in Madrid, Spain.

She can be reached at Navarro.C@gust.edu.kw

Toluwani C. Oloke is a doctoral student in the College of Journalism and Communication at the University of Florida. Toluwani's research concentration is in the areas of international public relations, social advocacy and cultural gaps in health communication strategies by NGOs. She earned her Master's degree in Communication from Florida State University in 2013. She earned her Bachelor's degree in English in 2007 from the University of Ilorin in Nigeria where she received the University Senate award as the best graduating student in her department. Prior to pursuing her doctoral degree, Toluwani was the public information officer for the African Union Support to Ebola Outbreak in West Africa. She had prior teaching experience as a visiting instructor of public speaking at Florida

A&M University, teaching assistant for fundamentals of speech and mass media law at Florida State University and as a English teacher in a high school in Nigeria. She currently teaches public relations writing at the University of Florida. She can be reached at folaketolu@ufl.edu

Dariya Orlova is a media researcher and senior lecturer at the Mohyla School of Journalism (National University of Kyiv-Mohyla Academy, Ukraine). She received a PhD degree in mass communication from Autonomous University of Barcelona and National University of Kyiv-Mohyla Academy in 2013 with a thesis titled "Representation of 'Europe' in the Mediatized Discourse of Ukrainian Political Elites." Orlova was a visiting assistant professor at Stanford University's Center for Russian, East European and Eurasian Studies during the spring term in 2016, where she taught a course, "Media, Democratization and Political Transformations in the Post-Soviet Societies." Her recent research projects included comparative analysis of media coverage of the conflict in Eastern Ukraine and exploration of the evolving changes in Ukraine's journalism culture and media landscape after EuroMaidan. She is a senior editor of the Ukrainian website of the European Journalism Observatory network, which unites 14 non-profit media research institutes in 11 countries. Orlova has also served as an independent media expert with various NGOs. She can be reached at dasha.orlova@gmail.com

Katie Delahaye Paine is founder and CEO of Paine Publishing, LLC and Publisher of *The Measurement Advisor*, a newsletter devoted entirely to measurement topics. She has spent the last three decades helping organizations define and measure success for their communications programs. She has designed measurement programs and bespoke metrics for some of the world's most admired organizations including NATO, PBS, National Wildlife Federation, AbbVie, Pfizer, Viacom, Procter & Gamble, Southwest Airlines, Raytheon and the Federal Reserve Bank.

Paine was a leading force behind The Conclave's Standards for Social Media Measurement as well as the Barcelona Principles crafted by the Global Alliance for Public Relations Communication and Management. She is the founder of two research companies, The Delahaye Group (now Cision) and KDPaine & Partners (now Carma.) She has authored three books: *Measure What Matters* (Wiley, March 2011) *Measuring Public Relationships* (KDPaine & Partners 2007) and *"Measuring the Networked Nonprofit, Using Data to Change the World,"* which won the 2013 Terry McAdam Book Award for non-profits. Paine is also a founding member of Institute for Public Relations' Measurement Commission, a member of the *PRNews* Measurement Hall of Fame and a board member of the Society for New Communications Research. For

the past decade she has served on the board of Exeter Health Resources, a local community health system that includes the top-ranked hospital in New Hampshire.

She can be reached at measurementqueen@gmail.com

Dr. Swaran Sandhu is a professor of public relations and corporate communication at Stuttgart Media University (Germany). He is responsible for the public relations program in the BA program for Crossmedia Journalism/Public Relations. His research interests cover the nexus between public relation and social theory with a special focus on institutional theory, legitimacy processes and social network analysis. Swaran has published more than 20 articles or book chapters in the *International Journal of Strategic Communication,* and *Management Communication Quarterly* and has contributed to the *German Handbook of PR* (Froehlich/Szyszka/Bentele, 3rd ed.) and *Handbook of Corporate Communication* (Piwinger/Zerfass, 2nd ed.). After receiving his M.S. in public relations (PR) from Syracuse University, Swaran worked in various capacities for the federal state of Baden-Wuerttemberg's innovation agency, covering international project development and innovation management. From 2006 until 2012 he worked as a research assistant at Lucerne University (Switzerland) and finished his PhD in cooperation with Hohenheim University (Germany). During this time he was also a visiting lecturer in communication management at Fribourg and Zurich University (Switzerland). He was a member of the German National Science Foundation funded post-doctoral research group "Organization as Communication" which challenged conventional perspectives on organizational communication. His doctoral dissertation on PR and legitimacy (2012) received the PhD award of the PR division of the German Association for Communication Science (DGPuK). Since 2012 Swaran has been a professor at Stuttgart Media University; his teaching portfolio encompasses public relations theory, organizational communication, social network theory and analysis, and corporate communications and content strategy on BA and MA levels. He was named a Stuttgart Media University teaching fellow in 2015 for excellence in teaching.

He can be reached at sandhu@hdm-stuttgart.de

Masamichi Shimizu is a corporate communication consultant in Tokyo, Japan with extensive experience as both practitioner and educator. He joined Shukutoku University College of Cross-Cultural Communication and Business in 2002 as an assistant professor and became a full professor in 2005, leaving in 2014 to begin his consultancy. He taught courses including public relations, environmental communication and corporate social responsibility. Prior

to that, he worked for an insurance company in the public relations department for three years and at a management consulting/publishing company for 25 years. He has extensive experience in internal communication, magazine editorial communication, corporate identity consulting, local administrative reform consulting, environmental management consulting and public relations management. He has served as general manager of the public relations department at the Japan Management Association. He also is one of the founding members of the Japan Society for Corporate Communication Studies for which he served as president from 2013 until 2015. He has served as a member of various committees for several government agencies and local governments including Japan's Ministry of Economy, Trade, and Industry; Ministry of Defense; Ministry of Labor, and Kawasaki City, among others. He also has published many articles on public relations, local government reform, environmental communication, public relations measurement and corporate social responsibility. Shimiz also has (co) authored many books including *Corporate Culture and Public Relations, Corporate Communication Strategy, PR and AD Propaganda, Introduction to P,* and *PR Practice.* His book titled *Environmental Communication* received the 2010 academic contribution award from the Japan Society for Corporate Communication Studies. He currently heads the Corporate Communication Initiative, a boutique communication consultancy. He also serves as a board member of the Japan Society for Corporate Communication Studies and the Public Relations Society of Japan. He is a member of the Brand Message Promotion Advisory Panel of Kawasaki City.

He can be reached at env.com@shimizu.nifty.jp

Nancy Snow is Pax Mundi Professor of Public Diplomacy at Kyoto University of Foreign Studies in Japan. Snow was previously a visiting professor and Abe Fellow at Keio University (2013–2015) where she conducted research on Japan's image and reputation since March 2011. In 2012 she was Fulbright lecturer in U.S. foreign policy and American culture at Sophia University in Tokyo. An author or editor of 11 books, she is professor emerita of communications at California State University, Fullerton. She was a founding faculty consultant and senior research fellow at the Center on Public Diplomacy, University of Southern California, where she was also an adjunct professor in the Annenberg School. Snow served as the first public diplomacy professor in the S.I. Newhouse School of Public Communications at Syracuse University (2008–2010). Snow is an internationally recognized writer with hundreds of chapters, journal articles, reviews and opinion pieces published in various media, including the *Journal of Communication, The ANNALS of the American*

Academy of Political and Social Science, Los Angeles Times, Japan Times, New York Times, The Diplomat, and *The Guardian.* She has held visiting faculty appointments in Israel and Malaysia and taught public diplomacy at Tsinghua University in Beijing. She advises Tokyo-based Langley Esquire in media and public affairs, and serves as global strategy director for La Ditta Limited, a firm that specializes in Japan product and service promotion.

Francisco Solanich is director and professor at the School of Publics Relations at the Universidad del Pacifico, Chile, and professor of organizational communication at the School of Journalism at the Universidad del Desarrollo, Chile. He has over 18 years of academic and professional experience, emphasizing the teaching of public relations at the national level and being a pioneer in the development of academic publications in Chile on issues related to strategic communications. Solanich earned his Bachelor of Information Sciences degree (1997) and the title of Journalist (1997) at the Universidad Gabriela Mistral. Later he graduated with a Master's degree in educational planning and management (2001) at the Universidad Diego Portales. Additionally, he has taken courses in managing innovation and development program skills for innovation, University of Brighton (Centre for Research on Innovation Management) in conjunction with the Chile Foundation, and introduction to e-learning in higher education, given by the University of Seville, Spain. Solanich is a member of the Council of Social Sciences of the Accrediting Agency of Chile and peer evaluator in the area of social sciences of the agencies Qualitas, Acreditación and Aespigar, responsible for checking the academic quality of institutions of higher education in Chile. Between 2011–2013 he was director of the professional association of public liaisons of Chile and is now part of the board of the Latin American Association of Public Relations university courses, ALA-CAURP, serving as director of research and publications of that entity.

He can be reached at fsolanich@upacificio.cl

Don W. Stacks, Ph.D., is professor of public relations in the Department of Strategic Communication in the School of Communication at the University of Miami, Coral Gables, FL. Stacks has written and published or presented more than 200 scholarly articles, chapters and papers. Stacks has won professional awards, including the Pathfinder Award of the Institute for Public Relations (1999), the University of Miami's Provost's Award for Outstanding Research and Theory (1998); the Public Relations Society of America named him Outstanding Educator (2003) and awarded him the Jackson, Jackson & Wagner Behavioral Science Prize (2005); he was named Outstanding Professor by University of Miami students (1994). Stacks has authored or coauthored 12

books on communication topics, including the award-winning *Primer of Public Relations Research* (now it its 3rd edition), and was awarded the Measurement Standard's "measurement tool" for 2003. He was inducted into the *PRNews* Measurement Hall of Fame in 2012. Stacks was the editor of *Communication Research Reports* (vols. 31–33) and currently serves as co-editor for Business Expert Press collection of public relations books. His awards for public service earned him the Dorothy Bowles Award for Public Service awarded by the Association for Education in Journalism and Public Relations (2014) and the PRIDE Award for Lifetime Achievement in Public Relations. National Communication Association Public Relations Division (2015). He has served on the boards of the Institute for Public Relations (16 years), the International Public Relations Association (6 years), the Association for Education in Journalism & Mass Communication (3 years), and the Arthur W. Page Society (2 years) In addition, Stacks is the CEO and Executive Director of the International Public Relations Research Conference, as well as a founding member of the conference. He can be reached at don.stacks@Miami.edu

Inka Stever is an assistant professor at the College of Communication and Media Sciences at Zayed University in Abu Dhabi. She came to higher education with more than 15 years of work experience in public relations, most recently working in the Global Corporate Communications Department of Daimler-Chrysler Financial Services in Berlin, Germany.
She can be reached at Inka.Stever@zu.ac.ae.

Katerina Tsetsura, Ph.D., is a Gaylord Family Professor of strategic communications/public relations in the Gaylord College of Journalism and Mass Communication at the University of Oklahoma. She has published more than 60 peer-reviewed studies in the areas of international and global media and strategic communication, global journalism, public relations ethics and public affairs in transitional countries and within new digital media environments. She is the co-author of the book *Transparency, Public Relations and the Mass Media* (Taylor & Francis, 2017). Tsetsura serves on editorial boards of *Communication Theory, International Journal of Strategic Communication,* and *PR Review,* among other journals. Currently, Tsetsura is vice chair of the Public Relations Division of the International Communication Association (ICA). Tsetsura also works in Europe and Asia as an independent strategic communication and evaluation consultant.
She can be reached at tsetsura@ou.edu.

Donald K. Wright, Ph.D., is the Harold Burson Professor and Chair in Public Relations at Boston University's College of Communication. He is one

of the world's most published public relations scholars with the bulk of his work focusing on public relations ethics and the impact of emerging media and other new technologies on public relations practice. He is the founding editor of both *Public Relations Journal* published online by the Public Relations Society of America (PRSA) and the *Research Journal of the Institute for Public Relations* (IPR) published online by the IPR. Wright served 24 years on the Board of Trustees of the Arthur W. Page Society, is a past president of the International Public Relations Association (IPRA) and is a long-time trustee of the Institute for Public Relations (IPR). His awards include the Distinguished Service Award from the Arthur W. Page Society (2007), the Pathfinder Award for research excellence from IPR (1991), the Outstanding Educator Award from PRSA (1993) and the Jackson Jackson & Wagner Behavioral Science Award from the PRSA Foundation (2007). He was part of the original class of Research Fellows of the IPR in 2008. He holds a Ph.D. degree from the University of Minnesota and has worked full-time in public relations, advertising and both print and broadcast journalism.

He can be reached at donaldkwright@aol.com

Koichi Yamamura, Ph.D., is a communication consultant based in Osaka, Japan. He also holds a visiting senior researcher position at Waseda University in Tokyo. For more than 15 years, he has been engaged as a communication adviser for clients on cases including crisis management, battles for corporate control, hostile takeover defenses, reputation management, and marketing development. He has served clients including global and domestic companies in industries such as consulting, banking, food, liquor, paper, real estate, textiles, aviation, publishing and pharmaceuticals. He also has served as a communications consultant for investment funds and government agencies and managed a $7 million human resource development project for Japan's Ministry of Economy, Trade and Industry. His article on the historic evolution of public relations in Japan was published in *Public Relations Review*, and his article on hostile takeover defense in the paper mills industry was published online on the Institute for Public Relations website. Several articles in Japanese were also published in *Corporate Communication Studies* and other Japanese language periodicals. He has written case studies on hostile takeover defense and on post-earthquake corporate social responsibility (CSR) activities. He also is active in serving the international public relations research community. He is an advisory committee member of the International Public Relations Research Conference, and a board member of the Japan Society for Corporate Communication Studies. Prior to engaging in the communication

advisory business, he was in the aluminum industry for 18 years and has held senior management positions in most of those years. Dr. Yamamura received a Bachelor of Liberal Arts degree from International Christian University in Tokyo, a Master of Science in Public Relations degree from Boston University, and a Doctor of Philosophy in Communication degree from University of Miami.

He can be reached at koichi.yamamura.55@gmail.com

Xiaodong Yin is the founder of 17PR, the largest public relations online platform in China, and is the Vice Secretary-General of the Public Relations Society of China. Yin graduated from Xi-An University of Science and Technology and started her career in communication in 2000. She established 17PR in 2004 (www.17pr.com) and received he Golden Flag Award in 2010. Having extensive experience in advertising and media and a thorough observation of the development of public relations in China, Yin has expertise in branding, corporate social responsibility and crisis management consultancy. 17PR now is the major media platform for public relations resources and services and has played a significant role in the development of the public relations profession in China. The Golden Flag Award, which she received in 2010, highlights outstanding public relations practitioners and cases in China and is one of the main forces for enhancing public relations academia and industry collaborations in China.

She can be reached at: yinxd01@17pr.com.

Bo Ra Yook is a doctoral student with a focus on public relations in the School of Communication at the University of Miami. Her research interests are risk and crisis communication, issue management, corporate communication and social media. Her academic presentations and publications focus on finding influential factors on publics' perceptions and judgements in crisis communication, and the use of social media in corporate communication and its effect on managing issues, risks, and relationships with stakeholders. Yook is currently working on several book chapters and scholarly articles related to these topics. She utilizes both quantitative and qualitative research methods in her research studies. She is a research and teaching assistant at the University of Miami, and serves as a conference coordinator the International Public Relations Research Conference (IPRRC). Yook earned her M.S. in public relations from Boston University and her B.S. degree in multimedia science with a double major in public relations and advertising from Sookmyung Women's University in South Korea. She formerly worked as an account executive for more than four years at AdAsia, a multicultural marketing communication

agency in New Jersey. In her professional experience, she managed public relations and advertising campaigns with corporate clients from financial, telecommunications, healthcare, automobile and cosmetic industries. She won the Advertising Excellence Award from the Institute of Advanced Advertising Studies I New York presented by the American Association of Advertising Agencies (4A's) in 2011. She worked as an intern in the 17th South Korean presidential campaign and for the Korean Broadcasting System (KBS) in Seoul, South Korea.

She can be reached at bxy91@miami.edu

Robina Xavier is Executive Dean of the QUT Business School at the Queensland University of Technology (QUT) in Brisbane, Australia. She has more than 20 years' experience in public relations and communication both as an academic and executive. Prior to joining QUT, Xavier worked as a consultant to both the private and public sectors, specializing in corporate and financial relations. She is a former national president of Australia's leading public relations industry body, the Public Relations Institute of Australia (PRIA), and is a former chair of the industry's National Education Committee that oversees accreditation of Australian university programs. Xavier is a Fellow of the PRIA and a Senior Fellow of the Financial Services Institute of Australasia. She also is the co-editor of *Public Relations Campaigns* published by Oxford University Press.

She can be reached at r.xavier@qut.edu.au

Index